FUTURIST PERFORMANCE

D1433033

FUTURIST PERFORMANCE

includes manifestos, playscripts, and illustrations

Michael Kirby

and

Victoria Nes Kirby

PAJ PUBLICATIONS
New York

© 1986 Copyright by PAJ Publications
© 1971, 1986 Copyright by Michael Kirby and Victoria Nes Kirby

All rights reserved
No part of this publication may be reproduced or transmitted in any form or by any means, electronic or mechanical, including photocopy, recording, or any information storage or retrieval system now known or to be invented, without permission in writing from the publishers, except by a reviewer who wishes to quote brief passages in connection with a review written for inclusion in a magazine, newspaper, or broadcast.

All rights reserved under the International and Pan-American Copyright Conventions. For information, write to PAJ Publications, 325 Spring Street, Suite 318, New York, N.Y. 10013.

Library of Congress Cataloging in Publication Data
Futurist Performance
Library of Congress Catalog Card No.: 86-63186
ISBN: 1-55554-009-0

Printed in the United States of America

Publication of this book has been made possible in part by grants received from the National Endowment for the Arts, Washington, D.C., a federal agency, and the New York State Council on the Arts.

PN
2684
K57
1986

OLSON LIBRARY
NORTHERN MICHIGAN UNIVERSITY
MARQUETTE MICHIGAN 49855

TO MY FATHER
Captain Jack Kirby
(1900–1959)

Preface

Fortunato Depero, the Futurist painter and sculptor, died in Rovereto in November, 1960. When we visited his widow, Rosetta Depero, at her home in Rovereto in the summer of 1969, she was excited and pleased that people from the United States were interested in her husband's work, but she was also disturbed. "Why didn't you come before?" she asked. Why had no one studied Depero's work in performance while he was still alive? We didn't attempt to answer.

When asked about some detail of her husband's work on the *Plastic Dances,* Signora Depero thought very hard but could not remember. She had been there and had seen the performances, but she could no longer picture them in her mind. She seemed frustrated and helpless. History was slipping away. Like an unfixed photographic print exposed to the light, the images were growing dark and disappearing. Talking to Rosetta Depero, one realized that the past is almost impossible to reconstruct with accuracy. Even the history of our own century, involving the experiences of people who are still living, is becoming unavailable to us.

This is meant as an observation, not as an excuse. If this book had been written ten or twenty years ago, it might have been quite different. Written now, it attempts to halt the process of fading, to preserve a record of certain works, to make important manifestos and playscripts available in English translation, and to offer an interpretive survey of the performances of the Futurists.

There is no claim made for completeness. The conscious limitations of the book result, in part, from a purposeful emphasis upon what can be considered to be important in the light of contemporary trends in performance. Works that required great effort and, at the time, received considerable attention are not mentioned or are

referred to only briefly. It is possible that others might emphasize different aspects of Futurist performance.

Another reason that no claims can be made for completeness in this book is that it attempts to survey the field, emphasizing particular significant points, rather than exhaustively detailing any area. In Rosetta Depero's living room is a brown wooden cabinet or sideboard about four feet high with double doors. The cabinet is completely filled with stacks of Depero's notes and sketches. Nobody, not even his wife, has gone through them since his death. Nobody knows what is there. Professor Ferruccio Trentini, the director of the Depero Museum in Rovereto, reached into the cabinet and took a paper, apparently at random: on it were notes made in 1915 by Depero for kinetic and sound-producing costumes.[1] That is the situation. One imagines, if only metaphorically, many cabinets like that in Depero's house. They contain notes, drawings, scripts, diaries filled with anecdotes. Somewhere *Vita Futurista* or other early film experiments might be found. Somewhere there may be photographs of early performances; somewhere, perhaps, there is a photograph of the airplanes in Azari's Aerial Theatre, painted in bold Futurist patterns. In recent years, Italian scholars have begun to do excellent research, but much more work can still be done, and needs to be done, on Futurist performance.

In addition to Rosetta Amadori Depero and Professor Trentini, many people aided our research in Italy. We should particularly like to thank Giovanni Calendoli; Cesare Sughi, editor of *Sipario*; Walter Alberti, of the *Cineteca Italiana* in Milan; Antonella Bragaglia, of the Bragaglia Studies Center in Rome; Dr. Alessandro Prampolini; Antonio Proietti, of the Biblioteca Nazionale di Roma; Luigiana Franco, of *La Biennale di Venezia*; Francesco Cangiullo; Guido Ballo; Mario Fratti; and Luce Marinetti Barbi. The help of James Card of Eastman House in Rochester, New York, and Jane Nes with our investigation of *Il Perfido Incanto* is also appreciated. Our research was made possible, in part, by the generosity of Emma Eaton ver Hulst and by a research grant from Saint Francis College in Brooklyn, New York.

Our deep gratitude is extended to those who very kindly gave us permission to publish material: Arnaldo Ginna Corradini and Dr.

[1] A translation of these notes appears in the Appendix, p. 207.

Ala Pratella, the daughter of F. Balilla Pratella, in addition to Dr. Alessandro Prampolini, the brother of Enrico Prampolini, and Francesco Cangiullo; the publications *Sipario, La Biennale di Venezia,* and *Bianco e Nero;* and the Gallerìa d'Arte l'Obelisco. The work of the Italian Society of Authors and Editors in reaching those who held rights to published material was most helpful.

For their contributions to the manuscript, we should like to thank Evelyn Kirby, E. T. Kirby, Brooks McNamara, Richard Schechner, and Monroe Lippman. The finished book would not be the same without their suggestions.

Livio Caroli and Betty Caroli were very generous in their help with the translation of the material. We are indebted to them for their extensive work and very valuable suggestions. We should also like to thank Nancy Nes for her help on certain portions of the translations.

Michael Kirby
Victoria Nes Kirby

Contents

Illustrations

FUTURIST PERFORMANCE

1] Introduction

Futurist performance is virtually unknown in the United States. Although the historical importance of Futurist painting and sculpture is widely appreciated, many people who are familiar with these aspects of the movement and even with its innovations in poetry are completely unaware that the Futurists also worked in all areas of performance: drama, opera, dance, music, and cinema. Theatre historians have either ignored Futurism almost completely or have rejected it. One illustration of this rejection, from a survey of "The Italian Theatre After the War," will suffice:

> We spoke, a moment ago, the word "futuristic." And the reader will probably wonder how . . . we have been able to speak of so many programs, schools and currents, without yet mentioning futurism. We confess frankly that we had forgotten it. And, in the last analysis, the serious thing is just this, that one can forget it.[1]

There is some irony in this. Even people who know little else about Futurism know the name of its charismatic founder, Filippo Tommaso Marinetti (1876–1944). Marinetti was not a painter, however, and only produced a very limited, if quite important, amount of sculpture or sculptural constructions. A great deal of Marinetti's seemingly limitless energy went into performance. When he issued the initial "Foundation and Manifesto of Futurism" in 1909, he already had a reputation as a playwright, having published *Le Roi Bombance* and *Poupées Électriques*.[2]

[1] Silvio D'Amico, "The Italian Theatre After the War," in *The Theatre in a Changing Europe*, ed. Thomas H. Dickinson (New York: Henry Holt and Company, 1937), p. 250.

[2] *Le Roi Bombance* was published in *Mercure de France* (Paris, 1905). *Poupeés Electriques* was published by Sansot, Paris, in 1909, prior to the pub-

It is, of course, the intent here to demonstrate that this rejection of, or lack of interest in, Futurist performance is unjustified historically and theoretically. There are three important reasons that this aspect of Futurism has been ignored: political thought, national bias, and historical change.

It is true that many of the Futurists were Fascists. It is true that Marinetti, as early as 1914, was a good friend of Benito Mussolini; that *Roma Futurista,* a daily newspaper printed to publicize the movement, also contained articles praising the future dictator, and that later Futurist publications were sometimes dedicated to him or contained his picture. This connection between Futurism and Fascism may be interesting sociologically. It may even help to explain certain aspects of the movement. The value of art, however, is not measured by political standards. Appreciation of a piece is not dependent upon knowing the beliefs of its creator. Great art is not necessarily produced by heroes, nor are "villains" unable to create major works.

Yet this type of thinking has been responsible, in part, for the denigration of Futurist performance. In discussing one of the most interesting theatrical developments of the Futurists, the Aerial Theatre of Fedele Azari, one well-known writer on the avant-garde states:

> Seen in its time, such ostentations seem like humorous occurrences, diverting but innocuous. They offer a very different character when confronted in the light of later history, because then their latent grotesqueness, if not tragedy, appears; when, for example, one remembers the "hurrah"s of the Italian Air Force burning the straw huts and adobes of Ethiopia.[3]

The writer makes his political bias even clearer by going on to explain that true aerial heroism was not embodied by any Futurist but by Lauro de Bosis, a poet who, while dropping anti-Fascist leaf-

lication of the manifesto. The later play was produced at the Teatro Regio in Turin on January 15, 1909.

[3] Guillermo de Torre, *Historia de las Literaturas de Vanguardia* (Madrid: Ediciones Guadarrama, 1965), pp. 147–148. (My translation.)

lets over Rome in 1931, crashed and was killed, thus giving "actual form to his poem 'Icarus.' "

If it is true that the accomplishments of the Futurists in performance have been ignored or rejected because of the political affiliations of many members of the movement, why has the same thing not happened to Futurist painting and sculpture? If memories of World War II have hindered American understanding of Italian art in this second *dopoguèrra,* why has the effect not been equally strong on all aspects of the Futurist movement? The answer is that appreciation and criticism of painting and sculpture exist at an entirely different level from the appreciation and criticism of theatre. In theatre, there is an orientation toward what a piece *means* rather than what it *is;* the response is *interpretative,* explaining the work in terms of something else. This "something else" is frequently politics. Whereas painting and sculpture are more commonly accepted without interpretation, a secondary elaboration of meaning, which is often political, tends to occur in theatre.

This is not to argue merely that totally abstract or nonrepresentational sculpture and painting are widely accepted, while comparable forms of theatre are not. The process of subjective secondary elaboration of meaning can occur with both nonrepresentational and representational works. Azari's Aerial Theatre was basically nonrepresentational; it was the spirit of his work, rather than any literal content, that was interpreted as political. Most of the Futurist performances were "about" something, however. They, too, are dismissed for political reasons, even though few of them were political in any way and none was explicitly Fascist. The guilt, if any exists, is only by association, but theatre historians and critics still use this type of interpretative thought to deprecate the Futurists.

The second reason for the neglect of Futurist performance may be referred to as "national bias." This means that we have tended to take our view of the history of the arts from the French and that they, in turn, have tended to stress the importance of French developments at the expense of those in other countries. The fact that until after World War II Paris was considered the art center of the world might be enough to establish the first part of this contention: many, if not most, of the important artistic innovations of the

nineteenth and early twentieth centuries did occur in France, and it was the logical place to look for an understanding of these developments. That the French view of art has tended to be chauvinistic is more difficult to establish. It could be pointed out that books dealing with avant-garde drama and the Theatre of the Absurd, for example, stress the importance of Dada without devoting space to Futurism; but there is the possibility that no oversight is involved and that Futurist performance is, indeed, unimportant. Once its true importance is understood, however, the chauvinistic bias becomes apparent. Dada, it might be argued, is accepted by the "French school" of avant-garde chronology even though it originated in Switzerland. But Dada migrated, in part, to Paris—its history in Germany is still not well documented in English—and was crucial in the development of a truly French movement, Surrealism. Although Futurism should not be elevated at the expense of Dada, the earlier movement achieved many of the things for which Dada is given credit, and its work in, and contributions to, performance are much more extensive.

In order to support these first two claims, it must be demonstrated that Futurism made significant contributions to, or was vitally necessary for, the historical development of theatre as it is generally understood. As we shall see, Futurism influenced nonrealistic playwrights such as Pirandello and Thornton Wilder and was basic in a line of development leading through Dada and Surrealism to the Theatre of the Absurd.

Twenty years ago, however, there was little interest in Dada and Surrealism. Until the popularity of the Theatre of the Absurd, little attention was paid to its forebears. This indicates that, like other histories, the history of theatre is not fixed. It is constantly being modified, changed, rewritten. These changes are made primarily in an attempt to understand the present: As contemporary theatre changes, it is necessary to alter our view of what is historically important. The meaning and significance of the theatre of the past is being created by the performances of the present.

From this point of view, it is understandable why there has been little interest in Futurist performance. The Futurist theatre had

little relationship to the tradition of realism, frequently tinged with the poetic, that dominated serious theatrical thought in the United States during the third and fourth decades of this century. Although Futurist painting had a place in the historical development of its art form, Futurist drama did not. There appeared to be no need, so to speak, to understand it.

This situation has changed completely. Since about 1960, a new theatre has developed that has attracted much attention both in this country and in Europe. Many of the concerns of this new theatre may be traced to Futurism, making the theories and performances of the Futurists of great interest and importance.

Although the aesthetic interests that define the new theatre are shared by many individuals and groups, a great deal of diversity can be recognized and no individual or group can be said to typify all of them. Basically, the new theatre is manifest in two forms: performances that retain an information structure analogous to literature and those that eschew such structures for alogical ones.[4] In the first category are, among others, Jerzy Grotowski's Polish Laboratory Theatre, the Living Theatre, and the Open Theatre; in the second are so-called Happenings and related forms. Both branches of the new theatre generally share an interest in the physical audience-performance relationship and in a physicalization of performance that leads, in part, to circus and circus-like techniques. Frequent use is made of simultaneous presentation. The nonrepresentational presentations, in particular, have tended toward extending performance through the use of motion pictures, television, amplified sound, and other mechanical and technological means. All of these concerns can be found in Futurist performance and performance theory.

The alogical branch of the new theatre has been produced almost exclusively by painters and sculptors and is fundamentally art-oriented. It is the most recent manifestation of an art theatre that, finding its origins to a great extent in Futurist performance, has

[4] For a discussion of informational and alogical structures, see: Michael Kirby, *Happenings* (New York: E. P. Dutton & Co., 1966), pp. 13–14; or, by the same author, "The New Theatre," in *The Art of Time* (New York: E. P. Dutton & Co., 1969), pp. 75–98.

existed in an unbroken line of development until the present time. In understanding these developments, an awareness of Futurist thought and production is crucial.

In these terms it is important to stress the close relationship between Futurist performance concepts and developments in other arts. The movement programmatically attracted artists from all fields and brought them into contact with each other; the typical Futurist, no matter what his major area, tended to work in more than one discipline. Thus Futurist performance developed in a milieu involving all the arts and was produced to a great extent by artists who also worked in nonperformance areas. Luigi Russolo (1885–1947) was a painter and one of the five signers of the basic 1910 "Manifesto of Futurist Painting" before switching his attention to music. Umberto Boccioni (1882–1916), Giacomo Balla (1871–1953), and Fortunato Depero (1892–1960), who primarily devoted themselves to sculpture and painting, also wrote plays. The painter-writer Arnaldo Ginna (1890–) was responsible for the first Futurist film.[5]

Before beginning the study of Futurist performance itself, it is important to decide what we mean by the word "Futurism." The artists who constitute some art movements—Pop Art, for example—are determined on stylistic grounds by critical judgment; "membership" is frequently denied by many of those who have been designated as belonging. Since Futurism was a formal art movement with membership and a self-proclaimed identity, however, it seems relatively simple to determine what may or may not be considered a "Futurist" performance. Any work by an artist who identified himself with, and was accepted by, the Futurists can be judged as "Futurist."

Although it may seem obvious, such a preliminary distinction can help to clarify certain points. Anton Giulio Bragaglia (1890–

[5] If this interrelation of Futurist performance with other art forms can be presented as a justification of its importance and a reason for its study, it may also be an additional explanation of its dismissal by theatre historians. The history of performance has been seen to have little relationship to the history of painting or sculpture except as those arts have been used to decorate stages. Aesthetic/philosophical connections have been scarce, and the development of performance has been traced as a more or less self-sufficient discipline.

1960), for example, is frequently identified as a Futurist and his work used to exemplify Futurist theatre. There is no question that Bragaglia was an early member of the movement: the photographs of moving figures published in his *Fotodinamismo Futurista* in 1911 had great influence on Futurist painting and stand as lucid examples of certain basic concerns of the movement. Yet, according to his daughter, Antonella Bragaglia, who maintains the Bragaglia Studies Center in Rome, the artist separated from—or was expelled by—the Futurist movement in 1913. His work after that time should not be considered Futurist. As might be expected, there were Futurist elements in some of it, just as might be found in the creations of other theatre artists working at the time. Bragaglia remained friends with the Futurists and staged many of their plays at the Teatro Sperimentale degli Indipendenti that he had established in the ancient Roman baths of Septimus Severus under Mussolini's modern Palazzo Titoni at 6 and 7 via degli Avignonesi. Bragaglia, however, was an eclectic involved with the *commedia dell'arte* and Oriental theatre as well as with contemporary developments. Just as his review of the arts, *Cronache d'Attualità* (1916–22), published Schiele, Kokoschka, Klimt, Maeterlinck, Pirandello, and Archipenko in addition to Balla, Depero, Prampolini, and Pratella, his theatre, which was founded in 1922 and which he directed until 1936, presented productions by Jarry, Apollinaire, Strindberg, Chekhov, Büchner, O'Neill, and Brecht in addition to Marinetti, Settimelli, Folgore, and Carli.

Official adherence to the Futurist movement can be accepted as a useful criterion in trying to ascertain the nature of Futurist performance, but it is only a preliminary one. All works by self-proclaimed Futurists are not worthy of equal attention. Many playwrights were nominally accepted into the movement and were even published and extolled by Marinetti and the Futurists in what must have been primarily an attempt to gain strength through numbers. This was especially true in the later years of the movement. Examples of every current style and trend were labeled as "officially" Futurist with little apparent discrimination. Dramatists of many different persuasions and inclinations can be found in the ranks. The movement seemed to be open to those who wanted to join and support it without much regard for stylistic consistency.

Thus, in addition to membership in the movement, a second criterion is necessary in focusing upon Futurist performance: it is important to understand to what extent a work truly represents the important and unique contributions of Futurism. Although the image of Futurism can become blurred if we take a broad view, it is possible to discover and define those elements that belong only or primarily to Futurism and give it its character, quality, and identity. To some extent this type of judgment is stylistic. To some extent it involves relating Futurist performance to what we know of Futurism in the other arts. To some extent it means relating the statements of purpose and intent that are found in the Futurist manifestos to the actual work in performance. The point is not to catalogue the range of performances that may be called "Futurist" because their creators were, at the time, members of the movement, but to attempt to understand the nature of Futurism itself and its particular manifestations in performance. As with any movement, Futurism may best be understood in terms of certain works that most accurately represent its achievement and contribution; other works, equally substantial or even more substantial as productions, may safely be ignored.

It is not necessary to go further than the work of Marinetti to establish this point. From a purely technical point of view, all of Marinetti's plays written after 1909 may be considered as Futurist. But on stylistic grounds, his longer plays such as *Il Tamburo di Fuoco* (1922), *Prigionieri* (1925), and *Vulcano* (1926) seem to relate much more clearly to Symbolism and Expressionism than to the movement he headed. They contribute little or nothing to our understanding of the important contributions of Futurism to performance. In a brief note introducing *Il Tamburo di Fuoco*, Marinetti wrote:

> I have not been able to achieve my goal with a synthetic drama. I then wrote this impressionist drama with comparable theatrical development. No concession to your traditional tastes! You shall soon have new ultrafuturist theatrical *sintesi*! [6]

The truth may be read clearly through Marinetti's bravado: *Il Tamburo di Fuoco* was one of his concessions to somewhat traditional

[6] *Teatro F. T. Marinetti,* ed. Giovanni Calendoli, 3 vols., Vol. 3, p. 3. (My translation.)

tastes. Even his use of Futurist music in the performance was inadequate in terms of Futurism itself, as will be pointed out later. But Marinetti himself did create "ultrafuturist" theatrical works of great originality and importance. Even as late as the nineteen-thirties when he was producing his "Radio Sintesi," he was able to create performance pieces that were pure and powerful examples of Futurist concerns.

It is important to point out that "Futurism" is not used here to include Russian Futurism. There is no question that, although the Russians claimed complete originality, they were influenced by the Italians. Marinetti's manifestos apparently were circulated among the Russian artists and were republished in both French and Russian; the name of the movement itself was adopted by the Russians from Marinetti, perhaps because it was receiving wide attention if not understanding. Marinetti visited Russia in 1914, where he spoke in both Moscow and St. Petersburg.[7] But just as Italian Futurism owed a large debt to French Cubism while establishing its clear and independent identity as a movement, the Russian Futurists, who were also greatly influenced by Cubism, deserve to be studied on their own terms. Their work in performance is very important and their relationship to the Italian group very complex: Mayakovsky's *Vladimir Mayakovsky* and Kruchenykh's *Pobeda nad Solntsem* (*Victory Over the Sun*), for example, were produced as early as December, 1913. But the development of Russian Futurist theatre is most properly considered as a basically independent one and is beyond the scope of this investigation.

[7] Raffaele Carrieri, *Futurism* (Milan: Edizione del Milione, 1963), pp. 129, 133. Vladimir Markov, *Russian Futurism: A History* (Berkeley: University of California Press, 1968), pp. 147–163. Carrieri (p. 129) and other Italian writers state that Marinetti also visited Russia in 1910. Markov says that Marinetti made only one trip. Since the 1914 visit is fully documented and no details are available about the earlier trip, Markov's view seems correct. By 1914, of course, Russian Futurism already had a distinct character, and it would seem that some Italians are a little too anxious to show that it was merely a subdivision of their native movement.

II] The Origins of Futurist Performance

The basic character of Futurist performance began to crystallize very early in the history of the movement. The impulses that later were to become modified by specific concerns in the areas of drama, music, and scenography were, at this stage, primordial and, to some extent, nonaesthetic. They involved the very foundations of performance: the relationship between the presentation and the audience. And they were impossible to isolate from the basic thrust of Futurism itself.

When Marinetti published the initial Futurist manifesto in *Le Figaro* on February 20, 1909, he was known as a playwright, as has been previously mentioned. He was, however, primarily a poet. The manifesto speaks more specifically of the poet than of other artists, and the basic orientation of Futurism at that time can be considered to be toward poetry. Painters and sculptors were among the first to join the movement, and one might assume that the tendency would have been away from performance. Two factors carried the formative group into the area of theatre, however: in the first place, while much of the poetry explored and exploited the visual possibilities of the printed page, much of it was intended to be read aloud; in the second place, the proliferating manifestos were not merely published documents but also were declaimed from the stages of theatres.

As early as 1910, when the focus of the movement was settling in Italy after its official birth in another country and language, the Futurists presented public readings of their poetry and manifestos. These were not the hushed and dignified poetry readings that were known in the nineteenth-century salons or the genteel and politely appreciative gatherings we find today. The initial manifesto had opened with the words "We wish to sing of the love of danger, the habit of energy and audacity"; several lines later it stated flatly that

12

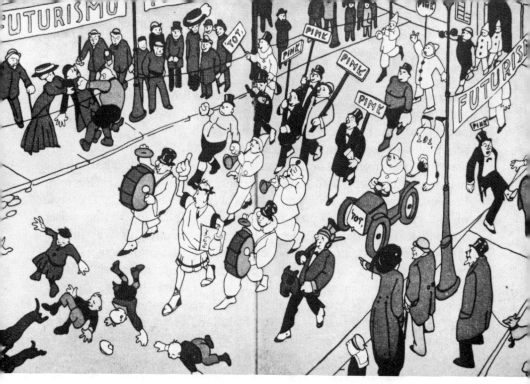

Fig. 1. A Futurist parade. Cartoon by Manca from *Poesia,* August–October 1909. The figure leading the parade, wearing Roman clothing, and carrying a copy of *Poesia* appears to represent Marinetti. Note the aggression toward the spectators demonstrated, even at this early date, by some of the Futurists. (From a reproduction in *Futurist Art and Theory 1909–1915* by Marianne W. Martin [Oxford: Clarendon Press, 1968].)

"There is no more beauty except in strife." In their own terms, the Futurist readings were very beautiful: Most of them generated a very active response by the audience and created a dangerous environment for the performers. Several presentations ended in actual riots.

Many plays had provoked riots in the past: the reaction to Victor Hugo's *Hernani* in 1830 was legendary; in order to increase the spectators' anger and resentment, Alfred Jarry had spent ten minutes talking to the audience before the curtain went up at the tumultuous 1896 opening of his *Ubu Roi;* Marinetti himself had emulated Ubu closely enough with his oral/anal *Le Roi Bombance* to create a stormy uprising in the audience when it was first staged by Aurelien Lugné-Poë in 1909 at the same Théâtre de l'Oeuvre in

Paris where Jarry's plays had been produced. But the confrontation of the audience by the Futurist was completely direct, systematic, thorough, and protracted. Moving from city to city, they presented a series of outrageous and provocative opening nights in which every aspect of the evening contributed to the desired effect. The attitude of the readers was arrogant, confident, energetic, and belligerent; they exchanged comments and insults with the spectators. The style of the reading was loud and direct, making use of supporting noises and musical sounds. And the content of the manifestos was inflammatory: their programmatic rejection of the past and their exhortations to burn the libraries and flood the museums was enough, in itself, to infuriate most of the people in a country that was strongly oriented toward its artistic heritage. (A favorite target of the Futurists was the *"passatista"*—an old-fashioned, conservative or *passé* person; the term may be translated as "passéist.")

At first these evenings belonged to Futurist poetry and the reading of manifestos. The first evening in which the painters also participated was held at the Teatro Ciarella in Turin on March 8, 1910. The reputation of the Futurists preceded them, and the audiences knew what to expect: Bruno Corra tells of the small vegetable store that dramatically reversed its bad fortune for the day and sold out its entire stock when, just before closing time, people attending the Futurist presentation at a nearby theatre rushed in for missiles.

The history of Futurism is filled with accounts of these *serate* or Futurist evenings. Francesco Cangiullo (1888–) remembers a winter evening in Florence in 1914 at the Verdi Theatre:

> . . . the showers of potatoes, oranges and bunches of fennel became infernal. Suddenly he [Marinetti] cried, "Damn!" slapping his hand to his eye. We ran to help him; many in the public who had seen the missiles land protested indignantly against the bestial cowardice, and, with what we shouted from the stage, the place became a ghetto market where things were said that cannot be repeated, much less written.
>
> I see Russolo again with saliva running from his mouth; I hear Carrà roaring, "Throw an idea instead of potatoes, idiots!" And now the spectators shouted at Filiberto Scarpelli who, to demonstrate

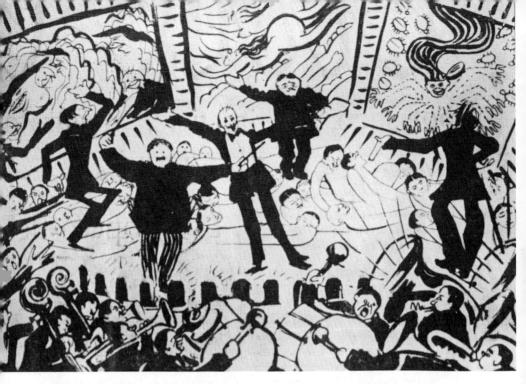

Fig. 2. A caricature (published in 1911) of a Futurist *serata* by Umberto Boccioni. The Futurists on stage are, from left to right, Boccioni, Pratella, Marinetti, Carrà, and Russolo. Note the paintings displayed from the stage and the piles of defeated and unconscious passéists. (From a reproduction in *Futurism* by Raffaele Carrieri [Milan: Edizioni del Milione, 1963].)

solidarity, wished to be with us on stage, "Hey you? You! Poor Gianchettino (that was his pseudonym), what do you want? Buffoon!"

I, with a table leg in my hand, wanted to look for a place . . . to support it in the audience. But Marinetti reproached me.[1]

If Marinetti was able to restrain Cangiullo and the other Futurists at "The Battle of Florence," it was not always that way. In 1921, when short plays were appearing in the presentations, the London *Times* reported an encounter at the Margherita Hall in Rome:

Few [of the scenes] could be understood because the showers of

[1] Francesco Cangiullo, "La Battaglia di Firenze," *Sipario* (December, 1967), p. 29. (Unless otherwise noted, all translations are by Victoria Nes Kirby.)

beans, potatoes, tomatoes, and apples often drove the actors off the stage . . .

. . . the audience grew so furious towards the end the actors could hardly be persuaded to come on stage at all. Marinetti himself, who fought well for Italy during the war, supported the bombardment almost without flinching, although he was hit on the head several times by apples and tomatoes, and his dress shirt was spotted with tomato juice, but the company was not quite so brave. When Futurist artists came on the stage carrying paintings they had achieved they used their masterpieces quite frankly as shields.

At one time when the curtain was down a member of the audience dashed on to the stage to fill his pockets with ammunition that was lying there, but one of the younger Futurists saw him and pursued him, giving him a mighty kick as he jumped into the nearest box, and thereafter the audience was definitely hostile. A vase, several saucers, and five and ten centesimi pieces were hurled at the actors, and the leading lady received a severe blow over the eye from an unripe tomato. The occupants of the orchestra stalls suffered considerably from tomato juice and beans. And the performance came to a premature end when the actors themselves began to hurl vegetables and fruit back at the audience.

After the theatre had closed Marinetti was badly handled by the mob in the street because he refused to return their money, and he had to be rescued by troops.[2]

And still another picture of Marinetti confronting an aroused audience appears years later, in 1925:

In Naples . . . at the Teatro Bellini, in the presence of immovable and inscrutable Italian police, the crowd threw real fruit at the stage and indulged in heavy repartee with the actors. Marinetti . . . looks like a solid little politician enjoying a comfortable berth with the government. Short and very bald, he stands on stage, ducking potatoes and apples with great aplomb and shaking his fist at the mob while he shouts to them that it would take a microscope to see their souls.[3]

[2] *Times* (London), quoted in "Making a Target of the Audience," *The Literary Digest* (December 3, 1921), p. 27.

[3] Maxim Gordon, "The Italian Futurists," *Theatre Magazine* (September, 1925), p. 50.

In these early *serate* lie the bases, however primitive, for almost all of the important Futurist developments in performance. But the "evenings" must not be considered only in terms of their most superficial and obvious qualities. One of the problems in evaluating them is to separate the artistic from the sociopolitical, the aesthetically viable from the merely polemic.

In addition to being artists, many of the pre-World-War-I Futurists were also political activists. Unlike the majority of contemporary artists, they were strongly in favor of war, and they staged

Fig. 3. A Futurist *serata* at Milan's Teatro Fossati in 1921. (From a reproduction in *Noi Futuristi* by Rodolfo DeAngelis [Venice: Edizioni del Cavallino, 1958].)

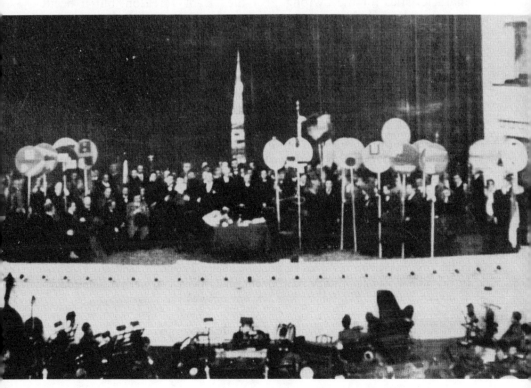

militant and anti-pacifist demonstrations that were quite similar—at least in their relationship with the audience—to their *serate* in the theatres.[4] The same style, so to speak, was being used for other purposes.

Even in the "evenings" themselves, the question arises of how much of the activity was "political" propaganda for the movement and how much of it was art. Unless one is ready to call everything art—in which case there would be no justification for using the word at all—the question is a valid one. But whether we consider the Futurists to be energetic opportunists who went to extremes with their personal publicity or whether they were committed artists with a messianic involvement with proselytizing, does not really matter in terms of their art. Why an artist produces a particular product may be interesting from a psychological or sociological point of view, but it is unimportant aesthetically. A work of art may have certain characteristics for the "wrong" (or the "right") reason, but it need be only the characteristics that concern us.

Thus each of the early *serate* cannot, as a whole, be considered as a work of art. They were not total aesthetic entities, but a mixture of art, polemics, and quasi-political action. They were also, however, the manifestation of an attitude toward life. This attitude would also affect and control any works of art that were produced, and when an authentic Futurist theatre did develop, it reflected these concerns. Even before the first pure examples of Futurist theatre were created, the fundamental aesthetics deriving from the *serate* were elucidated, if somewhat indirectly, in the manifesto of "The Variety Theatre." The manifesto does not refer to the "evenings" at all, but it can be read as a clear explanation of their basic implications for performance.

[4] Marinetti, Settimelli, and Corra refer to these anti-pacifist demonstrations in the first paragraph of "The Futurist Synthetic Theatre" manifesto (1915). In the second paragraph they state emphatically that *"it is not possible today to influence the warlike Italian soul, except through the theatre."*

III] "The Variety Theatre" Manifesto

The "official" date for the release of "The Variety Theatre" manifesto written by Marinetti was September 29, 1913; it first appeared in *Lacerba,* October 1, 1913.[1] Sometimes called the *"Caffè Concerto"* manifesto, it has been republished many times. One of the earliest republications—one that is sometimes indicated as the initial one in Italian sources—was in the London *Daily Mail* on November 21, 1913. The title in this English incarnation was "The Meaning of the Music Hall," and it bore the byline "By the only intelligible Futurist, F. T. Marinetti."

A note by the *Daily Mail* at the beginning of its version of the manifesto stated, in part, that:

> We accept no responsibility for this effusion, which is sure to interest both those who understand it and those who do not; except to this extent, that in the interest of the latter class, who are possibly less numerous than we suppose, it has been slightly—very slightly—edited.

The editing was more extensive than was admitted: it cut more than nine paragraphs, including some of the most interesting and important ones, but the translation was quite accurate, and, certainly, enough remained of the manifesto—which is quite repetitive—to establish its basic ideas and flavor.

The second early foreign publication of "The Variety Theatre" manifesto was in Gordon Craig's *The Mask* in January 1914. It now

[1] The official date assigned to a manifesto seldom indicated the day it actually was published. "Many manifestoes are dated on the eleventh of the month since Marinetti attached particular importance to that number." Joshua C. Taylor, *Futurism* (New York: The Museum of Modern Art, 1961) p. 121.

19

bore the title "In Praise of the Variety Theatre," and a footnote indicated that it was "The first unabridged English translation." This version was also incomplete. Although it retained the original format, three one-paragraph sections and Marinetti's fanciful *parole in libertà* ending were omitted, and one fabricated paragraph—apparently an attempt at summarizing the final poetic passages—was inserted.

At any rate, "The Variety Theatre" manifesto did receive wide distribution, if sometimes in a slightly altered form. In it can be found almost all of the major concerns of Futurist performance.

In considering the manifesto, it is very important, first of all, to realize that the variety theatre—music halls, cabarets, nightclubs, and circuses—was not intended to be taken literally as an example of Futurist theatre. It was the "only theatrical entertainment worthy of the true Futurist spirit," but it was only "the crucible in which the elements of a new sensibility that is coming into being are stirring." Although many of the facets and components of the variety theatre were used to exemplify Futurist concerns in a vivid way, Marinetti did not say that the works should be emulated. He was concerned with the spirit or content rather than with the details of style or form. The variety theatre became a giant and expanded metaphor for the Futurist theatre; it was not intended as a representation of it.

What were these "elements of a new sensibility" that could be seen in the variety theatre and that were proposed as the basis for true Futurist performance? In essence, they involved an emphasis on concrete or alogical presentation, on the use and combination of all modes and technical means of performance, and on the physical involvement of the spectators and the destruction of the "fourth wall" convention. They were manifested in two relatively distinct styles: the illogical or absurd and the mechanical or objective.

The single most important aspect of Futurist performance was to be its establishment of the concept of the *concrete* or the *alogical* in theatre. If a thing is experienced for its own sake rather than for its references and implications, it may be considered to be concrete: it is "there" rather than referring to something that is

not there. A performance or an element of that performance, there-fore, can be thought of as being concrete to the extent that it maximizes the sensory dimensions and minimizes or eliminates the intellectual aspects.

If the word "concrete" is used in reference to sensory emphasis and physical presence, it is apt and functional. It also has other meanings, however, that threaten its usefulness when applied to theatre. "Concrete" is the opposite of "abstract": it involves im-mediate experience rather than expressing an essence "abstracted from" a particular or material thing. But a new and special meaning of "abstract" has developed in this century in relation to art. A work of art is considered "abstract" if it has no recognizable forms, if it is nonobjective. This use of the word is extremely unfortunate. It means that a work of art can be *both* concrete and abstract. Although this is not the place to pursue the philosophical and philological implications of this terminology, it seems clear that the words "concrete" and "abstract" must be used with extreme care, if at all.

At any rate, as long as it is remembered that we are attempting to describe the *experience* of a work of art, rather than its creation, the word "alogical" may be used in place of "concrete" with less confusion and greater scope. The important point is to distinguish between works that make use of intellectual elaboration and refer-ences and those that do not.

A word is not concrete. That is, its concrete aspects—its sound or retinal pattern—are not its most significant parts. It is the symbolic process, the standing-for and representing something else, that is the essence of the word, and language is the combination of word/symbol into modified and accumulated meanings. Therefore, language process can be taken as the paradigm of logical experience. To the extent that a performance functions like language, it can be considered logical; to the extent that it does not symbolize and does not elaborate structures of intellectual meanings, it may be considered alogical.

One of the main things that attracted Marinetti to the variety theatre was its basically alogical nature. The variety theatre does not deal in illusion as a play or opera does. It does not tell a story

or represent anything. It tends to *be* rather than to refer. The female singer or dancer does not pretend to be someone else: she does not, in the words of "The Variety Theatre" manifesto, wear a "mask" of "sighs" and "romantic sobs" like an actress but presents directly all of her "admirable animal qualities." The acrobat and juggler do not aid in the development of a narrative or pretend to be anywhere other than where they really are. Nor do they generally embody abstract ideas and concepts: the trapeze artiste flies without representing flight. The actions of such variety performers are not symbolic but complete and self-sufficient. The immediate presence of a certain physical activity or action is enough to create a rewarding experience for the spectator. There is no intellectual elaboration, but there is the possibility of "new significations . . . in the most unexplored parts of our sensibility."

The distinction that Marinetti sets up in "The Variety Theatre" manifesto is between "psychology" and what he calls *"fisicofollia"* or "physical madness." "Psychology" in this case refers to "the internal life" of drives, ambitions, conscience, feelings, emotions, and so forth; it also includes the intellectual discussion and analysis of life. The "madness" that he prefers and contrasts with it is both intense and nonrational—an absolute involvement with the qualities of direct experience. He opposes the elaboration of interpretation with an "anti-academic" and functionally "primitive," alogical response. (In this "madness," as well as in his "significations of light, sound, noise, and speech with their mysterious and inexplicable prolongations," Marinetti prefigures Artaud.)

The variety theatre also was used by Marinetti to illustrate what he considered to be a more viable audience-performance relationship. The "fourth wall" conventions of drama, in which the actor performs in a room with three real walls and an imaginary fourth wall, while, theoretically, taking no cognizance of the audience, implicitly asked the observer to remain politely passive so as not to intrude on the "reality" of the work. The variety theatre was diametrically opposed to the conventions and implications of the "fourth wall." Just as the smoke-filled nightclubs created a single undivided ambience for performers and spectators, Marinetti

wanted to remove the separation between audience and presentation.

Perhaps thinking of how a singer in a nightclub sometimes walks among the tables singing to individual customers or clowns in a circus sometimes perform their antics with and among the spectators, Marinetti asked for a less rigid audience-performance relationship. He wanted the physical presentation to surround and involve the observers. He wanted "the necessity of acting among the spectators in the orchestra, the boxes and the gallery."

Such a change in the spatial relationship between the viewer and what is viewed does not necessarily make the spectator more active (except perhaps by requiring him to shift position frequently) or more involved physically. Yet the actual physical involvement of the spectator was Marinetti's intent. He admired the variety theatre because its spectators actively responded during the performance with indications of approval or disdain, rather than waiting passively until the curtain went down to applaud. They yelled comments and sang along with the music. There was an energetic exchange between performers and spectators. The audience helped to create the particular quality of the theatrical experience, rather than pretending that the experience would be the same without them.

But Marinetti wanted something more specific than a lively and demonstrative audience. In "The Variety Theatre" manifesto he made several suggestions for forcing the spectators to become a part of the performance whether they wanted to or not—the use of itching and sneezing powders, coating some of the auditorium seats with glue, provoking fights and disturbances by selling the same seat to two or more people. It should be noted that, like the juggler and acrobat, these devices are alogical. Marinetti was not suggesting that the incidents of a story be placed in and around the audience or that actors speak to the spectators "in character." The occurrences were to be sufficient in themselves without representing or symbolizing anything.

A third major aspect of "The Variety Theatre" manifesto was its emphasis on the utilization and combination of various theatrical media, means, or elements. Marinetti pointed out that variety

theatre made use of motion pictures whereas "legitimate theatre" did not. As implied by the phrase already quoted—"light, sound, noise, and speech"—each had its own "significations," and no performance possibilities were to be excluded. The variety of the variety theatre was seen as one of its most important characteristics.

There was also the suggestion in the manifesto that these various performance elements be presented at the same time. Like the three rings of a circus that are all employed at once, the Futurist performance was to make simultaneous presentations, creating a "dynamism of form and color."

Marinetti admired two distinct stylistic qualities of the variety theatre: its illogical absurdity and its speed, energy, and power. He saw humor as an antidote to "the Solemn, the Sacred, the Serious, the Sublime of Art with a capital *A*," and wanted to ridicule and parody accepted dramatic masterpieces in order to destroy the attachment to traditional values. There was a cleansing, purgative aspect to the incongruous and absurd. It was a way to "air the intelligence" and to destroy "all our conceptions of perspective, of proportion, of time and of space." In this sense, the illogical can be seen as a stage in a progression toward the alogical. It was "absolutely necessary to destroy all logic in the spectacles" so that things could be perceived for their own sake without intellectual elaboration.

The other stylistic characteristics of variety theatre that interested Marinetti were more obviously related to the basic concerns of Futurism as established in the "Foundation and Manifesto of Futurism": Dynamism was the focus of Futurist style. Just as the earlier manifesto extolled the "aggressive movement, feverish insomnia, the running step, the somersault, the insult and punches," "The Variety Theatre" manifesto exalted "jugglers, dancers, gymnasts, vari-colored riding troupes, spiraling cyclones of spinning dancers on points." Where the earlier publication said, "No work can be a masterpiece without an aggressive character," the later pointed out that the variety theatre was able to "create a strong and healthy atmosphere of danger upon the stage."

Like athletes, the acrobats and related artistes of the variety

theatre set standards of accomplishment that were objective: whether or not they were equaled or surpassed could be determined by anyone and did not depend upon personal, subjective judgment. Marinetti admired this objectification of standards and wrote of the "relentless emulation by brains and muscles in order to surpass the various records of agility, velocity, strength, complexity and grace."

Comparing theoretical performances of the same acting company in a play by Ibsen and in vaudeville, Bruno Corra explained that:

> . . . vaudeville, through *its inmost constitution, imposes* on the actors a rapid, uninvolved, nimble, modern delivery, absolutely *excluding:* grave tones, the *knowing* pause, careful engraving and all the other pedantic slownesses that instead fit like a hand in a glove with the gloomy Norwegian tragedian. In vaudeville the dialogue is rapid, the script cocky, the psychology synthetic.[2]

Thus there developed an emphasis on the impersonal and mechanistic rather than the personal and idiosyncratic. This involvement with the machine and with movement, force, speed, and power was fundamental to Futurist thought.

Although the Futurist *serate* or "evenings" had been presented since at least 1910, "The Variety Theatre" manifesto made no mention of them when it was printed in 1913. And yet the manifesto can be read as an explanation of those qualities and artistic tendencies found in the *serate*. The "evenings" were, of course, didactic and word-oriented, but a trend toward the alogical can be seen in their rejection of pretense and their emphasis on direct experience. The Futurist performers not only caused overt demonstrations in the audience, they responded to whatever the spectators did: the overall character of the presentation was determined as it progressed, both by the performers and by the audience. The *serate* made use of a variety of presentational modes and techniques, including, as we have seen in one of the descriptions, paintings carried onto the stage to be exhibited. Their style involved both absurdity and what were at least attempts at objectification and mechanization.

It is important to stress that the Futurists were actually carrying

[2] Bruno Corra, *Per L'Arte Nuova della Nuova Italia* (Milan: Studio Editoriale Lombardo, 1918), p. 170. (Hereinafter referred to as *L'Arte Nuova.*) (My translation.)

OLSON LIBRARY
NORTHERN MICHIGAN UNIVERSITY
MARQUETTE, MICHIGAN 49855

out most of the basic proposals, in however primitive a form, before "The Variety Theatre" was written. The Futurists wrote countless manifestos. Their style is frequently arrogant and verbose. The writings remain, although the performances do not. All this can create the feeling that the Futurists talked a lot and did very little, or that the performances were merely attempts, after the fact, to illustrate already-published concepts. It is true, of course, that they talked a lot, but they were also industrious producers of performances of many kinds. And it can be said that, in general, Futurist concepts were demonstrated artistically before they were promulgated in writing. The *serate* predated any formal elucidation of their characteristics.

"The Variety Theatre" was not the earliest theatre manifesto of the Futurists, however. The "Manifesto of Futurist Playwrights" was published almost three years earlier, in January, 1911. Indicative of the structure of the movement at that early date, the signatures on the manifesto included—in addition to that of Marinetti, who apparently composed the piece—those of thirteen poets, five painters, and one musician.

Compared with "The Variety Theatre," the "Manifesto of Futurist Playwrights" gave few specific indications of the kind of theatre the Futurists wanted. Most of it was devoted to attacking the theatre of the time, which was seen as a "poor industrial product" sold on the "market of townspeople's amusements and pleasures." Sentimental plays—"the inevitably piteous spectacle of a mother whose son is dead or that of a young girl who is unable to marry her loved one"—and historical dramas of all kinds were specifically and forcefully rejected. Realism, seen as the attempt to create a "psychological photograph," was also clearly and emphatically deprecated.

For the most part, the "Manifesto of Futurist Playwrights" was concerned with the general attitude and goals of the writers. It made only one concrete suggestion: free verse was to be used in the theatre rather than prose. This, of course, was hardly a radical innovation, nor did the Futurists themselves follow it to any great extent. The manifesto, however, did state certain basic concepts

that were to be developed later and were to be fundamental to much of Futurist performance. There was the statement that it was "necessary to introduce into theatre the feeling of the domination of the Machine . . . the new currents of ideas and the great discoveries of science." How this was to be done was not discussed, but such thought was to prove very important later.

More important at that time was the attitude toward the audience. Much of the "Manifesto of Futurist Playwrights" was concerned with overcoming the "domination of the public" that was seen as pushing the performer to "look for the easy effect" and alienating him from "any research toward profound interpretation." An antidote was offered: *"scorn of the public,"* especially the opening-night audience, and a *"horror of immediate success."* Since whistling, like the booing that is more common in this country, was an indication of the public's scorn, authors and actors were urged to "delight [in] being whistled at by the audience." "Everything that is whistled at," the manifesto stated, "is not necessarily beautiful or new," but "everything that is immediately applauded is certainly not superior to the average intelligence and is, therefore, *mediocre, banal, re-vomited and too-well digested."* Thus the unwillingness to appeal to the tastes of the audience, which, even at that time, was becoming manifest in the *serate* as, in part, an anti-audience attitude, was stated and explained at a very early stage in the development of Futurist performance theory.

A final point in the "Manifesto of Futurist Playwrights" that was to prove of great importance for the later development of Futurist performance was the reference, in one paragraph, to originality and innovation. Dramatic works that took "the conception, the plot or a part of their development" from other works of art were considered "absolutely despicable." More than ten years later this concept, elaborated and expanded, was to form the core of "The Theatre of Surprise" manifesto of 1922. And the urge toward artistic innovation was to underlie much of the Futurist work in performance.

IV | Dynamic and Synoptic Declamation

The relationship of the Futurist "evenings" to the principles stressed in "The Variety Theatre" is seen even more clearly in terms of what Marinetti called the "evenings of dynamic and synoptic declamation" that were held in 1914. The first such presentations were given on March 29, and April 5, 1914, at the Sprovieri Gallery in Rome. *Piedigrotta* by Cangiullo was a somewhat more intimate, integrated, and elaborate version of the earlier *serate,* making use of "scenography," costumes, and a variety of sound-music effects.

Perhaps "scenography" is too strong a word, but the room, which apparently functioned as both stage and auditorium, was "decorated." Balla had painted a large drop for the performance, and in one corner of the gallery space was a "still life" representing "three Crocean philosophers." The walls were hung with paintings by Boccioni, Carrà, Russolo, Balla, and Severini. Red lights encased in paper helped to create a consistent and specific atmosphere: one critic described the color of the light as being like "adulterated chianti." [1]

The Futurists were costumed for the presentation. In his manifesto on "Dynamic and Synoptic Declamation," Marinetti wrote that:

> the public greeted with frenzied applause the appearance of the . . . dwarf troupe, bristling with fantastic hats of tissue paper, that revolved round me while I declaimed. The multicolored ship that the painter Balla carried on his head was very much admired.

Although *Piedigrotta* was a *parole in libertà* [2] poem by Cangiullo, it was not presented by a single person but by several. Cangiullo

[1] P. Sgabelloni, *Giornale d'Italia,* March 31, 1914, quoted in Maurizio Fagiolo dell'Arco, *Balla: Ricostruzione Futurista dell'Universo* (Rome: Bulzone Editore, 1968), p. 104.

[2] *Parole in libertà,* which may be translated as "free words" or "words in freedom," was a Futurist concept that carried free verse one step farther by eliminating all the rules of versification, syntax, spelling, and typography.

and Balla joined Marinetti in the declamation, and the author played the piano from time to time. Although multiple performers may have been used in earlier readings, there is a definite record of it during this "evening" at the Sprovieri Gallery: The program of *Piedigrotta* listed a "final chorus of six voices." It was this use of several voices that caused Marinetti to call *Piedigrotta* the first evening of "dynamic and synoptic declamation."

Another important aspect of *Piedigrotta,* which was named after a yearly Neapolitan song festival, was the employment of fanciful "homemade" musical instruments. These instruments, together with certain details of the *serata,* are described in Marinetti's manifesto of "Dynamic and Synoptic Declamation," published on March 11, 1916, but actually written in 1914. They range from what appears to be a simple wind instrument, the *Tofa,* made from a large seashell, to the proto-Dada *Scetavaisse,* a "fiddle bow" that was actually a saw with additional rattles and pieces of tin hanging from it. The *Putipu* consisted, in part, of a "small box of tin or of terra-cotta covered with skin"; the *Triccabballacche* was "a kind of wooden lyre" whose delicate wooden "strings" were capped with hammer-like blocks. Five different instruments made up an orchestra during the presentation of *Piedigrotta,* adding their unusual sounds to the voices of the Futurists and the noises of the animated audience that filled the gallery.

Another presentation by the Futurists inaugurated an international exhibition at the Sprovieri Gallery on April 13, 1914. Now, the two hundred paintings that covered the walls of the gallery were by artists from Russia, Belgium, the United States, and England as well as from Italy. Although it could not be called "dynamic and synoptic declamation" because it did not make use of poetry, the evening continued the trend toward unification through the use of scenography and costumes.

A catafalque had been constructed at the rear of the room. Again there was a procession: in this case it was a "funeral procession." Balla, "disguised as a sacristan," led the way. He was followed by Depero and Radiente, whose heads were hidden in enormous tubes of black tissue paper with holes punched for eyes and nose;

on their shoulders they carried the "body" of a passéist "critic" who had succumbed to Futurist theory and insults. The "critic" was a head modeled by Cangiullo, with arms of cord and hands of paper; it lay on an old dilapidated book. While Cangiullo played a funeral march on an out-of-tune piano and Balla from time to time struck a large cowbell with a paint brush and chanted mournfully in a nasal voice, the procession moved slowly between the spectators, and the "body" was placed on the catafalque.[3]

Marinetti gave a funeral oration for the deceased critic, justifying the fatal statements of the Futurists. In order to overcome the "putrid stench" of the decaying body, he lit a cigarette and asked the spectators, who, of course, were noisily demonstrative throughout, to do the same. Smoke and the act of smoking became part of the performance.

In February, 1914, Marinetti had traveled to St. Petersburg and Moscow. After participating in *Piedigrotta* and the funeral of the passéist critic, he went to England where he gave what he described as the second "dynamic and synoptic declamation" on April 28, 1914, at the Doré Gallery in London. According to brief reviews in the London *Times*, the same reading/performance was given at least twice, and in all probability three times, in the gallery.[4]

Marinetti recited his own *Zang-Tumb-Tumb*, describing the siege of Adrianople during the Balkan War. The presentation was not so elaborate as *Piedigrotta*. Although many of the same characteristics were present, Marinetti was the only speaker, and no one other

[3] One source writes Balla's chant as "nieet, nieeeeet, nieeet, nieeeet, nieeet, nieet" (*Lacerba*, June 1, 1914) and another as "gniet-gniet" (Corra, *L'Arte Nuova*, p. 195). Apparently it sounded much like the Russian "no." Both writers agree that Balla's voice was nasal.

[4] April 28, 1914, is the only date given by Marinetti in the "Dynamic and Synoptic Declamation" manifesto. A review in the *Times* (London) of Friday, May 1, 1914, describes Marinetti's first reading at the Doré Gallery "last night," April 30, 1914. The next review in the *Times* (London), on May 6, 1914, is that of Marinetti's "third futurist conference"; again the time is designated as "last night." It is quite possible that one or both of the newspaper accounts were delayed and actually did not appear on the day following the performance they described.

than the English painter C. R. W. Nevinson is described as helping him during the performance. If there were no multiple voices as in *Piedigrotta,* however, the *parole in libertà* poem was theatricalized through its spatial presentation and through the use of accompanying sound.

As in Rome the "declamation" was surrounded by paintings and sculpture; the room, according to the *Times,* was "hung with many specimens of the ultra-modern school of art," including Marinetti's assemblage figure *Self Portrait,* "a suspended figure composed of various pieces of wood and a clothes brush," and *Mademoiselle Flicflic Chapchap* by Cangiullo and Marinetti, "a ballet dancer with cigar-holders for legs and cigarettes for neck." [5] Marinetti did not face the audience from one fixed point as in the usual poetry reading, but walked between and among them as he recited. In his manifesto he states that he had three blackboards placed at three different spots in the room and that he "alternately walked and ran" to them during the declamation; his marking on the blackboards became an additional visual element of the performance. None of the very brief notices in the London papers corroborates such an obvious detail as the blackboards, but the *Observer* notes how Marinetti "marched through the hall with dynamic gestures." [6] It is clear that Marinetti considered this physical penetration of the audience-space as a means to increase the spectator's involvement. In his description in the "Dynamic and Synoptic Declamation" manifesto, he explains that "the listeners turned continually to follow me in all my evolutions, participating with their whole bodies." This effect certainly could have been achieved whether or not blackboards actually were used.

This presentation of "dynamic and synoptic declamation" also made rather extensive use of sound effects and props. Marinetti says that a "telephone apparatus" was employed so that he could act out the sending of orders and direct Nevinson in the pounding of two large drums. Again, the London papers do not refer to a telephone, but the *Times* does mention "imitations of artillery with

[5] *Times* (London), May 8, 1914. These pieces continued the type of assemblage construction begun with the figure of the passéist critic, *Il Filòsofo Schiaffeggiato,* exhibited by Cangiullo in the Sprovieri Gallery.

[6] *Observer* (London), May 3, 1914, p. 11.

a hammer, and the thumping of a big drum behind the scenes"; the *Observer* describes how "with a hammer and a piece of wood he gave an excellent imitation of a machine gun which punctuated his words" and how he "concluded his poem by the beating of a big drum, which boomed like guns heard across the hills." It seems clear that the sound, too, was spatially distributed: it came from different parts of the room and moved with Marinetti when he moved.

The manifesto entitled "Geometrical and Mechanical Splendor and Numerical Sensibility'" was published on March 18, 1914, after *Piedigrotta* but before the presentations in London; in it Marinetti justifies "direct onomatopoeia," in which sounds imitate realistic elements, as a means to "enrich lyricism with brutal reality." Specifically using *Zang-Tumb-Tumb* as an example, he claims that such use of sound can prevent poetry from becoming "too abstract and too artistic." But the overwhelming emphasis in the "Dynamic and Synoptic Declamation" manifesto is on the generalized, the abstract, and the impersonal. Marinetti transforms, at least in theory, every aspect of the performer: he should wear anonymous clothing without any details of color or relief; his face should be free of personal expression; his voice should make no use of "modulation or nuance"; his movement should be "geometric." In describing the use of gesture, Marinetti suggests a repertoire of "cubes, cones, spirals, ellipses, etc." that prefigures the basic geometrical vocabulary of Bauhaus theory.

To what extent these concepts of the "Dynamic and Synoptic Declamation" manifesto were actually put into practice is not clear. First person descriptions are not that specific. Marinetti was undoubtedly a forceful, energetic, and "dynamic" interpreter, but if he did move toward the elimination of idiosyncratic detail, it was his personality that the spectators remembered. As theory, however, the proposals of "Dynamic and Synoptic Declamation" are significant in clearly establishing what could be called "the mechanization of the performer." This is an important and continuing concern of Futurist performance, leading to the marionettes and mechanical costumes of later years.

v] Russolo and the Art of Noise

Futurist performance is a complex phenomenon; different concerns developed simultaneously in the various disciplines. In order to trace the most important Futurist developments in music, we must now go back again to early 1913, before "The Variety Theatre" manifesto was published and before the evenings of "dynamic and synoptic declamation." On March 11, 1913, one of the most significant of all Futurist manifestos appeared. Although the subject was music, its author, Luigi Russolo, was a painter. The title of the piece was "The Art of Noise."

The theory of "The Art of Noise" was simple, profound, and far-reaching. In essence, it implied that although sound itself was limited only by the physiology of the ear and contained an infinite number of gradations of tone, pattern, and quality, only a small part of that infinite field of sound was acceptable in Western culture as "music." Russolo wanted all sound to be possible material for music.

In this case, theory may have preceded actual accomplishment. From the manifesto it is clear that Russolo could not demonstrate his theories in a practical form at that time. Indeed, he began by saying that Francesco Balilla Pratella (1880–1955), the futurist composer, was the only one who could create the "new art." At the same time, however, there was the suggestion that Russolo had been working to develop the physical means for embodying his theories: his description of the type of instrument that would be required by "the new orchestra" was quite specific and realistic, and he stated confidently that "we soon will accomplish" the theoretical goals "mechanically."

Certain suggestions for Russolo's ideas can be seen in the work of Pratella, the Futurist composer to whom "The Art of Noise" was addressed. In "The Technical Manifesto of Futurist Music," published

33

exactly two years before "The Art of Noise" on March 11, 1911, Pratella had urged "enharmonic music": a music that exploited small changes in pitch rather than being limited to the notes that could be indicated on the traditional staffs. Later, in "Enharmonic Notation for the Futurist Intonarumori," Russolo was to claim "the total conquest of the enharmonic system." Pratella also wanted to employ complicated, changing, and subtle rhythms in order to expand the sequential possibilities of music and to "crush the domination of dance rhythm." Russolo stated emphatically in "The Art of Noise" that "the rhythmic movements of a noise are infinite."

In "The Art of Noise," Russolo says that he "conceived of a new art" while listening to Pratella's Futurist music at the Teatro Costanzi. And indeed, Pratella conducted his own *Musica Futurista per Orchestra* at the Teatro Costanzi in Rome on February 21, 1913, and again on March 9, 1913. The later date is two days before the publication of "The Art of Noise," and it is entertaining to imagine Russolo having a sudden and complete aesthetic revelation during the performance. But if Pratella did work toward a music of greater tonal and rhythmic scope, he never seems to have considered abandoning the traditional musical instruments. He may have fought against the limitations of the instruments, saying in the "Technical Manifesto" that "the known technique of instrumentation must be conquered." He may have been dissatisfied with the standardized composition of orchestras, positing "a particular orchestra for every particular and diverse musical condition." But Pratella's *Musica Futurista per Orchestra* was for traditional instruments and orchestra.

Russolo, on the other hand, conceived of a music that made use of sounds that could not be produced by traditional instruments. Even though the limits of traditional musical sound could be expanded by artists like Pratella, Russolo wanted to include all of the sounds of everyday life. Perhaps he was taking Pratella literally when the older composer wrote in his "Technical Manifesto" that: "Sky, water, forests, rivers, mountains, the entanglements of ships and swarming cities are transformed . . . into marvelous and powerful voices." Certainly there is a literalness about Russolo's desire to

incorporate everyday sounds into music. This literal approach stems most directly from Marinetti's *parole in libertà*.

In "The Art of Noise," Russolo quotes extensively from Marineti's *Zang-Tumb-Tumb*, describing it as "one of his letters from the Bulgarian trenches at Adrianople"—and there is no reason to doubt that Marinetti had sent the piece to Russolo, as well as to other Futurists, at the time it was written in 1912. It was the same *Zang-Tumb-Tumb* Marinetti was to recite during the "dynamic and synoptic declamation" evenings in London. In attempting to translate into literature the sights, sounds, smells, and special relationships provided by the modern world, such *parole in libertà* made use of neologisms, compressed stream-of-consciousness structure, and onomatopoeic spelling: the title of *Zang-Tumb-Tumb* invokes the sound of artillery shells striking and exploding. Especially when read aloud, such writing had an intense musical flow and rhythm. It might have been no greater an influence than this, combined with Pratella's urgings that the range of music be increased, that brought Russolo to his extreme position.

Just as the alphabet can be used to approximate phonetically the diverse sounds of the environment, traditional musical instruments can, of course, also approximate those sounds: a drum can represent artillery, a flute can represent a twittering bird, and so forth. But Russolo realized that traditional instruments can *only approximate* many qualities and types of sound. The instruments are designed to provide only a limited range of auditory possibilities.[1]

Russolo went beyond Pratella in realizing that, in order to increase significantly the sound potential of an orchestra, new instruments would have to be created. Exactly how much Ugo Piatti contributed to the design and construction of these instruments is not clear. Piatti, who was also a painter, collaborated with Russolo, but only Russolo's name appeared on the manifestos, and he is usually given all the credit for the practical developments as well.

[1] A corollary of Russolo's position, which he does not state but which follows naturally from his basic concepts, is the realization that traditional instruments are used in limited ways and that the ways in which the instruments themselves can actually produce sound are much more numerous.

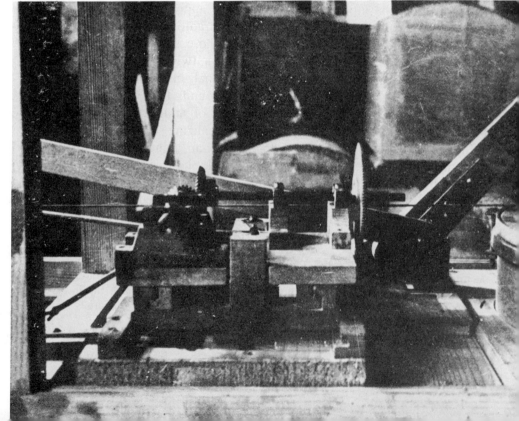

At any rate, whether or not work actually had begun on the innovations at the time "The Art of Noise" was published, a working model was completed within three months; it was demonstrated at the Teatro Stocchi in Modena on June 2, 1913. The new musical instruments were called *intonarumori* or "noise-intoners."

Externally, all of the *intonarumori* were quite similar. All were rectangular wooden boxes with funnel-shaped acoustical amplifiers, or megaphones, projecting from the front. The boxes, averaging about two-to-three feet in height, and the megaphones varied in size, but the general appearance was the same. They were "played" by means of a protruding handle that moved in a slot on the top or side of the instrument.

Inside the *intonarumori* were various motors and mechanisms, each producing one of the types of sound that Russolo had charted in "The Art of Noise." As he described in "The Futurist *Intona-rumori*," *exploding, crackling, humming,* and *rubbing,* for example, were all achieved by activating a stretched drumlike diaphragm in various ways. Although the quality of the sound remained constant, its pitch was variable. Just as the pitch of an electric motor changes as its rotors spin faster or slower, each "noise-intoner" had to create a variable sound; the most important technical aspect of the mechanical devices was the necessity that they produce a range of ten whole notes. Thus only certain options were available to the operator: He could start and stop the particular sound, and he could change its pitch by moving the protruding handle of the *intonarumori* in relation to a scale marked off next to the slot.

The new instruments needed a new kind of musical notation. In keeping with their basic characteristics of intoning the sound, Russolo eliminated the notes with which music had traditionally

OPPOSITE: Fig. 4 (ABOVE). A battery of *intonarumori.* Luigi Russolo is at the left and Ugo Piatti at the right. Note the handles used for changing the pitch of the instruments. Fig. 5 (BELOW). The sound-producing mechanism of an *intonarumori.* Part of what appears to be a drum can be seen at the right. (*La Biennale di Venezia*, #54, September, 1964.)

been written. In his system, the constant flow of sound was indicated by continuous solid lines that moved across the staff; the lines terminated and began again, indicating the cessation and reintroduction of the sound. He also made changes in the way duration was indicated by vertical lines, but these were relatively unimportant, and when, in May, 1914, Pratella published a composition that combined *intonarumori* and traditional instruments, he was able to use the same durational indications for his whole orchestra.

It was not long before Russolo, who had given up painting to devote all of his time to his new inventions, and Piatti had created an entire orchestra of *intonarumori,* and concerts replaced demonstrations. The first public performance was at Marinetti's Casa Rossa in Milan on August 11, 1913.

Soon after the "dynamic and synoptic declamation" evenings at the Doré Gallery, Russolo directed the "noise-intoners" in a program at the Coliseum in London on the afternoon of June 15, 1914.[2] They played two "noise spirals," listed by the London *Times* as *The Awakening of a Great City (Risveglio di una Città)* and *A Meeting of Motorcars and Aeroplanes (Convegno d'Aeroplani e d'Automobili).* According to the *Times* the music of the

> weird funnel-shaped instruments . . . resembled the sounds heard in the rigging of a channel-steamer during a bad crossing, and it was, perhaps, unwise of the players—or should we call them the "noisicians"?—to proceed with their second piece . . . after the pathetic cries of "no more" which greeted them from all the excited quarters of the auditorium.

Later, Marinetti used the *intonarumori* when his play *Il Tamburo di Fuoco* was produced in 1922, but the instruments were reduced to playing "background music" and providing sound effects. They could not be seen, and, for the most part, they were asked to produce realistic imitations of a drum in the distance, an elephant trumpeting, fowl clucking, and so forth.

[2] Actually, the program did not belong entirely to the *intonarumori.* There was also a ballet, described by the *Times* (London), June 16, 1914, p. 5, as demonstrating "superb illustrations of old-fashioned ballet technique" in telling a story involving, in part, "the village maiden locked in by her cruel parents, and the poor lover . . . who jumps in at the window."

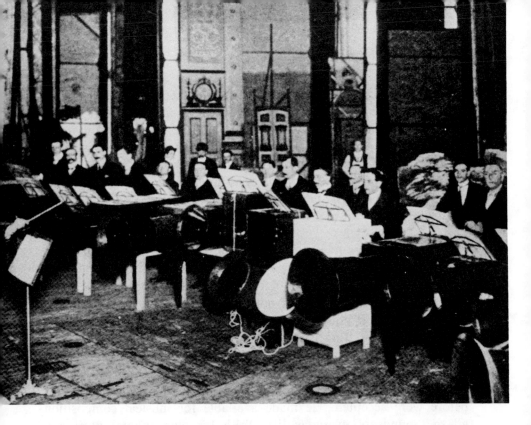

Fig. 6. An orchestra of *intonarumori* conducted by Luigi Russolo. (From a reproduction in *Teatro F. T. Marinetti* edited by Giovanni Calendoli [Rome: Vito Bianco Editore, 1960].)

Similarly, when Russolo went on to develop other instruments, their qualities were specifically related to nature. In 1926 he described his *psofarmoni,* keyboard instruments that, in a sense, seem to foreshadow John Cage's "prepared piano": "Some of these new sounds imitate nature: wind, water, etc. Others the voices of animals: frogs, cicadas, . . . "

But this later tendency toward literal representation seems to compromise some of the most important tenets of "The Art of Noise" and to be a concession to popular taste. In his basic manifesto Russolo states in capital letters that: "THE ART OF NOISE MUST NOT LIMIT ITSELF TO IMITATIVE REPRODUCTION," and stresses in his conclusions that the new orchestra will succeed "not by means of a succession of noises that imitate life." Again, in "The

Futurist *Intonarumori,"* Russolo attempts to correct the misunderstanding that his machines are intended for an "imitative or impressionistic" copy of the noises of life, and he discusses how noise, when used in music, "must . . . lose its own accidental character in order to become an element sufficiently abstract." Thus Russolo's theory, if not always his practice, is in keeping with the general tendency of Futurist performance toward the nonsymbolic and alogical.

Russolo seems to be one of the most underrated figures in the history of the arts in the twentieth century. His importance is certainly very great. It does not matter if a composer like Pierre Schaeffer can say that he knew nothing about Russolo when he began his own work on noise-music and *musique concrète*.[3] Russolo was responsible for putting certain ideas "in the air" where they were available, and he should be given full credit. Not only did he seek a greater variety of quality, pitch, and rhythm in music, but he extended the concept of music itself to include sounds that never before were accepted. He made available for musical composition all the sounds of everyday life. With his own *intonarumori* and *psofarmoni,* he demonstrated that the practical limits of music were only those of technology and inventiveness, preparing the field for such developments as *musique concrète,* electronic music, and the Moog Synthesizer. He rejected the "weak acoustical results" of traditional orchestras, and his emphasis on volume and intensity has now become widely accepted. He invented his own system of musical notation, showing the way for countless composers. Although more or less traditional music has retained at least statistical strength since Russolo, a very important segment of contemporary work, and some aspects of popular music, stem directly from this Futurist.

[3] Pierre Schaeffer, "La Galleria Sotto i Suoni Ovvero il Futuro Anteriore," *La Biennale di Venezia* (July–December, 1959).

VI] The Synthetic Theatre

The most important plays of the Futurists took the form of very short pieces called *sintesi*.[1] Marinetti, Pratella, Pino Masnata, and others wrote plays and operas of extended length, but the *sintesi* embody all of the major Futurist contributions in this area. During 1915 and 1916 several acting companies toured Italy presenting programs of *sintesi;* they included the companies of Gualtiero Tumiati, Annibale Ninchi, Ettore Berti, Luigi Zoncada, and Ettore Petrolini. Once again, the basic concepts of this type of performance were elucidated in a manifesto: "The Futurist Synthetic Theatre," written by Marinetti, Emilio Settimelli, and Bruno Corra; it is dated both January 11, 1915, and February 18, 1915.

The most obvious characteristic of the *sintesi* was its length. "Synthetic," it was flatly stated in the manifesto, meant "very brief": although most were somewhat longer, some of the scripts would take only a minute, or even less, to perform. This could be considered their one defining characteristic; however, the term became very popular, at least among the Futurists, and was occasionally attached to rather long works.

As explained by the manifesto, brevity was, most simply, a distillation, condensation, or compression of traditional drama. In keeping with the Futurist concern with speed and motion, the proper work of the playwright was seen as "synthesizing facts and ideas into the least number of words"; his pieces were to be "rapid and concise."

Actually, this compressed brevity was one of the aspects of nightclubs, circuses, and music halls that had been praised two

[1] In Italian, the plural of *"la sintesi"* is *"le sintesi."* Thus the word *sintesi* appears both as singular and as plural when it is used, untranslated, in an English sentence.—Trans.

41

years earlier in "The Variety Theatre" manifesto. The variety theatre, it had been pointed out, "explains in an incisive and rapid manner the most sentimental and abstruse problems," and there one sees "heaps of events dispatched in haste." Not only did Marinetti approve in "The Variety Theatre" of "the execution of *Parsifal* in forty minutes that is now in preparation for a large London music hall," but he suggested "representing, for example, in a single evening all the Greek, French and Italian tragedies condensed and comically mixed up" and reducing "the whole of Shakespeare to a single act."

When "The Synthetic Theatre" manifesto specifically advised the world to "abolish farce, vaudeville, sketches, comedy, drama, and tragedy, in order to create in their place numerous forms of Futurist theatre," the concepts of brevity and condensation had become more subtle and elaborate. The distillation or compression of existing dramatic works was only the crudest and most obvious form of synthesis. Now what was to be compressed and synthesized was the diversity of life itself, a diversity "present *for a moment* in a tram, in a café, at a station, and which remains filmed on our minds as dynamic, fragmentary symphonies of gestures, words, noises, and lights." The writers of "The Synthetic Theatre" might have been talking about the well-established *parole in libertà* rather than drama.

As with all Futurist art, the Synthetic Theatre can be clarified and, at least in part, explained in terms of its rejection of traditional forms. In this case, it was the conventions of exposition, structure, and characterization that, among other things, were rejected. In an extended analysis of the current techniques of playwriting, "The Synthetic Theatre" manifesto scorned the practice of "introducing only a tenth of the conceptions in the first act, five tenths in the second, four tenths in the third"; it claimed that it was "STUPID to be subjected to the impositions of *crescendo, exposition,* and *the final climax,*" and it mocked the public that "from habit and by infantile instinct, wishes to see how the character of a person emerges from a series of events." The age-old dichotomy between heroes and villains and the contingent processes of projection and identification

were dismissed as "the primitiveness of the crowd that wishes to see the agreeable person exalted and the disagreeable one defeated." But most important of all the Futurists rejected the "minute logic" that holds together traditional theatre and is the binding force in its structure; they dismissed the notion that the public must *"always completely understand the whys and wherefores of every scenic action."*

Like the other aspects of Futurist art and performance, however, the Synthetic Theatre was not merely a rejection of traditional concepts. If the brevity of the *sintesi* can be seen in part as a reaction against a theatre that was considered "monotonous and depressing" and in which the public was "in the disgusting attitude of a group of loafers who sip their distress and their pity, spying on the very slow agony of a horse fallen on the pavement," the short length of the new plays also had its positive side. Above all, the compression of the *sintesi* was seen as a means of intensifying the direct impact of the performance. "The Synthetic Theatre" manifesto might well have influenced Artaud's thought when it called for "synthetic expressions of cerebral energy" creating "a specialized reality that violently assaults the nerves." Unlike the "long-winded, analytical, pedantically psychological, explanatory, diluted, meticulous, static" traditional theatre, the new Synthetic Theatre moved away from information and logic and toward direct sensory appeal. According to the Futurists, "reality vibrates around us, hitting us with *bursts of fragments* with events amongst them, embedded one within the other, confused, entangled, chaotic." Although there is a somewhat telegraphic list in the manifesto indicating how these goals were being achieved in practice, the best way to understand how they were to take actual theatrical form is to look at the *sintesi* themselves.

There is a tremendous formal and stylistic diversity among so-called *sintesi*. In part this diversity is intentional and programmatic. Marinetti himself was quite catholic and eclectic, and the Futurists saw no need to develop a single style of performance. "The Synthetic Theatre" manifesto spoke of their discoveries in a variety of areas: "in the subconscious, in undefined forces, in pure abstrac-

tion, in pure cerebralism, in pure fantasy, in breaking records, and physical madness." The acceptance of one avenue of investigation—that of the unconscious, for example, that would eventually lead to Surrealism—did not preclude the investigation of other areas. But along with the more original forms, almost every trend that was then current in playwriting can be found represented in the *sintesi*. Calling a piece a *"sintesi"* was not a stylistic qualification.

Traditional standards of "verisimilitude" and "the photographic" were among those attacked in "The Synthetic Theatre," and, with very few exceptions, the *sintesi* rejected literal reality and naturalism. This in itself was no innovation, however: many of the *sintesi,* as well as some of the longer Futurist works, were influenced by Symbolism. But all of the *sintesi,* the innovative as well as the derivative, did tend to be nonnaturalistic. In their stylistic diversity, this tendency and their "very brief" length are the only defining characteristics that we have. Of course the common nonrealistic approach was not a rejection of reality itself, like all nonrealistic artists, the Futurists felt that imitation was superficial and that they were in touch with "reality" of a more meaningful kind.

The emphasis on compression in the *sintesi,* and their relationship to variety theatre, sometimes reduced the brief plays to a kind of staged "gag" or pun. *Bachelor Apartment (La Garçonnière)* by the sculptor Umberto Boccioni is an example of this type of *sintesi*. It may be seen to contain a certain compression of character and a shock element that were important to the Futurists, but basically its impact depends on the humor of a sudden reversal when an apparently unseducible woman becomes the seducer herself. Indeed, a number of writers borrow Papini's view that the *sintesi* can be traced back to a very short play by Verlaine in which a man enters to find a couple embracing, shoots them dead, and is astonished to discover that he has killed the wrong couple. But short humorous skits are much older than Verlaine. Comedy acts and variety shows would have easily provided many examples of the humorous reversal. And very few of the *sintesi* actually show this form. The great majority of them are basically serious, even when an element of humor is involved. It is clear that almost all of them were intended for something more than mere entertainment.

The *sintesi* may be divided into two general categories or groups. Some seem to have been written programmatically in response to the specific demands of "The Synthetic Theatre" manifesto, and others developed from existing theatrical styles. In the first group, the plays give the impression of being formed "externally" by the aesthetic rules and standards elucidated by the Futurist movement. In the second category, the development is more "internal," intuitively adapting current forms and techniques to Futurist ends. This distinction is primarily a practical one. It facilitates analysis and discussion. In actuality, works do not always fall easily and completely into one category or the other. Moreover, it should be noted that "internal" and "external" do not connote value. Neither approach is, in itself, good or bad. But there are many ways in which a work of art can develop, and the importance of the manifesto, with its power to objectify and promulgate aesthetic standards and goals, should not be overlooked.

If "The Synthetic Theatre" manifesto established reduction and compression as the basic requirements of the *sintesi,* these qualities could be achieved in a variety of ways. The simplest and most obvious method was to "condense" a long-existing work. *Parsifal* or one of Shakespeare's dramas could be cut down to play in a much shorter time. Marinetti himself demonstrated this approach during his trip to Russia in 1914—before "The Synthetic Theatre" manifesto was written—when he visited one of Vsevelod Meyerhold's classes. As the Russian director described it:

> He [Marinetti] suggested to a group which had just performed *Antony and Cleopatra* for him (three actors and four "proscenium servants") the theme of *Othello* for improvisation. After a three-minute discussion on stage of the tragedy's salient features, the group performed a three-minute résumé of it.[2]

Giuseppe Steiner's *"Saul" by Alfieri (Il "Saul" di Alfieri),* published six years later, is another example of this approach. Taking the best-known work of Italy's most famous tragedian, the *Saul* written in 1782 by Vittorio Alfieri, Steiner kept the five-act structure,

[2] Vsevelod Meyerhold, *Meyerhold on Theatre,* ed. and trans. Edward Braun (New York: Hill and Wang, 1969), p. 146.

but some of his "acts" are only two lines long. In a few very brief vignettes, the characters and even the story become surprisingly clear.

The compression of time that is contingent to an approach such as Steiner's could also be clarified, systematized, and focused until it became the main point of a presentation. It is interesting to compare *Old Age* (*Passatismo*) and *Sempronio's Lunch* (*Il Pranzo di Sempronio*), both coauthored by Corra and Settimelli. Each uses a different method of compressing time. In the former, the passage of fifty years is indicated, in three brief scenes, by a calendar and by lines of dialogue referring to the date. In the latter play, a much more sophisticated treatment that would be difficult to stage, Sempronio goes from the age of five to the age of ninety in five short scenes; space is also compressed as he moves from country to country, his appearance changing as he gets older, but the single action of eating a meal runs through all the scenes, creating a powerful unifying image.

At one extreme, the compression of the *sintesi* moved it completely away from story and characterization. The play became merely an image, a brief stage action that did not depend upon the interplay of individual characters. Since the exchange of information between the fictional figures and its extended retention and elaboration were not central to these pieces, some of them did not use any dialogue. Mario Dessy's *Madness* (*La Pazzia*) is the image of a motion-picture audience driven mad by progressive insanity in the film they are watching. *The Troop Train* (*La Tradotta*), by the same author, is a slightly symbolic vignette that contrasts a beautiful woman with soldiers on their way to the front. Although no dialogue is provided by Dessy in either play, they are far from silent, and the voices of the actors play an important part in the total image.

A second important tenet of Futurist theory that formed certain *sintesi* was the emphasis on simultaneity. The earliest example, published in 1915, was a play by Marinetti himself with the simple title of *Simultaneity* (*Simultaneità*). Two entirely different places and their particular inhabitants occupy the same stage at the same time. The life of a beautiful cocotte "penetrates," to use Marinetti's word.

the life of a bourgeois family. For most of the play, the occupants of one "world" are completely unaware of those in the other, although the cocotte's dressing table occupies part of the family's living room.

The following year Marinetti developed the concept of simultaneity even further in *The Communicating Vases* (*I Vasi Communicanti*). (Later the same title was used for a book by André Breton, the leader of the Surrealists.) In this play, three different, unrelated locations occupy the stage, which is divided by two partitions, and the action goes on in all three at the same time. It is interesting that in both of these plays Marinetti chose to fuse the disparate ambiences at the end: the cocotte suddenly enters the other world of the bourgeois living room, and, in *The Communicating Vases*, soldiers actually break through the partitions between the areas, moving from one to the other. "The Synthetic Theatre" manifesto had spoken of the "race with cinematography," and the use of simultaneity undoubtedly derived in part from an attempt to parallel in stage terms the way in which motion pictures moved instantaneously from one locale to another, eliminating distance while compressing time.

Waiting (*Attesa*) by Mario Dessy, published in his 1919 book *Your Husband Doesn't Work? . . . Change Him!*, is an example of simultaneity in which the script is written in two columns to indicate the coordination of two physically unrelated actions. Dessy's play, which has certain symbolic overtones, gains formal strength by comparing two similar actions: in each a single man is waiting for a woman who does not arrive.

Another element of Futurist doctrine that shaped certain performances was the emphasis in "The Variety Theatre" and "The Synthetic Theatre" manifestos on a more direct and noncontemplative involvement of the spectators with the presentation. "The Synthetic Theatre" manifesto said that the Futurists would "eliminate the preconceptions of the stage by flinging a net of sensations between the stage and the public, scenic action will invade the orchestra and the spectators." The influence of this concept on the writing of scripts is quite clear in *Gray + Red + Violet + Orange*

(*Grigio* + *Rosso* + *Violetto* + *Arancione*) by Corra and Settimelli: the subtitle of the play is "Net of Sensations."

Gray + *Red* + *Violet* + *Orange* was produced by Ettore Petrolini during his tour of Brazil in 1921, although the name was shortened to *Gray* + *Red* + *Orange* on a poster announcing the program at the Antarctica Theatre Casino in Rio de Janiero. The play changes suddenly from a realistic drama in the fourth-wall tradition to one involving the audience, at least as subject matter, when an actor accuses a spectator in the front row of murder. The empathy called for and exploited by traditional theatre is underlined by the early excessive suffering of the protagonist, who then converts the observer's state of mind into one of self-consciousness by turning attention to the audience.

Petrolini and Cangiullo carried the direct involvement of the audience to a physical level in *Radioscopia*, which was also in the repertory during the tour of Brazil. Too long, at a running time of forty minutes, to be called a *sintesi*, the "simultaneous penetration" mixed spectators and performers. At its initial presentation in Naples in 1917—a performance attended by Benito Mussolini—actors were scattered throughout the auditorium, eliminating rigid spatial distinctions between presentation and audience.

Unlike the accusatory actor in *Gray* + *Red* + *Violet* + *Orange*, the leading character in *The Great Remedy* (*La Grande Cura*) by Marinetti actually comes down from the stage to "almost graze" the spectators in the front row with her hands. As Marinetti describes it, "the first row of seats is occupied by very beautiful women, abundantly décolleté." He probably intended them to be "planted" members of the company rather than real spectators, but the use of the audience as an element in the performance is still clear.

The role of the audience becomes active and central in Cangiullo's *Lights!* (*Luce!*), published in *Dinamo* in March, 1919. Planted performers definitely were to be used in this piece. With the auditorium completely in darkness, the actors—who were not to be recognized as such—were, by their own example, to provoke the spectators into demanding light. Indeed, acting in the house rather than on the stage and actual physical involvement and participation of members of the audience were to make up the entire per-

formance: when the excitement reached its peak, the lights were finally to come on—and the curtain was to fall. This short but significant piece could be related to Dada and to later neo-Dada performances; it is also an example of Cangiullo's interest in mixing spectators and performers and in searching for new types of theatrical experience. In it he made a simple theatrical "object" out of the emotional audience, eliminating—along with character, place, and anecdote—the formal concept of "a presentation."

Earlier, a very strange and unusual attempt to increase the involvement of the spectator had been embodied by Arnaldo Ginna —who was using the name Arnaldo Corradini at that time—and Emilio Settimelli in *From the Window* (*Dalla Finestra*), published in 1915. The spectators were to "place themselves, by self-hypnotism, in the place of a paralyzed person" and watch the presentation, as if through a window, without moving or saying anything. Each member of the audience was to hypnotize himself into believing that the two actors in the piece were his or her father and sister. How this was to be done, or even how the concept was to be communicated to the spectators, is not clear. Perhaps instructions were to be published in the program. But, unlike the audience-oriented plays involving self-consciousness and physical involvement, *From the Window* can be seen as an attempt to carry the traditional psychic mechanisms of empathy and projection to an extreme degree. The observer is really to believe and to care about what he sees on stage. It also demonstrates that these traditional devices, like self-hypnotism, require the spectator's cooperation and mental effort.

Compression, simultaneity, and the involvement of the audience in the performance were demands of the Futurist manifestos that gave form to their *sintesi*; other concepts in the published writings provided particular content for certain of the plays. The basic rejection of accepted theatrical devices and techniques in the manifestos can be seen mirrored in several *sintesi* that satirize or parody traditional drama. *Dissonance* (*Dissonanza*) by Bruno Corra and Emilio Settimelli makes fun of the historical romance by exaggerating the elaborate declamatory style: a gentleman in contemporary clothes intrudes on a supposed scene of thirteenth-century dalliance in order, in part, to emphasize its artificiality.

Corra and Settimelli also parodied the grandiose emotions and strident rhetoric of traditional drama in *Toward Victory* (*Verso la Conquista*) published, as was *Dissonance,* in 1915. The concept of the all-powerful and successful hero is scornfully debunked when the protagonist, on his way "toward victory," slips on a fig skin and is killed falling downstairs.

Corra also teamed with his brother Arnaldo Corradini (Ginna) to write *Alternation of Character* (*Alternazione di Carattere*), an early *sintesi* that attacks traditional theatre in a less obvious and more formally interesting way. Aiming at the well-established concept of consistent characterization, "The Synthetic Theatre" scorned the "analytical, pedantically psychological" approach of drama designed to satisfy the "infantile instinct" of the public that wanted "to see how the character of a person emerges from a series of events." The two Futurist brothers contradicted the traditional approach in *Alternation of Character* by creating a husband and wife who are completely inconsistent and change with each line of dialogue.

Corra and Settimelli also wrote two *sintesi* that, without the same specific conventions to attack and without the corrective use of humor, were nihilistic and somewhat bitter. *Faced with the Infinite* (*Davanti all'Infinito*) presents a young philosopher who sees no important difference between reading the paper and shooting himself; choosing one, he commits suicide. In the aptly titled *Negative Act* (*Atto Negativo*) an unidentified man angrily walks on stage, tells the members of the audience that he has nothing to say to them, and calls for the curtain to be brought down. Of course it is too obvious, and perhaps misleading, to refer to these plays as negative. They are negative only in their philosophy. As statements of that philosophy, a philosophy that is not typical of Futurism in general, they are strong and positive representations. Published in 1915, the year before Hugo Ball opened the Cabaret Voltaire in Zürich, they seem to be clear forerunners of what was to become recognized as the Dada spirit of aesthetic nihilism.

Nor can these plays really be considered to be without humor. They manifest a kind of black humor as they deny completely our

expectations about what a play is. We may even laugh at the sud-
denness with which they end their own existence, making the com-
pression of the *sintesi* into a rejection of the drama itself.

Closely related to *Faced with the Infinite* and, especially, to
Negative Act are two extremely short *sintesi* by Francesco Cangiullo
entitled *Detonation* (*Detonazione*) and *There Is No Dog* (*Non c'è un
Cane*). Published in the same 1915 collection, they, too, may be
seen as indications of how the attitudes necessary for the Dada
movement were clearly established with Futurism, but they do not
have quite the same aggressive nihilism of the pieces by Corra and
Settimelli. No actors appear in either play. "A bullet" is the only
"character" in *Detonation*. The curtain goes up to reveal a scene
representing a deserted road on a cold winter night. After a moment,
a shot is heard, and the curtain falls.

In *There Is No Dog,* the scene is the same. A dog walks across
the road. The play ends. Both *sintesi* are examples of the play-as-an-
image carried to an extreme. The images are fleeting, nondeveloping,
and somberly evocative. They are simple, bare, and direct state-
ments rather than didactic demonstrations, like *Faced with the
Infinite,* or audience provocations, like *Negative Act.*

A final group of *sintesi* whose content is clearly related to the
proposals of the Futurist manifestos is that in which the Futurists
themselves play a part. Paolo Buzzi's *sintesi The Futurist Prize*
(*Il Premio di Futurismo*) is a kind of dramatized manifesto sum-
marizing in a humorous way the views of Futurists in the various
arts. When the prize of an airplane is to be awarded to the artist
most truly representative of Futurism, the members of the jury ex-
plain why one discipline or another should be considered most
worthy, but they agree to give the award to a man who, by replacing
damaged parts of his body, has actually become mechanical to a
great extent.

The Arrest (*L'Arresto*) by Marinetti gives an interesting and
apparently accurate view of how the Futurist plays were sometimes
performed. It takes place in "an elegant room, with chandeliers"; a
small stage has been set up in the room, and the audience of intel-
lectuals and socialites is sitting in armchairs and standing along the

walls. In the context of a play-within-a-play, Marinetti develops the theme of the virile, war-loving and combat-experienced Futurists opposed to passéist and effetely intellectual critics.

Historians have seen the wish, in the basic "Foundation and Manifesto of Futurism" of 1909, to "destroy the museums" as a proto-Dada attitude; *Runio Clacla,* published by Marinetti in the 1916 collection of *sintesi,* demonstrates that the Futurists meant to be as ruthless with their own work as with the creations of other artists. When Balla is awarded a prize in the play, he gives it to a hunchback, and, shouting "Runio clacla," he and the other Futurists destroy all of the paintings in his exhibition.

The Arrest carefully avoided mentioning the names of the characters. The "First Spectator" has forgotten the name of the "celebrated [Futurist] painter" who is playing the part of the Captain in the play-within-a-play. But Balla is a character in *Runio Clacla.* Marinetti and Boccioni appear as characters in Marinetti's play *The Dormice* (*I Ghiri*): as they were in real life, they are shown as soldiers fighting the Austrians during World War I. *The Dormice* was published in the 1916 collection of *sintesi,* before a fall from his horse killed Boccioni on August 17, 1916, while he was still in the service. Since the Futurists sometimes performed in their own pieces, one wonders whether Boccioni, Marinetti, and Balla were intended to, or ever did, play themselves in these *sintesi.*

The same is true of Cangiullo, who appears as a character in his own *The Paunch of the Vase* (*La Pancia del Vaso*), published in *Roma Futurista* on April 25, 1920. Cangiullo refers to himself in the first person—"I throw it on the table, light a cigarette and exit"—giving strength to the feeling that he at least hoped to play the part himself. Indeed, since the play hinges to a great extent upon the identity of the "I" figure, it would only be fully effective if the relationship to the author was clearly understood or if Cangiullo portrayed himself for spectators who recognized him.

At any rate, this Futurist attitude toward characterization is one of the elements in their work that seems to have influenced Luigi Pirandello. Not only did the Futurists attack the consistent, well-developed character, but they presented stage figures that, in playing

themselves, were more real than traditional representations. This questioning of characterization and the offering of new alternatives can be seen as establishing a theatrical context from which Pirandello, who knew the work of the Futurists, developed.

Futurism also influenced Pirandello by making the audience part of the performance, creating both an increased awareness of fourth-wall conventions and heightening requirements for "belief" or "the suspension of disbelief." Simultaneity, which sometimes bordered on paradox, and even the nihilism of some *sintesi* in which one alternative is as good as another can be seen as additional factors contributing to the development of Pirandello and the Theatre of the Grotesque.[3]

If certain of the *sintesi* can be discussed most easily in terms of the demands of the Futurist manifestos, others can be analyzed best in terms of their objective style. As has been mentioned, both of these approaches are somewhat arbitrary. To relate a play to particular concepts in the manifestos does not mean that it was actually written in reaction to the manifestos. It is merely as if this were true. The first collection of *sintesi* was apparently published after "The Synthetic Theatre" manifesto, but some of them were written and performed before the manifesto was published, and the exact dates of composition are mostly unknown. It is safe to say that almost all of the *sintesi* followed the publication of "The Variety Theatre," but some of them contributed concepts and terminology to the later manifesto.

All of the *sintesi* could, of course, be analyzed both in terms of their relation to the manifestos and in terms of their style. It is quite obvious that the completely abstract or alogical plays, for example, could also be related to the demands in "The Synthetic Theatre" for "autonomous" performances, "pure abstraction" and "pure cerebralism." Thus a discussion of the *sintesi* in terms of stylistic categories is primarily for convenience. An examination of style is important, however, to illustrate the range of Futurist work and to

[3] For a longer discussion of Futurism's influence on Pirandello, see: Giovanni Calendoli, "Dai Futuristi a Pirandello Attraverso il 'Grottesco,'" *Sipario* (December, 1967), pp. 14–16.

suggest a certain development of theatrical thought. Although his-
torical progression or development is indicated by such an approach,
it is not intended to be taken literally. Many different styles were
developing simultaneously in Futurism, and a clear line of historical
growth, with one style clearly leading to another, is impossible to
document. But, again, it is as if this were true. Perhaps the develop-
ment or progression was only within the minds of individual artists
who tended to follow the same line of aesthetic growth. At any rate,
a spectrum of styles can be laid out in which a logical and consistent
development can be traced, even though the actual history was much
more complicated and obscure.

At the base of this hypothetical history of stylistic development
lies Symbolism, a form inherited by the Futurists from Maeterlinck
and Andreyev. At least two branches can be seen to develop from
Symbolism. One moves toward the irrational, illogical, and absurd,
and the other emphasizes formal elements to create semi-abstract
and totally alogical performances.

Nocturnal (*Notturno*) by Francesco Balilla Pratella, the Futurist
composer, was one of the earliest *sintesi*. Produced, along with other
works, by Ettore Berti's company in January and February, 1915, and
subtitled a "Dramatized State of Mind," it was basically a Sym-
bolist piece. The "state of mind" concept that appeared so fre-
quently in Futurist performance was directly derived from Sym-
bolism, which attempted to portray not surface reality but the more
intangible aspects of life.[4] Mood, atmosphere, and a sense of mystery
were important elements of Symbolism; like *Nocturnal,* many *sintesi*
took place at night, and the characters performed actions, like count-
ing the stars, that were both realistic and symbolic. The huge glass
bell jar that contains a nude woman in Volt's *Flirt* is not intended to
be taken literally but as the representation of a state of mind or of
certain sociopsychological conditions of existence.

In Symbolism, characters became abstractions representing
types, categories, or concepts. Personal names and idiosyncratic
personality traits would interfere with *Flirt's* presentation of "states
of mind": the performers are referred to as "He" and "She." "The

[4] "Stato d'animo" may also be translated as "mood."

Artist" and "The Critic" in Boccioni's *Genius and Culture* (*Genio e Coltura*) represent all artists and all critics. The "Lady" in Buzzi's *Parallelepiped* (*Parallelepipedo*) is not a woman, but death. Death was a rather popular figure in Symbolist works.

In the same way, place or location in Symbolist drama was not particular or realistically detailed. Since abstractions and types do not need a practical environment in which to function, Symbolist plays frequently gave no indication of where they were taking place. The armchair and the bell jar in *Flirt* relate to character rather than to a specific location. They exist on a neutral ground that gives no indication of a unifying environment. The three characters in *Genius and Culture* are related, in the same way, to elements of decor that are emblematic of their categories. "The Critic," for example, is sitting at "a table overburdened with books and papers." But the three different types of stage furnishing are realistically unrelated to each other and "float," as it were, in an unspecified limbo. If ideas and concepts are represented, rather than people and situations, no particular environment or place is needed, although a sense of place, usually manifest through mood or atmosphere, is retained.

From one point of view, Marinetti's "drama of objects," in which inanimate things moved and spoke, could be considered an extension of Symbolism. If "states of mind" such as inhibition/frustration and objective concepts such as death could be personified on stage, it would seem that furniture, too, could take on life. The romantic and somewhat gloomy darkness of *The Little Theatre of Love* (*Il Teatrino dell'Amore*) is reminiscent of Symbolist atmosphere, but the use of nonhuman characters, however, is quite different. When the furniture speaks, it is to offer specific details about the weather, the offstage activities of people, and its own state of being. Anthropomorphic comments are used to create a very particular and exact environment. In the same way, *They Are Coming* (*Vengono*, Fig 7) by Marinetti uses people rather than concept characters and an individualized place rather than an emblematic one. The movement of the furniture that climaxes the *sintesi* can be contrasted with the revelation at the end of *Parallelepiped* that "The Lady" is death. Although both plays develop out of a milieu that is recognizably representational, Marinetti's *sintesi* does not provide an intel-

Fig. 7. The exit of the chairs in *They Are Coming* (*Vengono*, 1915) by Marinetti. (From a reproduction in *Teatro F. T. Marinetti* edited by Giovanni Calendoli [Rome: Vito Bianco Editore, 1960].)

lectual explanation or answer. As in Surrealism, another, more powerful, reality takes over and asserts itself. Like the protagonists of Ionesco's *The Chairs*, Marinetti's people are helpless when faced with animate furniture that contradicts the accepted laws of existence.

Thus we find in the Futurist *sintesi* the development of elements that were to lead directly to Dada, Surrealism, and the Theatre of the Absurd. The grotesque illogical humor of plays such as Cangiullo's *The Paunch of the Vase* and the exaggerated, physical, anti-establishment satire of *sintesi* like Marinetti's *Runio Clacla* can be clearly traced to the later works. *Vagrant Madmen* (*Pazzi Girovaghi*) by Chiti and Settimelli approaches the irrational from a somewhat Symbolist orientation, creating a stage world peopled only by two psychotics, but *The Body That Ascends* (*Il Corpo che Sale*) by

Umberto Boccioni focuses on the effect of an irrational occurrence in an everyday context, creating a basically surreal image.

At the same time, we can see developing in Futurism a tendency toward the abstract and alogical. Symbolism, like Realism and Naturalism, was fundamentally a logical form of theatre. The logical process is additive: one unit of information is joined to another in a consistent context. Symbolism was not always explicit, favoring ambiguity and suggestion as it did, but it accumulated connotative detail to arrive at an intellectually coherent statement.

Illogic, on the other hand, is a process of disruption and contradiction. Rather than "adding up," it "subtracts." The illogical elements of Futurist *sintesi* that later developed into Dada, Surrealism, and the Theatre of the Absurd work against expectancy, against probability, and against their context of logicality.

A third alternative, alogical theatre, is neither logical nor illogical. Alogical structure can be seen in a play like Marinetti's *Feet (Le Basi)*. Published in the January–February, 1915, supplement to *Gli Avvenimenti*, *Feet* consists of seven short scenes in which the audience sees only the performers' feet, although it can hear their voices. A photograph that still exists of a production in

Fig. 8. Photograph of a production of *Feet (Le Basi,* 1915) by Marinetti. (From a reproduction in *Teatro F. T. Marinetti* edited by Giovanni Calendoli [Rome: Vito Bianco Editore, 1960].)

1915 (Fig. 8) indicates that all of the actors, or at least their legs and feet, appeared on stage at the same time, the upper parts of their bodies hidden by the curtain, which was raised only a short way. The important point, however, is that one vignette does not explain another. The sections do not "add up" in an intellectual sense.

Feet may be compared with *Amore Pedestre* (*Pedestrian Love*), a short film made by Marcel Fabre in 1914. Running only about seven minutes, the film tells the story of a man who follows a woman onto a streetcar, where he flirts with her. A love note is intercepted by the woman's boyfriend (or husband), a soldier. The man and the soldier fight a duel. The man is wounded, but, after the soldier drives off in a car, the woman comes to him, and they go off together. In telling this whole story, the camera shows only feet. In the last shot, we see the feet of the man and woman turned toward each other; apparently they are embracing. The woman's skirt falls down around her ankles, she steps out of it, and the couple walks toward the bed that can be seen in the background. The important point is not the similarity between *Amore Pedestre* and *Feet* but their differences. Fabre tells a story; Marinetti's does not. Fabre's piece develops to a climax; Marinetti's does not. Fabre's intent is merely humorous entertainment; Marinetti, even though he makes use of humor, is attempting to create a more subtle and profound experience.

Hands (*Le Mani*) by Marinetti and Bruno Corra, also published in 1915 and perhaps written before *Feet*, is structurally similar. In it only the hands of the actors can be seen above a curtain stretched across the stage. Twenty different isolated images are presented in sequence: two hands shaking each other in greeting, hands praying, two hands writing at different speeds, a hand scratching, a hand with a revolver, a fist punching, a caressing female hand, and so forth. The use of only hands or feet gives a kind of unity to these pieces that is formal, imagistic, and isomorphic rather than literary. The expressive possibilities and, so to speak, the visual language involved are presented for their own sake rather than being used to create narrative development.

Whereas *Feet* retains the elements of place and interaction of characters and *Hands* makes use of specific human gestures in their

alogical structures, other *sintesi* like Depero's *Colors* (*Colori*) tend toward the elimination of all human qualities. Depero's "abstract theatrical synthesis" seems intended to create the stage equivalent of a nonobjective painting. Four three-dimensional shapes are moved by strings like giant puppets. Each a single color—gray, red, white, and black—they are seen within the blue cube of the stage. Each of the shapes "speaks," but it is in a pure sound language that is a vocal equivalent of music.

Fillia's *Mechanical Sensuality* (*Sensualità Meccanica*) is quite similar to Depero's *sintesi*. It is an actorless performance that presents moving, geometrical, monochrome shapes against a pure architectural ground. But because the shapes, in part, use actual words when they speak, they take on a degree of personification or characterization that is not present in *Colors*.

If completely alogical plays can be compared to abstract painting and sculpture, however, there are many that are not completely alogical and may be thought of as semi-abstract or semi-alogical. Just as a semi-abstract painting retains certain references to representational reality, the semi-alogical play retains representational elements. But in both the painting and the play, the predominant aesthetic emphasis is on the formal qualities of the work. Representation merely serves as a framework or point of origin for these formal elaborations and is subservient to them.

In analyzing the degree of representation in a performance, both detail and continuity through the dimension of time must be considered. The varying degrees to which the *sintesi* used representational detail can be illustrated by their elimination of the sense of place and by their use of abstract or invented language. The tendency away from representational time structures in the plays is seen in their approaches to the interaction of characters and to narrative.

Symbolism frequently did away with specific place. But the mood, atmosphere, or feeling of place still existed. The spectator felt that the performers were in an environment quite different from that of the audience. In certain of the Futurist *sintesi* even this poetic, nonspecific sense of place was eliminated, and the place of the action was the stage itself. *To Understand Weeping* (*Per Com-*

prendere il Pianto) by Giacomo Balla establishes a purely formal stage, half red and half green, that is without pretense or atmosphere. Much, if not all, of the action in *The Battle of the Backdrops* (*Lotta di Fondali*) by Marinetti refers directly to the curtains hung at the rear of the stage, and the play occurs in its own stage space rather than in an imaginary one. In *The Lady-Killer and the Four Seasons* (*Il Donnaiuolo e le 4 Stagioni*) by Cangiullo, the audience also is addressed directly, helping to establish the concrete reality of the stage as a real place rather than an imaginative one; although the relation of at least two of the four actresses to an imaginary place is quite specific, a single unified environment is never created, and the real stage remains as a ground for all of the isolated actions.

The degree of representation in a play also can be measured in the language that is used, but invented language is not necessarily completely nonrepresentational. The satirical and sarcastic Dadaistic chant from which *Runio Clacla* takes its title could be quite close to actual utterances of the Futurists. Although certain aspects of the play are obviously exaggerated and symbolic, the invented phrases retain a strong representational quality in their context. Nor is invented language abstract or nonrepresentational in Mario Carli's *States of Mind* (*Stati d'Animo*). The characters exist in a single unified place, a café, and they speak to each other. Although they speak, for the most part, words created by Carli, their behavior remains realistic, and the effect is somewhat like listening to people speak a foreign language: We can often gain a general understanding of what they are saying—and of their "states of mind"—without knowing the language.

A more abstract use of language occurs in *Words* (*Parole*) by Remo Chiti, even though none of the vocalizations is invented. The source and context of the lines are clear. A large crowd of people is waiting outside of a gate; the beginning and end of each sentence disappear in the general tumult, and are lost. The phrases we hear are perfectly clear, but their meaning cannot be understood because they are incomplete. We receive fragmentary impressions and suggestions. Phrases do not fit together or explain each other. Meaning does not accumulate, and the effect tends toward abstraction.

The degree to which invented language retains representational character in *To Understand Weeping* can be seen by comparing it with the abstract vocalizations in *Colors*. The two men in Balla's play talk to each other: most of their speech are meaningless sounds and numbers, although certain phrases can be understood literally, providing an emotional context and situation that frames the artificial vocabulary and controls its interpretation. On the other hand, since the nonhuman moving shapes in Depero's *Colors* do not talk to each other, express particular emotions, or play a scene, the invented language can remain as totally nonrepresentational as music.

The same range can be seen in the work of Balla himself, who showed an involvement with abstract language in many of his performance pieces. His *Discussion of Futurism by Two Sudanese Critics* (*Discussione di Due Critici Sudanesi sul Futurismo*, 1914) was performed by Balla, Cangiullo, and Marinetti, apparently at the Sprovieri Gallery in Rome about the time of *Piedigrotta*. The piece employed a piano, probably played by Cangiullo, and a guitar, played by Balla. Balla's notes suggest the "dialogue," which may have been improvised to a great extent:

Farcionisgnaco gurninfuturo bordubalotapompimagnusa
sfacataca mimitirichita plucu sbumu farufutusmaca
sgnacgnacgnac chr chr chr stechestecheteretete
maumauzizititititititi.[5]

Judging from the title, the "discussion" still retained a degree of representation. When thought of as being the speech of Africans —the performers undoubtedly elaborated on this idea with gestures, facial expressions, and, perhaps, costumes—the piece resembles a humorous cabaret act, but it helped to create the artistic climate that was to produce Dada.

In the same year, 1914, Balla produced another work that used representational sound of an entirely different kind. Each of the twelve performers in *Printing Press (Macchina Tipografica)* became part of a machine, moving rhythmically and repeating a partic-

[5] Maurizio Fagiolo dell'Arco, *Balla: Ricostruzione Futurista dell'Universo* (Rome: Mario Bulzone Editore, 1968), p. 81.

Fig. 9. *Printing Press* (*Macchina Tipografica*, 1914) by Balla—the vocal-sound script. (See Figs. 11 and 27.) (From a reproduction in *Balla: Ricostruzione Futurista dell'Universo* by Maurizio Fagiolo dell'Arco [Rome: Mario Bulzoni Editore, 1968].)

ular sound: "lalalala," "ftftftft," "riorioriorio," and so forth (Fig. 9).
It was not language that was represented, however abstractly, but
the sounds of machinery.

Parts of Balla's *Disconcerted States of Mind* (*Sconcertazione di
Stati d'Animo*, 1916) seem to have abandoned representation com-
pletely, although the title suggests subjective reference. Four per-
formers "dressed differently" stand in front of a white background.
In the first of four sections, which are separated from each other
by pauses, they each repeat loudly a single number. Speaking
simultaneously again in the second section, they say a single letter
over and over (or perhaps Balla intended them to make the sounds
indicated by the letters). In the third section, each of the four
performs a simple everyday action: looking at his watch, blowing
his nose, etc. Again the actions are done simultaneously. The last
section makes use of particular representational sounds ("no, no,
no, no . . ."), and the proper emotions and attitudes ("denial") are
indicated in the script. Each of the sections, like the sharply-defined
areas of pure color in a painting by Mondrian, was self-contained
and had its own particular and pronounced quality. Thus Balla
created a performance that, while making no use of an imaginary
place, created and juxtaposed visual and auditory textures or patterns
by combining pure sound, simple movements, and basic emotional
expressions.

Of course these elements of place and language exist in the
context of time. But we may pick out other aspects of a play, such
as the interaction of the characters and the sequential structure,
that are more intrinsically involved with time. Even though life is
merely sequential, and selection is required to derive a story or a
plot from it, narrative may be considered as the basic representa-
tional form of durational structure in a performance. In this dimen-
sion, then, a work is nonrepresentational to the degree that it eschews
narrative or story-line structure.

In a story, one thing leads to another. The storyline of *Weariness*
(*Stanchezza*), written in 1916 by Angelo Rognoni, is internalized,
narrating the progressive subjective states of a man falling asleep,
but it is still a story. In a plotted story, the relationship is even

stronger, and one thing causes another. But in many Futurist *sintesi* story and plot are ignored. As in *Colors,* one thing merely precedes, or follows, another.

Narrative structure can easily sustain itself over long periods of time, but short images may make use of other unifying devices and formal structures. *Vowel Refrains* (*Storneli Vocali*) by Cangiullo merely presents, in a somewhat symbolic way, the five vowel sounds.[6] The unity is imagistic rather than narrative. *The Lady-Killer and the Four Seasons* gives an entirely visual personification of abstract categories. Its unity is conceptual rather than causative.

The sense of place is one thing that creates imaginary time in performance. A single place is assumed to have a single consistent time. By eliminating place, such plays as *Synthesis of Syntheses* (*Sintesi delle Sintesi*) by Guglielmo Jannelli and Luciano Nicastro tend to weaken the narrative or story-line potential of their images. But causality is also a factor, and even without a definite sense of place, one image may be felt to cause or to be caused by another, thereby creating a plotlike time structure. In the *sintesi* by Jannelli and Nicastro, a revolver shot is followed by "confused screams," and it is not difficult to assume that one has caused the other. But in other *sintesi,* and in other parts of *Synthesis of Syntheses,* causal connections are very slight or nonexistent, and we have already seen that no such representational sequence exists in *sintesi* such as *Hands* and *Feet.*

Story or plot continuity may, of course, be clear and obvious, or it may be tenuous, indirect, and suggested. As narrative moves away from the explicit, it may be considered to become semi-abstract or relatively nonrepresentational. *Lights* (*Luci*) by Marinetti is basically a sequence of images all employing light in one way or another. Thus the structure, in making use of a single repeated element, seems, like *Hands* and *Feet,* to be isomorphic and completely formal. But the traces of an ill-fated love story can be perceived in the "poetic" implications of the images. Even though the light images are clearly separated from each other by blackouts, and there is no interaction between the two performers, the traces of

[6] *Storneli Vocali* has frequently been published as coauthored by Cangiullo and Rodolfo DeAngelis, but Cangiullo asserts that he alone wrote the piece.

story, plot, and situation remain. The work is not completely abstract or alogical.

The degree of interaction between the characters in a play can also be seen as a measure of abstraction or representation. In *sintesi* such as *The Battle of the Backdrops, The Lady-Killer and the Four Seasons,* and *Vowel Refrains,* any exchange between characters that could create a sense of place and causality is completely absent. This isolation of the characters tends to objectify the action and remove it from the areas of fantasy and imagination. As in the other measures of representation, the traditional realistic connections between things are weakened or eliminated in the *sintesi* as they move toward total abstraction and nonrepresentation.

VII] The Theatre of Surprise

By 1921 most of the important accomplishments of the Futurists were behind them. "The Theatre of Surprise" manifesto, written by Marinetti and Cangiullo on October 9, 1921, dated October 11, and published in *Il Futurismo* on January 11, 1922, retains the energy, optimism, and bravado of earlier manifestos, but it offers nothing basically new. There is a passing reference to a new *anti*political attitude that seems to contradict their prewar position: "The Theatre of Surprise," it said, "wishes to pull Italian youth away from monotonous, gloomy, mournful political obsessions." And one perhaps can detect a trace of bitterness over lack of recognition. The first version of Pirandello's *Six Characters in Search of an Author* was written in 1921; the Theatre of the Grotesque was reaching a popularity that Futurist performance had never attained; and "The Theatre of Surprise" claimed that: "If today a young Italian theatre exists with a serio-comic-grotesque mixture, unreal persons in real environments, simultaneity and interpenetration of time and space, it owes itself to our *synthetic theatre*." But the manifesto, although interesting, was nothing more than a recapitulation and extension of certain previously stated concepts of Futurist performance.

The idea of "surprise" itself, as explained in the manifesto, was nothing more than the basic Futurist emphasis on innovation. The worth of a work lay in its originality, and this originality was experienced by the spectator as surprise. "After many centuries filled with ingenious works," the manifesto explained, it is "very difficult to surprise today," but it was still of "absolute importance."

In mentioning performances of the Theatre of Surprise, the

66

manifesto indicated that some of them involved exhibiting paint-
ings, or sometimes merely the painter, from the stage, but this was
hardly a new idea. Improvisation had become more important,
perhaps, but the performances still mixed many different elements
and emphasized *fisicofollia,* the "physical madness" of deep involve-
ment with direct sensory experience that was stressed in "The
Variety Theatre" manifesto of 1913.

In its practical work, however, the Theatre of Surprise did
develop certain aspects of Futurist performance theory. The Theatre
of Surprise company was headed by the actor-manager Rodolfo
DeAngelis, whom Cangiullo had first met quite by accident on a
train. In addition to DeAngelis, Marinetti, and Cangiullo, it included
four actresses, three actors, two dancers, a small child, an acrobat,
and a dog. The company made its debut at the Teatro Mercadante
in Naples on September 30, 1921, and then toured Palermo, Rome,
Florence, Genoa, Turin, and Milan. The repertoire included some
earlier pieces such as Boccioni's *The Body That Ascends* and
Marinetti's *Vengono,* but there were also a number of works in forms
that were less literary.

The Futurists continued to develop simultaneity and the juxta-
posing of unrelated actions. *Public Gardens* (*Giardini Pubblici*) by
Marinetti and Cangiullo placed on stage, among other things, two
lovers kissing on a park bench, a "typical invert" who wandered
about effeminately, and five actors, supposedly sitting in a car, who
imitated all the motions and sounds of an automobile ride. There
was no development, story, or plot, and each action took place in its
own self-contained area.

This play is perhaps the clearest example of the influence of
Futurism on the work of Thornton Wilder. Wilder was in Rome in
1921 and may have seen *Public Gardens* when it was presented
by the Theatre of Surprise company. In his one-act play, *The Happy
Journey to Trenton and Camden,* four chairs are arranged in two
rows representing the front and back seats of an automobile. The
actors occupying the chairs pantomime the motions of the car.
Wilder's stage direction reads, *"PA's* hands hold an imaginary steer-
ing wheel and continually shift gears . . . there is a lurch or two and

they are off." [1] The staging technique of *Our Town* by Wilder also relates closely to that developed in the Theatre of Surprise: causally unrelated and spatially distant actions are presented simultaneously on a neutral or bare stage using a minimum of props.

At times the Theatre of Surprise presentations demonstrated the unitary structure and short duration that, during the 1960's, became known as "Events." [2] *Music of the Toilette* (*Musica da Toletta*) by Marinetti and Calderone was a single image that employed incongruity rather than juxtaposing. Two chambermaids dusted and washed the keyboard of a piano, "playing" it while they worked; the small child who was a member of the company, also dressed in a uniform, polished the "elegant, gilded, woman's shoes" in which the legs of the piano rested. Again, the image had no development. In its focus upon the activity of the performer and its freedom from required detail, the piece foreshadowed recent work with indeterminacy and task-based performing.

Other performance pieces eschewed characterization or the indication of place. In his *Simultaneity of Voluptuous War* (*Simultaneità di Guèrra Voluttà*) Marinetti read *Battle in the Fog* (*Battaglia nella Nebbia*) accompanied, as he had been in 1914, by a bass drum that imitated bombing; while he read, a well-dressed couple danced a "languid tango" around him. The two unrelated actions were intended to "interpenetrate" and combine "bellicose furor and voluptuous nostalgia." (In the previous year, 1920, under the direction of Achille Ricciardi, Marinetti had declaimed Mallarmé's *Un Coup de Dés* accompanied by the dancing of Lleana Leonidoff and a changing display of lights designed by Enrico Prampolini.)

The published "scripts" of these presentations by Marinetti seem more like descriptions written after the fact than they do directions for performances. Certainly the pieces are so simple that written instructions would not have been necessary for the actors.

[1] Thornton Wilder, *The Happy Journey to Trenton and Camden*, in *The Long Christmas Dinner & Other Plays in One Act* (New York: Coward-McCann, Inc.; New Haven: Yale University Press, 1931), p. 105.

[2] For a description of "Events," see: Michael Kirby, *The Art of Time*, p. 80.

To a great extent, the Theatre of Surprise presentations tended to continue the rather pugnacious audience-performer relationship of the earlier anti-passéist demonstrations and *serate*. "The Theatre of Surprise" manifesto bragged about battles that had been won and stated that one of the essential purposes of surprise was to "provoke absolutely improvised words and acts" from the spectators. The performance was seen as a stone thrown into water, and its widening ripples—the "new surprises in the orchestra, boxes, and in the city the same evening, the day after, to infinity"—were thought of as part of the whole. This concept, of course, was not original with "The Theatre of Surprise." Eight years earlier, "The Variety Theatre" had pointed out for emulation the way in which the relationship between spectators and performers in the music hall continued after the formal performance with a "crowd at the stage door" and subsequent romantic incidents. But later performances also indicated that the means had shifted from direct provocation to more indirect aesthetic "surprise." A "note" appended to each of Marinetti's descriptions of his surprise pieces emphasizes the "widening ripples" concept by explaining the "absolutely improvised words and acts of the spectators": one member of the audience began to hiss violently and then to applaud suddenly; another yelled "You aren't crazy, but this makes everyone go mad"; a third walked on his hands around the balcony; others, dressed in costumes, harangued each other.

Just as Cangiullo and Petrolini had sent actors into the auditorium in their 1917 *Radioscopia,* Cangiullo now scattered the instruments of the orchestra throughout the house.[3] A trombone was played from a box, a contrabass from an orchestra seat, a violin from the pit, and a bass drum from the upper gallery, while Cangiullo conducted.

The Theatre of Surprise company managed by Rodolfo DeAngelis continued to make tours, with changing personnel, until

[3] In the preceding year, 1920, Satie had deployed his instruments spatially for the first concert of *"Musique d'Ameublement"* or "furniture music." See: Roger Shattuck, *The Banquet Years* (Garden City, New York: Doubleday & Co., 1961), pp. 168–169.

1923. In 1924 DeAngelis organized the New Futurist Theatre that toured twenty-eight Italian cities with a repertoire of about forty works. At the same time as the Theatre of Surprise tours, Futurist performance was spreading to other countries. In 1921 Enrico Prampolini designed the sets for nine *sintesi* that were presented in Prague: the performances in Czechoslovakia included *Vengono, Parallelepiped, Bachelor Apartment,* and *Sempronio's Lunch.* The following year, in November, 1922, the Art et Action group performed a program of *sintesi* in a small experimental theatre on the seventh floor of an apartment building in Paris. Futurist works were also presented at the Théâtre des Champs Elysées in Paris and by Georges Pitoëff in Geneva and Zürich.

VIII] Futurist Scenography

An attempt to understand Futurist scenography faces several diffi-
culties. Few records remain, especially of the earlier and most im-
portant performances. The rare photographs that exist are, of course,
in black and white, and they can only suggest sequential develop-
ment, lighting, and movement. Designer's sketches and studies, even
though they may be in color, are frequently even more difficult to
relate to what actually was created on stage: the spatial depth,
which is sometimes difficult to "read" in a photograph, frequently
becomes flattened, and scale can only be guessed at. From a rendering
it is sometimes impossible to know whether the designer was plan-
ning a three-dimensional setting or merely a drop painted to suggest
depth. The Futurist stage designers were painters rather than archi-
tects; they left some indications of the two-dimensional views of
their conceptions, but ground plans that would demonstrate much
more clearly the total spatial elaboration of the stage are not
available.

Thus no visual record exists of many performances, including
some that have been among the most interesting achievements of
Futurist scenography. Conversely, the importance of a work may
have become magnified merely because there is an extant photograph
of it. This seems to be true of the huge three-dimensional flowers
that Depero built out of wood and cardboard in 1916–17 for
Diaghilev's production of Stravinsky's *Nightingale's Song* (*Chant du
Rossignol*). Three exceptionally clear photographs exist: two show-
ing the flowers under construction in the large studio Depero had
rented, and one showing them painted and assembled (Fig. 10). The
flowers are quite large—according to Depero, some leaves were five
meters long and the conical blossoms measured as much as two
meters across—and they are of a simplified "modern" design, but

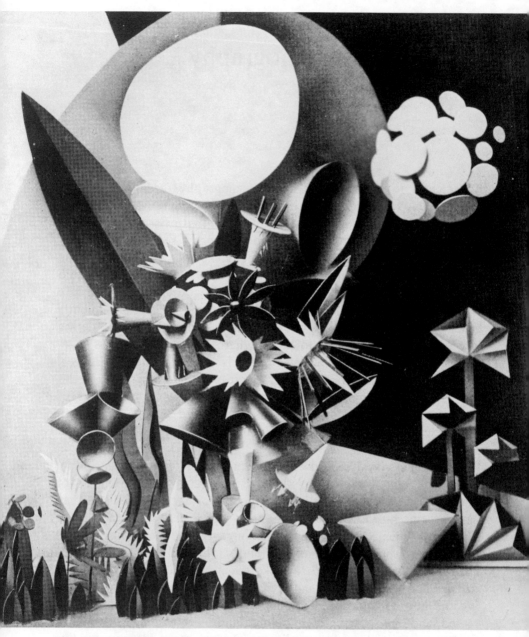

Fig. 10. Cardboard and plywood flowers—and what appears to be a cloud—by Depero for *Nightingale's Song* (*Chant du Rossignol*, 1916–17) by Stravinsky. (Courtesy of the Depero Museum, Rovereto)

they offer nothing particularly innovative or provocative in terms of stagecraft. In an apparent attempt to make them more interesting, some sources suggest that the flowers moved, but Rosetta Depero has said that this was not the case.[1] Diaghilev's company had to leave Italy, and Depero's flowers were never actually used on stage; and yet they are mentioned as somehow important in almost every study and chronology of Futurist scenography.

In spite of these difficulties and the lack of detailed descriptions of the settings for particular performances, certain general conclusions may be drawn about Futurist scenography. Many of the early *sintesi,* especially those that attacked realistic staging by employing the conventions of that style, made use of box sets and real furnishings. Since the *sintesi* most frequently were presented by touring companies, these were probably stock sets and props that could be found in any theatre. At any rate, settings of this kind did not attempt to make a contribution to stagecraft.

Many Futurist performances were presented by touring companies. In 1915 and 1916 the companies of Ettore Petrolini, Annibale Ninchi, Luciano Molineri, Gualtiero Tumiati, and Ettore Berti performed programs of *sintesi* in the principal Italian cities. The touring companies with their limited budgets probably transported very little scenery with them; in what was perhaps also an effort to cut down on long intermissions and reduce complicated backstage operations, the *sintesi* seem to have frequently been presented on a neutral stage with a few set pieces, by merely using a backdrop or by combining set pieces and a drop. Such backdrops were consistently painted in a modified Cubist style. Although Futurist painting was greatly influenced by Cubism, there was a distinct difference. Most simply, Cubism presented simultaneous views or facets of the subject at what could be considered a given moment, whereas Futurist painting, using similar stylistic devices, attempted to show movement that implied an extension through time. Although an angular Cubist

[1] Rosetta Depero, private interview in July, 1969. Sheldon Cheney, for example, has written that Depero's "mechanical flowers . . . move and speak through clusters of megaphones that convey the words of the drama." "International Theatre Exhibition," *Theatre Arts Monthly* (March, 1926), p. 206.

style was used consistently in the painting of Futurist scenic drops, there were few attempts to convey the idea of movement. The simplification of form and the purity of color in the drops may have derived from the necessity of being seen from a distance, but synthetic Cubism was following the same path. If the scale of the Futurist scenic drops had affected the scale of their paintings, they could have been significant, but, again, this kind of backdrop seems to have contributed little to either painting or stagecraft.

In a projected setting for his *Printing Press* (*Macchina Tipografica*, 1914, Fig. 11) Balla eliminated any sense of place. By spelling "TIPOGRAFIA" asymmetrically in huge letters across a drop and side wings—there was one wing at stage right and two at stage left—he created a setting that referred only to itself and

Fig. 11. Design by Balla for his *Printing Press* (*Macchina Tipografica*, 1914). (See Figs. 9 and 27.) (From a reproduction in *Balla: Ricostruzione Futurista dell'Universo* by Maurizio Fagiolo dell'Arco [Rome: Mario Bulzoni Editore, 1968].)

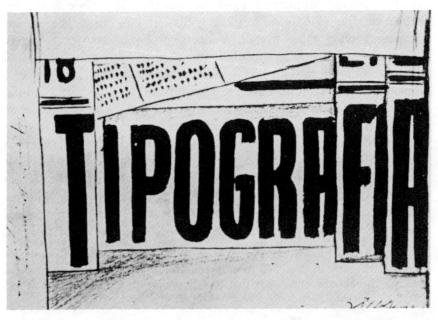

the performance of which it was to be a part. The design was apparently never realized, however, and this approach to staging had no noticeable effect.

Futurism did make positive contributions to stage setting and lighting, however, and these contributions can be most easily understood in terms of the work and thought of Enrico Prampolini (1894–1960). Prampolini was the most important Futurist figure in scenography. In addition to being a playwright, a director, and a widely exhibited painter, he designed more than 130 productions, and published the most important manifestos on Futurist staging.

Much of Prampolini's theory derives from that of Gordon Craig. However, Craig had a great influence not only on Futurist scenography but, it is quite possible, on the basic theories of Futurism itself. Craig's "monthly journal of the Art of the Theatre," *The Mask,* first appeared in March, 1908; it is enough to emphasize that, although printed only in English, it was published in Florence and distributed internationally and that Craig was a widely known and controversial figure in the theatre. It is quite probable that Marinetti was aware of his ideas when he wrote the "Foundation and Manifesto of Futurism" in 1909.

An involvement with dynamism and speed was at the heart of the initial Futurist manifesto: "A racing car . . ." an oft-quoted passage reads, "is more beautiful than the *Victory of Samothrace.*" Craig already had placed primary importance on movement in an article with a title that probably would have seemed striking to Marinetti and perhaps was influential: "The Artists of the Theatre of the Future" was published in two parts in *The Mask* in 1908 and was republished in 1911 in Craig's book *On the Art of the Theatre.* "I like to remember," Craig wrote, "that all things spring from movement, even music; and I like to think that it is to be our supreme honor to be ministers to the supreme force . . . Movement." [2] There is no question that Craig showed, at that time, a fervent involvement with motion similar to what was later to appear in Futurism. "I like to suppose," he said in the same article of 1908, "that this art

[2] Gordon Craig, "The Artists of the Theatre of the Future," *The Mask* (May–June, 1908), p. 68.

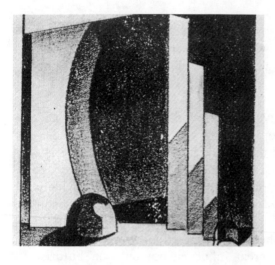

Sketches (1921) by Prampolini of settings for three *sintesi*. LEFT: Fig. 12. *Yellow—Red—Orange* (*Giallo—Rosso—Arancione*), by Settimelli. RIGHT: Fig. 13. *Antineutrality* (*Antineutralità*), by Marinetti. FAR RIGHT: Fig. 14. *Parallelepiped* (*Parallelepipedo*), by Buzzi. (Courtesy of Dr. Alessandro Prampolini)

which shall spring from movement will be the first and final Belief of the world." [3]

Whether or not Craig influenced the basic manifesto of Futurism, there is no doubt that his theories had a great effect on Futurist scenography, particularly that of Prampolini.

"Futurist Scenography," Prampolini's first manifesto concerned entirely with theatre, was published in 1915.[4] When he dramatically claims in it that "the absolutely new character that our innovation will give the theatre is *the abolition of the painted stage*," he is merely echoing Craig, who, he admits, had "made some limited innovations." (And, of course, Prampolini and the other Futurists did not actually stop painting backdrops.) Similarly, Prampolini's second important manifesto on scenography, "Futurist Scenic Atmosphere," owed much to the New Stagecraft. It was Craig who had said he wanted "an atmosphere, not a locality" on stage, and Prampolini's emphasis on "sceno-plastic" or "three-dimensional scenic environment" was entirely derived from Craig and Adolphe Appia.

[3] *Ibid.*, p. 70.

[4] "Futurist Scenography and Choreography" ("Scenografia e Coreografia Futurista") by Prampolini was published in *La Balza* in March, 1915. A slightly revised version, now called "Futurist Scenography" ("Scenografia Futurista") is dated April–May, 1915. For all practical purposes, the two manifestos can be considered to be the same.

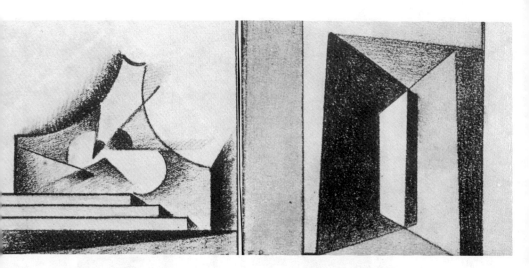

Prampolini's major emphasis, however, was on scenery that would move. Its activity would become an integral part of the performance. In the 1915 manifesto, he envisioned a neutral mechanized structure, an "uncolored electromechanical architecture," that would be illuminated by moving and changing colored lights. The "dynamic stage architecture" was described as "unleashing metallic arms, knocking over plastic frameworks, amidst an essentially new, modern noise."

Although Prampolini's imagery was more energetic and violent, Craig already had foreshadowed the basic concept of kinetic scenography. In January, 1908, he exhibited a series of etchings in Florence that showed a stage setting or "instrument" called "Scene" that was endlessly transformable and in which the movement of the physical elements was to be an important part of the performance.[5] The etchings do not actually show movement: each one, representing a moment in the progression of changing spaces, shapes, and lights, appears static. Craig's son, Edward Anthony Craig, has explained that until 1923 he "like so many others had presumed that they were various scenes for an imaginary drama."[6] And Craig, afraid

[5] See: Denis Bablet, *Edward Gordon Craig* (New York: Theatre Arts Books, 1966), pp. 117–122.
[6] Edward Craig, *Gordon Craig* (New York: Alfred A. Knopf, 1968), p. 316. Edward was only two years old at the time of the exhibition in Florence.

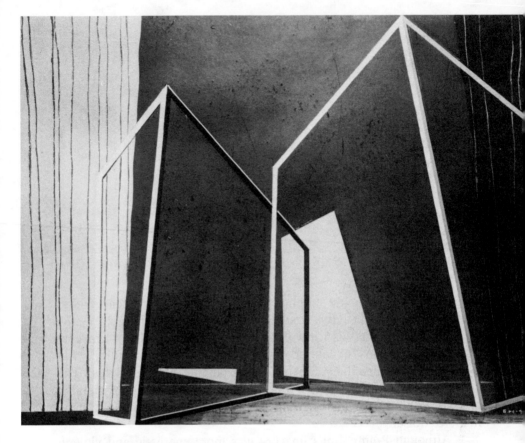

Fig. 15. Painting (1921) by Prampolini of the setting for *Parallelepiped* (*Parallelepipedo*), a *sintesi* by Buzzi. (Courtesy of Dr. Alessandro Prampolini)

that his idea would be "stolen," was not explicit in the preface to the catalogue. If read carefully, however, the preface—which was published, it is important to note, in both English and Italian—gives the picture of a kinetic "stage" where impersonal movement was the essence of the "performance." Although some of the etchings showed actors, there is no mention of performers in the preface, indicating Craig's concern for an actorless presentation. Republished in *The Mask* in December, 1908, under the title "Motion: Being the Preface to the Portfolio of Etchings by Gordon Craig," this essay also predated the initial Futurist manifesto; if its imagery

is not explicitly that of the stage, its appearance in a magazine devoted exclusively to theatre must have strengthened the reference to scenography.

At first the stage is empty, without walls, and movement begins in the center of the space: "Even now as we wait watching, in the very center of the void a single atom seems to stir . . . it spreads . . ." Shapes begin to rise: "A form simple and austere ascends with prolonged patience like the awakening of a thought in a dream. A second and a third seem to follow . . ." Then the square columns shown in Craig's drawings begin to open out like screens: "Look there to the East! Something seems to unfold, something to fold. Slowly quick'ning without haste, fold after fold loosens itself and clasps another till that which was void has become shapely." [7] The movement of the shapes and the changing space and volumes becomes a performance without actors: "Shapes continue to appear in endless procession while still the folds fold and unfold . . . some rising, others falling . . . passing and repassing one another." [8]

Futurist scenography developed these suggestions of kinetic settings and dynamic lighting. In "Futurist Scenography," Prampolini described what he called "the illuminant stage," a setting that would not only move but would be made of material like neon tubing that would irradiate its own light.

In an undated manifesto, "Notes on the Theatre," that was apparently written about 1916 but seems to have been unpublished during his lifetime, Fortunato Depero also wrote of dynamic scenography that combined a variety of active elements.[9] Here the moving decor was obviously figurative: "turning flowers, moving mountains, trees and steeples that oscillate, houses that uncover and open themselves." (It was also strongly proto-Surrealist in its emphasis

[7] Gordon Craig, "Motion: Being the Preface to the Portfolio of Etchings by Gordon Craig," *The Mask* (December, 1908), p. 185.

[8] *Ibid.*, p. 186.

[9] The manifesto "Appunti sul Teatro" is printed in a catalogue section covering the years 1916–18. No indication is given as to its previous publication or the date it was written, but it obviously follows "The Total Reconstruction of the Universe," published March 15, 1915, by Depero and Balla. *Fortunato Depero* (Turin: Gallerie d'Arte Martano, 1969), pp. 58–61.

on deformation and transformation.[10]) In "The Synthetic Theatre" manifesto, Marinetti had proposed the *sintesi* as a way to "win the race with cinematography," and Depero's manifesto makes clear that the kineticism of Futurist scenography was, in part, a reaction to the recently developed motion picture.

Although the concept of dynamic scenography is quite clear, it seems to have been rarely embodied in actual production by the Futurists. Russian Constructivist staging was the first extended practical application of these theories. But some of the pictorial records that remain of Futurist performances indicate attempts to integrate moving scenic elements with the actors. Prampolini's sketches for *The Merchant of Hearts* (*Il Mercante di Cuori*, 1926, Figs. 16 and 17) indicate hanging frames, screens, symbolic elements, and even abstract human figures that apparently moved during the performance. A photograph of his setting for *The Hour of the Puppet* (*L'Ora del Fantoccio*, Fig. 18) at the Lyric Theatre in Milan in 1928 shows a large cube or die, a large circle, and other solid elements that might have moved. These documents are from a relatively late period of Futurist stagecraft, but they show a completely practical development of the often vague and idealistic theories. Lightweight hanging elements or solid objects that could be moved by the actors themselves were two relatively simple and economical ways of creating kinetic stage settings.

Light was an equally important element in Futurist scenography. In his 1915 manifesto, Prampolini emphasized that his moving stage architecture would be *"powerfully vitalized by chromatic emanations*

[10] Depero's images had a pronounced dreamlike or surreal quality: he wrote of "the tragic fixity" of immobile characters, of the enlargement of eyes and their illumination, and of the transformation of a ballerina into a "floral vertex." "Appunti sul Teatro," p. 58.

OPPOSITE: Figs. 16 and 17. Sketches (1927) by Prampolini of settings for *The Merchant of Hearts* (*Il Mercante di Cuori*) by Prampolini and Casavola. Compare Fig. 17 (BELOW) with the designs for hanging figures (Figs. 39–41) and the photographs of the performance (Figs. 37 and 38). (Courtesy of Dr. Alessandro Prampolini)

Fig. 18. Setting by Prampolini for *The Hour of the Puppet* (*L'Ora del Fantoccio*), a pantomime by Luciano Folgore and Alfredo Casella presented at the Teatro Lirico in Milan in 1928. (From a reproduction in *Sipario* [Milan: December, 1967, No. 260].)

from a luminous source," and claimed that these colored lights "will give marvelous results of mutual permeation, of intersection of lights and shadows." Rather than establishing a mood, symbolic meaning, or the visual specifics of a particular place, lights were to take on their own autonomous character with the Futurists as an active element in the performance.

Thus one of the most significant and prophetic of all Futurist performances was Giacomo Balla's staging of Stravinsky's *Fireworks* (*Feu d'Artifice*) for Diaghilev's Ballet Russe at the Costanzi Theatre in Rome on April 12, 1917. Although it can be said that Balla "staged" the piece, Stravinsky's work was not a play, opera, or ballet; it had no story or characters and was merely a musical composition. For it Balla created a performance without actors in which the dynamics of light were of primary importance.

Balla filled the stage with what might best be described as a tremendously enlarged three-dimensional version of one of his non-objective paintings. Irregular prismatic forms jutted up at various angles to different heights above the stage floor. These solid forms were made of wood; Balla's working drawings for their construction still exist (Fig. 19). They were then covered with cloth and painted. On top of most of these large irregular shapes were smaller forms covered with translucent fabric and painted with brightly colored zigzags, rays, and bars. These smaller forms, which occupied the central areas of the stage composition, could be illuminated from inside. The entire grouping of shapes was displayed against a black background.

Balla built a "keyboard" of switches in the prompter's box,

Fig. 19. Working drawing by Balla for the construction of the front central section of his *Fireworks* (*Feu d'Artifice,* 1917). Dimensions are in meters. The rear edge of the top surface is about 11'6" long. (Courtesy of the Gallerìa d'Arte l'Obelisco, Rome)

Figs. 20–22. Model of Balla's *Fireworks* (*Feu d'Artifice*, 1917). These photographs show changes in the lighting.
(Courtesy of the Gallerìa d'Arte l'Obelisco, Rome)

so that he could watch and listen to the performance while he "played" the lights. His notes for the operation of the lights indicate forty-nine different settings, but, since some passages were repeated, there were actually more than that number of changes in the illumination. The performance, which was conducted by Ansermet, lasted five minutes. Thus, coordinated with the music, there was a change in the lighting about every five seconds, on the average. Lighting possibilities included various combinations of external illumination on the solid forms, internal illumination of the translucent shapes, and illumination of the black backdrop, which once was colored with rays of red light. Shadows also played a part in Balla's lighting design, and two of the cues on his plot indicate shadow projectors. It was not merely the stage that was lit, however: the auditorium itself was illuminated and darkened during the piece, relating the spectators to the actorless presentation on stage. In *Fireworks* sound,

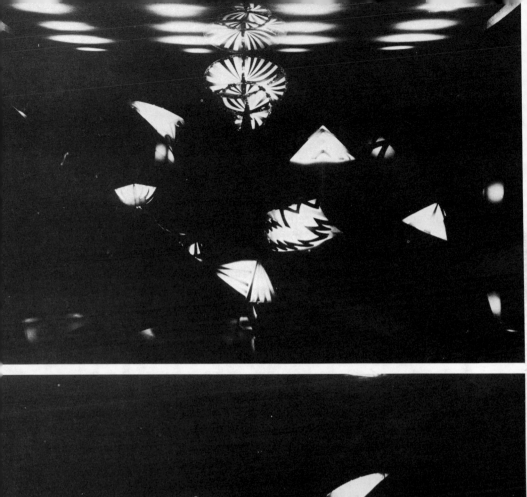
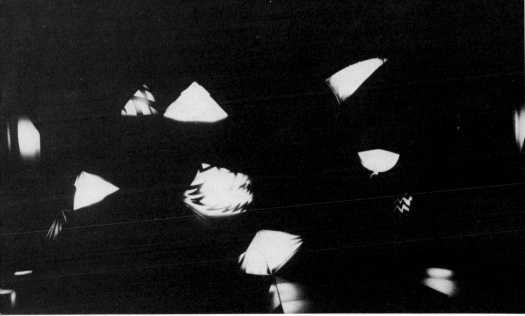

light, and color were orchestrated into a single, entirely nonrepresentational work.

More than ten years later, in 1928, Enrico Prampolini also created a performance without actors and without narrative in which light and music were the dynamic elements. *Sacred Speed* (*Santa Velocità*) made use of the noise music of Russolo's *intonarumori*, while the neutral decor of the stage acted as a colorless ground for moving and changing colored lights.

One of the best examples of these important Futurist scenographic concepts can be found in Prampolini's Magnetic Theatre, an ambitious project that was never actually realized in performance. Although the name was not used in the manifesto, "Futurist Scenic Atmosphere," published by Prampolini in 1924, it described the concept that was to be called the Magnetic Theatre, and later versions of the manifesto were changed slightly to include the new name. One of the main themes of "Futurist Scenic Atmosphere" is an extension of the kinetic concepts first stated by Prampolini in "Futurist Scenography": scenography, the later manifesto said, was "definitely condemning itself because it is a static compromise in direct antithesis to *scenic dynamism*, the essence of theatrical action." Scenography could only become "the essence of theatrical action" if the actor was completely eliminated. This had already been done in Balla's *Fireworks* of 1917 and Prampolini was to do it in *Sacred Speed* of 1928, but both of these performances depended primarily on lighting and neither used solid elements that moved. The Magnetic Theatre was to be a huge and complicated stage machine; the movements of its various elements were to replace the actor as focus of the performance. In Prampolini's words, the Magnetic Theatre was to be:

> . . . made up of a mass of plastic constructions in action which rises from the centre of the theatrical hollow instead of the periphery of the "scenic-arc." Auxiliary moving constructions rise, first on a square movable platform, standing on an elevator. On this in turn is erected a *moving, rolling platform* going in the opposite direction from the first, and likewise carrying other *planes* and *auxiliary volumes*. To these plastic constructions, *ascending, rotating* and

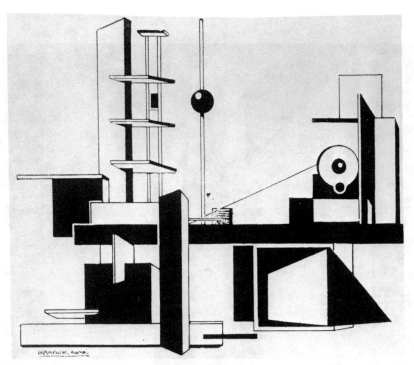

Fig. 23. Prampolini's drawing of his Magnetic Theatre. (Courtesy of Dr. Alessandro Prampolini)

shifting movements are given, in accordance with necessity. The scenic action of the chromatic light, an essential element of interaction in creating the scenic personality of space, unfolds parallel to the scenic development of these moving constructions. Its function is to give *spiritual life* to the environment or setting, while measuring time in *scenic space*. This chromatic ladder will be made with apparatuses of *projection, refraction, and diffusion*.[11]

Thus the Magnetic Theatre, a model of which won the Grand Prize for theatrical design at the huge International Exposition of Decorative Arts that was held in Paris in 1925, was basically a completely abstract or nonobjective composition of moving three-dimensional elements, light, and sound. (In his description, Prampolini

[11] Enrico Prampolini, "The Magnetic Theatre and the Futurist Scenic Atmosphere," trans. Rosamond Gilder, p. 108. Prampolini's Magnetic Theatre bears a striking resemblance to Craig's "Scene" of 1908, mentioned above, which also eliminated the scenic arc and rose from the center of the space.

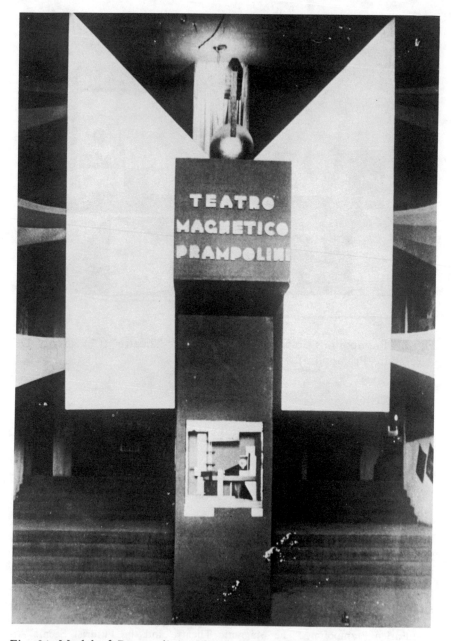

Fig. 24. Model of Prampolini's Magnetic Theatre shown at the International Exhibition of Decorative Arts held in Paris in 1925. (Courtesy of Dr. Alessandro Prampolini)

noted that the performance would also make use of the human voice, but he did not specify in what way.) In an attempt, in part, to overcome "cerebral psychologizing" and "to overthrow the speculative field of the theatrical theatre (*vide* Reinhardt-Tairov-Meyerhold) in order to give a new spiritual virginity to *scenic matter*," Prampolini had developed one of the main tenets of Futurist scenography to an extreme, if technically difficult, position. He made the relationships and changes in pure space and mass the basis of his Magnetic Theatre.

Although Prampolini spoke in the "Futurist Scenic Atmosphere" of "the *abolition of the stage and the scenic arc*," he did not do either with the Magnetic Theatre. As indicated in several drawings (Fig. 23) and the photographs of the model exhibited in 1925 (Fig. 24), the Magnetic Theatre was designed to be viewed like a proscenium peephole stage, and the stage floor was a dominant, if perhaps unused, element. Rather than being relegated to the outer edges of the stage space, as was usually done so that the actors would have room to perform in the center, the decor filled the center space with its own performance, but the rear and side walls of the stage—or masking of some sort—would have been visible, forming an arc behind the moving elements.

Just as the earlier evenings of Dynamic and Synoptic Declamation already had eliminated the stage and the proscenium arch, however, Marinetti's Total Theatre systematically intermixed performance and audience and radically changed the spectator's relationship to what he saw. Although, strictly speaking, it moved beyond scenography into theatre architecture, Marinetti's project, which was published in 1933, can be seen as the direct outgrowth of several Futurist concepts of space and scenic design.

Another ambitious and visionary project that was never actually completed, the circular Total Theatre, employed a large round central stage, eleven smaller stages scattered throughout the audience area, and a peripheral stage ringing the circumference of the auditorium. Rising high above the central stage was an apparatus, perhaps resembling the structures of the Magnetic Theatre, that "dramatized," in part, the movement of the sun and the moon. Seated, if they

wished, in revolving chairs, the spectators watched films, television images, poetry, and paintings projected on the curved walls of the theatre and simultaneous actions on the various stages that were at different distances from them. Music and even smells—"cancelled each time by special vacuum cleaners"—were part of the performance. The spectators were expected to participate in their usual way by throwing things at the actors and by "improvised intervention." In the Total Theatre, the dynamism, simultaneity, combination of many diverse elements, audience involvement, and the spatial distribution found in earlier Futurist performances reached one kind of theoretical synthesis.

IX] Acting and Costumes

In a sense it is not possible to understand Futurist scenography fully without taking into account Futurist concepts of costuming and acting. Conversely, the costuming and acting can best be considered in relationship to the theories of scenography. It is tempting to make the generalization that with the Futurists stage decor became a machine that replaced the actor while acting and costuming turned the performer into a machine and an element of scenic design. To some extent, this is certainly true; it must be understood, however, in terms of the concept of personification.

In his "Futurist Scenography" manifesto of 1915, Prampolini claimed that "in the final synthesis, human actors will no longer be tolerated," and he was even more positive in the "Futurist Scenic Atmosphere" manifesto of 1924 when he said, "the intervention of the actor in the theatre as an element of interpretation is one of the most absurd compromises in the art of the theatre." Abolishing the human actor does not abolish personification, however. Lights, sounds, or moving elements may be used to replace the human and to accomplish the task of personification. "Futurist Scenography" imagined "actor-gases" that would "wriggle and writhe dynamically" and "by shrill whistles and strange noises . . . give the unusual significations of theatrical interpretations . . . with much more effectiveness than some celebrated actor. . . ."

Personification by technology rather than by actors was to play a large part in the new theatre described in Mauro Montalti's "Electric-Vibrating-Luminous" manifesto of 1920. It was merely a large motion-picture screen that filled the entire rear wall of the stage; the motion of the Electric-Vibrating-Luminous Theatre did not come from projected film, however, but from the thousands of colored

lights that made up the screen. Mechanically programmed, these lights were meant to act out dramas, and Montalti described how they were to perform part of Andreyev's *The Life of Man:* " 'three boring and monotonous musicians' are expressed by three verticals of very gloomy violet"; "The Friends are expressed by a tonality of red and dark blue lights that move rhythmically and straight." The colored lights blink, move, dim, or brighten while representing the characters of the play.

Thus we can make an important distinction between kinetic elements that personify and those that do not. There was no personification in Balla's presentation of *Fireworks,* nor, apparently, in Prampolini's Magnetic Theatre and his staging of *Sacred Speed.* Montalti mentioned that his Electric-Vibrating-Luminous Theatre was also to be used to create visual representations of musical symphonies; it was not necessarily limited to personification. But we must be careful not to equate the elimination of the human actor with pure abstraction. Some Futurist performances were nonrepresentational, but most were still concerned with personification.

One pronounced aspect of Futurist performance was to turn the actor into a machine, to some extent, through costumes, the type of movement required, or both. But this mechanization of the performer was done for different reasons, and a distinction must be made between characterization and style. *Poupées Électriques,* for example, published by Marinetti in French in 1909, before the publication of the first Futurist manifesto, is a rather traditional play in which one of the characters has invented and manufactures mechanical people. The play may embody, to some extent, the theme of mechanization that was to interest the Futurists, but the appearance of actors pretending to be robots should not be mistaken for a significant innovation in acting or costuming. It is a question of characterization rather than style.

One might also use the example of the short ballet, presented with a repertoire of *sintesi* in 1925, descriptively called *The Love of Two Locomotives for the Stationmaster.* The three dancers in the

piece presented the story suggested by the title; it ended somewhat noncommittally with the stationmaster sending the engines off in opposite directions. Just because the costumes and movements of two of the dancers represented locomotives, the piece cannot be taken as an attempt to convert the actor into a machine. One actor still represented the stationmaster; the mechanization of the others was only in terms of characterization. Indeed, this is probably the same ballet known as *Aniccham del 3.000* or *Macchina del 3000,* with music by Franco Casavola, written and costumed by Depero in 1924. Two photographs of the piece exist (Figs. 25 and 26). One shows all three performers, the other only the two "locomotives." When seen by themselves the two tubular metallic costumes seem much more striking and radical. But this characterization of two love-struck locomotives can hardly be considered important or innovative.

In like manner, the mere use of mechanized scenery cannot, in itself, be considered as significant. As Prampolini staged *Three Moments (Trois Moments* or *I Tre Momenti),* a pantomime by Luciano Folgore, for his Théâtre de la Pantomime Futuriste at the Théâtre Madeleine in Paris in 1927, no actors were on stage in the second section, and only machines performed: a fan turned, a large red jukebox glowed, and an elevator went up and down. This, however, was part of a story about the adventures of a satyr and a nymph in a big city! The interest in technology and movement is certainly Futurist, if the satyr and nymph are not, but merely using machines to provide the setting for a story is not the kind of kinetic scenography for which the Futurists should be noted.

On the other hand, Giacomo Balla's *Printing Press (Macchina Tipografica,* 1914) is an early example of mechanization as a style of movement. The performance was to take place in front of a drop and wings that, rather than indicating a place, merely spelled out the word "TIPOGRAFIA" in large block letters (Fig. 11). Twelve performers were to become the parts of a machine; the sounds and movements of the machine were to constitute the entire piece.

A sketch by Balla shows six performers, represented by simple stick figures, and indicates something of the movement (Fig. 27).

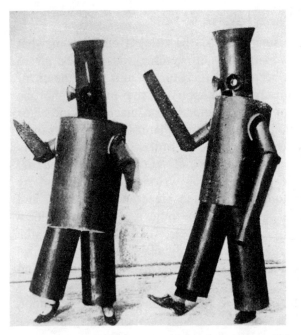

Figs. 25 and 26. Costumes by Depero for *Machine of 3000* (*Macchina del 3000*, 1924), a mechanical ballet with music by Casavola. In Fig. 26 (BELOW) note the railroad stationmaster at the left. (Courtesy of the Depero Museum, Rovereto)

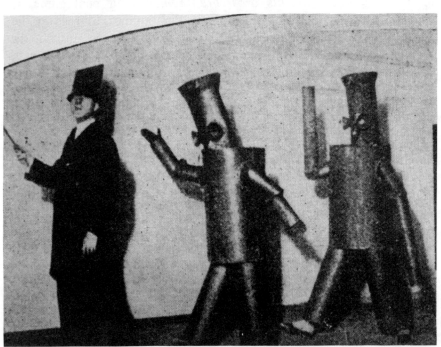

Standing one behind the other with their arms extended rigidly in front, two performers rock forward and back, making what could be a piston or drive shaft. There are two such pairs of performers, and each "piston" seems to drive a "wheel," created by another performer who sweeps his arm or arms in a full circle. The two "wheels" face each other, the overlapping of their arcs and the indication that their hands are held at right angles to their arms suggest that they are "cog wheels" whose movements work together.

Fig. 27. A sketch of movements for *Printing Press* (*Macchina Tipografica*, 1914) by Balla. (See Figs. 9 and 11.) (From a reproduction in *Balla: Ricostruzione Futurista dell'Universo* by Maurizio Fagiolo dell'-Arco [Rome: Mario Bulzoni Editore, 1968].)

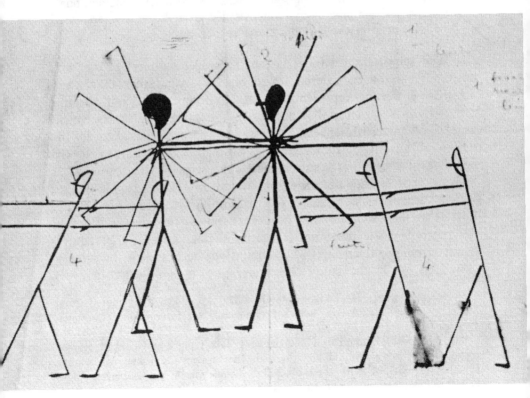

Although traditional dance movements were not used, the piece could be thought of as a dance with vocal sound, and Virgilio Marchi, the Futurist architect, has described an experience with what he refers to as "Balletto tipografico":

> One evening we all went to Diaghileff and Semenoff's salon to make the decision whether to choose *Fireworks* or the *Printing-Machine Ballet,* a mechanical invention of Balla's [for presentation by Diaghileff's Ballet Russe]. For the second, the author arranged us in geometrical patterns and, with his inevitable square grey stick, conducted the mechanical movements and gestures we all had to make to represent the soul of the individual pieces of a rotary printing-press. I was told to repeat with violence the syllable "STA," with one arm raised in gymnastic fashion, so that I felt that I was on the square of a training barracks. Balla, needless to say, had reserved for himself the more delicate syllables, onomatopoeic sounds and verbalizations, which issued from his lips interspersed with his unforgettable Piedmontese "neh" . . .[1]

The important distinction, then, for scenography, acting, and costumes can be considered to be one of style rather than characterization or the representation of environmental detail. In this sense, style is a factor that applies in the same way to equivalent aspects of a performance. If the same approach is taken in the design of all the costumes in a performance, we can isolate the common qualities that result as being the style of the costumes. If there is a consistency of concept and detail in a scenographic design, we may accept this consistency as constituting the style of the setting. But, as in the examples that have been noted, not all variations in design are stylistic ones, and causative factors such as the requirements of character and narrative should not be mistaken for style.

Thus, as in the study of scenography, it is difficult, in every

[1] Virgilio Marchi, *La Stripe* (March, 1928), pp. 159–163, quoted from Maurizio Fagiolo dell'Arco, "Balla's Prophecies," *Art International* (Summer, 1968), p. 67.

The relationship should be noted between Balla's piece and current "game" techniques of actor training in which the performers are asked to create a functioning machine with their own bodies and voices. Several recent plays have used the actor-machine as an image.

case, to appreciate the true significance of Futurist costumes from the records that remain. As illustrated in photographs, Ivo Pannaggi, for example, designed two Cubistic, machine-like, deforming costumes that covered the entire figure (Figs. 28 and 29). Although these seem at first glance to be in keeping with the general concepts of Futurist costuming that we will be discussing, their complete appreciation must be based on an understanding of the performances of which they were a part. Did the same kind of costuming principles, unrelated to character or situation, apply to all of the performers? Or did these figures represent special cases like mechanical men or astronauts? Once it is understood that details may be deceptive in these areas, we may proceed with an analysis of the limited material that is available, remembering that it is the stylistic aspects of Futurist costuming and the theory from which it derives that are of primary importance.

Theoretical and practical aspects of Futurist costume design and acting primarily focus around two concepts: the integration of the performer with the setting and what could be called the mechanization of the performer. Neither of these concerns originally derived from Futurism itself. Like Cubism they predated the Futurist movement, but also like Cubism, they were digested and modified, producing results that were completely Futurist.

In the program for his Theatre of Futurist Pantomime in Paris, Prampolini wrote:

> Decorative mimicry, which is superficial, must be abandoned in order to enter the domain of architecture, which is profound. All the elements of music, of painting, and of gesture must harmonize with each other without losing their independence. The rhythm of the sound and those of the scene and of the gesture must create a psychological synchronism in the soul of the spectator. This synchronism, which has nothing in common with the exterior and mechanical concordance of the three arts, answers to the laws of simultaneity that already regulate the world-wide futurist sensibility.[2]

[2] Quoted in Filiberto Menna, *Prampolini* (Rome: DeLuca Editore, [1967?]), p. 258. (My translation.)

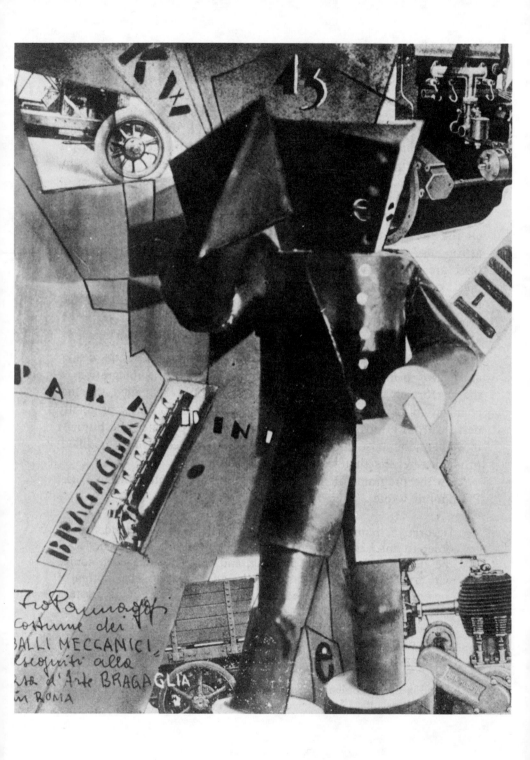

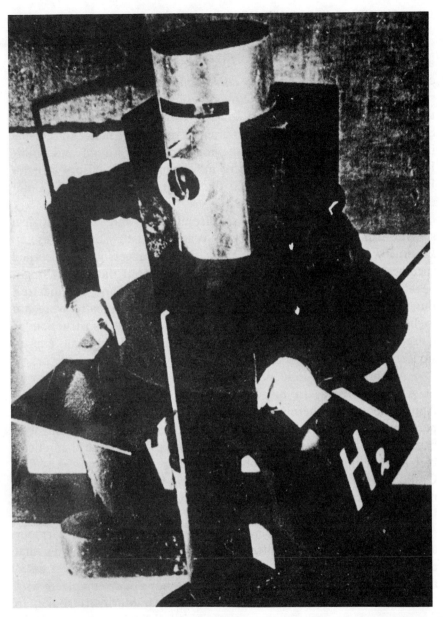

Figs. 28 and 29. Costumes by Ivo Pannaggi, for (LEFT) the *Mechanical Ballets* (*Balletti Meccanici*, 1919?), and (ABOVE) a ballet by M. Michailov. (From reproductions in *Sipario* [Milan: December, 1967, No. 260])

This demand for a unified spectacle that appealed to "intuition and instinct" and was "above all antilogical" derived from a concern with synesthesia and the correspondence between the various senses. Synesthesia refers to the hypothetical concept that the stimulation of one sense can cause a subjective response in another sense. Scriabin built a color organ in an attempt to convert music into visual images; Kandinsky considered the relationship of sound and color; Kupka wrote of the relationship of movement to the sensory centers; Prampolini himself published *La Cromafonia*, subtitled "The Color of Sound," in 1913.

This interest in sensory correspondence and "psychological synchronism" can be traced back to Wagner's theory of the *Gesamtkunstwerk* or "total artwork," and since Wagner was concerned specifically with music drama as a synthesis of all the arts, it might be assumed that such thinking would relate primarily to theatre.[3] But when Prampolini—whose first designs for the theatre were not to be realized until 1917—wrote of "the absolute construction of noise-motion" in 1915, the example he used for this ultimate expression of sensory fusion was not the stage but Futurist architecture.

A more specific influence on staging came from Wagner by way of Adolphe Appia. In his concern with staging Wagner's operas, Appia had written before 1900 of the necessity for a totally unified performance, and he had begun to create a clear production style based on his theories. Appia's concepts, both practical and theoretical, had a great influence on professional theatre people such as Anton Giulio Bragaglia and Achille Ricciardi, whose work was often connected in some way with the Futurists. They also had an influence on Prampolini.

It should be stressed, however, that the concept of harmony and psychological synchronism was a concern of Prampolini's that did not interest all of the Futurists; although the Futurists stressed the use of a variety of elements, they were not always involved with the harmonious integration of these elements. Marinetti spoke, in

[3] For a discussion of synesthesia and its historical relationship to Wagner and Symbolism, see: E. T. Kirby (ed.), *Total Theatre* (New York: E. P. Dutton & Co., 1969), pp. xvi–xxi.

"Futurist Synthetic Theatre," of the need to "symphonize the public sensibility," but he, and many of the other Futurists, emphasized diversity, simultaneity, and even the "improvised intervention" of the Total Theatre, rather than unity and harmony.

At any rate, the creation of psychological synchronism through the simultaneous perception of music, design, and movement was fundamental to Prampolini's approach as a designer-director. In the first sentence of the program statement quoted above, Prampolini, opposes "decorative mimicry, which is superficial" with "the domain of architecture, which is profound." One important way to unify a performance visually was to eliminate idiosyncratic and realistic details of human movement and to substitute for them a vocabulary of movements that would correspond more closely with the lines of the setting. This vocabulary could be considered to be similar to that suggested by Marinetti in the "Dynamic and Synoptic Declamation" manifesto: "an outlined and topographic gesticulation that synthetically creates cubes, cones, spirals, ellipses, etc., in the air." It is not unimportant that Prampolini's theatre was one that emphasized pantomime rather than spoken drama; judging from the photographs, the rhythmical stylized movement was actually a form of dance.

From the photographs of the Theatre of Futurist Pantomime, it also can be seen how Prampolini's solutions to sensory harmony and unity differed from those of Appia. Whereas Appia's space was deep, with provisions for strong up- and downstage movements, Prampolini's staging tended to stretch the performers across the proscenium opening. His acting space was shallow, approximating the two-dimensional, and sometimes, as in *Cocktail*, the solid setting acted as a wall behind it, extending the height of the pictorial composition and allowing action on two levels (Figs. 30 and 31). Like figures on a bas-relief or in a painting, the poses of the performers were opened almost completely toward the observer, their positions considered for their two-dimensional silhouettes rather than for their sculptural mass; costume designs for the Theatre of Futurist Pantomime also seems to emphasize the linear aspects of the human figure rather than its volume (Fig. 32).

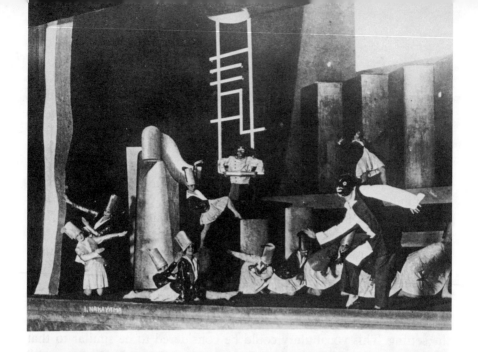

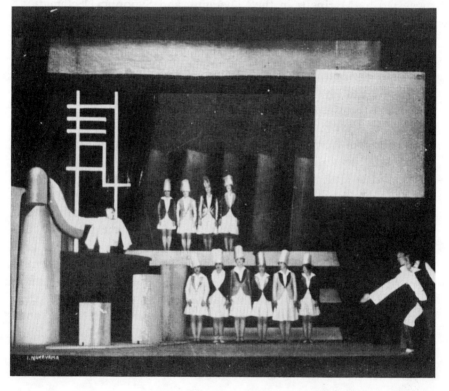

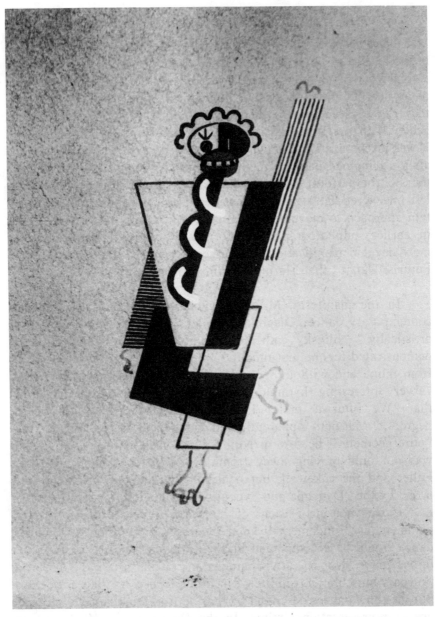

OPPOSITE: Figs. 30 and 31. *Cocktail* (1927), a pantomime by Marinetti and Silvio Mix, presented at the Théâtre de la Madeleine, Paris. Costumes and setting by Prampolini. ABOVE: Fig. 32. A costume sketch by Prampolini for *Cocktail*. (Courtesy of Dr. Alessandro Prampolini)

These performances in Paris in 1927 occurred relatively late in the history of Futurism. Perhaps because of the location and date, a somewhat better photographic record exists of some of them than of any earlier presentations. In both theory and practice, therefore, they can be seen to demonstrate a fusion of performer and setting, achieved in part through a certain mechanization of the actor. But it was mechanization through geometricized rhythmic movement that always remained basically human: loose costumes followed the contours of the performer's body, while arms, legs, and face were usually left uncovered. This may be considered as the culmination of a certain approach to movement on Prampolini's part that had its origins in earlier, unphotographed performances. Indeed, the concept of mechanical personification can be seen clearly in the "Manifesto of Futurist Dance" that Marinetti published on July 8, 1917.

In the manifesto, Marinetti uncharacteristically praised some contemporary dance: Diaghilev's Ballet Russe was "very interesting artistically," Nijinsky embodied "divinity of musculature" as he demonstrated for the first time the "pure geometry of dance liberated from mime and without sensual excitement," Dalcroze had created "a very interesting rhythmic gymnastics." Even though he could add that "We futurists prefer Loie Fuller and the cakewalk of the negroes," Marinetti apparently felt compelled to react against the "pure geometry" he saw in Nijinsky and Dalcroze. In doing so he was not only moving away from the powerful dynamics of Loie Fuller and the cakewalk but contradicting the pure geometry proposed by the "Dynamic and Synoptic Declamation" manifesto.

It was not inconsistent of Marinetti to reject musical accompaniment as "fundamentally and incurably old-fashioned." Futurist dance would be accompanied by the "organized noise" of Russolo's *intonarumori*. Nor was it uncharacteristic of him to ask the dancer to "surpass muscular possibilities" in order to become like a machine. But the three dances described by Marinetti in the manifesto all made use of representational mime. In the *Dance of the Machine Gun*, the dancer, on all fours, was to "imitate the form of the machine gun . . . her arm raised in front . . . like a barrel." In *Dance of a Flyer*, the dancer was to imitate an airplane: first, lying on a large

map, she was to "simulate, by quaking and swaying her body, the successive attempts that an airplane makes to lift itself"; later she was to jump over a "mountain" of green cloth, and "vibrating all over," chase a gold-colored cardboard "sun." The use of lettered signs was to add a somewhat original but particularly literal element to these dances. Before jumping over the pile of green cloth, for example, the airplane-dancer was to show a card reading, "600 METERS—AVOID A MOUNTAIN."

Another approach to mechanizing the performer can also be found in Futurist work during the years of World War I. It has already been shown that Prampolini, in both "Futurist Scenography" and "Futurist Scenic Atmosphere," wrote of the necessity of abolishing the actor. In doing this he was following Edward Gordon Craig who proposed in 1908 that the performer be replaced by a nonhuman *Übermarionette*. Even though Prampolini added in "Futurist Scenography" that he also wanted to eliminate "today's supermarionette recommended by recent reformers," his "actor-gases" are nothing but a development and refinement of Craig's concept, and there is no question that Craig's theories had a great influence on certain aspects of Futurist performance.

With its fundamental involvement with the products of modern technology, Futurism was ideally suited to adapt the *Übermarionette*, and if Craig never attempted to embody the theories in production, the Futurists did. In 1918 Gilbert Clavel, who is variously described as a Swiss art critic, a poet, and a professor of Egyptian history, rented the Teatro dei Piccoli at the Palazzo Odescalchi in Rome to present a program of five short performances choreographed by himself and Fortunato Depero. The Teatro dei Piccoli was a marionette theatre: the *Plastic Dances* were conceived for marionettes, and Clavel also retained the regular company of operators (Figs. 33–36). Although there was a general lightness of tone, the performances were not intended for children. The *Plastic Dances* were presented eighteen times, and were regarded with enthusiasm by the other Futurists. Although the stage and most of the marionettes were apparently less than full-sized, at least one of Depero's wooden figures, the "Great Savage," was taller than a man; the front of the

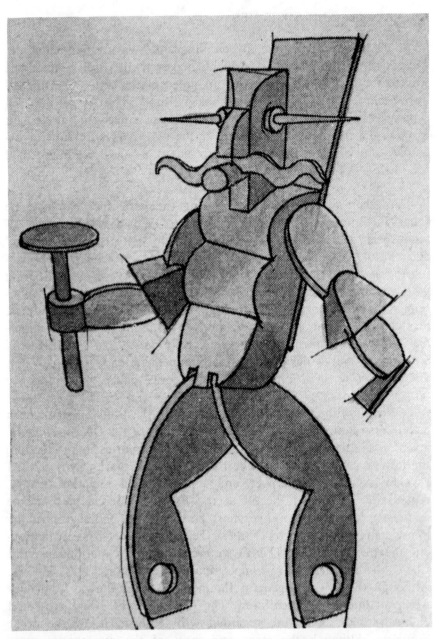

Figs. 33 and 34. Sketch and photograph of a puppet designed by Depero
for the *Plastic Dances* (*Balli Plastici,* 1918). (Courtesy of the Depero
Museum, Rovereto)

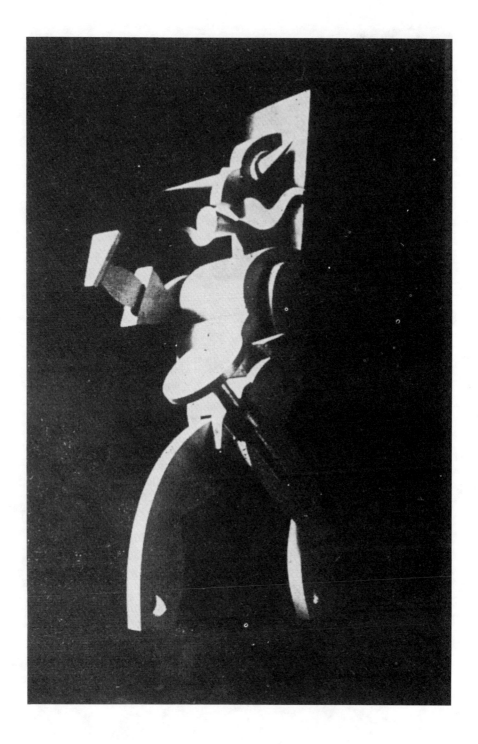

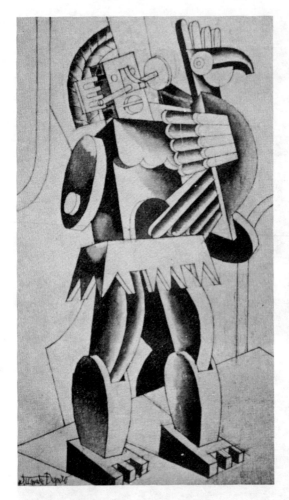

Figs. 35 and 36. Sketch and photograph of "The Great Savage," one of the puppets designed by Depero for his and Clavel's *Plastic Dances* (*Balli Plastici,* 1918). In the photographic reproduction (RIGHT) note the design on the stomach of the figure, which opened to become a dance floor for very small puppets. (From reproductions in *Sipario* [Milan: December, 1967, No. 260])

stomach of the marionette folded down, revealing tiny "Savages" that danced on the door-platform (Figs. 35 and 36).

The following year, 1919, Prampolini staged a symbolic drama, Albert-Birot's *Matoum et Tevibar,* with marionettes at the same Teatro dei Piccoli in Rome. Again, the marionettes may have been of various sizes: Filiberto Menna writes that at the end of the drama the doors used instead of a curtain were opened "showing Matoum with his head illuminated while carrying on his arms all of the other marionettes." [4]

[4] Menna, *Prampolini*, p. 107.

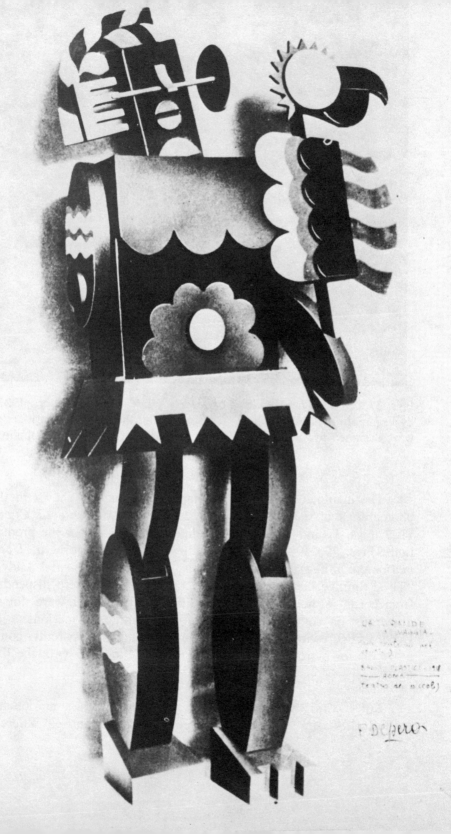

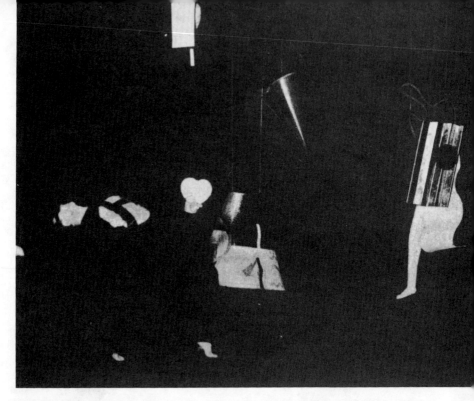

Figs. 37 and 38. *The Merchant of Hearts* (*Il Mercante di Cuori,* 1927) by Prampolini and Casavola. The costumes and the life-sized marionettes were designed by Prampolini. (Courtesy of Dr. Alessandro Prampolini)

The inanimate abstracted human shapes that are shown in the photographs of *The Merchant of Hearts* (*Il Mercante di Cuori,* 1927, Figs. 37 and 38) and in Prampolini's sketches for the production (Figs. 17, 39–41) may also be considered a form of *Über-marionette.* Life-sized representations of "The Sentimental Lady," "The Primitive Lady," and "The Mechanical Lady" were suspended from cords. Although their possibilities for movement were not so numerous or complex as those of the traditional marionette or Depero's figures in the *Plastic Dances,* the "ladies" apparently could move one or more parts as they "performed" together with the live actors.

But if Craig wanted to replace the actor with a marionette, the Futurists seem to have followed his theories for entirely different

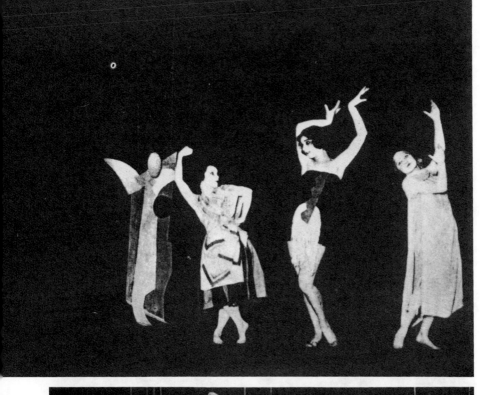

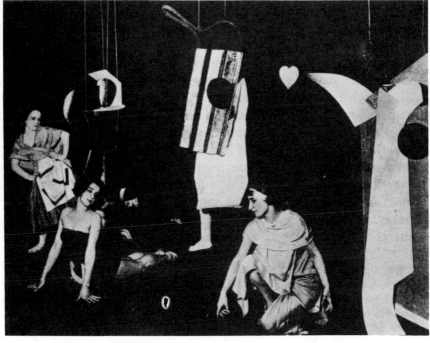

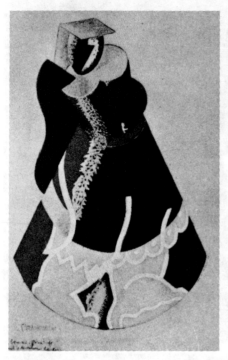

reasons. Craig felt that the human actor was imperfect because he could not be completely controlled by the director-designer. The personality of the actor was seen rather than that of the character, and no actor had the discipline to mirror completely the director's will and give exactly the same performance time after time.[5] The Futurists, on the other hand, seem to have used marionettes for more formal reasons. The most important of these was the integration of the performer and setting that has already been mentioned. By using marionettes, Depero could construct his actors and his scenery out of the same material, using the same kinds of stylized geometrical forms, and paint them with the same colors. Not only humans, but monkeys, bears, snakes, butterflies, and flowers could become moving parts of a consistent and homogeneous scenography. As Clavel ex-

[5] See: Charles R. Lyons," Gordon Craig's Concept of the Actor," *Educational Theatre Journal* (October, 1964), pp. 258–269. For earlier manifestations of *Übermarionette* thinking in writers such as Maeterlinck, see: E. T. Kirby's comments in *Total Theatre*, pp. 29–32. Kirby's anthology also contains Lyons' article and "The Actor and the *Übermarionette*" by Edward Gordon Craig.

Figs. 39–41. Sketches by Prampolini of life-sized hanging figures for *The Merchant of Hearts* (*Il Mercante di Cuori,* 1927); (FAR LEFT) "The Primitive Lady," (LEFT) "The Mechanical Lady," and (RIGHT) "The Sentimental Lady." (Courtesy of Dr. Alessandro Prampolini)

pressed it, "This unitary conformity . . . no longer makes a distinction between action and representation, between content and form, between character and setting." [6]

Changes in scale that would be impossible with human performers, effects related to scale such as the "rain of cigarettes" in the second of the *Plastic Dances,* and the employment of unusual figures that would be difficult or impossible with real actors were probably also reasons for the Futurist use of marionettes, but the most important justification would seem to be the stylistic integration of the performance. Indeed, the same reasoning may be used to justify the complete Futurist rejection of the actor, and the *Übermarionette*, in favor of a nonobjective, actorless performance.

In "Futurist Scenic Atmosphere," Prampolini stressed the necessity for "*unity* of action between man and his environment" on stage. He was disturbed by a "dualism between *man* (the dynamic ele-

[6] Gilberto Clavel [Gilbert Clavel], "Depero's Plastic Theater," *Art and the Stage in the Twentieth Century,* ed. Henning Rischbieter (Greenwich, Connecticut: New York Graphic Society, Ltd., 1968), p. 75.

ment) and his *environment* (the static element)," and, as we have
seen, he solved the problem in what he was later to call his Magnetic
Theatre by proposing a huge machine that would fill the stage space
with movement, light, and sound. All nonobjective performances—
Balla's *Fireworks*, Prampolini's *Sacred Speed*, and even the fourth
of the *Plastic Dances* called *Shadows*, that Depero described merely
as "dynamic constructed shadows—gray and black planes—games
of light"—may be seen, in part, as the ultimate product of the
impulse toward synthesis and unity.[7]

If, in this approach, the mechanization of the performer logically
led to his being abandoned in favor of kinetic decor that "acted,"
there is a third line of this same tendency toward mechanization that
does not reject the actor. Rather than being replaced by an *Über-
marionette* or machine, the human aspects of the actor are hidden or
deformed by costumes. One of the earliest and most interesting ex-
amples of such efforts of the Futurists appears in unpublished manu-
script notes by Depero, apparently made in 1915. The clothing "must
appear like a normal futurist costume" but a "framework of metallic
wire . . . will be made so as to open and close itself" and "various
movements with one's arms, hands, feet, legs . . . will open certain
fanlike contrivances like tongs, etc." At the same time there were
to be "bursts and rhythms of noise-like instruments" that were ap-
parently built into the costume. Depero noted that "this very new
principle . . . inaugurated by Marinetti at the extraordinary Depero-
Balla exhibition of 1915" would be the basis of the costumes for
"futurist abstract and dynamic theatre," but even though he wrote of
the "inauguration" as an accepted fact, it seems that the costume
was never actually built.

The mechanized costume that was to have been worn by Marin-
etti was described by Depero in his notes as a "complex simultaneity
of forms-colors-onomatopoeia-sounds and noises," and in 1916 he
sketched other costumes that made use of lights, sound sources, and
elaborate extensions and distorting elements (Figs. 42 and 43).
Ostensibly designed for a production he referred to as *Mimismagia*,

[7] Fortunato Depero, *So I Think/So I Paint,* trans. Raffaella Lotteri (Trento:
Mutilati e Invalidi, 1947), p. 75.

Figs. 42 and 43. Costume designs by Depero for an apparently hypothetical production, *Mimismagia* (dated 1916). (Courtesy of the Depero Museum, Rovereto)

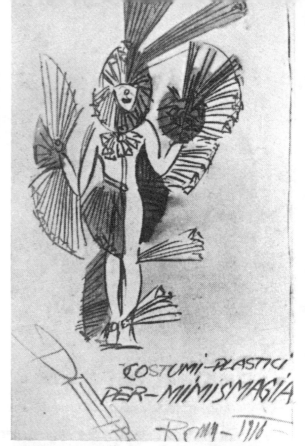

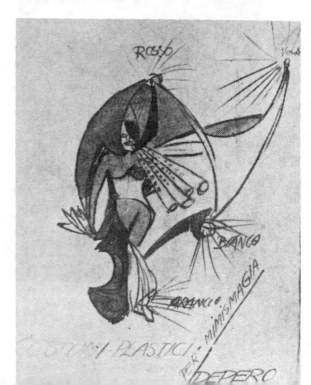

Figs. 44 and 45. Mask and setting by Prampolini for *Psychology of Machines* (*Psicologia di Macchine,* 1924) a "mechanical ballet" by Silvio Mix. (Courtesy of Dr. Alessandro Prampolini)

they too were never realized. One shows fanlike shapes protruding from and, in part, concealing a naked or neutrally-clothed figure. The second consists primarily of a large, somewhat conical, tentlike appendage with lights of various colors placed in it; its shaped legs, apparently also formed on a wire frame, completely hide the legs of the wearer, and it provides the performer with a set of flutelike pipes that he could play.

In his *Notes on the Theatre*, Depero listed some of the ways that the human actor could be transformed. In addition to "moustaches, beards, wigs," he called for "masks of all shapes; movable and intensely colored." Making the connection between man and machine, Depero wrote in the telegraphic style of his manifesto of "headlight—eyes / megaphone—mouths, funnel—ears / in movement and transformation / mechanical clothes."

The tendency to distort and hide the human figure should not be equated merely with mechanization, however. Even though the title of Silvio Mix's *Psychology of Machines* (*Psicologia di Macchine*, 1924) would seem to suggest mechanization, two photographs that exist (Figs. 44 and 45) show a primitive wooden mask and, against a Cubistic jungle background, two figures wearing these distinctly African masks. Although reference to the machine may have been clearer in other portions of the work, the use of masks was justified in this instance by reference to a completely nontechnological society.

Nor can costume designs always be taken as certain indications of mechanization and deformation. The Cubistic style of drawing can give the impression of machine-like qualities and rigid extensions where none was intended. A comparison of Prampolini's costume designs for *Cocktail* with photographs of the production shows that what might be interpreted from the sketches as being stiff material that deformed the figure in a rigidly geometrical way was actually cloth and that details such as collars and cuffs, which did not appear in the drawings, were part of the realized designs. In the same way, it is difficult to know exactly how to interpret other costume sketches by Prampolini, such as those for *The Metallic Night* (*La Nuit Métallique*, 1914, Fig. 46) and *The Plastic God* (*Le Dieu Plastique*, Fig. 47). Without photographs of the finished costumes, it is hard to know how much of the apparent deformation and geometricalization was

DANSE. pour le ww métallique.

E. PRAMPOLINI.
FUTURIST.

inherent in the concept and how much was a result of the style of rendering.

Such considerations, however, do not negate the point that mechanization and deformation were central concerns of Futurist costuming. The impersonal geometrical qualities of Cubism were embodied in many costumes that did not distort or rigidly encase the figure. They, too, represented a tendency toward the nonhuman and the abstract.

Figs. 46 and 47. Costume designs by Prampolini for (LEFT) a dance, *The Metallic Night* (*La Nuit Métallique,* 1924), and (RIGHT) for *The Plastic God* (*Le Dieu Plastique*). (Courtesy of Dr. Alessandro Prampolini) BELOW: Figs. 48 and 49. Costume designs (1916–17) by Depero for *Nightingale's Song* (*Chant du Rossignol*) by Stravinsky. (Courtesy of the Depero Museum, Rovereto)

x] Futurist Cinema

The cinema should have been the ideal medium for the Futurists. In it we find a modern technology involved with motion; it can employ the dynamics of speed, space, and light. Being a relatively recent invention, the cinema was, as the Futurists said, "lacking a past and . . . free from tradition," and it should have had great appeal for them. But very little actually was done by the Futurists in this medium. The reason was not a dearth of money or a lack of the particular technical knowledge necessary for filmmaking; some of the Futurists could supply these. It was probably merely that Filippo Tommaso Marinetti was not particularly interested, and his amazing energy and coordinating ability were not directed consistently toward the production of films. At any rate, no more can be said of the Futurist involvement with cinema than can be said of succeeding art movements in the twentieth century: as with Dada and Surrealism, Futurism did produce some film work, but it was not central to the movement. Indeed, interest in Futurist cinema focuses almost entirely on only two films, one of which is not completely Futurist.

Both *Vita Futurista* (*Futurist Life*) and *Il Perfido Incanto* (*The Wicked Enchantment*) were filmed in 1916, the former entirely by Futurists and the latter employing the Futurist designer Enrico Prampolini. Very little is known about these films, and almost none of the so-called facts about them are agreed upon by the various writers who have dealt with them. Even the names of the films are given differently by different sources. It is not difficult to see how *Il Perfido Incanto* becomes shortened to *Perfido Incanto:* it is like dropping the "The" and calling Tennessee Williams' play *Glass Menagerie*. *Vita Futurista*, however, is discussed under entirely different titles. One writer calls it "Futurist Cinematography," an-

120

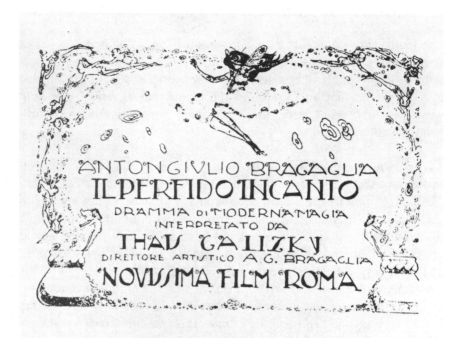

Fig. 50. Title card from the film *The Wicked Enchantment* (*Il Perfido Incanto*, 1916). (From a reproduction in *Sipario* [Milan: December, 1967, No. 260])

other "Documentario Futurista," a third merely "un cortometraggio futurista" ("a Futurist short").[1] Mario Verdone has established the real title of the film.

Confusion over these films is due in part to the fact that they were soon forgotten after their release, and the receding past makes the real facts hard to recover. But one cannot escape from the belief that, in a conscious or unconscious attempt to alter or disguise

[1] Cf. Raymond Durgnat, "Futurism and the Movies," *Art and Artists* (February, 1969), p. 13; Carlo Belloli, "Lo Spettacolo," *Fenarete* (Anno XV), p. 45; and Maria Drudi Gambillo and Teresa Fiori (eds.), *Archivi del Futurismo,* p. 499. Durgnat says that *Perfido Incanto* was subtitled "A Futurist Film," but a photograph of the title card (Fig. 50) shows the full title, *Il Perfido Incanto,* "a drama of modern magic." The decoration of the title card, showing winged fairies, is somewhat Art Nouveau and shows no traces of Futurism.

the truth and gain historical importance or to support what a writer wants to believe, the record has been falsified. Such falsification would probably not exist if the stakes were not high, and in this case they are: they focus around the claim that *Il Perfido Incanto* was "the first avant-garde film" or, more precisely, the first full-length avant-garde film.[2]

It is now apparent that the first avant-garde film was produced in Russia. According to A. M. Ripellino, *Drama v Kabare Futuristov No. 13* (*Drama of the Futurist Cabaret No. 13*) was shot by Vladimir Kasjanov in 1913.[3] Mikhail Larionov and Nathalie Goncharova directed the film and acted in it together with Mayakovsky and David and Nikolai Burliuk. Other sources date the work as being done in 1914. At any rate, this avant-garde work by the Russian Futurists was done well before either *Vita Futurista* or *Il Perfido Incanto*.

But *Drama of the Futurist Cabaret No. 13* was only 431 meters long.[4] It was not "full-length." Once this was realized by Italian critics, the question then became "which was the first *full-length* avant-garde film?" Ignoring the fact that the standard length is not one that is accepted by the avant-garde but one deriving from traditional practices, they stressed the lengths of the two films. *Il Perfido*

[2] The claim that *Il Perfido Incanto* was the "first avant-garde film" was apparently made first by Jacomo Comin in "Appunti sul Cinema d'Avanguardia," *Bianco e Nero*, No. 1 (1937). Comin was quoted by Anton Giulio Bragaglia, the director of *Il Perfido Incanto*, in "Un Articolo di A. G. Bragaglia" that appeared in a 1959 issue of *Ora Zero*. This was not the first time Bragaglia's article was published, however. Comin had quoted much of it in his 1937 article, and the critic's opinion that *Il Perfido Incanto* was the first avant-garde film was merely added to Bragaglia's piece when it was later republished, as in *Bianco e Nero* (May–June, 1965). Carlo Belloli quotes parts of the same article as being written to him by Bragaglia in 1948 "in regard to some of my questions"; see: Carlo Belloli, "Poetiche del Cinema d'Avanguardia dalle Origini agli Anno Trenta," *La Biennale di Venezia* (September, 1964), p. 41. (Hereinafter referred to as "Cinema d'Avanguardia.")

[3] Angelo Maria Ripellino, *Majakovskij e il Teatro Russo d'Avanguardia* (Turin: Piccola Biblioteca Einaudi, 1959), pp. 242–243.

[4] Guido Aristarco, "Teorica Futurista e Film d'Avanguardia," *La Biennale di Venezia* (July–December, 1959), p. 80. Other sources give the length of the film as 400 and 450 meters.

Incanto, it was agreed, was full-length: *lungometraggio* as opposed to *cortometraggio.* It was 1,500 meters long and ran about 75 minutes. But how long was *Vita Futurista?* In 1965, Ginna wrote that his film was 1,200 meters long or full-length.[5] But, many years before in 1917, he himself had written to Bragaglia that *Vita Futurista* was "about 800" meters long.[6] Twelve-hundred meters would run about an hour, whereas 800 meters would only run for about 40 minutes. It would seem that films that last under an hour should be considered "shorts," and those that last an hour or more are "full-length." At any rate, careful research by Mario Verdone seems to have discovered the real length of *Vita Futurista.* In his significant and detailed book-length study of "Ginna e Corra— Cinema e Letteratura del Futurismo," published in the Italian film and television journal *Bianco e Nero,* he explains that the "Alphabetical index of motion pictures approved by the Ministry of the Interior from 1 January 1916 to 31 December 1921" lists the length as 990 meters.[7] The ministry censored the last part of the film for political reasons, reducing the length by about 190 meters. This would make Ginna's earlier statement correct, when he described the length of *Vita Futurista* as "about 800" meters long.

It is now relatively clear that in the *Il Perfido Incanto—Vita Futurista* controversy the former had historical precedence as well as greater length. There has been little agreement about the date of *Vita Futurista.* Arnaldo Ginna, its producer-director-cameraman, says that his film "was shot in Florence in the summer of 1916."[8]

[5] Arnaldo Ginna, "Note sul Film d'Avanguardia *Vita Futurista," Bianco e Nero* (May–June, 1965), p. 156. (Hereinafter referred to as *"Vita Futurista."*) The article is reprinted in *Bianco e Nero* (October–December, 1967), pp. 104– 106, under the title "Note di Ginna sul *Vita Futurista."* Page numbers will refer to the later publication.

[6] Mario Verdone, "Ginna e Corra—Cinema e Letteratura del Futurismo," *Bianco e Nero* (October–November–December, 1967), p. 103. (Hereinafter referred to as "Cinema." All references to *Bianco e Nero* are to this issue.)

[7] Verdone, "Cinema," p. 104. It would have been interesting if he had also informed us of the date of the entry.

[8] Ginna, *"Vita Futurista,"* p. 104.

Carlo Belloli stated in 1963 that *Vita Futurista* was filmed in October, 1916; by the following year he had changed his mind and wrote that the Futurist film was shot in the summer.[9] Drudi Gambillo, one of the coeditors of *Archivi del Futurismo,* explains that "the futurist short" (i.e., *Vita Futurista*) was "shot in Florence from December, 1916 to January, 1917." [10] Research by Maurizio Fagiolo dell'Arco has clarified the situation. An article, from *L'Italia Futurista,* reprinted by Fagiolo, shows that many of the scenes in *Vita Futurista* were known to the Futurists on October 1, 1916.[11] It is clear that much, if not all, of the film had been shot by that time; quite possibly the work had begun in the summer.

Another article reproduced by Fagiolo proves that the first public showing of *Vita Futurista* took place at the Niccolini Theatre in Florence on January 28, 1917: it was presented together with four *sintesi* by Settimelli and Corra, and poetry readings by Settimelli and Chiti of the works of several Futurist writers.[12] Although we do not know the date of the first screening of *Il Perfido Incanto,* it was one of three films directed by Bragaglia in 1916, and it seems probable that it was shown in the same year.

The most important question, however, is the avant-garde character of the two films. Its answer lies, of course, in the nature of the films themselves and in what we mean by "avant-garde." Neither film is available for our study. Our understanding must be based on what has been written about them and on an interpretation of the still-photographs attributed to them.

Vita Futurista is lost. The last-known print was lent by Ginna to a friend many years ago, and it has disappeared. There is always

[9] Cf. Belloli, "Cinema d'Avanguardia," p. 39, and Belloli, "Lo Spettacolo Futurista: Teatro, Danza, Cinema, Radio," *Fenarete,* No. 1 (Anno XV, 1963), p. 45. (Hereinafter referred to as "Lo Spettacolo.")

[10] M. D. G. [Maria Drudi Gambillo] "Scheda per *Perfido Incanto* di A. G. Bragaglia," *La Biennale di Venezia* (July–December, 1959), p. 86.

[11] Maurizio Fagiolo dell'Arco, *Balla: Ricostruzione Futurista dell'Universo* (Rome: Mario Bulzoni Editore, 1968), p. 87. (Hereinafter referred to as *Balla.*)

[12] *Ibid.*

the possibility that it will be found or that a previously unknown print will be discovered, but as time passes the probability of deterioration and the certainty of loss increase.

Il Perfido Incanto may exist. Bragaglia said in his oft-reprinted article that he had given the film to the "museo del cinema" in Paris —to the Cinématèque. But for years the Cinématèque has not allowed anyone to see the film; sometimes they have claimed not to have it. Even important Italian film historians such as Mario Verdone and Walter Alberti have not seen the film.

Then on July 9, 1969, the Cinématèque showed what they said was *Il Perfido Incanto* at the gala opening of a film festival. A print of the film was sent to Eastman House, the cinema museum, in Rochester, New York. All of the still-photographs attributed to *Il Perfido Incanto*—except the title card (the print is untitled)—appear in the film. But it has an entirely different story from that described in an unsigned publicity pamphlet apparently distributed at the time *Il Perfido Incanto* was first released.[13] One may either accept the attribution of the still-photographs or the accuracy of the pamphlet; the pamphlet is easily the most convincing. It would appear that the film thought by the Paris Cinématèque to be *Il Perfido Incanto* is actually *Thais,* also directed by Bragaglia in 1916 with settings by Prampolini, and that still-photographs of that film have been inaccurately ascribed to *Il Perfido Incanto.* Thus it seems likely that *Il Perfido Incanto,* like *Vita Futurista,* is lost. Nevertheless, a comparison of the structures, at least, of *Il Perfido Incanto* and *Vita Futurista* can be made with some degree of certainty on the basis of existing material, and a tentative evaluation of their respective avant-garde characteristics can be proposed.

Omitting the final section of the film, which was censored by the Ministry of the Interior, Arnaldo Ginna described *Vita Futurista* as having eight parts.[14] The first was shot at a restaurant on the Michelangelo Esplanade in Florence. A still-photograph of the scene

[13] *La Travia del Film, Bianco e Nero* (May–June, 1965), pp. 69–71.

[14] Ginna, "*Vita Futurista,*" pp. 104–106. All of Ginna's descriptions of *Vita Futurista* are from this source.

Fig. 51. *Futurist Life* (*Vita Futurista*) was filmed in 1916 and first shown in 1917 at the Niccolini Theatre in Florence. This photograph is from the opening scene—"Futurist Lunch." Lucio Venna, wearing a false white beard, appears in the background at left-center. (Courtesy *Bianco e Nero,* October–November–December, 1967)

exists, showing well-dressed diners seated at two tables covered with clean white tablecloths; although pillars in the background seem to support an arcade over the tables, it is apparently an out-door scene with natural light (Fig. 51). Giacomo Balla, Remo Chiti, and Emilio Settimelli played the parts of diners. Between them, in the photograph, can be seen an old man with a large Santa Claus beard: this was Lucio Venna, a painter and Ginna's chief assistant on the film, wearing a false beard. As the scene developed, the young Futurists were to taunt the old man, mocking his old-fashioned way of eating. Ginna describes how an Englishman came on the scene during the shooting and, not realizing what was going on, protested to Marinetti that elderly people should not be insulted. Apparently the "real" addition was left in when the scene was shown, but one wonders how clear the Englishman's position was without an accompanying sound track.

In the second scene, a young Futurist "allows himself to be

overwhelmed by amorous sentimentality." Exactly how this was portrayed is unclear, but apparently a short story of some kind was involved. In order to give, in Ginna's words, "the impression of a state of mind," the film was given a light-blue color through toning. Whether this coloring was consistent through the entire scene or whether it was used with more specific effect in different parts, is, again, a matter of conjecture.[15]

Ginna claims that when he was developing some of the film, he found it dotted with white specks caused by dust. In another attempt to represent "states of mind," he and Venna carefully and patiently colored in the white dots. Verdone, who has talked extensively with Ginna, writes that this was done on the second scene in Ginna's outline and that, possibly contradicting the claim that the sequence was colored blue by toning, the dots were painted red.[16] If hand-coloring occurred on this scene, it would not have registered as color on any prints, and there is no photographic record of it.

A still-photograph of the third scene in Ginna's chronology shows a kind of split-screen technique (Fig. 52). It compares the way a Futurist sleeps with the way a passéist sleeps. Settimelli, on the left in the photograph, sits on a bed fully clothed with his hat on; one hand is raised, partly obscuring his face, and perhaps he is in the act of springing out of bed. In a bed at the right, an old-fashioned sleeper lies almost unseen under the blankets. Ginna writes that the beds were placed "vertically rather than horizontally," but only Settimelli's bed seems to be tilted, as indicated by the angle his vertical body makes with the bed. How the split-screen effect was achieved is a problem. Ginna says that both beds are "in a room," but the backgrounds, lighting, and relative angles of the two beds seem to indicate two separate pictures joined together. On the other hand, although the demarcation between areas is very distinct at the top of the photograph, the blankets or sheets of both beds overlap the adjoining area at the bottom.

According to Ginna, the fourth scene of *Vita Futurista* involved a "caricature of the Hamlet symbol of pessimistic traditionalism" in

[15] Ginna may have been thinking of the distortion scene (see below) in which Balla fell in love with a chair, but this would not account for the toning.

[16] Verdone, "Cinema," p. 108.

Fig. 52. From *Futurist Life* (*Vita Futurista*), the third scene—"How the Futurist Sleeps." Settimelli appears at the left and a passéist at the right. (Courtesy of *Bianco e Nero* [October–November–December, 1967])

which moving figures were "deformed by concave and convex mirrors." Actually, the distortion scene involved a love affair between Balla and a chair. This is shown in both the October 1, 1916, and February 10, 1917, articles in *L'Italia Futurista*.[17] The first explains that "Balla falls in love with and marries a chair, a footstool is born."

Two still-photographs of this scene exist (Figs. 53 and 54). In one of the photos, Balla crouches in front of what appears to be the ornate woodwork decorating the lower portion of a wall. His arms

[17] Fagiolo, *Balla*, pp. 86–88. All references to the articles in *L'Italia Futurista* are from this source.

stretch horizontally to the sides, and his head and legs seem flattened and compressed. What were undoubtedly parallel vertical lines in the wallpaper behind him arch and bend, distorted as they would be in concave or convex mirrors. Balla's loved one, the chair, is in front of him. Perhaps he is kneeling as he proposes to "her."

Balla, the chair, and the same ornate wall appear in another photograph showing distortion. Actually this second photograph is a three-picture sequence from the film (Fig. 54). Although essentially the same picture, movement is indicated by the small differences in the position of images from frame to frame. At the right, Balla, standing this time but with his arm again extended, draws back as if in fear or amazement. In the left foreground is the figure of a girl wearing a loose, sleeveless white dress and what appears to be an extremely long ribbon-like necklace. Unlike Balla and the background, the girl does not seem to be distorted, and her figure is semitransparent, allowing the lines of the wallpaper to be seen through her. Although Ginna and other sources do not mention it, the scene seems to have been shot as a double exposure. In the three-frame sequence, the girl, her arms moving in a dancelike gesture, fades in or "appears," her presence becoming more definite in succeeding pictures. Even here, however, there are grounds to question the proper order of the pictures in sequence: one source prints them in one order and another source shows a different order.[18] Perhaps the girl is disappearing rather than appearing. It is possible that she represents the spirit or soul of the chair. At any rate, the interpretation of the pictures as being made by double exposure is reinforced by the fact that the figure of the girl seems to extend slightly below the edge of the frame, an effect that could be caused by a misalignment when the film, after being exposed once, was rewound for the second shooting.

Ginna mentioned no girl in the "Hamlet" scene, although he does refer to girls in the fifth section, "The Dance of Geometric Splendor." Probably because the girl in the double-exposure sequence seems to be dancing, Verdone ascribed the pictures to this latter

[18] Cf. Belloli, "Cinema d'Avanguardia," p. 36 and the photographs, referred to as a "dissolve" even though the faintest picture is first, in *Bianco e Nero,* illustration section.

section. But the dance in the fifth section described by Ginna is
performed by "girls dressed entirely in pieces of *stagnola*," which
could be either tin or tinfoil. The white dress of the girl in the
photographs looks soft and falls easily; her movements look graceful
rather than "geometric." It would seem that the costumes in "The
Dance of Geometric Splendor" were more like those designed by
Fortunato Depero eight years later for *Machine of 3000* (Figs. 25 and
26). Depero's costumes were composed of variously sized tubes of
metal that covered the legs, torso, arms, and head of the dancer;
Ginna notes that the metal in the costumes of *Vita Futurista* was
"variously shaped," but both costumes were metallic. In *Vita Fu-
turista*, bright spotlights were trained on the metal-covered girls
while they moved in a "dynamic-rhythmic" dance. In a possibly un-
foreseen effect, the flashes of light reflected from the costumes
burned out sections of the photographic image, making it impossible
to see parts, or perhaps even all, of the figures at times and "destroy-
ing the ponderousness of the bodies." In his article in *L'Italia
Futurista*, Settimelli wrote of the "new effects of light" obtained in
the scene "by reflections of moving rays."

Figs. 53 and 54. Scenes from *Futurist Life* (*Vita Futurista*). (LEFT) "Love Story of the Painter Balla and a Chair." The distortion effect was achieved by using a concave or convex mirror. Balla is the performer. (RIGHT) The double exposure sequence is from the same scene in the film. The background and Balla's figure (at the right) were filmed in a distorting mirror. (Courtesy of *Bianco e Nero* [October–November–December, 1967])

No photographs exist of what Ginna described as the sixth scene of *Vita Futurista*. Apparently it was merely the recitation of poetry. The earlier article in *L'Italia Futurista*, "Some Parts of the Film *Vita Futurista*," indicated declamation by Settimelli, Ungari, and Chiti. Ginna mentioned only Remo Chiti reciting poetry "with simultaneous accompaniment of arm movements." Certainly the arm movements would have been very important because this was a silent film. Perhaps they were the "geometric" or "outlined and topographic" gesticulation described by Marinetti in the manifesto of "Dynamic and Synoptic Declamation" published on March 11, 1916, the same year *Vita Futurista* was made.

Ginna called the seventh section in his outline of *Vita Futurista* "Introspective Research of States of Mind." Although neither of the articles in *L'Italia Futurista* (including the two reviews of the first screening of *Vita Futurista* reprinted in the later one) mentions the use of color, he explained that this section, like the second scene, was colored by toning—this time to a deep violet. A photograph from *Vita Futurista* that has never been ascribed to a particular scene might very probably be from this part (Fig. 55). It shows Remo Chiti with his head bandaged and his eyes closed. The print, filled with swirls and blotches, appears to be in very bad condition, but it is possible that at least some of the marks and discolorations are attempts to create "states of mind." Certainly the combination of close-up, asymmetrical composition, physical expression, and atmospheric indications create a strong emotional/psychological effect.

Ginna remembered Chiti, Venna, and Nannetti sitting on saw-horses; at least one of them dangled carrots from a string "held between the index finger and the thumb." He ascribed this image to the "Introspective Research of States of Mind" section, but it would seem possible that it actually belonged to the eighth and final scene in his outline. In "Some Parts of the Film *Vita Futurista*," the section was called the "Drama of Objects." The article in *L'Italia Futurista* mentioned the "exploration of herrings, of carrots, and of eggplants" in this section.

Several short sequences apparently made up the "Drama of

Fig. 55. From the film *Futurist Life* (*Vita Futurista*)—Remo Chiti with a bandaged head. (Courtesy of *Bianco e Nero* [October–November–December, 1967])

Objects." In addition to herrings, carrots, and eggplants, *L'Italia Futurista* mentioned a "discussion between a foot, a hammer and an umbrella" and described how "Marinetti and Settimelli [would] approach strangely assembled objects with every precaution." [19] It explained how the Futurists were attempting "to understand

[19] It would be several years before the Surrealists called attention to Lautréamont's "chance meeting of an umbrella and a sewing machine on a dissecting table" and developed their own theories of the irrational object and the object removed from its proper environment.

FINALLY these animals and these vegetables [by] placing them absolutely outside their usual environment."

It is perhaps most unfortunate of all that no photographs exist of this final scene in Ginna's reconstruction. He remembered how Balla showed "several objects" and "neckties" made of "colored wood." It would be very interesting to compare these creations with the paintings and sculptures of Balla and the other Futurists.[20] There is a possibility that they were exhibited at the "Futurist House" that Balla opened to the public in Rome (1918–20).[21]

Unfortunately, even though Ginna made *Vita Futurista*, his recollections many years later cannot be considered to be an accurate record of the film. Two sections were omitted from his reconstruction that are indicated by other sources to have been part of the work. "Some Parts of the Film *Vita Futurista*" mentions a section that includes "Morning Exercises," a "Futurist Attack with Sword[s] between Marinetti and Ungari," and a "Discussion with Boxing Gloves" between the same two. A photograph of the last sequence exists (Fig. 56). Marinetti and Ungari, both wearing boxing gloves, are sparring in the middle of a grassy field with trees in the background.[22] Marinetti, facing the camera, has just landed a blow, and his opponent is falling. Apparently, the scene was meant as a direct representation of how well a Futurist could fight.

Another section not mentioned by Ginna in his outline-from-memory was said by the 1916 article in *L'Italia Futurista* to contain several sequences: the first heading or catchphrase given in the telegraphic style of writing is "futurist walk." A review mentions

[20] Photographs of three proto-Constructivist sculptures, now lost or destroyed, appear in *Ricostruzione Futurista dell'Universo* (*The Futurist Reconstruction of the Universe*) by Balla and Depero. The manifesto was published in *La Balza* in March, 1915, the year before the filming of *Vita Futurista*.

[21] An advertisement for "La Casa Futurista" that appeared in *Roma Futurista* on February 22, 1920, shows the same three photographs from *The Futurist Reconstruction of the Universe*, so it may be assumed that the pieces were still in existence in 1920 and were exhibited at the house.

[22] The trees in full leaf would seem to indicate that the scene was shot, as Ginna said, in the summer.

one of the scenes.[23] It describes how a man is seen walking timidly and hesitantly. Then Marinetti appears, running with great strides and springing over all obstacles. The intent apparently was to con-

[23] Corrado Pavolini, *Tevere*. Pavolini was quoted by Marinetti in his manifesto "La Cinematografia Astratta è un'Invenzione Italiana," published in 1926. In the manifesto, Marinetti refers to "Marinetti's film" and does not mention Ginna's role in the production. Since he only quotes the critic's description of the scene he was in, he might have been referring to his appearance in using the possessive.

Fig. 56. From the final scene in the film *Futurist Life* (*Vita Futurista*): "Discussion with Boxing Gloves Between Marinetti and Ungari." Marinetti is facing the camera; Ungari is falling. (Courtesy of *Bianco e Nero* [October–November–December, 1967])

trast how a "passive neutralist" walked with the way a Futurist walked.

After mentioning a *"futurist march* interpreted by Marinetti, Settimelli, Balla, Chiti, etc.," the *L'Italia Futurista* article tells, in its somewhat breathless style, of the "invasion of a passéist tea—conquest of women—Marinetti declaims amidst their enthusiasm." All of the scenes in this section would appear to be obvious, didactic, and uninvolved with cinematic techniques.

Even though it was not part of the exhibited film, mention should be made of the censored segment, "Why Cecco Beppe Does Not Die." [24] It indicates the satirical aspect of Futurist performance —*L'Italia Futurista* called it a "ferocious caricature"—and illustrates a somewhat simple and probably obvious attempt at trick photography. Death, played by Remo Chiti, comes for Beppe. The background of the scene is black, and Chiti wears black clothing with a white skeleton on it: the figure is supposed to appear insubstantial. But Beppe has a very bad odor. Death cannot stand it and collapses, allowing his victim to live on.

Assuming that the limited information that we have about *Vita Futurista* is accurate for the most part, certain conclusions can be drawn about the significance of the film. One of the most important aspects of the film is its structure: a series of segments that do not tell a story and do not explain each other. To a great extent, the combination and juxtapositioning of various kinds of material must derive from the manner in which the film was made. Although Ginna was the controlling figure as cameraman and, especially, as editor, *Vita Futurista* seems to have been created by a committee; its structure allowing the various ideas of the several contributors to keep

[24] Mario Verdone says that the censored part was listed by the Ministry of the Interior as "Why Francesco Giuseppe Did Not Die," and he quotes Ginna as using that name ("Cinema," pp. 104, 106). The October 1, 1916, article in *L'Italia Futurista,* published by the Futurists themselves, headlined "Why Cecco Beppe Does Not Die," and Fagiolo, who had read Verdone, continued to refer to "Cecco Beppe" (*Balla,* p. 88). Perhaps the nickname was replaced by the given name before the film was submitted to the Ministry of the Interior, but this indicates the difficulties involved in trying to get an accurate understanding of *Vita Futurista.*

their own conceptual identity without requiring compromise or consensus. Marinetti, Ginna, Settimelli, Corra, and Balla are all listed as the writers in *L'Italia Futurista*. Balla probably conceived of the distortion scene and, perhaps, of the "Drama of Objects." Marinetti probably conceived of the outdoor scenes in which he performed, and he may not have been in Florence when some of the other sections were created. The alogical nature of the resulting structure undoubtedly contributed to the difficulty Ginna seems to have had in recalling all of the scenes, but it is fundamental to the nature of the film.

It would seem that, rather than starting with a complete script and overall concept, the film was assembled out of more or less autonomous sections that were created somewhat independently in several places over a period of time. Giovanni Calendoli has said that when he was a young Futurist poet he saw "part" of *Vita Futurista*. But, because the various creators were all Futurists and shared common aesthetic principles, the film is more than the sum of its parts. None of the scenes in itself could clarify or embody the many-faceted nature of Futurism, but the combination, in its diversity, creates an interestingly accurate and complex representation of the movement's values and goals. The film included the literal, didactic, and anecdotal as well as the allusive and the primarily visual.

In 1926 Marinetti published a manifesto entitled "Abstract Cinema Is an Italian Invention." His claim does not seem completely justified, but there is an element of truth in it. Since it contained recognizable imagery throughout, *Vita Futurista* was not the first abstract film. It was not completely "anti-anecdotal" or "anti-descriptive," as Marinetti said, since both types of thought were involved in certain sections. It was not "pure" like the totally abstract or nonobjective films that Viking Eggeling and Hans Richter were soon to produce. But it was "without a plot." The structure was abstract, and the noninformational continuity of *Vita Futurista* may have influenced later filmmakers.

We would have to see *Vita Futurista* itself in order to know for sure whether any of the imagery was totally abstract; most of

it obviously was not. Several of the scenes had a literal point or message that could easily be translated into a literary statement. Other scenes seem to be nonsymbolic, referring to nothing outside of themselves. But the girls in the reflecting costumes, for example, might have danced a little story or illustrated a didactic point. We do not know. Balla's painted objects might have been as Dadaistically illogical as the carrots dangling from a string. There is certainly a Duchamp-like irony in his necktie made of wood, and even the voiceless poetry recital by Chiti might have been more abstract and alogical than anecdotal and illogical.

Vita Futurista certainly represents an investigation of new cinematic techniques: toning to color the black-and-white film, coloring the print by hand, the use of mirrors to distort the filmed image, split-screen techniques, and double exposures. It was not the first time that such techniques had been used in motion pictures. Georges Méliès, for example, used double exposure and hand-painted film to add color. But in *Vita Futurista* the image quality of these effects —the abstract emphasis on the-thing-for-its-own-sake—is heightened by the structure and the lack of overall narrative. They, too, would seem to move the entire film in an abstract direction.

There is no question that *Vita Futurista* was an avant-garde film. It qualifies on both sociological and stylistic grounds. It was produced independently by a group of artists for their own aesthetic purposes, and it attempted to be innovative, breaking with the traditions of filmmaking.

On the other hand, it does not seem that *Il Perfido Incanto* can accurately be called an avant-garde film. Unlike the films that are usually referred to as avant-garde, Bragaglia's picture was produced by a commercial company, Novissima Film. Established by Emidio de Medio in Rome, Novissima Film made three films directed by Bragaglia in 1916: *Il Mio Cadavere, Il Perfido Incanto,* and *Thais.* Prampolini designed the sets for *Il Perfido Incanto* and *Thais.* Professional actors were used in all the films, although the two leading ladies of *Il Perfido Incanto,* Thais Galitzky and Lleana Leonidoff, a ballet dancer, were not professional actresses. But only *Il Perfido Incanto* is described as "avant-garde." Bragaglia's explanation is that the

losses sustained on a "very modern" film were to be made up by "some commercial productions."

Even if this rationale were acceptable, the aesthetic importance of *Il Perfido Incanto* is questionable on the basis of the material that is available. The story, as told in the publicity pamphlet apparently distributed at the time *Il Perfido Incanto* was released, is romantic, melodramatic, and old-fashioned.[25] It involves a sorcerer and fortune-teller, Atanor, who lives with his ward, Circe, in an "enchanted palace" in a "large modern city." Circe, in her role as the "Duchess of Tiana," falls in love with Mario Berry. In order not to lose Circe, who provides him with the private information upon which his reputation as a seer depends, Atanor kills Berry's wife. Later, after a bank robbery, Atanor threatens to kill Berry, too, if Circe "does not give in to his desires." Berry arrives at the sorcerer's house just after Circe, having been raped by Atanor, has killed "the satyr" by driving a pin in his neck. Believing that she also killed his wife, Berry leaves, and Circe "falls down overcome with madness."

Thus neither of the two apparently reliable documents relating to *Il Perfido Incanto,* the title card and the publicity pamphlet, would indicate that the film was unusual or innovative in any way. *Il Perfido Incanto*'s real claim to being an avant-garde film may lie, as Bragaglia states, in its "surreal" scenography that made use of lenses and prisms of different kinds and, like *Vita Futurista,* employed concave and convex mirrors. None of these effects appears in the film owned by Eastman House, and, since none of the still-photographs attributed to *Il Perfido Incanto* shows distortion of any kind, it is impossible to investigate the claim. If it is true, the effects were probably used as narrative elements justified by the bizarre (but not "surreal") story. The most ambitious claim that would seem to be justified for *Il Perfido Incanto* is that it is a film, created for the tastes of certain intellectuals, that made limited use of unusual technical effects. The fact that these effects were also used in *Vita Futurista* and other, later, avant-garde films does not, in itself, make *Il Perfido Incanto* an avant-garde film.

[25] *La Travia del Film, Bianco e Nero* (May–June, 1965), pp. 69–71.

The difference between *Vita Futurista* and *Il Perfido Incanto* —the difference, indeed, between *Vita Futurista* and any other film of the time—was clearly indicated in the "Futurist Cinematography" manifesto, published on September 1, 1916. The main tenet of the manifesto was that "cinematography is an art in itself," and that it should "never, therefore, copy the stage." Just as they attempted to replace the traditional literary theatre with their Synthetic Theatre, the Futurists wanted to replace the literary film with a film of "plural-sensibility." The evidence that we have indicates that *Il Perfido Incanto* was basically a filmed stage play with a contrived plot and painted canvas flats. By combining unrelated sections of different kinds, *Vita Futurista,* on the other hand, made an approach to the "omnipresence" and "polyexpressiveness" called for in the manifesto. Although the didactic scenes such as "How the Futurist Sleeps" and Marinetti's race with the passéist apparently had the quality of a play, others showed varying approaches to abstraction, narrative, logic, and technical means.

Simultaneity, accomplished with the split-screen, and "states of mind," represented by toning and coloring the film, were goals of the manifesto that were achieved in *Vita Futurista.* Both had already been realized on the stage in various *sintesi.* The "discussion between a foot, a hammer and an umbrella" may have been akin to *Feet,* the *sintesi* by Marinetti. Certainly it and Balla's presentation of painted wooden objects were an example of the demand by "Futurist Cinematography" for a "filmed drama of objects."

Other proposals—"unreal reconstructions of the human body," typographic and geometric "dramas," and "filmed musical research," for example—apparently were not found in *Vita Futurista.* Like other Futurist manifestos, the importance of "Futurist Cinematography" should not be underrated, however, merely because the Futurists themselves never put all of its proposals into actual practice. It was an influential document. After describing books as an "absolutely old-fashioned means of conserving and communicating thought," the manifesto candidly admits that "the necessities of propaganda compel us to publish a book from time to time": the machinery of Futurist "propaganda" was elaborate and powerful. Although no figures are available from which to make an estimate,

it would not be surprising if, during 1917, more people read "Futurist Cinematography" than saw *Vita Futurista*. There is no indication that *Vita Futurista* was shown in other countries; the Futurist manifestos were distributed internationally.

Many of the points in "Futurist Cinematography" prefigure films of the international avant-garde. "Chromatic and Plastic Music" describes nonobjective films such as those of Eggeling and Richter. "Animated objects" and a "symphony of gestures, events, colors, lines" suggest the approach of Man Ray in *Emak Bakia* and Fernand Léger in *Ballet Méchanique*. The transformation of poetic images into their cinematic equivalents, a section probably contributed by Marinetti, seems related to the type of thought used in the first part of Francis Picabia's *Entr'acte*. Many recent avant-garde films could be described quite accurately as "cinematic *parole in libertà*."

In this context it should be pointed out that the brothers Bruno Corra and Arnaldo Ginna apparently made completely abstract colored films before 1910. These short, hand-painted films, translating poetry and music into moving color, are described by Bruno Corra in "Musica Cromatica," an article dated 1912 and published in Mario Verdone's Futurist issue of *Bianco e Nero*. Again, the importance of this work is hard to determine. Apparently the films were not shown to anyone; they had no influence, and the privately-printed book in which the article appeared must have had a very small circulation. The Futurists, at least, knew about these concepts, however, and attempted to interest others. Settimelli begins his article in *L'Italia Futurista,* which describes the first screening of *Vita Futurista,* with a mention of Ginna and Corra and their "chromatic music" theories of filmmaking.

Although they were never made into films, Mario Scaparro's "Cinemagraphic Poems" are an example of the influence of cinematic thought and of the tendency among the Futurists to combine different artistic disciplines. Poetic in their freedom of imagery and dramatic in their use of a traditional script format that begins with a list of the performers, Scaparro's pieces could be staged only with great difficulty, although they could be filmed. Published in 1920, at a time

when French Surrealism was just beginning to establish its character, the imagery of *The Improvised Balloon* (*Il Pallone Improvvisato*) is basically surreal in its transformation of the human into the inanimate: a man inhales a cloud, swells into a huge spherical balloon with the head of a man, and floats away with three people riding in the observation basket. Since the sound of a hurricane is prominent in *The Rainbow of Italy* (*L'Arcobaleno d'Italia*), it is doubtful that Scaparro thought of his pieces as actual film scripts, but he creates a "cinema of the mind" by placing unusual images in the terse form of a film scenario.

XI] Radio

Although some writers, especially those primarily concerned with painting, tend to denigrate the accomplishments of Futurism after World War I, and most of the important achievements of the movement do not date from later than the early 1920's, the last significant contribution of Futurism to performance took place in 1933. The area of concern was radio. Once again, a manifesto explaining the artistic goals exists along with actual performance material.

The "Futurist Radiophonic Theatre" manifesto, also called "La Radia," was published by Marinetti and Pino Masnata in October, 1933. The first part of the manifesto lists a series of claims by the "Second National Congress of Futurism" and is merely another summary of past accomplishments in various fields. True to the Futurist spirit, the portion of the manifesto devoted to radio begins with a rejection of the arts of the past: theatre, motion pictures, and literature are all dead or dying. The basic proposal of "Futurist Radiophonic Theatre" is that radio, or "radia," as the Futurists called their work in the medium, must not borrow from these outworn forms but must become "a new art that begins where theatre, cinematography, and narration stop."

Once narration or storytelling was rejected, the radio performance became a "pure organism of radiophonic sensations." Since it dealt only with sound, this "essential art" became a kind of music: the organization of sounds in time. Since the materials for these sound compositions were not limited to pure musical tones, but included all sounds, the manifesto can be seen as a continuation of Russolo's earlier concept of "noise music." The radio, in these terms, was to become a sophisticated *intonarumori* or "noise-intoner." Yet, both in theory and in practice, Futurist radio went significantly beyond the earlier work.

"Futurist Radiophonic Theatre" emphasized the extreme range of sound materials and structural techniques that were to be used. Sounds that could not be heard by humans but could only be registered by ultrasensitive equipment were to become the raw material for transformation into radio performance. The "infinite variety" of possible music, sound, and voice was to be extended to include the "detection" and "amplification" of "vibrations issuing from living beings" and from "material" such as diamonds and flowers. All the devices of "harmony, simultaneity, . . . crescendo, diminuendo" were to become "strange brushes for painting" this spectrum of sound. Even the "interference between stations" was to be used. But it was perhaps in its focus on the "delimitation and geometric construction of silence" that "Futurist Radiophonic Theatre" had its greatest importance.

Marinetti wrote five short pieces for radio. He called them "radio *sintesi*." Two of the compositions make intensive use of silence as a compositional element. "Silences Speak Among Themselves" ("I Silenzi Parlano fra di Loro") employs traditional musical sounds (a note or brief series of notes on a piano, flute, trumpet) and both nonhuman and human sounds (a motor, a baby crying, "amazed ooooooo's from an eleven-year-old little girl"). Each sound is separated from the others in the series by from eight to forty seconds of "pure silence." The tension created by the silence makes it an active element in the composition. When, as in this piece, the single note "sol" on a piano is preceded by twenty-nine seconds of silence and followed by forty seconds of silence, the silence stops functioning as a neutral ground against which the sound that makes up the composition is heard. Like the reversible figure/ground of Gestalt psychology's optical illusion, silence is "heard" against a "background" of sound; silence becomes equal to sound as an aesthetic tool. Obviously, thought of this kind has much to do with the work of contemporary composers such as John Cage.

Marinetti's "Battle of Rhythms" ("Battaglia di Ritmi") is extreme in its use of silence. The "repeated ring of an electric bell" —like those of the other sounds in the piece, its exact duration

is not given—is followed by three minutes of silence. Apparently tension of prolonged waiting for the next sound and uncertainty about whether or not the piece had ended were among the responses that Marinetti was trying to arouse. Sound finally returns to the composition with the "labor of a key in a lock," but doubt about the ending is established again with the last element of the piece: a silence one minute long.

Marinetti's other radio *sintesi* also made use of "found" sound from everyday life. "A Landscape Heard" ("Un Paesaggio Udito") alternates the sound of fire crackling for from five to thirty-five seconds with one-second segments of water lapping; the piece ends with the whistle of a blackbird. "Drama of Distance" ("Dramma di Distanze") combines music, such as a "Neapolitan aria sung in the Hotel Copa Cabaña in Rio de Janeiro," from very particular places in different parts of the world in the same sequence with the sound of a boxing match in New York. "The Construction of a Silence" ("La Costruzione di un Silenzio") does not use silence as compositional material but may be an attempt to employ as a critical datum the apparent distance from which a sound is heard: four sounds are to create the four "walls" of an imaginary "room."

XII] The Extension of Categories

Among the most interesting and significant Futurist performances are those that, even today, seem to extend the limits of traditional forms in an extreme and unusual way. Of course, any important innovation may appear unusual and drastic, and most of the presentations and theories already discussed were radical and original extensions of what had previously been accepted as art. But for anyone familiar with contemporary art and performance and with the history of the avant-garde in this century, much of their radical quality can be fully appreciated only in retrospect. Exactly because Futurism has had such a great influence on the advanced art of our time, with succeeding artists perfecting and elaborating the aesthetic ideas they made available, our view of what art is has changed tremendously in the last fifty years. Many elements of Futurist performance that once were received as extreme and unusual no longer strike us that way. The sounds of Russolo's *intonarumori,* for example, probably would be quite acceptable to audiences familiar with the volumes and textural varieties of John Cage and rock music.

It is something of a paradox, then, that certain Futurist developments in performance seem to retain a more pronounced quality of striking innovation for the very reason that they apparently had little direct influence on later work. They are still somewhat outside the limits of contemporary avant-garde production, and they seem more provocative because they were not surpassed or simplified by any aesthetic offspring.

As we have seen, the Futurist desire to escape from established standards, rules, and classifications was rigorous and programmatic. "The Futurist Synthetic Theatre" manifesto stated boldly in capital letters that: "IT IS STUPID TO RENOUNCE THE DYNAMIC LEAP INTO THE VACUUM OF TOTAL CREATION OUTSIDE

OF ALL EXPLORED FIELDS" and explained that: "EVERY-THING IS THEATRICAL WHEN IT HAS VALUE." In following this line of thought, the Futurists, among other things, drastically altered performance space and time, increased the sensory constituents of performance, and produced unusual and unorthodox scripts.

Marinetti's *parole in libertà* served as a kind of theoretical focus for much Futurist thought, even in areas other than literature. One of its basic tenets was the creative spatial distribution of words and phrases over the printed page. In part, the space between words indicated the time between ideas or illustrated physical relationships of proximity and distance. Sometimes the words formed recognizable or symbolic shapes, and sometimes drawing was combined with the writing to make the visual aspects of the work even more specific. When transferred to performance, the concepts of *parole in libertà* created an unusual script that was part visual and part verbal. The space, time, and auditory qualities of a performance were represented visually.

Colors (*Colori*) by Fortunato Depero and *Mechanical Sensuality* (*Sensualità Meccanica*) by Fillia make use of both typography and layout. In both, sounds are spelled out phonetically, and the size of the letters indicates their relative volume: small uncapitalized sound-words indicate softness, words in which all letters are capitals indicate moderate volume, and large capitals indicate loud sounds. In Fillia's *sintesi,* for example, the sound-word "PUM" is written with capital letters of increasing size, representing an increase in volume. Time relationships are established by relative locations of words on the page, and when different sound groupings occur simultaneously they appear in vertical columns at opposite sides of the script or score.

Looooove (*Amooooore*) by Volt, published in his 1916 volume *Archivoltaici,* represents three different stage locations—the hall of a hotel, a telephone booth, and a lawyer's office—by three columns in the script. The activity in each location is described in its own column, and the correspondence in time between the sometimes-simultaneous actions is determined by reading horizontally across

the three sections. Again sound is spelled phonetically. The spelling of the title itself indicates how the word "love" is to be pronounced. When "Her" calls the lawyer on the telephone, a line of *r*'s representing ringing stretches across the two columns, showing that the phone can be heard in both the booth and the office. When "Her" calls her friend Christine, who is not seen on stage, the *r*'s appear only in the "telephone booth" column. Volt also includes figurative, if very simplified, drawing in his script. On what is apparently the lawyer's desk, he sketches a revolver lying on top of two books labeled "penal code" and "Tolstoy." In Volt's drawing, the lawyer, cuckolded, appears with large horns on his head and a "huge heart" filling his whole chest.

Paolo Buzzi's book *The Ellipse and the Spiral* (*L'Ellisse e il Spirale*), published in 1915, carried the pictorial-verbal representation of activity in space to a point where diagrammatic drawing outweighed, or at least balanced, the linguistic content. In his *Trinomial (or 3nomial) Voices Whirlpool Destruction* (*3nomio Voci Gorgo Distruzione*) a symmetrical, eight-pointed figure labeled "theatre" is filled with three circular "mouths of fire" and jagged lines indicating "dancing lamps." If Buzzi's piece was not a "script" from which a performance could be created, it was an unusual, somewhat poetic statement or description of a violent theatrical experience.

In their pursuit of "creation outside of all explored fields," the Futurists also extended, at least in theory, the sensory dimensions of performance. Marinetti's proposed Total Theatre was to include the use of odor. A "perfumer" operating a keyboard mechanism was to release various smells into the air; they would be removed, and the air cleaned, by special vacuum devices.

Temperature was intended to be an aesthetic element in Fillia's *Mechanical Sensuality*. Ventilators on three sides of the hall or auditorium were to change the temperature during different parts of the presentation. In the first part, the room was to be "very cool," in the second "normal," and in the third "very hot."

The creation of a "Tactile Theatre" that focused primarily upon the sense of touch was also proposed by Marinetti. He actually

created displays, which he called "tactile tables," that were intended to be felt rather than seen and which presented an organized variety of textures and surface qualities. In "Tactilism," a manifesto read at the Théâtre de l'Oeuvre in Paris and published in January, 1921, Marinetti described his theoretical distribution of tactile qualities into categories and scales that were somewhat similar to Russolo's organization and grouping of various kinds of noise. As explained in a short section of the "Tactilism" manifesto, Marinetti's Tactile Theatre was to be composed of long moving bands or turning wheels that were to be touched by the spectators. Time was an element in the performance, and other senses besides that of touch were to be involved. As the bands flowed smoothly or the wheels revolved, providing different textural rhythms as well as a variety of tactile qualities, there would be "accompaniments of music and light."

Of course it cannot be claimed that tactile elements have been completely absent from contemporary theatre. Several attempts to involve the audience more directly and immediately have employed physical contact between performers and spectators: Audience members have been touched, stroked, physically led or moved, and have had various things dropped or thrown on them. The involvement of the sense of touch in these cases, however, has been episodic and limited, whereas Marinetti had proposed that central importance be given to the tactile elements.

Marinetti's Tactile Theatre should not be confused with his "tactile *sintesi*" such as *The Great Remedy* and *The Tactile Quartet* (*Il Quartetto Tattile*). There is no direct contact in the plays between the spectators and the presentation. As has been mentioned, when "The Sensible One" goes into the auditorium in *The Great Remedy,* she "almost grazes . . . with her hands" the "very beautiful women" in the front row of seats: she looks at them, smells them, but does not actually touch them. Tactile elements abound in the plays, but they are to be experienced imaginatively by the audience, rather than directly. The dilemma faced by "The Sensible One" opposes two contrasting images—a slanting wall bristling with sharp blades and a "marvelous semi-nude woman"—that are tactile to a high degree. The texture of paper, the eating of fruit and fruit skins, and the feel of bare skin play important parts in *The Tactile Quartet*. Both plays

employ the violent physical contact of blows, kicks, and falls, but all of these tactile elements must be understood and experienced by the spectator through imagination, projection, and empathy.

We have already seen how the Futurists sought to open and extend the time dimension of a performance by provoking the spectators and creating "ripples" of physical reaction that, as stated in "The Theatre of Surprise" manifesto, would spread through "the city the same evening, the day after, to infinity." In a like manner, they also enlarged the dimension of space in their presentations: Fedele Azari created an Aerial Theatre in which the sky was the stage and airplanes were the actors.

Azari, an aviator in the Italian air corps during the war and a painter, presented "elementary aerial theatre" and the "first flights of expressive dialogue" in the sky over Busto Arsizio in the spring of 1918. In April, 1919, he scattered the manifesto, "Futurist Aerial Theatre," from his airplane, which described the theory and some of the physical vocabulary of his new performances. Azari saw his Aerial Theatre as being akin to both music and dance. Working with Luigi Russolo, he developed a device to control the volume and quality of sound produced by the airplane's engine, turning it into a kind of flying *intonarumori*. In Azari's "dance," the "gestures" and movements were derived from the acrobatics of the fliers during the war, but he emphasized the translation of maneuvers "already used without artistic purposes" into an aerial aesthetics. Just as Futurist playwrights sought to present "states of mind" on stage, Azari felt that they could be expressed in flight through the "absolute identification between the pilot and his airplane." Improvisation and the "rhythm of wish" were fundamental to this approach.

In his manifesto, Azari described an expressive vocabulary of maneuvers similar to the connotative human acrobatics of Constructivist staging: looping denoted "happiness," a long "dead-leaf" descent represented "nostalgia" or "tiredness," and so forth Although solo performances were possible in Azari's theatre, aerial "dialogues" and group performances were also proposed in the manifesto. Azari explained how the Futurist painters had agreed

to decorate the planes and how the discharge of "colored and perfumed dust, confetti, rockets, parachutes, puppets, varicolored balloons," and colored smoke would become part of the presentations, which would take place both in the daytime and, with the help of searchlights, at night. Azari explained that people might choose to pay an admission fee to sit in a grandstand where they could see the painted planes land and take off, but he felt that one of the most important aspects of his Aerial Theatre was the fact that it was a free performance for extremely large numbers of spectators.

Obviously influenced by Azari's ideas but more involved with story and incident than the flier-painter had been, Mario Scaparro wrote *A Birth* (*Un Parto*), published in *Roma Futurista* on February 1, 1920. Airplanes, anthropomorphically seen as having personalities, played the leading roles in Scaparro's aerial drama. In his manifesto, Azari had written how the Sva make of airplane was "evidently masculine, while a Henriot . . . has all the characteristics of femininity." *A Birth* showed the meeting between a "masculine" Albatross and a "female" seaplane. The third scene or "vision," which Scaparro tastefully leaves out of his script, finds the "two young airplanes" wrapped in a cloud where their intercourse is unseen. Unlike the "fantasies" of his "cinemagraphic poems," Scaparro seems to have considered the practical means for implementing his story. When a biplane flies out of the cloud, "one is very well aware that this other plane is only the seaplane pregnant," and she lands on a grassy meadow to "give birth" to four human performers: four completely equipped aviators who jump out of the plane to end the performance.

XIII] Summary and Conclusions

The Futurists were active in almost every area of performance. Except for the field of dance, they made important theoretical and practical contributions in each.

In drama, the Futurists compressed represented time and space and originated techniques of simultaneous staging in which two or more unrelated actions were presented at the same time. Stylistically, they developed in several directions, including the symbolic and subjective, the irrational and "absurd," and the formalistic. They wrote and presented plays that were antipsychological and antiliterary, and that made use of semi-alogical and alogical structures. They experimented with various psychological and physical relationships between the spectators and the performance, developments that involved both purposeful confrontation with the audience and acting in the auditorium as well as on the stage.

Futurist scenography was, to some extent, influenced by concepts that had already been clearly established by others. Their implementation of the ideas of Appia and Craig tended to be a continuation rather than a real extension and elaboration. But they did develop Craig's suggestions for kinetic scenography. They used light for its dynamic rather than its atmospheric qualities, and, both in practice and, more elaborately, in theory they developed the concept of the actorless abstract scenographic presentation. On the other hand, they worked extensively with the mechanization of the performer both in costuming and in acting style.

In *Vita Futurista*, the one motion picture they produced, the Futurists helped to establish the tradition of the independent film made noncommercially by artists for their own purposes. They made early use of unusual lenses, curved mirrors, and other means of achieving expression through visual distortion. Certain sections

152

of their film seem to have been imagistic rather than narrative in structure, and, by combining different unrelated scenes or segments of various styles, they produced a film based on an alogical progression through time: these developments helped to establish the basic principles of abstract cinema.

Futurist music made use of atonality and improvisation. It contributed to the development of the field in the twentieth century by opening musical composition to impure "nonmusical" sounds or "noise." The Futurists invented and produced their own musical instruments and developed new kinds of musical notation for their scores. Their work for radio was, in part, an extension of their music and made use of "found" sounds from everyday life, the amplification of sounds that could not ordinarily be heard by the human ear, and extended silences.

The presentations of the Futurists both broke down the distinction between performance forms by combining them and extended the concept of performance itself. Readings, visual displays, dance, sound effects, and representational actions were mixed at one moment of a production or followed each other in close sequence. Futurist Aerial Theatre used space on a gigantic scale and produced spectacles that could be seen simultaneously by huge numbers of people. At least in their writings, the Futurists added the perception of odor, temperature, and tactile quality to the sensory materials traditionally employed in theatre.

These developments had little effect on the mainstream of theatre that progressed in a generally realistic direction, and encompassed both stylization and naturalism. But Futurism did have a great influence on practically every nonrealistic approach to theatre. It stimulated Pirandello in Italy and Wilder in the United States. It influenced the Russian Futurists and, eventually, the Constructivists. It led directly to Dada in almost all its manifestations. It was an impetus to pre-Surrealists like Apollinaire, demi-Surrealists like Cocteau, Surrealism itself, and to the entire French avant-garde theatre. In Germany, it contributed to the development of the theatre of the Bauhaus in an entirely different direction.

One of the most important aspects of Futurism was its involve-

ment with all of the arts. The "Futurist Cinematography" manifesto spoke of how the Futurists would "break the limits of literature," extending the film art by "marching towards painting, music, the art of noise and throwing a marvelous bridge between words and real objects." And this was true of all of the arts and for each of the areas of performance. Each took what it could from the other, moving in that direction. Although Futurism had a clear personality and identity, it also produced aesthetic products of great diversity. Its theories and presentations in almost every area of performance were significant contributions to the history of the performance art.

Appendix

MANIFESTOS and PLAYSCRIPTS
translated from the Italian
by Victoria Nes Kirby

Appendix Contents

Manifestos

Playscripts *

* Dates are those of *publication*. The date given is the earliest one verified during preparation of this volume. It seems certain that some, and perhaps all, of the *sintesi* dated "1916" (published in the *"Teatro Futurista Sintetico"* supplement of *Gli Avvenimenti*, April 2–9, 1916) were first published in a 1915 collection, *Teatro Futurista* (Istituto Editoriale Italiano, Milan), but this source was not found. Dessy's *I Think It Would Be Correct To Do It This Way* and Fillia's *Mechanical Sensuality* were probably written and published somewhat earlier than 1927.

FRANCESCO BALILLA PRATELLA, Musician

Futurist Music

TECHNICAL MANIFESTO

(March 11, 1911)

All innovators have logically been Futurists in relation to their time. Palestrina would have judged Bach crazy, and thus Bach would have judged Beethoven, and thus Beethoven would have judged Wagner. Rossini boasted of having finally understood the music of Wagner by reading it in reverse! Verdi, after an audition of the overture of *Tannhäuser,* called Wagner *insane* in a letter to one of his friends!

We are, therefore, at the window of a glorious mental hospital, while we declare, without hesitation, that counterpoint and the fugue, still considered today as the most important branch of musical education, do not represent anything other than the ruins belonging to the history of polyphony, properly of that period that runs from the Flemish until J. S. Bach. In their place, harmonic polyphony, the rational fusion of counterpoint and harmony, will prevent the musician, once and for all, from splitting himself between two cultures: a trespasser on some other century, as well as part of his own contemporary culture; these being irreconcilable with each other because the products of the two are very different in manner of feeling and conception. The second, for logical reasons of progress and evolution, is already a remote and unattainable consequence of the first by having summarized, transformed, and surpassed it by a great distance.

Harmony, historically a matter of course in the melody—played subsequently according to diverse modes of the scale—was born when each sound of the melody was considered in relationship to the combinations of all the other sounds in the mode of the scale to which it belonged.

In such a manner, there developed an understanding that the

melody is an expressive synthesis of a harmonic succession. Today people cry and lament that the young musicians no longer know how to find melody, alluding, no doubt, to those of Rossini, Bellini, Verdi, and Ponchielli. . . . Instead, these musicians conceive of the melody harmonically; they hear harmony through different and more complex combinations and successions of sounds and then find new foundations for melodies.

Young musicians, once and for all, will stop being vile imitators of the past that no longer has a reason for existing and imitators of the venal flatterers of the public's base taste.

We Futurists proclaim that the diverse modes of old scales, the various sensations of *major, minor, augmented, diminished,* and also the very recent modes of scales for internal tones are none other than simple details of a unique harmonic and atonal mode of a chromatic scale. We declare, moreover, that the values of consonance and dissonance are nonexistent.

The Futurist melody will be embellished by the innumerable combinations and by the various relationships that derive from them. *This other melody will only be the synthesis of harmony,* similar to thousands of sea waves in unequal crests.

We Futurists proclaim as progress and as a victory of the future the chromatic atonal mode, the research and realization of the *enharmonic mode.* Whereas chromatism uniquely rewards us with all the sounds contained in a scale that is divided into minor and major semitones, enharmonic music, by using even smaller subdivisions of tones, will offer in addition the maximum number of interminable and combined sounds to our renewed sensibility. Enharmonic music will also permit the newest and most varied relations of chords and timbres.

But above all, *enharmonic music* renders the possibility of intonation and the natural and instinctive modulations of enharmonic intervals, which at present are not feasible, given the artificiality of our scale within the tempered system that we wish to overcome. For a long time we Futurists have loved these enharmonic intervals that we find only in the dissonance of an orchestra when the instruments play out of tune and in the spontaneous songs of the people when they are intoned without a knowledge of art.

The rhythm of dance: monotonous, limited, decrepit, and barbarous, will have to yield its rule of polyphony to a free polyrhythmic process and limit itself to remaining a characteristic detail of it.

Therefore, one must recognize that a relationship between even, uneven, and mixed tempos is possible just as the relationship between binary, ternary, ternary-binary, and binary-ternary rhythms is accepted. For example, one or more bars of uneven tempo placed in the middle or at the end of a musical phrase, which is either in even or mixed tempo or vice versa, cannot be considered wrong by using the ridiculous rules and fallacies of the so-called *quadratura* [continuous steady rhythm], the disgraceful umbrella of all the impotents who teach in the conservatories.

The technical knowledge of instrumentation must be conquered experimentally. The instrumental composition may be conceived by *imagining and hearing a particular orchestra for every particular and diverse musical condition of inspiration.*

All this will be possible when the conservatories, schools, and academies are deserted and closed and when the necessity of experience is finally provided for by giving a character of absolute freedom to musical studies. The masters of today, transformed into the experts of tomorrow, will be the guides and objective collaborators of the studious. They will cease from their unconscious corruption of budding geniuses that they have caused by suppressing them with their own personalities and by imposing their own errors and criteria on them.

For man the absolute truth is in what he feels as a human being. The artist, by purely interpreting nature, makes nature human.

Sky, water, forests, rivers, mountains, the entanglements of ships, and swarming cities are transformed through the soul of the musician into marvelous and powerful voices that humanly sing the passions and the desires of man, his joy and his sorrows, and they are revealed to him by virtue of art as the common and indissoluble bond that binds him to all the rest of nature.

The musical forms are none other than an aspect and a fragment of a unique and complete whole. Every form exists in relation to the potentiality of expression, to the development of a passionate and generated motive, and to the sensibility and intuition of the

artistic creator. Rhetoric and pompousness, proceeding from a disproportion between the passionate motive and its explanatory form, produce, for the most part, cases influenced and blinded by traditions, culture, environment, and often by cerebral limitations.

The only passionate motive imposed on the musician is his own formal and synthetic explanation, since synthesis is the cardinal property of expression of musical aesthetics.

The contrast of several passionate motives and the relationship between their potential of expansion and development constitute symphony.

The Futurist symphony considers as its maximum forms: *the symphonic, orchestral, and vocal poem, and the theatrical opera.*

The pure symphonist, drawing from his passionate motives, developments, contrasts, lines, and forms, with ample and free imagination, must not conform to any criterion that is not a result of his artistic sense of equilibrium and proportion, but he must find his goal in the complex of expressive means and proper aesthetics of pure musical art. This sense of Futurist equilibrium is nothing more than the attainment of maximum intensity of expression.

The opera composer, in contrast, attracts all the reflections of other arts into his orbit of inspiration and musical aesthetics—in powerful competition with the multiplication of expressive and communicative effectiveness. The opera composer must conceive these other secondary elements as being controlled by his inspiration and musical aesthetics.

The human voice, also being a maximum means of expression because it is ours and comes from us, will be surrounded by the orchestra, sonorous atmosphere full of all the voices of nature, rendered through art.

The vision of a poem written as a scenario leaps to the imagination of the artistic creator to meet his particular necessity, emerging from a wish to explain the generated and inspired passionate motives. The dramatic or tragic poem will not be able to be conceived with the music if it is not the result of a musical state of inspiration and a unique vision of musical aesthetics. The opera composer, creating rhythms in connection with the words, already creates musically and is the only author of his own opera. By writing music for the poetry

of others, instead, he stupidly renounces his particular fountain of original inspiration, his musical aesthetics, and takes the rhythmic part of his melody from others.

Free verse is the only suitable one, not being bound by the limitations of rhythm and of accents monotonously repeated in restricted and insufficient formulas. The polyphonic wave of human poetry finds every rhythm, every accent, and every mode in free verse. These are necessary for the exuberant expression of itself as in a charming symphony of words. Such freedom of rhythmic expression is certainly Futurist music.

Man and the multitudes of men on the stage must no longer imitate common speech phonically but must sing, as when we, unconscious of the place and the work, seized by a deep wish to expand and to dominate, burst out instinctively in essential and charming human language: natural, spontaneous song, without the music of rhythm or of intervals, artificial limitations of expressions that sometimes make us regret the efficiency of words.

We conclude:

1. It is necessary to conceive of melody as a "synthesis of harmony," considering the harmonic definitions of major, minor, augmented, and diminished as simple details of a unique chromatic atonal mode.

2. Consider enharmonic music as a magnificent conquest by Futurism.

3. Crush the domination of dance rhythm, considering this rhythm as a detail of free rhythm, just as the hendecasyllable can be a detail of the strophe in free verse.

4. Create polyphony in an absolute sense by fusing harmony and counterpoint; never tried until today.

5. Take possession of all the expressive, technical, and dynamic values of the orchestra, and consider instrumentation as an aspect of universal sound that is incessantly mobile and that constitutes a unique whole through the fusion of all its parts.

6. Consider musical form consistent and dependent on generated passionate motives.

7. Do not mistake the usual traditional dead and buried schemes of symphony for symphonic form.

8. Conceive of theatrical opera as a symphonic form.

9. Proclaim that the musician must be the author of dramatic or tragic poems for his music. The symbolic action of the poem must leap to the imagination of the musician, urged by his wish to explain passionate motives. The written verses of others require the musician to accept the rhythm for his own music from others.

10. Recognize free verse as the only way to arrive at a criterion of polyrhythmic freedom.

11. Contain in music all the new attitudes of nature that are always tamed by man in different ways by virtue of his incessant scientific discoveries. Give musical animation to crowds, great industrial shipyards, trains, transatlantic steamers, battleships, automobiles, and airplanes. Add the domination of the machine and the victorious reign of Electricity to the great central motive of a musical poem.

LUIGI RUSSOLO, Painter

The Art of Noise

(*Milan, March 11, 1913*)

DEAR BALILLA PRATELLA, great Futurist musician,

In Rome, in the very crowded Teatro Costanzi while with my Futurist friends Marinetti, Boccioni, Carrà, Balla, Soffici, Papini, Cavocchioli, I listened to the orchestral execution of your forcible FUTURIST MUSIC, I conceived of a new art that only you can create: the Art of Noise, the logical consequence of your marvelous innovations.

In antiquity there was only silence. In the nineteenth century, with the invention of the machine, Noise was born. Today, Noise triumphs and reigns supreme over the sensibility of men. For many centuries life occurred in silence, or, for the most part, mutely. The strongest noises that interrupted this silence were neither intense, nor prolonged, nor varied. In fact, except for exceptional telluric movements, hurricanes, tempests, avalanches, and cascades, nature is silent.

In this scarcity of *noise*, the first *sounds* which man was able to draw from a reed hole or from a stretched string astonished him as new and admirable things. *Sound* was attributed to God by primitive people; it was considered sacred and was reserved for the priests, whom it served by enriching their rites with mystery. Thus was born the concept of sound as something by itself, different from and independent of life. The result of this was music, a fantastic world superimposed upon reality, an inviolable and sacred world. It is easily understood how such a conception of music must have necessarily slowed down its progress in comparison to the other arts. The Greeks with their mathematically systematic music theory of Pythagoras, according to which the use of only some consonant intervals were admitted, have greatly limited the field of music, thus rendering harmony, which they ignored, impossible.

In the Middle Ages musical art progressed through the develop-

166

ment and modification of the Greek tetrachord system and through Gregorian chant and popular songs. But people still considered sound *in its unfolding in time,* a restricted conception that persisted for several centuries and that we still find in the more complicated polyphonies of the Flemish counterpoint musicians. *Harmony* did not exist; the development of diverse parts was not subordinate to the harmony that these parts could produce together; the conception of these parts was horizontal, after all, not vertical. The desire, research, and taste for the simultaneous union of diverse sounds, in other words, for *harmony* (complete sound) came gradually, passing from the perfect assonant harmony with some dissonant passages, to the complicated and persistent dissonance that characterizes contemporary music.

Musical art, first of all, looked for and obtained purity, limpidness, and sweetness of sound, then it amalgamated different sounds, occupying itself, however, with caressing the ear with suave harmonies. Today, musical art, complicating itself still more, searches for the amalgamation of sounds more dissonant, strange, and harsh to the ear. Thus, we are always getting closer to "noise-sound."

THIS EVOLUTION OF MUSIC IS PARALLELED BY THE MULTIPLICATION OF THE MACHINE, which collaborates with man everywhere. Today, the machine has created many varieties and a competition of noises, not only in the noisy atmosphere of the large cities but also in the country that, until yesterday, was normally silent, so that pure sound, in its monotony and exiguity, no longer arouses emotion.

To excite and exalt our sensibility, music has developed a more complex polyphony and a greater variety of instrumental timbres and colorings. It has researched more complicated successions of dissonant chords and has vaguely prepared for the creation of MUSICAL NOISE. This evolution toward "noise-sound" was not possible before today. Man's ear in the eighteenth century was not able to support the disharmonic intensity of certain chords produced by our orchestra (whose performers are three times as numerous); now our ears enjoy it, for they are already educated to modern life, which is full of various noises. Our ears, however, are not content with them and ask for more ample acoustic emotions.

On the other hand, musical sound is too limited in the qualitative variety of its timbres. The most complicated orchestra can be reduced to four or five classes of instruments different in timbre and sound: string instruments, brass instruments, woodwinds, and percussion. As a result, modern music struggles in this small circle, vainly trying to create new varieties of timbres.

IT IS NECESSARY TO BREAK THIS RESTRICTED CIRCLE OF PURE SOUNDS AND CONQUER THE INFINITE VARIETY OF "NOISE-SOUNDS."

Everyone knows, moreover, that each pure sound carries with it a tangle of foreknown and worn-out sensations that predispose the auditor to boredom in spite of the power of all the innovating musicians. We Futurists have all profoundly loved and enjoyed the harmonies of the great masters. Beethoven and Wagner have shaken our nerves and hearts for many years. Now we are satiated by them, and WE TAKE GREATER PLEASURE IN IDEALLY COMBINING THE NOISES OF TRAMS, EXPLOSIONS OF MOTORS, TRAINS, AND SHOUTING CROWDS THAN IN LISTENING AGAIN, FOR EXAMPLE, TO THE "EROICA" OR THE "PASTORALE."

We are unable to see the enormous display of force that a modern orchestra represents without feeling the most profound disillusionment with its weak acoustical results. Do you know of a more ridiculous spectacle than twenty men who persist in redoubling the mewing of a violin? All this will naturally make the music maniacs scream, which will perhaps arouse the sleepy atmosphere of the concert halls.

Shall we enter together, as Futurists, into one of these hospitals for anemic sounds. See here: the first bar that reaches our ears is boring from being heard already and gives us a foretaste of the boredom of the bar that will follow. In this way, we sip from bar to bar two or three kinds of undiluted boredom while always waiting for the extraordinary sensation that never comes. Meanwhile, we see a repugnant mixture being formed by the monotony of sensations and by the stupid religious emotions of the Buddhist-like listeners who are intoxicated by the thousandth repetition of their ecstasy, which is

more or less snobbish and learned. Away! Let's leave, since we can no longer restrain our desire finally to create a new musical reality with an ample distribution of sonorous musical slaps, altogether skipping the violins, pianos, contrabasses, and moaning organs. Let's leave!

Some will argue that noise is only loud and unpleasant to the ear. It seems useless to me to enumerate all the tenuous and delicate noises that give pleasant acoustic sensations.

To convince you then of the surprising variety of noises, it is enough to think of the roar of thunder, the hissing of the wind, the thunder of a waterfall, the gurgle of a brook, the rustle of leaves, a horse's trot that fades away, the shaky starts of a carriage on the pavement, and the ample, solemn, and white respiration of a city at night, all the noises made by wild and domestic animals and all those that man's mouth can make without talking or singing.

Let's walk through a large modern capital with our ear more attentive than our eye and find pleasure in distinguishing between the gurglings of water, air, and gas inside metallic pipes, the grumbling of motors that breathe and pulse with an indisputable animality, the throbbing of valves, the rising and falling of pistons, the screeching of mechanical saws, the jumping of trams on their rails, the cracking of whips, the waving of awnings and flags. We shall amuse ourselves by ideally orchestrating together the rattle of a store's rolling shutters, banging doors, the hubbub and patter of the crowds, the different rackets of the railroad stations, of the textile mills, of the printers, of the electrical plants, and of the subways.

Nor must we forget the very new noises of modern warfare. Recently the poet Marinetti, in one of his letters from the Bulgarian trenches at Adrianople, described to me the orchestra of a great battle using marvelous *parole in libertà:*

> Every five seconds siege cannons disembowel space by a chord TAM-TUUUMB mutiny of 500 echoes to gore it mince it scatter it to infinity. In the center of these crushed TAM-TUUUMBS width 50 kilometers square jump explosions fissures fists rapid-fire batteries Violence ferocity regularity this grave bass scans the strange very very agitated crowds high notes of the battle Fury breathless-

ness ears eyes nostrils open! Beware! Strength! what joy to see to hear to smell everything everything taratatatata of the machine gunners to shriek breathlessly under bits slaps traak-traak lashes pic-pac-pam-tumb bizarre leaps to 200 meters high by rifle shots Below below at the bottom of the orchestra pools to whip buffalo spurs trucks pluff plaff horses rearing up flic flac zing zing sciaaaack hilarious whinnies iiiiiii pattering tinkling 3 Bulgarian battalions marching croooc-craaac (*very slowly*) Sciumi Maritza or Karvavena croooc-craaac officer's shouts striking like copper plates against each other pan from here paack from there cing BUUUM cing ciak (*quickly*) ciaciacia ciaiaak over here there there all around above look out for your head ciaack beautiful! flames flames flames flames flames flames leap from forts over there behind that river Sciukri Pasha communicates by telephone to 27 forts in Turkish in German hello! Ibraim! Rudolf! hello! hello! actors roles echoes prompters scenery of smoke forests applause odors of hay mire dung I can no longer feel my frozen feet odor of saltpeter rotten odor Timpani flutes clarinets are everywhere low high birds twitter beatitude share cip-cip-cip breeze greenness herds don-dan-don-din neeee Orchestra Madmen are hitting orchestra professors they very beaten play play great crashing noises not erasing stressing cutting off tiny noises very tiny fragments of echoes in the wide theatre 300 kilometers square rivers Maritza Tundzha stretched out Rhodope Mountains standing highground boxes logges 20,000 shrapnel flailing about exploding very white handkerchiefs full of gold TUM-TUMB 20,000 grenades outstretched pulling very black hairs bursting ZANG-TUMB-TUMB-ZANG-TUMB-TUUUMB the orchestra of warfare noise enjoys itself under a note of silence hanging in the sky above spherical golden balloons that oversee the shots

WE WANT TO SCORE AND REGULATE HARMONICALLY AND RHYTHMICALLY THESE EXTREMELY VARIED NOISES. In scoring the noises, we shall not subtract all the movements and irregular vibrations of tempo and intensity from them, but, on the contrary, we shall give a position and tone to the most dominant and the strongest of these vibrations. Noise, in fact, is different from sound only in that the vibrations that produce it are confused and irregular in tempo and intensity. EVERY NOISE HAS A TONE,

SOMETIMES EVEN A CHORD, THAT DOMINATES OVER THE WHOLE OF ITS IRREGULAR VIBRATIONS. Now, the existence of this predominant characteristic tone gives us the practical possibility of scoring noises, that is to say, of giving to a noise not only one tone but a certain variety of tones without losing its characteristic —in other words, the timbre that distinguishes it. Thus certain noises obtained through a rotating movement can give us a complete ascending or descending chromatic scale by speeding up or slowing down the movement.

Every manifestation of our life is accompanied by noise. Noise is, therefore, familiar to our ear and has the power to recall us immediately to life. Whereas sound, foreign to life, always musical, a thing by itself, an occasional element that is not necessary, has come by now to strike our ears no more than an overly familiar face does our eye. Noise, instead, coming confusedly and irregularly from the irregular confusion of our life, is never totally revealed to us and keeps innumerable surprises for us. We are certain, therefore, that in choosing, coordinating, and dominating all noises, we are enriching mankind with a new unsuspected voluptuousness. Although the characteristic of noise is to bring us brutally back to life, THE ART OF NOISE MUST NOT LIMIT ITSELF TO IMITATIVE REPRODUCTION. It will draw most of its emotive power from the special acoustical enjoyment that the inspired artist will get from combining the noises.

Here are six "families of noises" of the Futurist orchestra that we shall soon achieve mechanically:

1. Roars
 Thunders
 Explosions
 Bursts
 Crashes
 Booms

2. Whistles
 Hisses
 Puffs

3. Whispers
 Murmurs
 Grumbles
 Buzzes
 Bubblings

4. Screeches
 Creaks
 Rustles
 Hums
 Crackles
 Rubs

5. Percussion noises using:
 metal, wood, skin, rock, terra-cotta, etc.

6. Voices of animals and humans:
 Shouts, Shrieks, Moans, Yells, Howls, Laughs,
 Groans, Sobs.

In this list we have included the most characteristic of fundamental noises; the others are only associations and combinations of these. THE RHYTHMIC MOVEMENTS OF A NOISE ARE INFINITE. A PREDOMINANT RHYTHM ALWAYS EXISTS, AS DOES A TONE, but around them numerous other secondary rhythms are equally perceptible.

CONCLUSIONS

1. Futurist musicians must always enlarge and enrich the field of sounds more. That is, they must respond to the need of our sensibilities. In fact, we notice that in the contemporary composers of genius there is a tendency toward the most complicated dissonances. They always move away from pure sound toward "noise-sound." This need and this tendency can only be satisfied by *joining and substituting noises to and for musical sounds.*

2. Futurist musicians must replace the limited variety of timbres of the instruments that the orchestra possesses today with an in-

finite variety of timbres of noises, reproduced with proper mechanisms.

3. It is necessary for the musician's sensibility, liberated from the easy and traditional rhythms, to find in noises the means to increase and renew itself, since each noise offers the union of the most diverse rhythms as well as its dominant one.

4. Every noise possesses among its irregular vibrations A PREDOMINANT GENERAL TONE. This will be easy to obtain by constructing instruments that imitate a variety of sufficiently wide tones, semitones, and quarter-tones. This variety of tones will not deprive each noise of its characteristic timbre, but rather increase its texture or range.

5. The practical difficulties presented by the construction of these instruments are not grave. When we have found the mechanical principles that produce a certain noise, we shall be able to change the tone, regulating it by the same general laws of acoustics. For example, we shall speed up or slow down the velocity if the instrument has a rotating movement, or increase or decrease the size or the tension of the sound-making parts if the instrument does not have a rotating movement.

6. The new orchestra will obtain the most complete and the newest sonic emotions, not by means of a succession of noises that imitate life, but by means of a fantastic association of these various timbres and rhythms. Therefore, every instrument must offer the possibility of changing pitch and must have a more or less large range of extension.

7. The variety of noises is infinite. If today we perhaps possess a thousand diverse machines and we are able to distinguish a thousand diverse noises, tomorrow, with the multiplication of new machines, we shall be able to distinguish ten, twenty, or THIRTY-THOUSAND DIVERSE NOISES, NOT BY SIMPLE IMITATION BUT BY COMBINATION ACCORDING TO OUR IMAGINATION.

8. We, therefore, invite young musicians of genius and audacity to observe all noises with continual attention in order to understand their various rhythms, their principal and secondary tones. Then, by comparing the various timbres of the noises and timbres of sounds, they will convince themselves that the first are more numerous than

the second. This will not only give them comprehension of, but also a taste and passion for, noise. Our multiplied sensibility, after being conquered by Futurist eyes, will finally have Futurist ears. Thus motors and machines of our industrial cities will one day be skillfully tuned in order to make every factory an intoxicated orchestra of noises.

Dear Pratella, I submit to your Futurist genius these new ideas of mine, inviting you to discuss them. I am not a musician; I, therefore, do not have acoustic predilections or works to defend. I am a Futurist painter who projects beyond himself on a much-loved art his own wish to renew everything. That is why, being bolder than if I were a professional musician, unpreoccupied by my apparent incompetence and convinced that audacity has all rights and all possibilities, I have been able to perceive by intuition the great renovation of music through the **Art of Noise.**

LUIGI RUSSOLO

The Futurist *Intonarumori*

(May 22, 1913)

On June 2, [1913 [1]] at a Futurist evening in Modena before 2,000 people who overcrowded the Teatro Stocchi, I explained and demonstrated one of the first *intonarumori* instruments invented and constructed by me in collaboration with the painter, Ugo Piatti. The perfect function of this apparatus or instrument (that has the special name of exploder), reproducing by a series of 10 whole tones the characteristic noise of a motor starting up, provoked violent enthusiasm and at the same time—like everything about our forceful movement—infinite discussions, and, naturally, bursts of imbecile or superficial laughter.

After having read numerous and diverse comments about the "Art of Noise" (March 11, 1913) that have been published principally by foreign newspapers—from *Temps* to *Matin*, from *Berliner Tageblatt* to *Neues Wiener*, from the *Daily Chronicle* to the *Evening Standard*—I was persuaded that all these newspapers have not understood in its essence, however clearly enunciated, the intuitive principle of that manifesto, and what should have been the practical realization that must have been logically derived from the principle.

Several—the major part—have imagined only a cacophony as a practical result; a deafening and disorderly medley of noise without sense or any logic; others have imagined a simple imitative or impressionistic intention to copy the noises of life. Lastly, others have seen in that manifesto only the desire to launch sentences and snobbish theories to amaze the good bourgeoisie.

All this, naturally, did not discourage me and it also did not hide from me the many and grave difficulties that must be overcome

[1] The fact that the event discussed occurred *after* the official date of the article (published in *Lacerba* on July 1, 1913) is another indication of the casualness with which the Futurists dated their writings.—Ed.

in order to arrive at a practical realization of the manifesto. I continued to work and to do research on the subject.

If from afar I heard and still hear laughter, jokes, or expressions of incredulity about my idea, near me, instead, I have had and have among my old and new Futurist brothers an atmosphere of rousing enthusiasm.

I will point, first of all, to the enthusiasm and to the inexhaustible young faith of that great animator who is my dear and great friend, Marinetti, who is still vibrating from the great acoustic emotion of his experience assisting in the siege of Adrianople.

In my long and patient laboratory research I have had and I have a faithful companion, an ingenious and untiring researcher, the painter Ugo Piatti.

What I said in the manifesto, "We want to intone and regulate harmonically and rhythmically these extremely varied noises," is today a reality, and the instruments that realized the "intoned noises" are, by now, incessantly multiplying them.

Without going into the particular techniques, I shall briefly point out the practical results already obtained and those that are deemed to be possible in a short time by already completed studies.

Acoustics has taught us very little, since, having been applied to the study of pure sounds until now, it has almost completely neglected the study of noise.

Except for several general laws on sounds that also serve in part for noise, acoustics had to proceed almost uniquely by means of continual and repeated experiments.

Above all, it was necessary for practicability for these *intonarumori* instruments to be of the greatest simplicity possible and it is this, exactly, that we have succeeded in perfectly.

It is enough to say that a single taut diaphragm suitably placed gives, by variation of its tension, a gamut of more than 10 whole tones, with all the passages of semitones, of quarter-tones and also smaller fractions of tones.

The preparation of the material for this diaphragm by means of special chemical baths varies according to the timbre of noise that one wishes to obtain. Then, by varying the means of excitation of the

same diaphragm, one also can obtain a different noise, *in type and in timbre,* always preserving, naturally, the possibility of varying the *tone.* There are four different means of excitation used before now and the corresponding instruments have already been completed.

The first gives the sound of *exploding,* automobile-motor type; the second gives a *crackling* sound, the fusillade type; the third gives a *humming* sound, the dynamic type; the fourth gives the sound of different varieties of *rubbing.*

In these instruments it is enough that the simple shifting of a graduated lever gives the tone of noise that one wants, also its smallest fraction. The rhythm of every single noise can also be equally regulated, so one can easily calculate in bars the even and uneven tempos that exist.

These instruments, because of their extreme simplicity, are already perfect enough so that they need only small modifications of a secondary nature.

The research to obtain noises (always, it is well understood, tunable) of the first series listed in the manifesto is now already complete: the "Roars," "Thunders," and the "Bursts"; of the second series: the "Hisses"; of the third: the "Bubblings"; of the fourth: the "Screeches" and the "Rustles." The relative instruments for these noises are already in execution: the "Roarer," "Thunderer," "Burster," and the "Bubbler."

And now I shall say some words about the effects that noises thus intoned produce on those who listen.

As I pointed out in the manifesto, noise that comes from life we immediately restore to the same life (contrary to that which makes the sound) reminiscing quickly in our minds about the things that produce the determined noise that we hear. The restoration to life has, therefore, a character of an impressionistic fragmented episode of the same life. But as in every art, and thus also in the Art of Noise, we must not limit ourselves to an impressionistic fragmented reproduction of life.

Noise must become a primary element in shaping the work of art. That is, it must lose its own accidental character in order to become an element sufficiently abstract so that it can reach the neces-

sary transfiguration of every primary element in the abstract material of art.

Well then, although the resemblance of timbre to imitated natural noise is attained in these instruments, almost to the point of misleading, nevertheless, as soon as one hears that noise varies in tone, one becomes aware that it quickly loses its episodic, uniquely imitative character. It loses, that is, all its character of *result* and *effect,* tied to *causes* that produce it (motor energy, percussions, rubbings produced by speed, clashes, etc.) and that are due to and inherent in the same purpose of the machine or of some other thing that produces the noise.

It loses this character of *effect* by transforming itself into *element* and into *primary material.*

And when noise is thus liberated from the things that produce it we dominate it, transforming it into our desired tone, intensity, and rhythm; we hear noise quickly become automatic material, malleable, ready to be shaped by the wishes of the artist who transforms it into an element of emotion, into a work of art.

And it is thus that choosing, dominating, and coordinating noises, we have already in part reached that new unexpected *delight* of which we spoke in the manifesto "The Art of Noise."

FILIPPO TOMMASO MARINETTI

The Variety Theatre*

(September 29, 1913)

We are deeply disgusted with the contemporary theatre (verse, prose, and musical) because it vacillates stupidly between historical reconstruction (pastiche or plagiarism) and photographic reproduction of our daily life; a finicking, slow, analytic, and diluted theatre worthy, all in all, of the age of the oil lamp.

FUTURISM EXALTS THE VARIETY THEATRE because:

1. The Variety Theatre, born as we are from electricity, is lucky in having no tradition, no masters, no dogma, and it is fed by swift actuality.

2. The Variety Theatre is absolutely practical, because it proposes to distract and amuse the public with comic effects, erotic stimulation, or imaginative astonishment.

3. The authors, actors, and technicians of the Variety Theatre have only one reason for existing and triumphing: incessantly to invent new elements of astonishment. Hence the absolute impossibility of arresting or repeating oneself, hence an excited competition of brains and muscles to conquer the various records of agility, speed, force, complication, and elegance.

4. The Variety Theatre is unique today in its use of the cinema, which enriches it with an incalculable number of visions and otherwise unrealizable spectacles (battles, riots, horse races, automobile and airplane meets, trips, voyages, depths of the city, the countryside, oceans, and skies).

5. The Variety Theatre, being a profitable show window for

* Translated by R. W. Flint. Published by permission of Farrar, Straus & Giroux, Inc. and the heirs of Filippo Tommaso Marinetti. From *Selected Works of Filippo Tommaso Marinetti* to be published in 1972 by Farrar, Straus & Giroux, Inc.

countless inventive forces, naturally generates what I call "the futurist marvelous," produced by modern mechanics. Here are some of the elements of this "marvelous": (*a*) powerful caricatures; (*b*) abysses of the ridiculous; (*c*) delicious, impalpable ironies; (*d*) all-embracing, definitive symbols; (*e*) cascades of uncontrollable hilarity; (*f*) profound analogies between humanity, the animal, vegetable, and mechanical worlds; (*g*) flashes of revealing cynicism; (*h*) plots full of the wit, repartee, and conundrums that aerate the intelligence; (*i*) the whole gamut of laughter and smiles, to flex the nerves; (*j*) the whole gamut of stupidity, imbecility, doltishness, and absurdity, insensibly pushing the intelligence to the very border of madness; (*k*) all the new significations of light, sound, noise, and language, with their mysterious and inexplicable extensions into the least-explored part of our sensibility; (*l*) a cumulus of events unfolded at great speed, of stage characters pushed from right to left in two minutes ("and now let's have a look at the Balkans": King Nicolas, Enver-Bey, Daneff, Venizelos, belly-blows and fistfights between Serbs and Bulgars, a *couplet,* and everything vanishes); (*m*) instructive satirical pantomimes; (*n*) caricatures of suffering and nostalgia, strongly impressed on the sensibility through gestures exasperating in their spasmodic, hesitant, weary slowness; grave words made ridiculous by funny gestures, bizarre disguises, mutilated words, ugly faces, pratfalls.

6. Today the Variety Theatre is the crucible in which the elements of an emergent new sensibility are seething. Here you find an ironic decomposition of all the worn-out prototypes of the Beautiful, the Grand, the Solemn, the Religious, the Ferocious, the Seductive, and the Terrifying, and also the abstract elaboration of the new prototypes that will succeed these.

The Variety Theatre is thus the synthesis of everything that humanity has up to now refined in its nerves to divert itself by laughing at material and moral grief; it is also the bubbling fusion of all the laughter, all the smiles, all the mocking grins, all the contortions and grimaces of future humanity. Here you sample the joy that will shake men for another century, their poetry, painting, philosophy, and the leaps of their architecture.

7. The Variety Theatre offers the healthiest of all spectacles in

its dynamism of form and color (simultaneous movement of jugglers, ballerinas, gymnasts, colorful riding masters, spiral cyclones of dancers spinning on the points of their feet). In its swift, overpowering dance rhythms the Variety Theatre forcibly drags the slowest souls out of their torpor and forces them to run and jump.

8. The Variety Theatre is alone in seeking the audience's collaboration. It doesn't remain static like a stupid *voyeur*, but joins noisily in the action, in the singing, accompanying the orchestra, communicating with the actors in surprising actions and bizarre dialogues. And the actors bicker clownishly with the musicians.

The Variety Theatre uses the smoke of cigars and cigarettes to join the atmosphere of the theatre to that of the stage. And because the audience cooperates in this way with the actors' fantasy, the action develops simultaneously on the stage, in the boxes, and in the orchestra. It continues to the end of the performance, among the battalions of fans, the honeyed dandies who crowd the stage door to fight over the *star*; double final victory: chic dinner and bed.

9. The Variety Theatre is a school of sincerity for man because it exalts his rapacious instincts and snatches every veil from woman, all the phrases, all the sighs, all the romantic sobs that mask and deform her. On the other hand it brings to light all woman's marvelous animal qualities, her grasp, her powers of seduction, her faithlessness, and her resistance.

10. The Variety Theatre is a school of heroism in the difficulty of setting records and conquering resistances, and it creates on the stage the strong, sane atmosphere of danger. (E.g., death-diving, "Looping the loop" on bicycles, in cars, and on horseback.)

11. The Variety Theatre is a school of subtlety, complication, and mental synthesis, in its clowns, magicians, mind readers, brilliant calculators, writers of skits, imitators and parodists, its musical jugglers and eccentric Americans, its fantastic pregnancies that give birth to objects and weird mechanisms.

12. The Variety Theatre is the only school that one can recommend to adolescents and to talented young men, because it explains, quickly and incisively, the most abstruse problems and most complicated political events. Example: A year ago at the Folies-Bergère, two dancers were acting out the meandering discussions between

Cambon and Kinderlen-Watcher on the question of Morocco and the Congo in a revealing symbolic dance that was equivalent to at least three years' study of foreign affairs. Facing the audience, their arms entwined, glued together, they kept making mutual territorial concessions, jumping back and forth, to left and right, never separating, neither of them ever losing sight of his goal, which was to become more and more entangled. They gave an impression of extreme courtesy, of skillful, flawlessly diplomatic vacillation, ferocity, diffidence, stubbornness, meticulousness.

Furthermore the Variety Theatre luminously explains the governing laws of life:

 a) the necessity of complication and varying rhythms;

 b) the fatality of the lie and the contradiction (e.g., two-faced English *danseuses*: little shepherd girl and fearful soldier);

 c) the omnipotence of a methodical will that modifies human powers;

 d) a synthesis of speed + transformations.

13. The Variety Theatre systematically disparages ideal love and its romantic obsession that repeats the nostalgic languors of passion to satiety, with the robot-like monotony of a daily profession. It whimsically mechanizes sentiment, disparages and healthily tramples down the compulsion toward carnal possession, lowers lust to the natural function of coitus, deprives it of every mystery, every crippling anxiety, every unhealthy idealism.

Instead, the Variety Theatre gives a feeling and a taste for easy, light and ironic loves. Café-concert performances in the open air on the terraces of casinos offer a most amusing battle between spasmodic moonlight, tormented by infinite desperations, and the electric light that bounces off the fake jewelry, painted flesh, multicolored petticoats, velvets, tinsel, the counterfeit color of lips. Naturally the energetic electric light triumphs and the soft decadent moonlight is defeated.

14. The Variety Theatre is naturally anti-academic, primitive, and naïve, hence the more significant for the unexpectedness of its discoveries and the simplicity of its means. (E.g., the systematic tour of the stage that the *chanteuses* make, like caged animals, at the end of every *couplet*.)

15. The Variety Theatre destroys the Solemn, the Sacred, the Serious, and the Sublime in Art with a capital *A*. It cooperates in the Futurist destruction of immortal masterworks, plagiarizing them, parodying them, making them look commonplace by stripping them of their solemn apparatus as if they were mere *attractions*. So we unconditionally endorse the performance of *Parsifal* in forty minutes, now in rehearsal in a great London music hall.

16. The Variety Theatre destroys all our conceptions of perspective, proportion, time, and space. (E.g., a little doorway and gate, thirty centimeters high, alone in the middle of the stage, which certain eccentric Americans open and close as they pass and repass, very seriously as if they couldn't do otherwise.)

17. The Variety Theatre offers us all the records so far attained: the greatest speed and the finest gymnastics and acrobatics of the Japanese, the greatest muscular frenzy of the Negroes, the greatest development of animal intelligence (horses, elephants, seals, dogs, trained birds), the finest melodic inspiration of the Gulf of Naples and the Russian steppes, the best Parisian wit, the greatest competitive force of different races (boxing and wrestling), the greatest anatomical monstrosity, the greatest female beauty.

18. The conventional theatre exalts the inner life, professorial meditation, libraries, museums, monotonous crises of conscience, stupid analyses of feelings, in other words (dirty thing and dirty word), *psychology*, whereas, on the other hand, the Variety Theatre exalts action, heroism, life in the open air, dexterity, the authority of instinct and intuition. To psychology it opposes what I call "body-madness" (*fisicofollia*).

19. Finally, the Variety Theatre offers to every country (like Italy) that has no great single capital city a brilliant résumé of Paris considered as the one magnetic center of luxury and ultrarefined pleasure.

FUTURISM WANTS TO TRANSFORM THE VARIETY THEATRE INTO A THEATRE OF AMAZEMENT, RECORD-SETTING, AND BODY-MADNESS.

1. One must completely destroy all logic in Variety Theatre performances, exaggerate their luxuriousness in strange ways, mul-

tiply contrasts and make the absurd and the unlifelike complete masters of the stage. (Example: Oblige the *chanteuses* to dye their décolletage, their arms and especially their hair, in all the colors hitherto neglected as means of seduction. Green hair, violet arms, blue décolletage, orange chignon, etc. Interrupt a song and continue with a revolutionary speech. Spew out a *romanza* of insults and profanity, etc.

2. Prevent a set of traditions from establishing itself in the Variety Theatre. Therefore oppose and abolish the stupid Parisian "Revues," as tedious as Greek tragedy with their *Compère* and *Commère* playing the part of the ancient chorus, their parade of political personalities and events set off by wisecracks in a most irritating logical sequence. The Variety Theatre, in fact, must not be what it unfortunately still is today, nearly always a more or less amusing newspaper.

3. Introduce surprise and the need to move among the spectators of the orchestra, boxes, and balcony. Some random suggestions: spread a powerful glue on some of the seats, so that the male or female spectator will stay glued down and make everyone laugh (the damaged frock coat or toilette will naturally be paid for at the door).—Sell the same ticket to ten people: traffic jam, bickering, and wrangling.—Offer free tickets to gentlemen or ladies who are notoriously unbalanced, irritable, or eccentric and likely to provoke uproars with obscene gestures, pinching women, or other freakishness. Sprinkle the seats with dust to make people itch and sneeze, etc.

4. Systematically prostitute all of classic art on the stage, performing for example all the Greek, French, and Italian tragedies, condensed and comically mixed up, in a single evening.—Put life into the works of Beethoven, Wagner, Bach, Bellini, Chopin, introducing them with Neapolitan songs.—Put Duse, Sarah Bernhardt, Zacconi,[1] Mayol,[2] and Fregoli[3] side by side on the stage.—Play a Beethoven symphony backwards, beginning with the last note.—Boil all of Shakespeare down to a single act.—Do the same with all the most venerated actors.—Have actors recite *Hernani* tied in sacks up

[1] Ermele Zacconi, famous Italian actor (tragedian).—Ed.

[2] Felix Mayol, French café-concert and music hall singer.—Ed.

[3] Leopoldo Fregoli, famous transformist in the variety theatre.—Ed.

to their necks. Soap the floorboards to cause amusing tumbles at the most tragic moments.

5. In every way encourage the *type* of the eccentric American, the impression he gives of exciting grotesquerie, of frightening dynamism; his crude jokes, his enormous brutalities, his trick weskits and pants as deep as a ship's hold out of which, with a thousand other things, will come the great Futurist hilarity that should make the world's face young again.

Because, and don't forget it, we Futurists are YOUNG ARTIL-LERYMEN ON A TOOT, as we proclaimed in our manifesto, "Let's Murder the Moonlight," fire + fire + light against moonlight and against old firmaments war every night great cities to blaze with electric signs Immense black face (30 meters high + 150 meters height of the building = 180 meters) open close open close a golden eye 3 meters high SMOKE SMOKE MANOLI SMOKE MANOLI CIGARETTES woman in a blouse (50 meters + 120 meters of building = 170 meters) stretch relax a violet rosy lilac blue bust froth of electric light in a champagne glass (30 meters) sizzle evaporate in a mouthful of darkness electric signs dim die under a dark stiff hand come to life again continue stretch out in the night the human day's activity courage + folly never to die or cease or sleep electric signs = formation and disaggregation of mineral and vegetable center of the earth circulation of blood in the ferrous faces of Futurist houses increases, empurples (joy anger more more still stronger) as soon as the negative pessimist senti-mental nostalgic shadows besiege the city brilliant revival of streets that channel a smoky swarm of workers by day two horses (30 meters tall) rolling golden balls with their hoofs GIOCONDA PURGATIVE WATERS crisscross of *trrrr trrrrr* Elevated *trrrr trrrrr* overhead trrrombone whissstle ambulance sirens and fire-trucks transformation of the streets into splendid corridors to guide push logic necessity the crowd toward trepidation + laughter + music hall uproar FOLIES-BERGÈRE EMPIRE CREME-ÉCLIPSE tubes of mercury red red red blue violet huge letter-eels of gold purple diamond fire Futurist defiance to the weepy night the stars' defeat warmth enthusiasm faith conviction will power penetration of an

electric sign into the house across the street *yellow slaps* for that gouty, dozy bibliophile in slippers 3 mirrors watch him the sign plunges to 3 redgold abysses open close open close 3-thousand meters deep horror quick go out out hat stick steps taximeter push shove *zuu zuoeu* here we are dazzle of the promenade solemnity of the panther-cocottes in their comic-opera tropics fat warm smell of music hall gaiety = tireless ventilation of the world's Futurist brain.

LUIGI RUSSOLO

Enharmonic Notation for the Futurist *Intonarumori*

(*March 1, 1914*)

The total conquest of the enharmonic system obtained by Futurist *intonarumori* has rendered several modifications in the current system of musical notation necessary (as written in the November 21, 1913, issue of *Lacerba*).

This system, in fact, as it is today, only considers the subdivision of semitones, whereas the *intonarumori* can produce any fractions of tones. It is necessary, therefore, to find an easy and simple means to indicate these subdivisions, in other words, the means to write down *enharmonic music*. Different systems of present musical writing were proposed on several occasions but quickly dropped because of their uselessness or their impracticality.

A system that is certainly logical and rational is a musical notation using numbers, calling 1 the first grade of the scale, and 2,3,4,5,6, and 7, the successive grades. But this system, though logical in appearance, became enormously complicated and was above all slow and difficult to read, because of the fact that the eye, finding itself in front of a page completely filled with numbers, must read these figures one by one identifying them with the grades of the scale, without the arrangement of these numbers helping to accelerate this operation.

Thus it happens that, although it is enough that a very rapid glance at a musical page having the usual staff gives one a complete idea of the degree of the music's harmonic and rhythmic complication, a musical page written with a system of numbers teaches one nothing except that one has not read it all, identifying them number by number. And this happens because the usual system of musical notation forms a variable and characteristic *arabesque* with dots and lines placed at various heights on the staff. This arabesque, with its complete form, greatly helps us to identify immediately the

music that we are reading and to transform it in our minds into music that we hear.

There is no one who does not see the decisive importance of a system of musical notation giving the possibility of rapid and easy reading, and I quickly rejected ciphered writing. I was thus able to resolve the difficult problem of enharmonic notation by preserving the current staff and only varying the form and the means of indicating the notes on it.

It was not, therefore, necessary to vary the number of lines as others had proposed, since the result, even if logical sometimes (e.g., the whole tone written on a line, the semitone written in a space) was the inconvenience of overenlarging the space occupied by one octave. This created the necessity, therefore, of numerous transfers to the octave above or below.

In this entire course through the various systems of musical notation no one found anything that might have suggested the precise purpose of notation for enharmonic music. And this was logical. What purpose was there in creating a system of enharmonic notation if the instruments for performing enharmonic music did not exist? And wasn't it the realization of enharmonic music by the Futurist *intonarumori* that has rendered the relative system of writing indispensable?

At present, it is necessary to observe that enharmonic music as a total system and as being performed by the *intonarumori* has as its characteristic the possibility not only of fractionizing the interval of a tone into a given number of sounds, but of giving precisely the *change* from one tone to another, the sliding, as one could say, that a tone makes in order to arrive at the tone immediately above or immediately below it. This dynamic passage is not logically divisible, as a shading of a color from light to dark is divisible. If it were possible to establish the stages, that is to say, the degrees of fourths, or of eighths, etc., of a tone, still in doing so it would thus break the *dynamic continuity* of the tone.

Dynamic continuity This is the essence of enharmonic music; this is the difference between it and music of a diatonic-chromatic system, which could, instead, be called *intermittent Dynamism,* or more correctly perhaps, *fragmentary Dynamism.*

Now, if a series of *dots* has served very well to indicate the stages and grades of sound in the diatonic system, what can give continuity to this sound if not the *line?*

Thus, we have exactly reported the value of the dot (fixed and static principle) and the value of the line (dynamic development) to explain exactly the values of the diatonic system in respect to the enharmonic system and to represent it in a logical and perfect way.

The development, therefore, of a line, its rise or its fall on the lines of the staff, will indicate to us in a logical, easy, immediate way the development, the rise or the fall of the tone of sound-noise.

The length of this line, enclosed between vertical lines, will give us the length or duration of the same sound, its absence will give us the pauses equally limited by vertical lines, according to their duration. These lines, which thus indicate the development of one or more sounds, form an arabesque that immediately gives a characteristic appearance to a given composition, rendering it easy to read rapidly.

It is easier and even more rapid than the current writing, since while the whole note or the half-note are no longer for the eye than a quarter-note or an eighth-note, in this new notation, instead, a whole note (that is to say, a value in time corresponding to a whole note) will be better represented because the line is really longer than that of a half-note or an eighth-note.

In the new notation, therefore, we will have:

Instead of empty or full dots that indicate the notes, a line that we shall call a "line-note" and that will run on five lines and will indicate the tone according to the line or the space on which it is written. The reading will always be related to the two clefs, G of the treble or F of the bass, that will be indicated at the beginning of the line. This line will be intersected by thin vertical lines (like the present ones that indicate the bar) that indicate, instead, the quarters of the bars and, by equally vertical but wider lines (or by two close thin ones) that indicate the bars.

For the subdivision of time smaller than a quarter of a bar,

RUSSOLO.

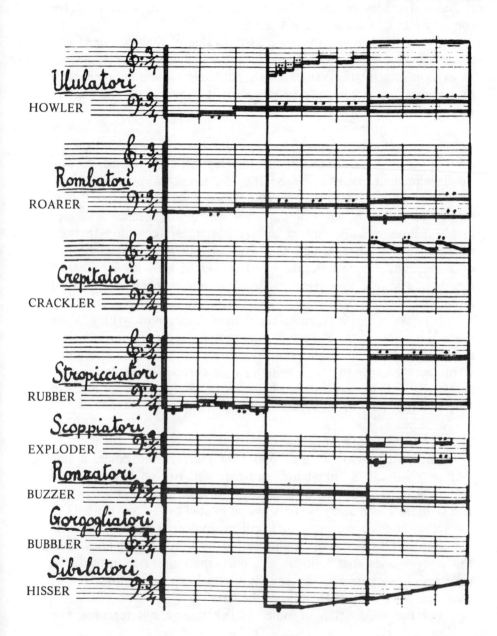

Dalla rete di rumori:

From the "Net of Noises":

Ululatori
HOWLER

Rombatori
ROARER

Crepitatori
CRACKLER

Stropicciatori
RUBBER

Scoppiatori
EXPLODER

Ronzatori
BUZZER

Gorgogliatori
BUBBLER

Sibilatori
HISSER

SVEGLIO DI UNA CITTÀ
AWAKENING OF A CITY

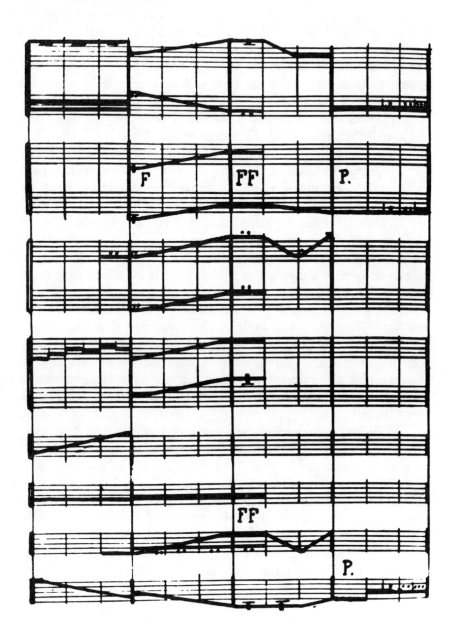

there will be used similar vertical lines, but shorter than those that indicate the quarter of a bar.

The line-note will naturally be able to go beyond the five lines in order to indicate the notes that are above or below the same lines. These notes will be identified by means of the usual thin, small, horizontal lines that indicate notes above or below the five lines. For greater clarity, the notes that are above the line, those, that is to say, that are above the top line, will be indicated by a small bar that will cross the line-note.

Imagine now, a line-note that goes from E, first line (treble clef) and that rises until E, fourth space. This line-note will not only indicate all the tones and intermediate semitones in this manner, but all the subdivisions of the tone. That is, it will give the dynamic and complete shading of the whole octave in an exact way graphically.

It is, however, necessary to have a graphic means to indicate the divisions that can be established between one tone and another.

We can divide the tone into four parts. The way to indicate these quarters will be by dots that we will put above (if it is necessary to raise the note) or under (if it is necessary to lower it). Thus, a dot will indicate a quarter-tone, two dots will indicate two quarters, in other words a semitone, and will correspond to sharps and flats. Three dots will indicate three-quarters of a tone.

Then, if it is desired to divide the tone into eighths, it will be possible to place a small number over or under the line-note, always using this number as the numerator of a fraction that will have as its denominator the eighth-note, thus a three means 3/8, a five 5/8, etc.

With this system we can therefore indicate any fractions of time and also give by exact graphic means that *dynamic continuity* of a changing sound.

This dynamic continuity and the possibility of a great variety of timbres are the two most important conquests that the *intona-rumori* have accomplished in the nature of means of expression. The two pages of enharmonic music reproduced here that I have taken from *Awakening of a City* (*Risveglio di una Città*) will give a clear idea of the new notation devised by me.

FRANCESCO BALILLA PRATELLA

The *Intonarumori* in the Orchestra

(*May 15, 1914*)

It is already almost a year since I should have answered the manifesto on the "Art of Noise" that my dearest friend and ingenious Futurist painter Luigi Russolo dedicated to me.

If until today I have not said anything officially, it is because I still have not found anything bad to say on the subject. Instead, I have thought very profoundly and above all else I have worked.

That is, I now grant myself the joy of offering to my friend Russolo a fresh, fresh novelty: the introduction of his *intonarumori* into my orchestra.

The *Trial of a Mixed Orchestra*, which one sees published in this issue of *Lacerba* [1] shows in synthesis the counteropposition of a group of *intonarumori* in a formed mass of other musical instruments.

Exploders and *Buzzers:* the clearly and precisely written parts are in their duration and in their loudness and variety of intonation relative to each *intonarumori*. The other instruments of the orchestra are on *trial,* notated, according to custom, on two single staffs, thereby rendering the execution of the music on the piano possible.

As one well sees, the *intonarumori* lose, in practice, some sense of objective reality; they part from an objective reality. By getting away from it immediately, they construct a new abstract reality —an *expressive abstract* element of a state of mind. Their *timbre* does not unite itself with the other *sonorous elements* like heterogeneous material, but unites itself as a new *sonorous, emotive,* and essentially *musical element.*

[1] Anno II, No. 10 (May 15, 1914).—Trans.

193

F. B. PRATELLA.

GIOIA. Saggio di Orchestra mista

JOY. Trial of a Mixed Orchestra

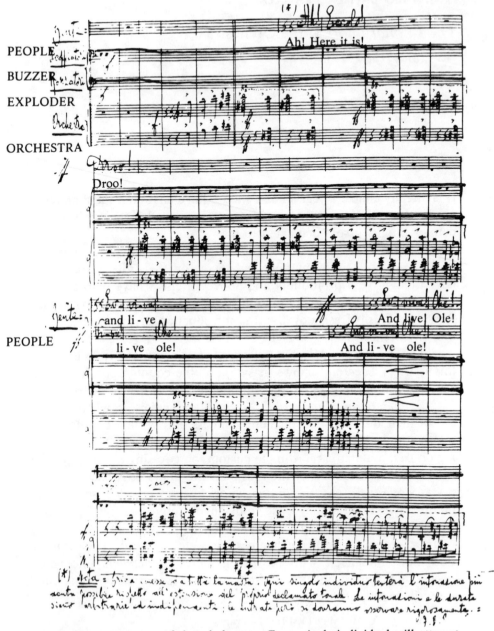

NOTE: Shouts come out of the whole mass. Every single individual will attempt the highest possible intonation in respect to the extension of the proper *declaimed tone*. The intonations and the durations may be arbitrary and independent; the entrances, however, must be strictly observed.

(Strumenti musicali + intonarumori)

(Musical instruments + *intonarumori*)

Signs for the *intonarumori*: ⟶ move handle

⎯ flat ⋯ sharp ⎯ or ″ cancel (natural)

FILIPPO TOMMASO MARINETTI, EMILIO SETTIMELLI, and BRUNO CORRA

The Futurist Synthetic Theatre*

(Milan, January 11, 1915; February 18, 1915)

As we await our much prayed-for great war, we Futurists carry our violent antineutralist action from city square to university and back again, using our art to prepare the Italian sensibility for the great hour of maximum danger. Italy must be fearless, eager, as swift and elastic as a fencer, as indifferent to blows as a boxer, as impassive at the news of a victory that may have cost fifty-thousand dead as at the news of a defeat.

For Italy to learn to make up its mind with lightning speed, to hurl itself into battle, to sustain every undertaking and every possible calamity, books and reviews are unnecessary. They interest and concern only a minority, are more or less tedious, obstructive, and relaxing. They cannot help chilling enthusiasm, aborting impulses, and poisoning with doubt a people at war. War—Futurism intensified—obliges us to march and not to rot [*marciare, non marcire*] in libraries and reading rooms. THEREFORE WE THINK THAT THE ONLY WAY TO INSPIRE ITALY WITH THE WARLIKE SPIRIT TODAY IS THROUGH THE THEATRE. In fact ninety percent of Italians go to the theatre, whereas only ten percent read books and reviews. But what is needed is a FUTURIST THEATRE, completely opposed to the passéist theatre that drags its monotonous, depressing processions around the sleepy Italian stages.

Not to dwell on the historical theatre, a sickening genre already abandoned by the passéist public, we condemn the whole contemporary theatre because it is too prolix, analytic, pedantically psychological, explanatory, diluted, finicking, static, as full of

* Translated by R. W. Flint. Published by permission of Farrar, Straus & Giroux, Inc. and the heirs of Filippo Tommaso Marinetti. From *Selected Works of Filippo Tommaso Marinetti* to be published in 1972 by Farrar, Straus & Giroux, Inc.

prohibitions as a police station, as cut up into cells as a monastery, as moss-grown as an old abandoned house. In other words it is a pacifistic, neutralist theatre, the antithesis of the fierce, overwhelming, synthesizing velocity of the war.

Our Futurist Theatre will be:

Synthetic. That is, very brief. To compress into a few minutes, into a few words and gestures, innumerable situations, sensibilities, ideas, sensations, facts, and symbols.

The writers who wanted to renew the theatre (Ibsen, Maeterlinck, Andreyev, Claudel, Shaw) never thought of arriving at a true synthesis, of freeing themselves from a technique that involves prolixity, meticulous analysis, drawn-out preparation. Before the works of these authors, the audience is in the indignant attitude of a circle of bystanders who swallow their anguish and pity as they watch the slow agony of a horse who has collapsed on the pavement. The sigh of applause that finally breaks out frees the audience's stomach from all the indigestible time it has swallowed. Each act is as painful as having to wait patiently in an antichamber for the minister (*coup de théâtre:* kiss, pistol shot, verbal revelation, etc.) to receive you. All this passéist or semi-Futurist theatre, instead of synthesizing fact and idea in the smallest number of words and gestures, savagely destroys the variety of place (source of dynamism and amazement), stuffs many city squares, landscapes, streets, into the sausage of a single room. For this reason this theatre is entirely static.

We are convinced that mechanically, by force of brevity, we can achieve an entirely new theatre perfectly in tune with our swift and laconic Futurist sensibility. Our acts can also be moments [*atti—attimi*] only a few seconds long. With this essential and synthetic brevity the theatre can bear and even overcome competition from the *cinema.*

Atechnical. The passéist theatre is the literary form that most distorts and diminishes an author's talent. This form, much more than lyric poetry or the novel, is subject to *the demands of technique:* (1) to omit every notion that doesn't conform to public

taste; (2) once a theatrical idea has been found (expressible in a few pages), to stretch it out over two, three or four acts; (3) to surround an interesting character with many pointless types: coat-holders, door-openers, all sorts of bizarre comic turns; (4) to make the length of each act vary between half and three-quarters of an hour; (5) to construct each act taking care to (*a*) begin with seven or eight absolutely useless pages, (*b*) introduce a tenth of your idea in the first act, five-tenths in the second, four-tenths in the third, (*c*) shape your acts for rising excitement, each act being no more than a preparation for the finale, (*d*) always make the first act *a little boring* so that the second can be *amusing* and the third *devouring*; (6) to set off every *essential* line with a hundred or more insignificant *preparatory* lines; (7) never to devote less than a page to explaining an entrance or an exit minutely; (8) to apply system-atically to the whole play *the rule of a superficial variety,* to the acts, scenes, and lines. For instance, to make one act a day, another an evening, another deep night; to make one act pathetic, another anguished, another sublime; when you have to prolong a dialogue between two actors, make something happen to interrupt it, a falling vase, a passing mandolin player. . . . Or else have the actors constantly move around from sitting to standing, from right to left, and mean-while vary the dialogue to make it seem as if a bomb might explode outside at any moment (e.g., the betrayed husband might catch his wife red-handed) when actually nothing is going to explode until the end of the act; (9) to be enormously careful about *the verisimil-itude of the plot;* (10) to write your play in such a manner that *the audience understands in the finest detail the how and why of every-thing that takes place on the stage, above all that it knows by the last act how the protagonists will end up.*

With our synthetist movement in the theatre, we want to destroy the Technique that from the Greeks until now, instead of simplifying itself, has become more and more dogmatic, stupid, logical, meticu-lous, pedantic, strangling. THEREFORE:

1. *It's stupid to write one hundred pages where one would do,* only because the audience through habit and infantile instinct wants to see character in a play result from a series of events, wants to fool itself into thinking that the character really exists in order to admire

the beauties of Art, meanwhile refusing to acknowledge any art if the author limits himself to sketching out a few of the character's traits.

2. *It's stupid* not to rebel against the prejudice of theatricality when life itself (which consists *of actions vastly more awkward, uniform, and predictable* than those which unfold in the world of art) is for the most part *antitheatrical* and even in this offers *innumerable possibilities for the stage.* EVERYTHING OF ANY VALUE IS THEATRICAL.

3. *It's stupid* to pander to the primitivism of the crowd, which, in the last analysis, wants to see the bad guy lose and the good guy win.

4. *It's stupid* to worry about verisimilitude (absurd because talent and worth have little to do with it).

5. *It's stupid* to want to explain with logical minuteness everything taking place on the stage, when even in life one never grasps an event entirely, in all its causes and consequences, because reality throbs around us, bombards us *with squalls of fragments of interconnected events, mortised and tenoned together, confused, mixed up, chaotic.* E.g., it's stupid to act out a contest between two persons *always* in an orderly, clear, and logical way, since in daily life we nearly always encounter mere *flashes of argument* made *momentary* by our modern experience, in a tram, a café, a railway station, which remain cinematic in our minds like fragmentary dynamic symphonies of gestures, words, lights, and sounds.

6. *It's stupid* to submit to obligatory *crescendi, prepared effects,* and *postponed climaxes.*

7. *It's stupid* to allow one's talent to be burdened with the weight of a technique that *anyone* (even imbeciles) *can acquire by study, practice, and patience.*

8. IT'S STUPID TO RENOUNCE THE DYNAMIC LEAP IN THE VOID OF TOTAL CREATION, BEYOND THE RANGE OF TERRITORY PREVIOUSLY EXPLORED.

Dynamic, simultaneous. That is, born of improvisation, lightning-like intuition, from suggestive and revealing actuality. We believe that a thing is valuable to the extent that it is improvised

(hours, minutes, seconds), not extensively prepared (months, years, centuries).

We feel an unconquerable repugnance for desk work, a priori, that fails to respect the ambience of the theatre itself. THE GREATER NUMBER OF OUR WORKS HAVE BEEN WRITTEN IN THE THEATRE. The theatrical ambience is our inexhaustible reservoir of inspirations: the magnetic circular sensation invading our tired brains during morning rehearsal in an empty gilded theatre; an actor's intonation that suggests the possibility of constructing a cluster of paradoxical thoughts on top of it; a movement of scenery that hints at a symphony of lights; an actress' fleshiness that fills our minds with genially full-bodied notions.

We overran Italy at the head of a heroic battalion of comedians who imposed on audiences *Electricità* and other Futurist syntheses (alive yesterday, today surpassed and condemned by us) that were revolutions imprisoned in auditoriums.—From the Politeama Garibaldi of Palermo to the Dal Verme of Milan. The Italian theatres smoothed the wrinkles in the raging massage of the crowd and rocked with bursts of volcanic laughter. We fraternized with the actors. Then, on sleepless nights in trains, we argued, goading each other to heights of genius to the rhythm of tunnels and stations. Our Futurist theatre jeers at Shakespeare but pays attention to the gossip of actors, is put to sleep by a line from Ibsen but is inspired by red or green reflections from the stalls. WE ACHIEVE AN ABSOLUTE DYNAMISM THROUGH THE INTERPENETRATION OF DIFFERENT ATMOSPHERES AND TIMES. E.g., whereas in a drama like *Più che L'Amore* [D'Annunzio], the important events (for instance, the murder of the gambling house keeper) don't take place on the stage but are narrated with a complete lack of dynamism; in the first act of *La Figlia di Jorio* [D'Annunzio] the events take place against a simple background with no jumps in space or time; and in the Futurist synthesis, *Simultaneità*, there are two ambiences that interpenetrate and many different times put into action simultaneously.

Autonomous, alogical, unreal. The Futurist theatrical synthesis will not be subject to logic, will pay no attention to photography; it

will be *autonomous,* will resemble nothing but itself, although it will take elements from reality and combine them as its whim dictates. Above all, just as the painter and composer discover, scattered through the outside world, a narrower but more intense life, made up of colors, forms, sounds, and noises, the same is true *for the man gifted with theatrical sensibility, for whom a specialized reality exists that violently assaults his nerves:* it consists of what is called THE THEATRICAL WORLD.

THE FUTURIST THEATRE IS BORN OF THE TWO MOST VITAL CURRENTS in the Futurist sensibility, defined in the two manifestoes: "The Variety Theatre" and "Weights, Measures, and Prices of Artistic Genius," which are: (1) our frenzied passion for real, swift, elegant, complicated, cynical, muscular, fugitive, Futurist life; (2) our very modern cerebral definition of art according to which no logic, no tradition, no aesthetic, no technique, no opportunity can be imposed on the artist's natural talent; he must be preoccupied only with creating synthetic expressions of cerebral energy that have THE ABSOLUTE VALUE OF NOVELTY.

The *Futurist theatre* will be able to excite its audience, that is make it forget the monotony of daily life, by sweeping it through *a labyrinth of sensations imprinted on the most exacerbated originality and combined in unpredictable ways.*

Every night the *Futurist theatre* will be a gymnasium to train our race's spirit to the swift, dangerous enthusiasms made necessary by this Futurist year.

CONCLUSIONS

1. TOTALLY ABOLISH THE TECHNIQUE THAT IS KILLING THE PASSÉIST THEATRE.

2. DRAMATIZE ALL THE DISCOVERIES (no matter how unlikely, weird, and antitheatrical) THAT OUR TALENT IS DISCOVERING IN THE SUBCONSCIOUS, IN ILL-DEFINED FORCES, IN PURE ABSTRACTION, IN THE PURELY CEREBRAL, THE PURELY FANTASTIC, IN RECORD-SETTING AND BODY-MADNESS. (E.g., *Vengono,* F. T. Marinetti's first drama of objects, a new vein of theatrical sensibility discovered by Futurism.)

3. SYMPHONIZE THE AUDIENCE'S SENSIBILITY BY EXPLORING IT, STIRRING UP ITS LAZIEST LAYERS WITH EVERY MEANS POSSIBLE; ELIMINATE THE PRECONCEPTION OF THE FOOTLIGHTS BY THROWING NETS OF SENSATION BETWEEN STAGE AND AUDIENCE; THE STAGE ACTION WILL INVADE THE ORCHESTRA SEATS, THE AUDIENCE.

4. FRATERNIZE WARMLY WITH THE ACTORS WHO ARE AMONG THE FEW THINKERS WHO FLEE FROM EVERY DEFORMING CULTURAL ENTERPRISE.

5. ABOLISH THE FARCE, THE VAUDEVILLE, THE SKETCH, THE COMEDY, THE SERIOUS DRAMA, AND TRAGEDY, AND CREATE IN THEIR PLACE THE MANY FORMS OF FUTURIST THEATRE, SUCH AS: LINES WRITTEN IN FREE WORDS, SIMULTANEITY, COMPENETRATION, THE SHORT, ACTED-OUT POEM, THE DRAMATIZED SENSATION, COMIC DIALOGUE, THE NEGATIVE ACT, THE REECHOING LINE, "EXTRA-LOGICAL" DISCUSSION, SYNTHETIC DEFORMATION, THE SCIENTIFIC OUTBURST THAT CLEARS THE AIR.

6. THROUGH UNBROKEN CONTACT, CREATE BETWEEN US AND THE CROWD A CURRENT OF CONFIDENCE RATHER THAN RESPECTFULNESS, IN ORDER TO INSTILL IN OUR AUDIENCES THE DYNAMIC VIVACITY OF A NEW FUTURIST THEATRICALITY.

These are the *first* words on the theatre. Our first eleven theatrical syntheses (by Marinetti, Settimelli, Bruno Corra, R. Chiti, Balilla Pratella) were victoriously imposed on crowded theatres in Ancona, Bologna, Padua, Naples, Venice, Verona, Florence, and Rome, by Ettore Berti, Zoncada, and Petrolini. In Milan we soon shall have the great metal building, enlivened by all the electro-mechanical inventions, which alone will permit us to realize our most free conceptions on the stage.

ENRICO PRAMPOLINI

Futurist Scenography

(April–May, 1915)

Let's reform the stage. To admit, to believe, that a stage exists today is to affirm that artistically man is absolutely blind. The stage is not equivalent to a photographic enlargement of a rectangle of reality or to a relative synthesis, but to the adoption of a theoretical and material system of subjective scenography completely opposed to the self-styled objective scenography of today.

It is not only a question of reforming the conception of the *mise-en-scène;* one must create an abstract entity that identifies itself with the scenic action of the play.

It is wrong to conceive of the stage separately, as a pictorial fact: (1) because now we are no longer dealing with scenography but with simple painting; (2) we are returning to the past (that is to say to the past . . . present) in which the stage expresses one subject, the play develops another. These two forces that have been diverging (playwright and scenographer) must converge so that a comprehensive synthesis of the play will result.

The stage must live the theatrical action in its dynamic synthesis; it must express the soul of the character conceived by the author just as the actor directly expresses and lives it within himself.

Therefore, in order to reform the stage it is necessary to:

1. Refuse the exact reconstruction of what the playwright has conceived, thus definitely abandoning every real relationship, every comparison between object and subject and vice versa; all these relationships weaken direct emotion through indirect sensations.

2. Substitute for scenic action an emotional order that awakens all sensations necessary to the development of the work; the resulting atmosphere will provide the interior milieu.

3. Have *absolute synthesis* in material expression of the stage,

that is to say, not the pictorial synthesis of all the elements, but synthesis excluding those elements of scenic architecture that are incapable of producing new sensations.

4. Make the scenic architecture be a connection for the audience's intuition rather than a picturesque and elaborate collaboration.

5. Have the colors and the stage arouse in the spectator those emotional values that neither the poet's words nor the actor's gestures can evoke.

There are no reformers of the stage today: Dresa and Rouché experimented in France with ingenious and infantile expressions; Meyerhold and Stanislavsky in Russia with revivals of nauseating classicism (we leave out the Assyrian-Persian-Egyptian-Nordic plagiarist Bakst); Adolphe Appia, Fritz Erler, Littman Fuchs, and Max Reinhardt (organizer) in Germany have attempted reforms directed more toward tedious elaboration, rich in glacial appearances, than toward the essential idea of interpretive reform; Granville-Barker and Gordon Craig in England have made some limited innovations, some objective syntheses.

Displays and material simplification, not rebellion against the past. It is this necessary revolution that we intend to provoke, because no one has had the artistic austerity to renovate the interpretive conception of the element to be expressed.

To us, scenography is a monstrous thing. Today's scenographers, sterile whitewashers, still prowl around the dusty and stinking corners of classical architecture. We must rebel and assert ourselves and say to our poet and musician friends: this action demands this stage rather than that one.

Let us be artists too, and no longer merely executors. Let us create the stage, give life to the text with all the evocative power of our art. It is natural that we need plays suited to our sensibility, which imply a more intense and synthetic conception in the scenic development of subjects.

Let's renovate the stage. The absolutely new character that our innovation will give the theatre is *the abolition of the painted stage.* The stage will no longer be a colored backdrop but a *colorless*

electromechanical architecture, powerfully vitalized by chromatic emanations from a luminous source, produced by electric reflectors with multicolored panes of glass, arranged, coordinated analogically with the psyche of each scenic action.

With the luminous irradiations of these beams, of these planes of colored lights, the dynamic combinations will give marvelous results of mutual permeation, of intersection of lights and shadows. From these will arise vacant abandonments, exultant, luminous corporalities.

These assemblages, these unreal shocks, this exuberance of sensations combined with dynamic stage architecture that will move, unleashing metallic arms, knocking over plastic planes, amidst an essentially new modern noise, will augment the vital intensity of the scenic action.

On a stage illuminated in such a way, the actors will gain unexpected dynamic effects that are neglected or very seldom employed in today's theatres, mostly because of the ancient prejudice that one must imitate, represent reality.

And with what purpose?

Perhaps scenographers believe it is absolutely necessary to represent this reality? Idiots! Don't you understand that your efforts, your useless realistic preoccupations have no effect other than that of diminishing the intensity and emotional content, which can be attained precisely through the interpretive equivalents of these realities, i.e., abstractions?

Let's create the stage. In the above lines we have upheld the idea of a *dynamic stage* as opposed to the static stage of another time; with the fundamental principles that we shall set forth, we intend not only to carry the stage to its most advanced expression but also to attribute to it the essential values that belong to it and that no one has thought of giving it until now.

Let's reverse the roles. Instead of the illuminated stage, let's create the *illuminating stage: luminous expression that will irradiate the colors demanded by the theatrical action with all its emotional power.*

The material means of expressing this illuminating stage consist in the use of electrochemical colors, fluorescent mixtures that have the chemical property of being susceptible to electric current and diffusing luminous colorations of all tonalities according to the combinations of fluorine and other mixtures of gases. The desired effects of exciting luminosity will be obtained with electric neon (ultraviolet) tubes, systematically arranging these mixtures according to an agreed-upon design in this immense scenodynamic architecture. But the Futurist scenographic and choreographic evolution must not stop there. In the final synthesis, human actors will no longer be tolerated, like children's marionettes or today's supermarionettes recommended by recent reformers; neither one nor the other can sufficiently express the multiple aspects conceived by the playwright.

In the totally realizable epoch of Futurism we shall see the luminous dynamic architectures of the stage emanate from chromatic incandescences that, climbing tragically or showing themselves voluptuously, will inevitably arouse new sensations and emotional values in the spectator.

Vibrations, luminous forms (produced by electric currents and colored gases) will wriggle and writhe dynamically, and these authentic actor-gases of an unknown theatre will have to replace living actors. By shrill whistles and strange noises these actor-gases will be able to give the unusual significations of theatrical interpretations quite well; they will be able to express these multiform emotive tonalities with much more effectiveness than some celebrated actor or other can with his displays. These exhilarant, explosive gases will fill the audience with joy or terror, and the audience will perhaps become an actor itself as well.

But these words are not our last. We still have much more to say. First let's carry out what we have set forth above.

FORTUNATO DEPERO

Notes on the Theatre

(Ca. 1916)

Not only must every event, act, and phenomenon be represented by lines, colors, forms, environments, and costumes of renewed style, but movement also must be a vast re-creation of mimicry.

Every displacement of an object or figure, every thought, dream, intention, and vision will be mimetically in direct relationship to the environment: also mimicry will be the only scenario in some cases; e.g., turning flowers, moving mountains, trees and steeples that oscillate, houses that uncover and open themselves; wind that tosses, shakes, drops, and overturns the landscape with whirlwinds, while, in a tragic fixity, characters remain immobile. A single figure, too, can become the protagonist of plastic-magic phenomena: enlargement of the eyes and various illuminations of them. Decompositions of the figure and the deformation of it, even until its absolute transformation; e.g., a dancing ballerina who continually accelerates, transforming herself into a floral vortex, etc.

Also, the construction of the stage must be completely redone and amplified in all electrical and mechanical senses. The stage must be ready and prepared for all possibilities, in order that every intention of the artist can be rendered feasible.

Appearances at the sides on a fixed horizontal floor are not enough, nor are the usual lowerings from the ceiling; but every side including the floor, indeed the floor itself, will be raised and the scenes will be seen in their vast topography, or the floors will be multiplied and the characters will be at disproportionate perspectives, etc.

Mobile Scenery. The complex *motorumorista* [1] suggested to

[1] Depero refers to his kinetic sculpture done in 1914–15. A photograph of one of the pieces, now lost, appeared in *The Futurist Reconstruction of the Universe* (*Ricostruzione Futurista dell'Universo,* March 11, 1915) by Depero and Balla.—Ed.

me mobile scenery and transformation. The sun appears and disappears every day. The clouds pass, men and animals walk. Machines wind, rotate, and pull; toothed, geared, complicated, and simple.

Cycles, motors, autos, running noisily or silently, in gusts, in darts. Trains with nostril-tubes puff carelessly, bullets flashing-threads, fish rolling-lights in water, birds fluttering-mastiffs of the air.

The luxurious autos in the squares and on the black, glossy rubber boulevards create snares of lights and phosphorescent bolas that, thrown by invisible gauchos, ensnare the fleeing taxis red-devil-bats.

Everything turns-disappears-reappears, multiplies and breaks, pulverizes and overturns, trembles and transforms into a cosmic machine that is life. And theatre?

The wings may turn on their own flashing-arc, the backcloths may turn on changeable multipivots. Pieces of furniture may flee and may fight one another, or, rallied, may hunt the tenants; oil lanterns and electric lamps may clash, bombarding each other, or may foxtrot on the backcloth or in the madness of the crowd; sensational news and dramatic situations may create typographic scenery, those luminous advertising walls, originating sonorously in all timbres from megaphones of the heart and the soul.

The theatre must interpret, synthesize, infinitely re-create all the *visual-auditory-olfactory-dramatic-electric-hypnotic and magic* round dances of our life.

				LIGHTS	colors
colors		colors		LIGHTS	colors
colors SURPRISE		colors SURPRISE	lights		lights colors
colors INNOVATION		colors INNOVATION	lights		lights colors
colors				LIGHTS	colors
				LIGHTS	colors

| *express rapidly*
| *awaken interest*
| *entertain*

and inexhaustibly vary—create

Life is lived speedily. Theatre errs through slowness.

Why does cinematography triumph? In spite of lacking color, constructions, and relief, voices and living characters!

And still a simple succession of black-and-white photographs! It wins because it is fast, because it moves and transforms rapidly. Cinematography is varied and rich, improvised, and surprising.

> . . . *a hand that robs*
> . . . *two others that turn a wheel*
> . . . *a forest that flys*
> . . . *a palace that collapses*
> . . . *a tunnel that sucks itself up*
> . . . *a steamer that lies on the sea*
> . . . *a New York street with congested traffic*
> . . . *and the solitary banks of a river*

One runs, navigates, flies, takes a voyage, lives intensely, while resting comfortably seated in an armchair.

Cinematography, removed from the assassin's hands of certain reconstructors of historical dramas, perfectly fake and useless, and of melancholy makers of banal human passions who wish to bring it back to the boring idiocies of the theatre, will become a powerful means of artistic creation.

It is necessary to add to theatre everything that is suggested by cinematography.

<p align="center">CONTRASTS—TRICKS
panoramas—events</p>

UNLIKELIHOODS.
EXAGGERATIONS and jests *in libertà,* completely invented and paradoxical

VARIETY	
NOVELTY	ONLY IN THIS WAY will theatre still
SURPRISE	be able to interest
SPEED	

EXAGGERATE THE MAKEUP

Moustaches, beards, wigs; red, yellow, green, gold
masks of all shapes;
moveable and intensely colored,
headlight-eyes
megaphone-mouths, funnel-ears
in movement and transformation
mechanical clothes,
DEVELOP TRANSFORMATION
hands-feet; plastically artificial

Color nudes

green nudes	gold nudes
red nudes	metallic nudes
yellow nudes	very white and very black nudes
blue nudes	changeable mother-of-pearl nudes

DISPROPORTION according to necessity
DISSOLVE characters, scenes, and objects
Masks, feet, hands, objects that act separately on their own behalf.
ARTIFICIAL FLORA AND FAUNA

FORTUNATO DEPERO

Description of Costumes by Depero*

(*Ca. 1915*)

Apparition-like costume equivalent (magical, mechanical) to *complex simultaneity of forms—colors—onomatopoeia—sounds and noises.* Constructed on a framework of metallic wire—light—forms of transparent material—brightly colored.

The framework will be made so as to open and close itself, that is to say, it must appear like a normal Futurist costume but the jacket opens by clicking one's heels; various movements with one's arms, hands, feet, legs, or raising one's hat, etc. . . . will open certain fanlike contrivances like tongs, etc. . . . simultaneously with luminous apparitions in bursts and rhythms of noiselike instruments.

The costumes for the Futurist abstract and dynamic theatre to come will be constructed on this very new principle of Depero's that was inaugurated by Marinetti at the extraordinary Depero-Balla Exposition of 1915.

* This description was found in one of Depero's notebooks. It refers to costumes that were never actually executed. They were not designed for any particular piece, according to Depero's widow.—Trans.

FILIPPO TOMMASO MARINETTI, BRUNO CORRA, EMILIO SETTIMELLI, ARNALDO GINNA, GIACOMO BALLA, and REMO CHITI

The Futurist Cinema*

(September 11, 1916)

The book, a wholly passéist means of preserving and communicating thought, has for a long time been fated to disappear like cathedrals, towers, crenellated walls, museums, and the pacifist ideal. The book, static companion of the sedentary, the nostalgic, the neutralist, cannot entertain or exalt the new Futurist generations intoxicated with revolutionary and bellicose dynamism.

The conflagration is steadily enlivening the European sensibility. Our great hygienic war, which should satisfy *all* our national aspirations, centuples the renewing power of the Italian race. The Futurist cinema, which we are preparing, a joyful deformation of the universe, an alogical, fleeting synthesis of life in the world, will become the best school for boys: a school of joy, of speed, of force, of courage, and heroism. The Futurist cinema will sharpen, develop the sensibility, will quicken the creative imagination, will give the intelligence a prodigious sense of simultaneity and omnipresence. The Futurist cinema will thus cooperate in the general renewal, taking the place of the literary review (always pedantic), the drama (always predictable), and killing the book (always tedious and oppressive). The necessities of propaganda will force us to publish a book once in a while. But we prefer to express ourselves through the cinema, through great tables of words-in-freedom and mobile illuminated signs.

With our manifesto, "The Futurist Synthetic Theatre," with the

* Translated by R. W. Flint. Published by permission of Farrar, Straus & Giroux, Inc. and the heirs of Filippo Tommaso Marinetti. From *Selected Works of Filippo Tommaso Marinetti* to be published in 1972 by Farrar, Straus & Giroux, Inc.

victorious tours of the theatre companies of Gualtiero Tumiati, Ettore Berti, Annibale Ninchi, Luigi Zoncada, with the two volumes of *Futurist Synthetic Theatre* containing eighty theatrical syntheses, we have begun the revolution in the Italian prose theatre. An earlier Futurist manifesto had rehabilitated, glorified, and perfected the Variety Theatre. It is logical therefore for us to carry our vivifying energies into a new theatrical zone: the *cinema*.

At first look the cinema, born only a few years ago, may seem to be Futurist already, lacking a past and free from traditions. Actually, by appearing in the guise of *theatre without words*, it has inherited all the most traditional sweepings of the literary theatre. Consequently, everything we have said and done about the stage applies to the cinema. Our action is legitimate and necessary insofar as the cinema up to now *has been and tends to remain profoundly passéist*, whereas we see in it the possibility of an eminently Futurist art and *the expressive medium most adapted to the complex sensibility of a Futurist artist*.

Except for interesting films of travel, hunting, wars, etc., the filmmakers have done no more than inflict on us the most backward-looking dramas, great and small. The same scenario whose brevity and variety may make it seem advanced is, in most cases, nothing but the most trite and pious *analysis*. Therefore all the immense *artistic* possibilities of the cinema still rest entirely in the future.

The cinema is an autonomous art. The cinema must therefore never copy the stage. The cinema, being essentially visual, must above all fulfill the evolution of painting, detach itself from reality, from photography, from the graceful and solemn. It must become antigraceful, deforming, impressionistic, synthetic, dynamic, free-wording.

ONE MUST FREE THE CINEMA AS AN EXPRESSIVE MEDIUM in order to make it the ideal instrument *of a new art*, immensely vaster and lighter than all the existing arts. We are convinced that only in this way can one reach that *polyexpressiveness* toward which all the most modern artistic researches are moving. Today the *Futurist cinema* creates precisely the POLYEXPRESSIVE

SYMPHONY which just a year ago we announced in our manifesto, "Weights, Measures, and Prices of Artistic Genius." The most varied elements will enter into the Futurist film as expressive means: from the slice of life to the streak of color, from the conventional line to words-in-freedom, from chromatic and plastic music to the music of objects. In other words it will be painting, architecture, sculpture, words-in-freedom, music of colors, lines, and forms, a jumble of objects and reality thrown together at random. We shall offer new inspirations for the researches of painters, which will tend to break out of the limits of the frame. We shall set in motion the words-in-freedom that smash the boundaries of literature as they march toward painting, music, noise-art, and throw a marvelous bridge between the word and the real object.

Our films will be:

1. CINEMATIC ANALOGIES that use reality directly as one of the two elements of the analogy. Example: If we should want to express the anguished state of one of our protagonists, instead of describing it in its various phases of suffering, we would give an equivalent impression with the sight of a jagged and cavernous mountain.

The mountains, seas, woods, cities, crowds, armies, squadrons, airplanes will often be our formidable expressive words: THE UNIVERSE WILL BE OUR VOCABULARY. Example: We want to give a sensation of strange cheerfulness: we show a chair cover flying comically around an enormous coat stand until they decide to join. We want to give the sensation of anger: we fracture the angry man into a whirlwind of little yellow balls. We want to give the anguish of a hero who has lost his faith and lapsed into a dead neutral skepticism: we show the hero in the act of making an inspired speech to a great crowd; suddenly we bring on Giovanni Giolitti who treasonably stuffs a thick forkful of macaroni into the hero's mouth, drowning his winged words in tomato sauce.

We shall add color to the dialogue by swiftly, simultaneously showing every image that passes through the actors' brains. Example: representing a man who will say to his woman: "You're as lovely as a gazelle," we shall show the gazelle. Example: if a character says,

"I contemplate your fresh and luminous smile as a traveler after a long rough trip contemplates the sea from high on a mountain," we shall show traveler, sea, mountain.

This is how we shall make our characters as understandable *as if they talked*.

2. CINEMATIC POEMS, SPEECHES, AND POETRY. We shall make all of their component images pass across the screen.

Example: "Canto dell'Amore" ("Song of Love") by Giosuè Carducci:

> In their German strongholds perched
> Like falcons meditating the hunt

We shall show the strongholds, the falcons in ambush.

> From the churches which raise long marble
> arms to heaven, in prayer to God

> From the convents between villages and towns
> crouching darkly to the sound of bells
> like cuckoos among far-spaced trees
> singing boredoms and unexpected joys . . .

We shall show churches that little by little are changed into imploring women, God beaming down from on high, the convents, the cuckoos, etc.

Example: "Sogno d'Estate" ("Summer's Dream") by Giosuè Carducci:

> Among your ever-sounding strains of battle, Homer, I am
> conquered by
> the warm hour: I bow my head in sleep on Scamander's
> bank, but my
> heart flees to the Tyrrhenian Sea.

We shall show Carducci wandering amid the tumult of the Achaians, deftly avoiding the galloping horses, paying his respects to Homer, going for a drink with Ajax to the inn, The Red Scamander, and at the third glass of wine his heart, whose palpitations we ought to see, pops out of his jacket like a huge red balloon and flies over the Gulf of Rapallo. This is how we make films out of the most secret movements of genius.

Thus we shall ridicule the works of the passèist poets, transforming to the great benefit of the public the most nostalgically monotonous, weepy poetry into violent, exciting, and highly exhilarating spectacles.

3. CINEMATIC SIMULTANEITY AND INTERPENETRATION of different times and places. We shall project two or three different visual episodes at the same time, one next to the other.

4. CINEMATIC MUSICAL RESEARCHES (dissonances, harmonies, symphonies of gestures, events, colors, lines, etc.).

5. DRAMATIZED STATES OF MIND ON FILM.

6. DAILY EXERCISES IN FREEING OURSELVES FROM MERE PHOTOGRAPHED LOGIC.

7. FILMED DRAMAS OF OBJECTS. (Objects animated, humanized, baffled, dressed up, impassioned, civilized, dancing—objects removed from their normal surroundings and put into an abnormal state that, by contrast, throws into relief their amazing construction and nonhuman life.)

8. SHOW WINDOWS OF FILMED IDEAS, EVENTS, TYPES, OBJECTS, ETC.

9. CONGRESSES, FLIRTS, FIGHTS AND MARRIAGES OF FUNNY FACES, MIMICRY, etc. Example: a big nose that silences a thousand congressional fingers by ringing an ear, while two policeman's moustaches arrest a tooth.

10. FILMED UNREAL RECONSTRUCTIONS OF THE HUMAN BODY.

11. FILMED DRAMAS OF DISPROPORTION (a thirsty man who pulls out a tiny drinking straw that lengthens umbilically as far as a lake and dries it up *instantly*).

12. POTENTIAL DRAMAS AND STRATEGIC PLANS OF FILMED FEELINGS.

13. LINEAR, PLASTIC, CHROMATIC EQUIVALENCES, ETC., of men, women, events, thoughts, music, feelings, weights, smells, noises (with white lines on black we shall show the inner, physical rhythm of a husband who discovers his wife in adultery and chases the lover—rhythm of soul and rhythm of legs).

14. FILMED WORDS-IN-FREEDOM IN MOVEMENT (synoptic tables of lyric values—dramas of humanized or animated let-

ters—orthographic dramas—typographical dramas—geometric dramas—numeric sensibility, etc.) .

Painting + sculpture + plastic dynamism + words-in-freedom + composed noises + architecture + synthetic theatre = Futurist cinema.

THIS IS HOW WE DECOMPOSE AND RECOMPOSE THE UNIVERSE ACCORDING TO OUR MARVELOUS WHIMS, to centuple the powers of the Italian creative genius and its absolute preeminence in the world.

[FEDELE] AZARI, Futurist pilot aviator

Futurist Aerial Theatre

(*Milan, April 11, 1919*)

Flight as an Artistic Expression of States of Mind.
Dialogued Flights. Aerial Pantomine and Dance.
Futurist Aerial Paintings. Aerial *Parole in Libertà*

The Italian aviator who has conquered the better-armed enemy, surprising him with more inventive and amazing maneuvers, has created a style of marvelous, fantastic, unsurpassable aerial acrobatics.

The French can vindicate their boast of having first studied and performed loops, spins, and barrel rolls. The English demonstrate the greatest self-control and disdain for danger by systematically performing such acrobatics at the lowest possible altitude. But the Italian aviator in the Sva, Macchi, Savoia, and Caproni, designed and constructed by us, is the acrobat par excellence, the juggler of space, clown of the celestial pavilion, restless, bizarre, very beautiful.

We Futurist aviators, we love to roar up perpendicularly and dive vertically into the void; to turn in the intoxication of yaws with our bodies glued to the small seats by centrifugal force, and to abandon ourselves to the whirl of spirals that press around the spiral staircase embedded in the void; to turn over two, three, ten times in an increasing happiness of loops and to lean over in whirling barrel rolls; to swirl, skidding; to rock ourselves into long falls like dead leaves or to stun ourselves with a breathless series of spins; in short, to rock, to roll, to flip over on the invisible trapezes of the atmosphere, to form with our airplanes a great aerial pinwheel. We Futurist aviators today are able to create by means of

218

flight a new artistic form with expressions of the most complex states of mind.

We shout our sensations and our aviators' lyricism from above with the rocking and the darting of our airplanes, with the most bizarre evolutions, the most improvised hieroglyphs, and the most merry somersaults performed in accordance with the rhythm of our desire.

The artistic form that we create with flight is analogous to dance, but is infinitely superior to it because of its grandiose background, because of its superlative dynamism, and the greatly varied possibilities that it permits, thereby completing the evolutions according to the three dimensions of space.

I HAVE MYSELF PERFORMED, IN 1918, MANY EXPRESSIVE FLIGHTS AND EXAMPLES OF ELEMENTARY AERIAL THEATRE OVER THE CAMP OF BUSTO ARSIZIO. I perceived that it was easy for the spectators to follow all the nuances of the aviator's states of mind, given the absolute identification between the pilot and his airplane, which becomes like an extension of his body: his bones, tendons, muscles, and nerves extend into longerons and metallic wires. Everyone has noticed, besides, that although there is little difference between one chauffeur and another chauffeur driving an automobile, there is a great difference between one aviator and another aviator in his manner of flying. The same aviator does not always fly in the same way. Flight is, therefore, always the precise expression of the pilot's state of mind.

In fact, looping denotes happiness, spins denote impatience or irritation, repeatedly tilting the wings from right to left indicates light-heartedness, and long falls like dead leaves give a sense of nostalgia or of tiredness. Sudden halts followed by more or less prolonged zooming, dives, loops, all the infinite varieties of maneuvers joined and coordinated in a planned succession, give the spectator an *immediate* and *clear* comprehension of how much the aviator wishes to represent or declaim with the airplane.

If, then, such representations or declamations are performed with two or more airplanes, it is possible to perform entire dialogues

and dramatic actions. Whoever has watched aerial battles has been able to notice the various attitudes of the combatants, to guess the sensations and to distinguish between the brave leaps and winding-up movements of the assailant and the wriggling movements of the assaulted, and their opposing feline or openly aggressive, impulsive or cautious tactics. This is only a phase of the multi-expressivity of an airplane. In other words, we are going to create a marvelous aerial art with new acrobatics by artistically composing those that have already been used without artistic purposes.

In our flight dialogues, in our aerial *parole in libertà*, the sense of character will also be expressed by the type of airplane, by the voice of the motor, and by the diverse lines of flight. For example, a Sva, a regular fixed motor of 200 h.p., which climbs with continual majestic zooming is evidently masculine, while an Henriot, a rotating motor of 110 h.p., which flies with a rhythmic swaying from side to side, has all the characteristics of femininity. The voice of the motor can be regulated to fullness or reduced, broken up into clearly defined and precise points, or modulated in scale from high to low, thus forming a way to supplement musical and "rumoristic" expression very effectively.

In collaboration with my friend, Russolo, genius inventor of the Futurist *intonarumori,* we have invented a special type of hood to increase the resonance of motors and a type of exhaust that regulates the sonority of the motor without modifying its potential.

Every airplane will be painted and signed by a Futurist painter. The Futurist painters Balla, Russolo, Funi, Depero, Dudreville, Baldessari, Rosai, Ferazzi, A. Ginna, Primo Conti, Mario Sironi, etc., have already found fantastic decorations for airplanes. A special compartment will also release an expressive discharge of colored and perfumed dust, confetti, rockets, parachutes, puppets, varicolored small balloons, etc.

WE HAVE THE AGREEMENT OF THE GLORIOUS FUTURIST PILOT GIACOMO MACCHI OF THE ST. MARK SQUADRON, OF THE GREAT ACROBAT DE BRIGANTI, OF MARIO D'URSO, THE ASTONISHING VIRTUOSO OF FLYING

UPSIDE DOWN, OF THE BUILDER-PILOT BERGONZI, AND OF THE PILOT GUIDO KELLER.

As soon as freedom of the air is restored, we Futurist aviators will perform in the Milan sky daytime and nocturnal representations of aerial theatre with dialogue flights, pantomime, dance, and great poems of aerial *paroliberi*, composed by the Futurist poets Marinetti, Buzzi, Corra, Settimelli, Folgore, etc. Above innumerable spread-out spectators, painted airplanes will dance during the day in a colored aerial environment formed by their own diffuse smoke, and at night they will compose mobile constellations and fantastic dances, invested with lights of electric projections.

1. The Futurist Aerial Theatre, having heroism as its essence in addition to artistic genius, will be a marvelous popular school for courage.

2. The Aerial Theatre will be a truly popular theatre since (except for the grandstands reserved for those who wish to admire the aviator and the Futurist colorings of the airplanes from close up) it will be offered free to millions of spectators. Thus the poor also will finally have their theatre.

3. The Aerial Theatre, because of ample space for its spectacles, the attendance of the crowd, and the emulation of its flying actors of the air, from whom will emerge actors like Zucconi, Duse, Caruso, Tamagno, will also stimulate commercial and industrial aviation.

4. Thus Aerial Theatre will be the true, worthwhile, absolutely free, virile, energetic, and practical theatre of the great Futurist nation that we advocate.

MAURO MONTALTI, Futurist

For a New Theatre: "Electric-Vibrating-Luminous"
(*1920*)

Brief, elementary hints and a small practical example of Electric-Vibrating-Luminous Theatre will serve to give to youth a concept of what the new form of art wishes to be and what it proposes to do.

It does not wish to throw away completely the other innovating schools, but it searches only to *translate* and *simplify*, in colored and luminous vibrations, concepts of art that have already been treated by other techniques (theatre-music-painting-poetry-etc.).

Not all men, in fact, have their own sensitivity equitably distributed in the five senses, so that they indifferently perceive a work of art that the artist created according to his own ability. For example, since not all men completely perceive a dramatic-auditory action with characters on stage, the Electric-Vibrating-Luminous Theatre *translates* the same dramatic conception, with its equivalent emotional power, in such a way that the deaf can also perceive the different cerebral vibrations that gave rise to the dramatic concept.

However, one must deduce from this that the Electric-Vibrating-Luminous Theatre is only the *primary formula of a work of art, the synthetic-symptomatic and aesthetic* exposition of a pure work, free from frivolous technical means of expression.

But, since there is no art if there is no creation, and the Electric-Vibrating-Luminous Theatre wishes to be art it later will be able to attain a superior state of technical proficiency, to create dramas, musical symphonies, symbolic dances, etc., for this new form of ultradynamic art. This new art form, if well felt by the artist, will offer him a new way to express his own sensibility and his own thoughts, by means of luminous, aesthetic, and clear vibrations.

The stage looks like an enormous dark chamber of a camera,

that is to say, a floor, backdrop, ceiling, and lateral faces of black planes (of board or velvet) hermetically welded together.

The backcloth, which constitutes the scenery and which we shall call "sensitive darkness," is formed from myriads of electric lamps of every color and tonality. The studied distribution of colors and the studied distribution of electrical currents comprise the subject and treatment of the work. Behind the backcloth an electrical cylinder switch works, which, acting like a phonograph cylinder, lights up now one, now another, zone of the sensitive darkness.

It is well to bear in mind that the Electric Theatre, being eminently dynamic and based on color and movement, does not allow its luminous vibrations to be geometric expressions like triangles, squares, trapezoids, etc., etc. Instead, they are light-points, nebulas, straight segments, curves, parabolas, hyperbolas, helicoids, ellipses, ellipsoids, spirals, circles, concentrics, eccentrics, ovals, etc.

To summarize with a brief example, we condense the third act of *The Life of Man* by Leonid Andreyev. To be precise, the "ball."

First Scene. A red curtain rises. The sensitive darkness is covered by a nebula of points of every color, paired two by two, which turn with a rotating and revolving motion. They crisscross one another.

Tonality: Reds, greens, yellows, dark blues, etc. etc., with a cold tonality predominant.

At Left: Almost lost in the sensitive darkness "He" stands immobile, represented by a row of yellowish lights in the form of an S, in the middle of which a tuft of "bluish-red" trembles.

At Right: In a corner at the back "three boring and monotonous musicians" are expressed by three verticals of a very gloomy violet in three different sizes, as in Indian file. The three verticals light up and darken rhythmically and gradually, controlled by the electrical current. For the entire duration of the act they continue their vibro-luminous sound at the same tempo.

The ball lights up. It is formed by swift spirals of every color that turn in all directions. Several lights move automatically between the dancing couples. They form small nebulas of blue and red lights that quickly break up in all directions.

Colored merrymaking. Now and then, the sensitive darkness freezes the multicolored expressions for several seconds and only the three musicians operate dimly.

At other times a determined image curves quickly and deliberately toward the right for a moment before returning to the ball.

Second Scene. The sensitive darkness finishes with the colored expression. From the right a deep orange splash expands and distends itself until it totally covers the surface of the sensitive darkness. Then a second of darkness. Then again two luminous beams of light come from the right. Golden lights stop at the head of Man and Woman. Behind is a retinue of Friends and Enemies.

The Friends are expressed by a tonality of red and dark-blue lights that move rhythmically and straight ahead. The Enemies are expressed by a yellow and green tonality and proceed to cast off small arcs of circles in a zigzag manner.

On each side of the two beams the dancers, with uniform and equal movement, separate and come together, expressing solemn curtsies. *Whisper of lights.* Comments of color. The three musicians play just as in the first scene.

Third Scene. The two luminous processions collect on the left at the back and come down bowing. The dancers move and slowly seek each other, grouping themselves by color and by tone. Nebulas of reds, yellows, greens, purples, violets, browns, whites, etc. etc.

Then, in small dancing groups they disappear to the right. Only a very yellowish yellow (other than He and the musicians) remains on the sensitive darkness. It makes a turn on the floor, pirouettes, and then disappears to the right.

Last Scene. Darkness, except that the left is occupied by He, who is immobile, and the right corner is occupied by the three musicians, who are still playing. Slowly the three musicians creep to the middle of the sensitive darkness. They meet in the center and enlarge proportionately until the tallest occupies the entire height of the backcloth. Thus they continue to play, greatly slackening the tempo.

He rapidly crosses the stage and stands immobile on the left. His bluish-red tuft in the center diminishes to three-fourths its original height and pauses, flickering.

<center>DARKNESS CURTAIN</center>

ENRICO PRAMPOLINI

Futurist Scenic Atmosphere
TECHNICAL MANIFESTO

(*1924*)

Scenosynthesis Scenoplastics Scenodynamics
Polydimensional Scenospace Actor-Space
Polyexpressive Theatre

Contemporary scenic art is developing in a completely Futurist atmosphere. The scenic arc [1] of the traditional theatre definitely collapsed at the cry of revolt that we Futurists launched in 1915. That year, contemporaneously with Marinetti's and Settimelli's manifesto on "Futurist Synthetic Theatre," I set forth the basis of the new *Futurist scenic technique* in my manifesto on "Futurist Scenography and Choreography" (published by *Balza Futurista*, March 15, and successively in more than fifteen other Italian and foreign periodicals).

In summarizing and coordinating the prophetic and essential principles of my *scenic system*, I shall remind the slow-moving meddlers of the Italian theatre (actor-managers and producers) that each apparently *theoretic viewpoint* has already found its concrete realization in the light of *technical experience*: in 1919 at the Teatro delle Marionette in Rome, in 1920 at the Teatro Argentina in Rome, in 1921 at the Teatro Svandovo in Prague, in 1922 at the National Theatre in Prague, in 1923 at the Teatro degli Indipendenti in Rome.

Whereas in the past scenic art limited itself to suggestion rather than to representation, as in Greek and medieval theatre, after the appearance of Wagner a rapid, although empirical, evolution took

[1] By "scenic arc" Prampolini does not mean the proscenium arch but the scenery that encloses the playing space of the stage at the sides and rear, forming an approximate semicircle around the action.—Ed.

place, and scenic art participated as an integral element in scenic action.

The scenographic *suggestions* produced by the pretense of perspective in the work of our scene designers of the 1700's in the scenic arc of the theatre of that time have been transformed today into *plastic representations* of magic and unreal scenic constructions.

Scenography, that is to say, the prevailing traditional stage, understood as a description of apparent reality, as a realistic make-believe of the visual world, is definitely condemning itself because it is a static compromise in direct antithesis to *scenic dynamism*, the essence of theatrical action.

The scenic experiments that have been recently performed in European theatres flow into empiricism, the causal and the ephemeral, since such scenic experiences were the product of singular aspirations, of individuality that pretends to give life to its scenic vision without studying, considering, and analyzing the aesthetic and spiritual problems that invest the techniques of the theatre and the contingency of the life of the mind.

The value of Futurist scenic reform consists exactly in having framed the proper scenic conception in time and space, in having considered the measure of time and the dimensions of space at stake in the scenic arc, in having studied the scenic-theatrical evolution in relation to new aesthetic currents, both spiritual and mental, created by Italian Futurists and by the consequent artistic tendencies.

Just as the avant-garde in plastic art turns for its own inspiration toward the forms created by modern industry, just as lyricism turns toward telegraphy, so theatrical technique orients itself toward the plastic dynamism of contemporary life, action.

The fundamental principles that animate *Futuristic scenic atmosphere* are the very essence of spiritualism, of aesthetics and of Futurist art, that is: *dynamism, simultaneity,* and *unity* of action between man and his environment.

The *technique of traditional theatre,* on the contrary, while neglecting and leaving unsolved these essential principles that are necessary for the vitality of theatrical action, created this dualism

between *man* (the dynamic element) and his *environment* (the static element), between synthesis and analysis.

We Futurists have attained and proclaimed this *scenic unity* by compenetrating the *human element* with the *environmental element* in a *living scenic synthesis* of theatrical action.

The theatre and Futurist art are, therefore, the consequent projection of the world and the mind moving rhythmically in scenic space.

The sphere of action in *Futurist scenic technique* wishes:

1. To summarize the essential through the purity of *synthesis*.

2. To render the dimensional evidence by means of *plastic* power.

3. To express the action of forces involved in *dynamics*.

SYNTHESIS PLASTIC ART DYNAMICS

This is the magic triangle that singles out and simultaneously summarizes the three different parts of the technical evolution of the Futurist stage.

From *scenography*, the empirical pictorial description of realistic elements, to *scenosynthesis*, the architectural synopsis of chromatic areas.

From *scenoplastics*, the volumetric construction of plastic elements of scenic environment, to *scenodynamics*, the spatial-chromatic architecture of dynamic elements of luminous scenic atmosphere.

SCHEMATIC TABLE

Scenosynthesis. Two-dimensional scenic environment—
predominance of the chromatic element—
intervention of architecture as a geometric element of linear
synthesis—
scenic action in two planes—
chromatic abstraction—
areas.

Scenoplastics. Three-dimensional scenic environment—
plastic predominance—

intervention of architecture, not as a perspective-pictorial
pretense, but as a living plastic reality, as a constructive
organism—
abolition of the stage [2]—
scenic action in three planes—
plastic abstraction—
volume.

Scenodynamics. Four-dimensional scenic environment—
predominance of spatial architectural elements—
intervention of rhythmic movement as a dynamic element
essential to the unity and to the simultaneous
development between environment and
theatrical action—
abolition of the painted stage—
luminous architecture of chromatic spaces—
polydimensional and polyexpressive scenic action—
dynamic abstraction—
space.

POLYDIMENSIONAL SCENOSPACE

Vast horizons for contemporary theatrical art are opened up by
this schematic table of Futurist scenic possibilities that is the result
of our research, which goes beyond the technique of the stage and
of interpretation toward a more complete and panoramic vision of
the problems that concern the future of the theatre.

While some daring *master-regisseurs* of the modern Russian
and German theatre are still involved in a search for a system of
framing the *scene* in the *scenic arc*, of perfecting the technical me-
chanism of the *stage*, simple or multiple, we Futurists already be-
lieve now that these hysterics of the *theatrical stagehand* of the
1700's have been surpassed, because we have substituted the
Futuristic polydimensional scenospace for the *traditional scenic arc.*

The stage and the scenic arc of the contemporary theatre no
longer respond to the technical and aesthetic requirements of the

[2] Prampolini is referring to the "abolition of the stage" *floor* as a single flat
plane upon which all of the action is presented.—Ed.

new theatrical sensibility. The flat, horizontal surface of the *stage*, as well as the cubic dimensions of the *scenic arc*, chain and limit the further developments of theatrical action, making it a slave to the scenic frame and the fixed-perspective visual angle. With the *abolition of the stage and the scenic arc*, the technical possibilities of theatrical action find a more ample agreement by trespassing upon the three-dimensional limits of tradition. By breaking the horizontal surfaces by the intervention of new vertical, oblique, and poly-dimensional elements, by forcing the cubic resistance of the scenic arc by means of the spherical expansion of rhythmic plastic planes in space, we arrive at the *creation of Futurist polydimensional sceno-space.*

Electrodynamic polydimensional architecture of luminous plastic elements in movement in the center of the theatrical concavity. This new *theatrical construction,* owing to its location, enlarges the perspective *visual angle* above the horizontal line by displacing it at the vertex and vice versa in simultaneous penetration toward a centrifugal irradiation of infinite visual and emotional angles of scenic action.

The polydimensional scenospace, the new Futurist creation for the theatre, opens new worlds for theatrical technique and magic.

ACTOR-SPACE

In the traditional and antitraditional theatre of today, the actor is always considered a *unique and indispensable element* dominating theatrical action. The most recent theoreticians and maestros of the contemporary theatre, like Craig, Appia, and Tairov, have disciplined the function of the actor and diminished his importance. Craig defines him as a *spot of color;* Appia establishes a hierarchy between *author, actors,* and *space;* Tairov considers him as an object, that is to say, like one of many elements in a scene.

I consider the actor as a *useless element* in theatrical action, and, moreover, dangerous to the future of theatre. The actor is the element of interpretation that presents the greatest unknowns and the smallest guarantees.

Whereas the *scenic conception* of a theatrical production represents an absolute of scenic transposition, the actor always represents

a *relative viewpoint*. In fact, the unknown quality of the actor is what deforms and determines the significance of a theatrical production, endangering the efficiency of the result. *Therefore, I consider that the intervention of the actor in the theatre as an element of interpretation is one of the most absurd compromises in the art of the theatre.*

The theatre, understood in its purest expression, is in fact a center of *revelation of mysteries—tragic, dramatic, comic,* beyond human appearance. By now we have had enough of this piece of *grotesque humanity* agitating itself under the vault of the stage in an effort to move itself emotionally. The appearance of the human element on the *stage* shatters the mystery *of the beyond* that must reign in the theatre, the temple of spiritual abstraction.

Space is the metaphysical aureole of the environment.
Environment is the spiritual projection of human actions.
What, then, can exalt and project the contents of theatrical action better than space, rhythmical space in the scenic environment?

The *personification of space* in the role of actor, as a dynamic and interacting element between the scenic environment and the public spectator, constitutes one of the most important conquests for the evolution of art and of theatrical technique, since the problem of *scenic unity* is definitely solved.

Considering *space* as a *scenic individual* dominating theatrical action and the elements agitating it as accessories, it is evident that this *scenic unity* is attained by the *synchronism* between the dynamics of the *scenic environment* and the dynamics of the *actor-space* at play in the rhythmic succession of the scenic atmosphere.

POLYEXPRESSIVE THEATRE
AND THE FUTURIST SCENIC ATMOSPHERE

Total metamorphosis of scenic technique toward the discovery of new polyexpressive horizons of theatrical interpretation.

From painting, *scenosynthesis,* to plastics, *scenoplastics;* from this to the architecture of plastic planes in movement, *scenodynamics.* From the traditional stage in three dimensions, to the creation of the *polydimensional scenospace;* from the human actor, to the new

scenic individual of *actor-space;* from this to *Futurist polyexpressive theatre,* which I already see outlined architectonically in the center of a valley of spiral terraces, *dynamic hills* on which boldly rise the *polydimensional construction of scenic space,* center of irradiation of Futurist scenic atmosphere. The theatre must abandon its character of experimental curiosities, of episodical extemporization on the life of a single person, to assume the function of a transcendental organism of spiritual education in a collective life. Out of the gymnasium of visual exercise, the theatre must also become the gymnasium for the exercise of thought.

The *Futurist polyexpressive theatre* will be a superpowerful center of abstract forces in play. Every *spectacle* will be a *mechanical rite* of eternal transcendence of matter, a magical revelation of a spiritual and scientific mystery.

A panoramic synthesis of action, understood as a mystical rite of spiritual dynamism.

A center of spiritual abstraction for the new religion of the future.

GIACOMO BALLA

Disconcerted States of Mind /
Sconcertazione di Stati d'Animo

Four people dressed differently.
White stage.
Begin all together.

1ST PERSON	(*loudly*) :	666 666 666 666	together liras
2ND PERSON	"	333 333 333 333	
3RD PERSON	"	444 444 444 444	
4TH PERSON	"	999 999 999 999	

(*Pause, always seriously.*)

1ST PERSON	(*loudly*) :	aaa aaa aaa aaa	together
2ND PERSON	"	ttt ttt ttt ttt	
3RD PERSON	"	sss sss sss sss	
4TH PERSON	"	uuu uuu uuu uuu	

(*Always seriously.*)

1ST PERSON	*raises his hat*	together
2ND PERSON	*looks at his watch*	
3RD PERSON	*blows his nose*	
4TH PERSON	*reads a newspaper*	

(*Pause, very expressive.*)

1ST PERSON	(*loudly*) :	sadness—aiaiaiaiaiaiaiai	together
2ND PERSON	"	quickness—quickly, quickly	
3RD PERSON	"	pleasure—si si si si si	
4TH PERSON	"	denial—no no no no no no	

(*Leave the stage, walking rigidly.*)

GIACOMO BALLA

To Understand Weeping / *Per Comprendere il Pianto*

MAN DRESSED IN WHITE (*summer suit*)
MAN DRESSED IN BLACK (*a woman's mourning suit*)

Background: square frame, half-red, half-green.
The two characters are talking, always very seriously.

MAN DRESSED IN BLACK: To understand weeping . . .
MAN DRESSED IN WHITE: mispicchirtitotiti
MAN DRESSED IN BLACK: 48
MAN DRESSED IN WHITE: brancapatarsa
MAN DRESSED IN BLACK: 1215 but mi . . .
MAN DRESSED IN WHITE: ullurbusssssut
MAN DRESSED IN BLACK: 1 it seems like you are laughing
MAN DRESSED IN WHITE: sgnacarsnaipir
MAN DRESSED IN BLACK: 111.111.011 I forbid you to laugh
MAN DRESSED IN WHITE: parplecurplototplaplint
MAN DRESSED IN BLACK: 888 but for G-o-d-'-s sake don't laugh!
MAN DRESSED IN WHITE: iiiiiirrrrririrriri
MAN DRESSED IN BLACK: 12344 Enough! Stop it! Stop laughing.
MAN DRESSED IN WHITE: I must laugh.

CURTAIN

UMBERTO BOCCIONI

Bachelor Apartment / *La Garçonnière*
THEATRICAL SYNTHESIS

Idiotic interior of an elegant youth's bachelor apartment—prints on the walls, a very low divan, several vases of flowers, as in all bachelor apartments. A newly-acquired painting is in front of the divan on an easel.

THE YOUTH (*listening eagerly near the door*): Here we are! (*Opens it.*) Good morning! . . . How are you? [1]

THE WOMAN (*advancing, with a certain reserve*): Good morning. (*Looking around her.*) It's nice in here . . .

THE YOUTH (*with fervor*): How beautiful you are! Very elegant! Thank you for coming . . . I doubted . . .

THE WOMAN: Why? Where is the painting? I came to see it.

THE YOUTH: It's this one. (*He takes her by the hand and conducts her in front of the painting. While* THE WOMAN *looks at it squinting,* THE YOUTH *takes her in his arms and kisses the nape of her neck.*)

THE WOMAN (*struggling energetically*): Sir! What are you thinking of? . . . These are really cowardly . . .

THE YOUTH: Excuse me. (*He grasps her again forcefully and speaks close to her mouth.*) You are very beautiful! You are mine! You must be mine! . . .

THE WOMAN (*struggling in a way that makes her seem serious*): Sir! Leave me alone! . . . I'll call for someone! I am a respectable woman! . . . Leave me alone!

THE YOUTH (*mortified, letting her go*): You are right. I ask your pardon . . . I don't know what I am doing . . . I will leave you.

THE WOMAN: Open the door for me! I want to get out of here!

[1] The formal "you" ("voi") is used throughout this *sintesi,* instead of the more familiar form, "tu."—Trans.

THE YOUTH (*going to open the door*): Go!

(*With this word,* THE WOMAN *lets her fur coat fall, and appears in black silk panties, with her bosom, shoulders, and arms nude. With coquetry and modesty, she runs to crouch on the divan.*)

THE WOMAN: You are timid, after all. . . . Turn that painting, and come here! . . .

UMBERTO BOCCIONI

The Body That Ascends / *Il Corpo che Sale*

An ordinary room on the second floor of a large apartment building. At the back, a large open window.

SECOND-FLOOR TENANT (*he is sitting in an armchair near the window, smoking. He springs up suddenly when an elongated body passes rapidly in front of the window going upward from below. Shouting, he leans out the window and looks up. Meanwhile, he hears his doorbell ring. He runs to open it.*): Oh God! Hello! Run! Have you seen it! A body rose from the street . . .

THIRD-FLOOR TENANT (*entering breathlessly*): You saw it too??!! A kind of gray cloud passed, grazing my window . . . I live on the third floor.

FIRST-FLOOR TENANT (*arriving*): I have gone crazy, or the supernatural is present! . . . Something passed in front of my window on the first floor . . . a solid, hairy body that rose dizzily! . . .

FOURTH-FLOOR TENANT (*entering terrified and clinging to the furniture*): Me too, I saw it also! But it seemed to me like a soft body, like liquid! . . .

FIRST-FLOOR TENANT: But no! It was long and hairy!

THIRD-FLOOR TENANT: No! No! No! I assure you. . . . It was evanescent like a gas . . .

SECOND-FLOOR TENANT: The concièrge would have seen it. . . . Let's call him.

THE OTHERS (*in chorus*): Yes! Yes! Let's call him! Concièrge! . . . Concièrge! . . .

(*The* CONCIERGE *enters.*)

ALL THE TENANTS (*with great confusion*): Have you seen it? Have you seen it? What rose from the street?

THE CONCIÈRGE (*calm, with a smile of compassion*): Calm your-

selves! Calm yourselves! It's nothing extraordinary! It is the young woman on the fifth floor who every day sucks up her lover with her glance . . . of course, he doesn't go up the stairs, that dirty pig! I maintain the honor of the building!

CURTAIN

UMBERTO BOCCIONI

Genius and Culture / *Genio e Coltura*

In the center, a costly dressing table with a mirror in front of which a very elegant WOMAN, *already dressed to leave, finishes putting on rouge. At the right, a* CRITIC, *an ambiguous being, neither dirty nor clean, neither old nor young, neutral, is sitting at a table over-burdened with books and papers, on which shines a large paper knife, neither modern nor antique. He turns his shoulder to the dressing table. At left, the* ARTIST, *an elegant youth, searches in a large file, sitting on thick cushions on the floor.*

THE ARTIST (*leaving the file, and with his head between his hands*):
It's terrible! (*Pause.*) I must get out of here! To be renewed!
(*He gets up, tearing the abstract designs from the file with convulsive hands.*) Liberation!! These empty forms, worn out.
Everything is fragmentary, weak! Oh! Art! . . . who, who will help me!? (*He looks around; continues to tear up the designs with sorrowful and convulsive motions.*)

(THE WOMAN *is very near him, but doesn't hear him. The* CRITIC *becomes annoyed, but not very, and going near her, takes a book with a yellow jacket.*)

THE CRITIC (*half-asking the* WOMAN, *and half-talking to himself*):
But what's the matter with that clown that he acts and shouts that way?

THE WOMAN (*without looking*): Oh well, he is an artist . . . he wants to renew himself, and he hasn't a cent!

THE CRITIC (*bewildered*): Strange! An artist! Impossible! For twenty years I have profoundly studied this marvelous phenomenon, but I can't recognize it. (*Obviously with archeological curiosity.*) That one is crazy! Or a protester! He wants to

238

change! But creation is a serene thing. A work of art is done naturally, in silence, and in recollection, like a nightingale sings . . . Spirit, in the sense that Hegel means spirit . . .

THE WOMAN (*intrigued*): And if you know how it is done, why don't you tell him? Poor thing! He is distressed . . .

THE CRITIC (*strutting*): For centuries, the critic has told the artist how to make a work of art. . . . Since ethics and aesthetics are functions of the spirit . . .

THE WOMAN: But you, you've never made any?

THE CRITIC (*nonplussed*): Me? . . . Not me!

THE WOMAN (*laughing with malice*): Well, then, you know how to do it, but you don't do it. You are neutral. How boring you must be in bed! (*She continues putting on her rouge.*)

THE ARTIST (*always walking back and forth sorrowfully, wringing his hands*): Glory! Ah! Glory! (*Tightening his fists.*) I am strong! I am young! I can face anything! Oh! Divine electric lights . . . sun . . . To electrify the crowds . . . Burn them! Dominate them!

THE WOMAN (*looking at him with sympathy and compassion*): Poor thing! Without any money . . .

THE ARTIST (*struck*): Ah! I am wounded! I can't resist any longer! (*Toward the* WOMAN, *who doesn't hear him.*) Oh! A woman! (*Toward the* CRITIC, *who has already taken and returned a good many books, and who leafs through them and cuts them.*) You! You, sir, who are a man, listen . . . Help me!

THE CRITIC: Calm down . . . let's realize the differences. I am not a man, I am a critic. I am a man of culture. The artist is a man, a slave, a baby, therefore, he makes mistakes. I don't see myself as being like him. In him nature is chaos. The critic and history are between nature and the artist. History is history, in other words subjective fact, that is to say fact, in other words history. Anyway it is itself objective.

(*At these words, the* ARTIST, *who has listened in a stupor, falls on the cushions as if struck by lightning. The* CRITIC, *unaware of this, turns, and goes slowly to the table to consult his books.*)

THE WOMAN (*getting up dumbfounded*): My God! That poor youth

is dying! (*She kneels in front of the* ARTIST *and caresses him kindly.*)

THE ARTIST (*reviving*): Oh! Signora! Thank you! Oh! Love . . . maybe love . . . (*Revives more and more.*) How beautiful you are! Listen . . . Listen to me . . . If you know what a terrible thing the struggle is without love! I want to love, understand?

THE WOMAN (*pulling away from him*): My friend, I understand you . . . but now I haven't time. I must go out . . . I am expected by my friend. It is dangerous. . . . He is a man . . . that is to say, he has a secure position . . .

THE CRITIC (*very embarrassed*): What's going on? I don't understand anything . . .

THE WOMAN (*irritated*): Shut up, idiot! You don't understand anything. . . . Come! Help me to lift him! We must cut this knot that is choking his throat!

THE CRITIC (*very embarrassed*): Just a minute . . . (*He carefully lays down the books and puts the others aside on the chair.*) Hegel . . . Kant . . . Hartmann . . . Spinoza.

THE WOMAN (*goes near the youth, crying irritably*): Run! . . . come here, help me to unfasten it.

THE CRITIC (*nonplussed*): What are you saying?

THE WOMAN: Come over here! Are you afraid! Hurry . . . back here there is an artist who is dying because of an ideal.

THE CRITIC (*coming closer with extreme prudence*): But one never knows! An impulse . . . a passion . . . without control . . . without culture . . . in short, I prefer him dead. The artist must be . . . (*He stumbles, and falls clumsily on the* ARTIST, *stabbing his neck with the paper knife.*)

THE WOMAN (*screaming and getting up*): Idiot! Assassin! You have killed him. You are red with blood!

THE CRITIC (*getting up, still more clumsily*): I, Signora? How?! I don't understand. . . . Red? Red? Yours is a case of color blindness.

THE WOMAN: Enough! Enough! (*Returns to her dressing table.*) It is late. I must go! (*Leaving.*) Poor youth! He was different and likable! (*Exits.*)

THE CRITIC: I can't find my bearings! (*Looks attentively and long*

at the dead ARTIST.) Oh my God! He is dead! (*Going over to look at him.*) The artist is really dead! Ah . . . he is breathing. I will make a monograph. (*He goes slowly to his table. From a case, he takes a beard a meter long and applies it to his chin. He puts on his glasses, takes paper and pencil, then looks among his books without finding anything. He is irritated for the first time and pounds his fists, shouting.*) Aesthetics! Aesthetics! Where is Aesthetics? (*Finding it, he passionately holds a large volume to his chest.*) Ah! Here it is! (*Skipping, he goes to crouch like a raven near the dead* ARTIST. *He looks at the body, and writes, talking in a loud voice.*) Toward 1915, a marvelous artist blossomed . . . (*He takes a tape measure from his pocket and measures the body.*) Like all the great ones, he was 1.68 [meters] tall, and his width . . . (*While he talks, the curtain falls.*)

PAOLO BUZZI

The Futurist Prize / *Il Premio di Futurismo*
THEATRICAL SYNTHESIS

A hall that could be in an Academy. A jury table, a presidential bench. Behind the President's head is a bust that could be that of F. T. Marinetti.

PRESIDENT: Honorable colleagues! And now it is a question of assigning the Futurist Prize. A Blériot [airplane] of the latest model that, as you know, is good for breaking all records of operation, height, and speed. There are a good many competitors. Poets, painters, sculptors, musicians, architects.

1ST JURY MEMBER: I propose a poet. We must reward the audacious free trading of these human eagles [1] giving them the means *really to fly* with proper wings.

2ND MEMBER: I propose, instead, a painter. Imagine the treasures of plastic dynamism that these devils should know how to discover up there with a palette!

3RD MEMBER: No, no, I propose a sculptor. Think what modelings of spaces by spirals, what bridges between plastic exterior infinity and interior could be created by a Michelangelo of the atmospheres!

4TH MEMBER: I suggest, instead, a musician. Enharmonics can only be fully conquered 8,000 meters from the ground.

5TH MEMBER: And I am for an architect. The building plan for a future city can only be studied there where the points of the skyscraper's groins reach.

PRESIDENT: Well? Let's decide. The first thing is to vote by secret ballot. Let's first vote for the genus of candidate. Then let's vote for the species, or in other words, for the names.

[1] The word "aquila" in Italian can also mean "genius."—Trans.

USHER: Very distinguished gentlemen, here is a new candidate. He asserts that the announcement of the contest did not have a category for the presentation of titles; and since he comes from far away and was unable to hasten his steps . . .

1ST MEMBER: Ah, for a Futurist . . . !

USHER: Thus, he asks to be admitted equally to the contest.

2ND MEMBER: And the titles?

USHER: He says he will present them himself, in person.

3RD MEMBER: I quickly withdraw my unfavorable prejudice.

4TH MEMBER: And I, mine.

5TH MEMBER: And I associate myself with both my colleagues.

PRESIDENT: Good, let's see him.

ARTIFICIAL MAN (*enters with slow steps*): Honorable sirs, I declare myself to be the most artificial man in the world. I have a cork leg, a plaited-rope arm, a rubber ear, a glass eye, and if this is not enough, a wig . . .

PRESIDENT: And you aspire, for this, to the Futurist Prize?

ARTIFICIAL MAN: Certainly. I was reduced thus by an explosion in a workshop in which I did chemical research into the basis of nitroglycerin . . . and of prussic acid . . .

PRESIDENT: What do you say to this? Honorable colleagues?

MEMBERS (*unanimously*): He wins the prize, by acclamation.

CURTAIN

PAOLO BUZZI

Parallelepiped / *Parallelepipedo*

THEATRICAL SYNTHESIS

An empty room. On the floor, a mattress in a parallelepiped form. On one side, a taut curtain.

LADY IN BLACK (*enters accompanied by a* POET, *occupant of the room*): But let's understand each other. I am not a woman who comes to a young man's bachelor apartment. I am a curious intellectual coming to see the house of an enigmatic poet.

POET: Good heavens, of course! It's natural!

LADY (*looking around her*): Where do you write?

POET: On the floor.

LADY: Where do you eat?

POET: On the floor.

LADY (*looking at the mattress*): And you sleep on the floor, very simple, but what a bizarre form your bed has!

POET: Parallelepiped.

LADY (*noticing the curtain*): And behind that curtain . . . the toilet!?

POET: Furniture.

LADY (*with surprise, ironically*): You have furniture?

POET: Parallelepiped. (*He pulls the curtain back; a straight, rigid, upright bier can be seen. He opens the cover by the hinges like a door of a closet. Inside one sees a hat, coat, and a pair of pants hanging up, and a pair of shoes at the bottom.*) As long as I stay on my feet, it also stays on its feet. When I sleep, I use only the bottom: it's soft, as you can see. (*Points to the mattress.*)

LADY: You are right. It is a very bizarre thing . . . and this mattress?

POET: Deliciously soft.

LADY: Wool? Moss?

POET: Hair. Woman's hair. The hair of all my women.

LADY: You don't say! You plucked them well, your little hens!

POET (*with sudden ardor, hugs the* LADY *around her waist*): I have been waiting for the day to pluck an eagle.[1]

LADY (*in an imperial manner*): Stop there. I am the one who will pluck you! (*Goes to close the door.*) Now, you must do everything that I want! (*Leads him near the upright bier, from which she takes the hat, coat, pants, and shoes*)

POET: Command!

LADY (*as if exercising a hypnotic power over the man*): Carry it!

(*He places the bier horizontally on the floor.*)

POET: And then?

LADY: And then, thus. (*She makes him put the mattress in the bier.*)

POET: And then?

LADY: And then, I AM DEATH. So let's hear no more! You must get in there.

POET (*with a last glimmer of hope*): With you?

LADY: You will see!

(*The man gets in the bier and falls as if struck. The woman closes the lid, turns the key, and puts it in her pocket, leaving silently.*)

[1] The word "aquila" in Italian can also mean "genius."—Trans.

PAOLO BUZZI

3nomial Voices Whirlpool Destruction /
3nomio Voci Gorgo Distruzione

FRANCESCO CANGIULLO

Detonation / *Detonazione*
SYNTHESIS OF ALL MODERN THEATRE

CHARACTER

A BULLET

Road at night, cold, deserted.

A minute of silence.—A gunshot.

CURTAIN

FRANCESCO CANGIULLO

The Lady-Killer and the Four Seasons /
Il Donnaiuolo e le 4 Stagioni
SYNTHESIS OF TWENTY YEARS OF LOVE

(I am sorry but I absolutely cannot give the names of the characters —and it is also necessary to forbid the actor-manager to give them.)

Neutral stage—side and back entrances—three seconds after the curtain rises a SCHOOLGIRL *in uniform enters from the left, reading a small book,* Month of Mary.[1] *With her eyes on the book, she comes slowly forward to the stage apron. A sacred picture falls from the pages. With great simplicity she picks it up and places it back between the pages. She begins to read again, remains in front of the foot-lights until the end.*

After ten seconds, a BATHER *enters from the rear. Of course she is in a swimming suit; blue trunks, sailor's blouse. Wearing a life jacket, the* BATHER *swims until the end always in a circum-scribed space reserved for her on the stage.*

After ten seconds a WIDOW *also enters from the back, bringing in a tomb furnished with a wreath and lighted church candles. Arranging it with the back almost in the right corner, she kneels and bows her head and remains motionless like someone who is being photo-graphed at length from behind.*

After ten seconds, a BRIDE *enters from the right, with her face hid-*

[1] A missal and appointment book.—Trans.

den in a bent arm. She is dressed in white satin, with a long veil, and a garland of orange flowers around her head. Timidly she comes forward to the apron and remains there until the end.

After twenty seconds, a very chic LADY-KILLER *bursts in from the back with great ease, smoking a cigarette. Nimbly and very self-confidently he throws himself on the edge of the stage apron, spreads his arms out with great openness to the audience, encases his head in his upper arms (the actor will remember Renato Simoni at the fourth curtain call) and, with a diplomatic smile, he fixes the whole audience with a sweeping and precise glance—then says:*

Voilà!

and agilely draws back electrically on his toes.

C
U
R
T
A
I
N

FRANCESCO CANGIULLO

The Paunch of the Vase / *La Pancia del Vaso*
THEATRICAL SYNTHESIS

Act 1

The laboratory of a scientist. In the middle, a cluttered table on which a glass vase is seen. Seated at the table, the SCIENTIST, *with the eyes of an idiot, mummified, looks through the paunch of the vase. Immobility of the surroundings. After three minutes—*
CURTAIN

Act 2

Repeat Act 1 identically.

Act 3

Like the first and second acts, except that: a minute after the curtain rises, I *come out . . . with a cudgel,* I *split the head of the* SCIENTIST, *who, very coldly, without losing his composure, his eyes still staring at the paunch of the glass vase, says to me*:

SCIENTIST: Would you please leave me your visiting card . . .

(I *throw it on the table, light a cigarette, and exit.*)

(*A minute later, without hurrying, the* SCIENTIST *rings a bell.*)

(TYPIST *appears.*)

SCIENTIST (*always intent*): Sew up my head and wrap it up well . . .

(TYPIST *takes the materials, disinfects them, sews, wraps his big head until she covers his eyes.*)

250

SCIENTIST (*hasn't moved*): Sit down, write.

(TYPIST *sitting at the typewriter.*)

SCIENTIST (*looks as best he can at the visiting card; then says, turning to the glass vase*): Signor Francesco Cangiullo, paragraph, Sirignano district, comma, Naples, Italy, in parenthesis. Dear Sir, comma, and paragraph, Italians, comma, especially Neapolitans, comma, are always very generous, period. Therefore, comma, I will be eternally grateful for this, comma, dear sir, comma, that you split my head rather than the glass vase, period and paragraph. With regards, comma, your . . .

(TYPIST *takes the letter to be signed.*)

(SCIENTIST *looks at it with what are left of his eyes and signs.*)

(TYPIST *leaves with the letter.*)

(SCIENTIST *turns, amazed and blind toward his glass vase.*)

FRANCESCO CANGIULLO

There Is No Dog / *Non c'è un Cane*
SYNTHESIS OF NIGHT

CHARACTER

HE WHO IS NOT THERE

Road at night, cold, deserted.

A dog crosses the street.

CURTAIN

FRANCESCO CANGIULLO

Vowel Refrains / *Stornelli Vocali*
VERSES OF LIFE—MUSIC OF DEATH

Neutral stage.

The curtain rises. Five CHARACTERS *are on the stage:* FOUR MEN *and one* WOMAN *are lined up at the center of the apron, the* WOMAN *last. Near the wings at right a* MAN *says:*

THE MAN: The refrain of the dying man
FIRST CHARACTER: Aaaah . . . !
THE MAN: The refrain of the doctor
SECOND CHARACTER: Eh . . . !
THE MAN: The refrain of the relatives
THIRD CHARACTER: Iiiih . . . !
THE MAN: The refrain of the brother
FOURTH CHARACTER: Oh, oh, oh, oh . . . !
THE MAN: The refrain of the crowd
FIFTH CHARACTER (*the woman*): Uh!!
THE MAN (*mechanically*): A.E.I.O.U.

CURTAIN

253

FRANCESCO CANGIULLO

Lights! / *Luce!*

Raised curtain.—Neutral stage.—Stage and auditorium completely in DARKNESS *for 3* BLACK *minutes.*

Voices of the PUBLIC

1.[1] ——Lights!
2. ——Lights!
4. ——Lights!
20. ——Lights!! Lights!!
50. ——Lights!! Lights!! Lights!! Lights!!

(*Contagious*)

THE ENTIRE THEATRE

L I G H T S ! ! ! ! !

(*The obsession for light must be provoked—so that it becomes wild, crazy—by various actors scattered in the auditorium, who excite the spectators and encourage their shouting.*)

The stage and auditorium are illuminated in an EXAGGER- ATED way.

At the same moment, the curtain slowly falls.

[1] The numerals indicate the number of speakers.—Trans.

254

FRANCESCO CANGIULLO

Lights [1] / *Luce*

The curtain rises. The apron, stage, and auditorium of the theatre are in darkness. Dark pause. Until someone shouts LIGHTS! (*Still darkness.*) *Then two spectators shout* LIGHTS! LIGHTS! (*Still darkness.*) *Then four, then the impatient shout becomes magnified, contagious, and half the theatre shouts:* LIGHTS LIGHTS LIIIGHTSSS! *The entire theatre:* LIIIIGHTSSSS!!! *Suddenly, the lights come up everywhere on the apron, stage, and in the auditorium. Four minutes of blazing fear. CURTAIN. And everything is clear.*

[1] Another script for the same presentation, *Lights* published in *Teatro della Sorpresa* (1922).

MARIO CARLI

States of Mind / *Stati d'Animo*
THEATRICAL SYNTHESIS

An open-air café. Various tables with people seated drinking, reading newspapers, gossiping, thinking, observing.

THE SPECULATOR (*continuously biting his fingernails*): Astrr ghrr frr magnakalacafu bragimaciucuanu astru gru frusciu micene micene.

THE STUDENT (*with nostalgia and slight bitterness*): Auflin bergin ochiputecio sesisettot orazz birrvin adlgo artu vioo bacimentosa.

THE COQUETTE (*glancing at the student and the speculator in turn, and sipping a mint seltzer*): Chiono chiono psi psi psi mari ninni mari ninni moitu tuasi coccolo coccolo coccolo coscela cicciala mormoragua.

THE CLERK (*leafing through a newspaper*): Ito rito marito oro coro coloro aso naso rimaso ugo nugo rifugo ito oro aso ugo ugo aso oro ito ito ugo oro aso aso oro ugo ugo ito ito it to o.

THE JOURNALIST (*speaking animatedly with his neighbor*): Icc acc birichich biriciach ciaciabo cinciabo perafara garatina mitalura vatrasaca oidone oidone psciatt inglaness farazona blim blam blumm!

THE DEPUTY (*with great oratorical gestures and a thundering voice*): Mirafago prorfon caralazz brugun fala neidor prokolifrogotipo campogofu tlombo!

THE LOVERS (*to each other*): Pci ni hai vir cir pui pui pui pui tu cchiu glu glu glu ingin vlin slin fuffi doddo kai kai kai kai.

THE POET (*with ecstatic eyes toward the* sky): Shudder mystery wings sunset icily. Showers lover moon suffered breathtaking murmur supine foliage strutting zooms rose-colored sighs blue.

THE PHILOSOPHER (*with his elbows on his knees and his temples between his hands*): Comparisons forces origins tension

256

casuistry universal perspicuity laws settlement overturn problem necessity we simplify corollary ambiguous time pessimism lucidity tumble.

THE WRESTLER (*enters like a racer, fights everyone, and overturns the tables*): Brututum zum pum!

REMO CHITI

Words / *Parole*

SUPPOSITION

THE CROWD
THE GATEKEEPER

Near the door of a government palace, courthouse or tribunal, parliament or treasury. Near the gate, an old, white-haired, automatic GATEKEEPER. *In front a* CROWD *speaks and argues; waiting, debating. Today the* CROWD *has an adamant wish; a strange influence murmurs something from its innumerable mouths: an unrestrainable irritation gushes from everyone; in the grayness of the compressed and dark air the stone walls of the palace ooze an enormous fatigue; here a thousand wishes come to a standstill, fight, and fall down, ruined, stopped.*

The life of the plaza, overflowing with conflict, shows signs of forming around a determined movement; a thousand glances strike the GATEKEEPER *who, pallid and in braided uniform, bars the door.*

THE CROWD (*from various points*):
 . . . and why ARE THEY also a . . .
 . . . exactly! And in FIFTY YEARS not . . .
 . . . go there! THAT IS enough . . .
 . . . of him who WAITS some more . . .
 . . . that is SOMETHING that doesn't work . . .
 . . . he put it BY THE DOOR and he said . . .
 . . . it is better FROM him . . .
 . . . he has a PALACE for . . .
 . . . and you UNDERSTAND that it isn't . . .
 . . . prove he DOESN'T wish to say . . .
 . . . and it doesn't INTEREST YOU AT ALL that . . .

. . . yesterday . . . TODAY . . . tomorrow . . .
. . . and FINALLY he said . . .
. . . he told me to BESTOW on you a . . .
. . . ONE is better than two . . .
. . . dream of a GOAL and then . . .
. . . if you have REACHED it, take . . .
. . . it is a blamable THING . . .
. . . you WOULDN'T WANT IT, give me . . .
. . . it is from DYING of laughter . . .
. . . do you have it, IS IT TRUE?, well then . . .
. . . ARE YOU TIRED so soon? Don't go . . .
. . . more than FIFTY or than . . .
. . . and the YEARS pass . . .
. . . they say one word ALWAYS . . .
. . . better AND better if . . .
. . . kiss the FEET of the Pope . . .
. . . if THEY STAY all the . . .
. . . oh! Here FINALLY that . . .
. . . to wait FOR it after not . . .
. . . and always! ALWAYS! always like this . . .

(*The* GATEKEEPER *wavers and falls to the ground, stricken by a strange and sudden illness.*)

REMO CHITI and EMILIO SETTIMELLI

Vagrant Madmen / *Pazzi Girovaghi*

Night. In a public garden near a lamp. Summer. On a bench a YOUNG
MADMAN *counts some gravel.*

YOUNG MADMAN: 1 . . . 2 . . . 3 . . . 4 . . . 5 . . . 6 . . . 7 . . . 8
. . . 9 . . . 10 . . . 11 . . . 12 . . . 13 . . . thousand 20,000! eve-
ning + evening = evening . . . then finally . . . (*Finishing in
a heap.*) a million! . . . A beautiful night to count pebbles from
1 to a million . . . too bad there is no moon . . . but there is a
lamp . . . ah! Men are cunning . . . evening + evening = eve-
ning . . . The lamp! . . . It's better when there is a moon . . .
The lamp is like a dried-up and pale moon . . . one pebble +
one pebble = moon + lamp = stars and atmospheric haze
outside and inside us . . . I knew a poem in the night . . . I
only understand it now . . . that it is: pebble + pebble—moon
+ lamps = scent of jasmine and a streetlight . . .

(*During this time another* MADMAN, *an old one, appears.*)

OLD MADMAN: Stop taking rocks for lanterns! . . . Stop it!

YOUNG MADMAN: Evening + evening = evening. Pebble + lamp =
scent of jasmine and a streetlight.

OLD MADMAN (*losing his patience*): Yes, look if you succeed in
blowing my nose with your shoes! . . .

YOUNG MADMAN: Do you know? . . . I have now understood an old
poem that I learned from a baby in a corner . . . No! Enough! . . .
I know it . . . streetlight less, but moon more . . .

OLD MADMAN: You provoke my gangrene! . . . stop speaking and slip
my hat in your pocket! . . . I am hungry, by God! . . . I am
hungry . . . No! I am not hungry . . . I have the hat on my
head . . . however, stop tormenting that octopus and slip the
hat in your pocket! . . . Enough! Enough! I am hungry! . . .

YOUNG MADMAN: Do you want some bread? . . . I have a lot of it

here in my body. I am twenty years old and I have eaten a lot of it every day! . . . You are hungry! . . . Turn the jacket inside out! . . .

OLD MADMAN: No! . . . The flies go respected! . . .

YOUNG MADMAN: Torment the handkerchief immediately! . . . or the tomato is lost . . . the cicadas have always amused me! I want to save it, the red tomato! . . . Watch out! . . . Watch out that the night and the night . . .

OLD MADMAN: Ah! Coward! I will give you the histories of the restaurant! . . . (*And he grasps him by the throat.*) You make me laugh . . . you clown! . . . Now I will give you a massage (*He strangles him, lets him go, and the youth falls to the ground.*) Damn! New shoes . . . it's better to go in the fields. (*And he disappears.*)

CURTAIN

BRUNO CORRA and EMILIO SETTIMELLI

Dissonance / *Dissonanza*

Thirteenth-century environment, thirteenth-century costumes. Shoes, velvets, blond wigs. A LADY *and* PAGE *are on stage. The* LADY *sits, listening to the* PAGE *who is speaking with passion.*

PAGE: Love, love, finally in this perfumed and mystic night of silver I can tell you of all my pains; love, love, finally the dream suffused in this clear night shadow tears from my heart the word that my lips would never dare say. I am timid in front of your wax pallor; ah! finally! and my steel heart breaks apart like pomegranate seeds, ah! finally! and my pride crouches under your dominating feet.

LADY: I receive with trembling spirit the gift that you are giving me with pure hands; in this air I also feel a dizziness of one thousand songs opening in my blood, I also feel a frost running through my heart that divides it like a sweet fruit, and my hesitating icy fingers tremble as if they were butterflies over your head of ardent blondness.

PAGE: Ah! If it were possible to have this moment as a gift from almighty Destiny in order to preserve it at the bottom of our hearts and thus always to be able to enjoy it when we feel like it. I don't want it to die and be over, I don't want it to flee and destroy itself in the very foggy ocean of time, I don't want it to go . . .

(At this moment a GENTLEMAN, *dressed in very modern clothes —overcoat, scarf, top hat—enters to the right with rapid steps, approaches the* PAGE, *and slaps him on the shoulder.)*

GENTLEMAN: Excuse me please, have you a match?

PAGE *(turns toward the* GENTLEMAN, *then looks around him and in his pockets with naturalness, saying)*: No, I'm sorry . . .

GENTLEMAN: It's nothing . . . Don't mention it. Thanks just the same. (*He leaves to the left, rapidly and elegantly.*)

PAGE (*turns again toward the* LADY *and starts again more lyrically and more passionately*): Love, love, we will find the force to make the indestructible moment eternal; we will perform a fruitful miracle.

CURTAIN

BRUNO CORRA and EMILIO SETTIMELLI

Faced with the Infinite / *Davanti all'Infinito*

A wild PHILOSOPHER, *quite young, ruddy-complexioned, "Berliner type" philosopher. He walks back and forth, gravely. He holds a revolver in his right hand, in his left a copy of* Berliner Tageblatt.

PHILOSOPHER: It is useless! . . . Faced with the infinite all things are equal . . . all things are on the same plane. Their birth, their life, their death—a mystery! And so, which thing should I choose? Ah! the doubt, the uncertainty! I really don't know today . . . 1915, if after my usual breakfast, I should start reading *Berliner Tageblatt* or I should fire a revolver shot instead . . . (*He looks at his right hand then at his left, raising the revolver and the newspaper with indifference. Bored.*) Well! Let's fire a revolver. (*He fires it and falls, shot.*)

CURTAIN

BRUNO CORRA and EMILIO SETTIMELLI

Gray + Red + Violet + Orange /
Grigio + Rosso + Violetto + Arancione
NET OF SENSATIONS

Community room: ordinary. A PATIENT *with bandages on his right arm and leg, sitting in a chair, speaks to his old* MOTHER, *a humble housewife. The young* PATIENT *is thirty years old but has long hair and is plentifully bearded.*

PATIENT: Ah Mama! What pain . . . what torture! . . . If I think that for two more months I must stay riveted to this chair, I am seized with agony . . . an agony . . . but then, Mama, will I be able to save this arm? I feel I will remain hampered all my life . . . my leg is better . . . but my arm!

MOTHER (*staying lovingly close to him*): But don't think these horrible thoughts! It's bad for you. You must look for distractions . . .

PATIENT: I can't, Mama. . . .

SERVANT (*entering*): Here is the Doctor.

MOTHER: Let him come in.

PATIENT: Oh! Thank goodness he came early!

(*The old* DOCTOR *enters gravely.*)

DOCTOR (*to the* MOTHER): Good morning . . .

MOTHER (*going up to him and shaking hands*): Doctor . . .

DOCTOR (*to the* PATIENT): Good morning . . . How are you?

PATIENT: Ah! My arm hurts terribly . . . and also my leg . . .

DOCTOR (*putting on his glasses*): Well! Let's take a look . . . (*He begins to unbandage the arm with care.*)

PATIENT: Ahi! . . . ahi! . . . ahi! . . . oh!!

MOTHER: Holy Madonna . . .

265

DOCTOR: Hand me the water basin with the sublimate, and also give me a little cotton . . .

(MOTHER *goes to do this.*)

DOCTOR (*looking at the wound*): Not bad! Not bad . . . courage . . . it is healing . . .

MOTHER: And the leg?

DOCTOR: It's better not to touch it today . . . we shall look at it tomorrow. (*To the* PATIENT.) I recommend not moving . . . stay absolutely still . . . the smallest movement can destroy everything good that was done in a week of absolute rest . . . (*After bandaging the wound again, he goes, with his hands stretched out in front of him, to wash himself.*)

MOTHER (*carrying another washbasin*): Here, Doctor . . .

DOCTOR: Thank you. (*They are to one side. The* DOCTOR *washes himself.*)

MOTHER: Well?

DOCTOR: He will recover . . . he will recover . . .

MOTHER: Nothing will remain to hamper him?

DOCTOR: Oh Lord, Signora! It's not easy to tell . . . it is certain, however, that the arm will not be able to stretch or move . . .

(*The* PATIENT, *who has looked fixedly at a spectator in the first row of the orchestra, at this point springs out of his chair with a savage leap and, pointing at the particular spectator, yells at the top of his voice.*)

PATIENT: Ah! It's him . . . it's him . . . he is the murderer of my brother! Seize him . . . don't let him escape! There . . . first row . . . seat number eight (*He starts to jump down from the apron.*)

(*The actors who play the parts of the* MOTHER *and the* DOCTOR *grasp him, other actors, stagehands, and firemen enter from the wings.*)

EVERYONE (*pulling him*): Stop it! Stop it! . . . what is it? . . . stop it! . . . for pity's sake . . . hold him . . . stop it! . . . come away! . . .

THE STAGE DIRECTOR (*runs in*): Lower it, lower the curtain!! Lower it!

(*The curtain falls while the recovered* PATIENT *is carried away by force. Half-a-minute pause. The footlights are relit and the cured* PATIENT *comes out sweetly, humiliated, with a loutish air and without a beard, and makes a gesture to speak.*)

HEALED PATIENT: No! Don't inconvenience yourselves, ladies and gentlemen! Forget it! Now I remember, the murderer of my brother had one eye less . . . the gentleman has both of his . . . excuse me . . . we shall begin the performance immediately. (*With a sigh.*) Ah! It was really a regrettable misunderstanding . . .

BRUNO CORRA and EMILIO SETTIMELLI

Negative Act / *Atto Negativo*

A MAN *enters, busy, preoccupied. He takes off his overcoat, his hat, and walks furiously.*

MAN: What a fantastic thing! Incredible! (*He turns toward the public, is irritated to see them, then coming to the apron, says categorically.*) I . . . I have absolutely nothing to tell you. . . . Bring down the curtain!

<div align="center">CURTAIN</div>

BRUNO CORRA and EMILIO SETTIMELLI

Old Age / *Passatismo*

Act 1

An OLD MAN *and an* OLD WOMAN *are sitting at a table across from each other. Near them is a calendar.*

OLD MAN: How are you?

OLD WOMAN: I am content. And you, how are you?

OLD MAN: I am content. (*Pause.*) What a beautiful day it will be tomorrow! (*Pause.*) Let's also remove the usual leaf today: Januray 10, 1860. (*Pause.*) Have you digested well?

OLD WOMAN: I am content.

OLD MAN: Have you conquered your dyspepsia?

OLD WOMAN: I ate well enough and have digested well. So I am content.

DARKNESS

Act 2

The same scene. The same arrangement.

OLD MAN: How are you?

OLD WOMAN: I am content. And you, how are you?

OLD MAN: I am content. (*Pause.*) What a beautiful day it will be tomorrow! (*Pause.*) Let's also remove the usual leaf today: January 10, 1880. (*Pause.*) Have you digested well?

OLD WOMAN: I am content.

OLD MAN: Have you conquered your dyspepsia?

OLD WOMAN: I ate well enough and have digested well. So I am content.

DARKNESS

Act 3

The same scene. The same arrangement.

OLD MAN: How are you?

OLD WOMAN: I am content. And you, how are you?

OLD MAN: I am content. (*Pause.*) Let's remove the usual leaf today: January 10, 1910.

OLD WOMAN: Oh God! What a stab in my heart! I am dying . . . (*She falls over and remains immobile.*)

OLD MAN: Oh God! What a stab in my heart! I am dying . . . (*He falls over and remains immobile.*)

CURTAIN

BRUNO CORRA and EMILIO SETTIMELLI

Sempronio's Lunch / *Il Pranzo di Sempronio*
SELECTION AND COMBINATION OF MOMENTS

SEMPRONIO, *five years old, is eating his soup at a small table. An old maid looks at him with affection.*

SEMPRONIO (*finishing his soup*): I have finished . . . I want some boiled meat!

<div align="center">DARKNESS</div>

SEMPRONIO, *twenty-five years old, robust, with a Vandyke beard and moustache, and very elegant. He is in a restaurant.*

SERVANT (*going toward the table*): Here is the boiled meat!
SEMPRONIO: Wonderful, Giovanni. (*Eats.*) What can you give me now?
SERVANT: Roast veal with vegetables, roast chicken, boiled chicken . . .
SEMPRONIO (*interrupting*): A little of the roast with vegetables . . . but right away . . .

<div align="center">DARKNESS</div>

African background, palms, red light of the setting sun. A Negro SERVANT *brings a piece of roast kid.*

SERVANT: Here . . . the roast . . .
SEMPRONIO: Wonderful, Karscia . . . What a smell! . . . Wonderful. (*He eats it with his hands. He is dressed as an explorer.*) Oh! Look, I'd also like some fruit! . . .

271

SERVANT: Right away. (*He leaves.*)

DARKNESS

Parisian cabaret. SEMPRONIO *is almost sixty years old, but he is still vigorous—Supper with a colorfully made-up young coquette.*

SERVANT: You asked me for some fruit? (*Going to a table, taking a tray, and bringing it over.*) Here is some . . .
SEMPRONIO: Take some, Nina . . . you're not having any?
NINA (*with a slight grimace*): No, I don't want any, *mon chéri* . . .
SEMPRONIO: Well, then . . . two coffees . . .

DARKNESS

SEMPRONIO *is ninety years old. He is sitting in an armchair completely covered by a blanket. Nearby the remains of a breakfast are on a table.*

SEMPRONIO: This coffee, is it coming or not?
MAID (*young and fresh-looking, carrying the coffee*): Here I am, sir, . . . here I am! (*She serves him.*)
SEMPRONIO (*takes the coffee with pleasure, then lays the cup down with a trembling hand*): Thank you, Antonietta . . . I have had a quick breakfast . . . but I've eaten well . . .

BRUNO CORRA and EMILIO SETTIMELLI

Toward Victory / *Verso la Conquista*

The hero is absorbed in his own thoughts. The woman caresses him treacherously.

ANNA: So, so my love . . . Do you completely understand my torment? Do you understand it? No! No! You must be faithful to me, you must be faithful to our wonderful dream! Stay! Iacopo, stay! . . .

IACOPO: Anna! Anna! You make me sick! You have performed an unworthy work on me . . . you have fought against the Hero in me who wants to prove himself at every cost!

(ANNA *doesn't speak, pulls him to her, taking his hands.*)

No! Anna! Please . . . don't speak to me anymore with your sweet voice, resembling an intoxicating and enervating perfume, don't touch me anymore with your expert hands that are putting my burning head to sleep . . . No! Anna! No! This depreciating work is not worthy of you, you must help me, you must throw me toward the future, your divine hand must help mine in case it trembles in the cutting of that sweet unbreakable string that unites our spirits! . . . No! Anna! I am not waiting for dissuasion, discouragement from you, I am waiting for the cry that encourages, the fated voice that precedes us and draws us like a spiritual magnetic pole! Shout to me that I must go, don't murmur to me so sweetly that I should remain! In this moment your caresses are my enemies! Your smiles, your tears are the chains that bind me to the ground! Love me truly, Anna, and then urge me to leave!

ANNA: Iacopo! Iacopo! I understand your agony, I understand your frenzy, but my love for you is too strong. I can't, I can't give you more! Stay, Iacopo! Stay! . . .

IACOPO: No! Leave me alone . . . I wanted to try to win you with every dignity. I indicated to you the way of duty, of love, I conceded to you all that I am able. . . . Now enough! . . . I shall be able to win by myself! Leave me alone! I am strong enough to sail alone, in spite of everything, toward the ways of Heroism! . . .

ANNA: You won't be able to do it!

IACOPO: I won't be able to? You incorrectly count on a moment of weakness. . . . Now I have become myself again . . . I shall leave here in spite of everything! . . .

ANNA: You won't be able to.

IACOPO: Ah! . . . You are very strange in your childish stubbornness! . . . I pity you because you ignore my Idea, my mission! Ah! My Idea! It is the greatest in the universe, it is purer and brighter than the sun, it is more intoxicating than the most intoxicating drink! I have my way mapped out! I have drawn it with the steel of my desire! I have illuminated it with the fire of my genius! . . . Look how I shatter your resistance, look how I am leaving here without even touching you, without even crying! Good-bye Anna! I am going toward victory, I am the master of my interior God, I am immortal now, I cannot fear any danger, any obstacle, everything will fall before me! Good-bye. (*He leaves resolutely.*)

ANNA: Iacopo! Iacopo! It's true, it's true, if you leave here! . . . and thus without even kissing me . . . ah . . . he is truly a God, if he was able to overcome my love . . . I shall follow him on his marvelous road!

(*A great noise is heard, and almost immediately a frightened* MAID *appears, breathless.*)

MAID: He is dead! Signor Iacopo is dead! His head is crushed! He rolled down the long stairs . . . sliding on a fig skin!

THE TWO WOMEN: Oh God! Oh God! (*They run toward the victim.*)

CURTAIN

ARNALDO CORRADINI [GINNA] and BRUNO CORRA

Alternation of Character /
Alternazione di Carattere

HUSBAND: No. It is useless. It is time to finish it! I shall not deceive myself any longer because I make you cry immediately!

WIFE (*crying*): No! Carlo no! . . . come here . . . come here . . . listen to me! . . .

HUSBAND (*crying tenderly*): Pardon me, Rosetta! Pardon me! . . .

WIFE (*enraged*): For God's sake! If you don't stop with this inopportune sentimentality, I will slap you . . .

HUSBAND (*at the height of his fury*): Enough! . . . or I shall hurl you out of the window . . .

WIFE: Darling! Darling! *How much* I love you! Tenderness grips my heart . . . give me again your delicious reprimands.

HUSBAND: Ah! Rosetta . . . Rosetta! . . . my infinite love . . .

WIFE (*exasperated*): If you repeat that another time, I will divorce you! . . . (*Precisely.*) I will divorce you! . . .

HUSBAND (*exploding*): Ah! Ah! Wretch! . . . go away! . . . go away! . . . go away! . . .

WIFE: I have never loved you more sweetly!

HUSBAND: Ah! Rosetta! Rosetta! . . .

WIFE: Enough . . . (*She slaps him.*)

HUSBAND: Enough, I say. (*Slaps her twice.*)

WIFE (*languidly*): Give me your lips! Give me your lips . . .

HUSBAND: Here, treasure!

CURTAIN

ARNALDO CORRADINI [GINNA] and EMILIO SETTIMELLI

From the Window / *Dalla Finestra*

THREE MOMENTS
CHARACTERS

ALL THE SPECTATORS
SLEEPWALKING FATHER
SLEEPWALKING DAUGHTER

To understand the drama, ALL THE SPECTATORS, *the protagonist characters, who are here must place themselves, by self-hypnotism, in the place of a paralyzed person who is unable to move or speak, to whom only life and light remain for the intelligence imprisoned in a dead body and who finds himself in bed near a window with its shutters opened by the wind during the three moonlit nights in which the* moments *of the action take place.*

FIRST MOMENT (First Night)

At the rise of the curtain one sees the very high wall of a castle looming in a moonlit night. Gusts of wind. Midnight strikes on a monotonous clock nearby. A completely dressed man appears from the left on the castle wall, a sleepwalker who moves against the wind (which makes his cloak flutter) with mechanical and secure steps. He disappears. Every SPECTATOR *hypnotizes himself into believing that the man is his father.*

CURTAIN

SECOND MOMENT (Second Night)

Same scene, same wind, same clock, same time. A young woman

276

comes from the right with her clothes on and her loose hair blowing in the wind. She crosses the stage with the same sleepwalking steps, walking on the same very high castle wall. Every SPECTATOR *hypnotizes himself into believing she is his sister.*

CURTAIN

THIRD MOMENT (Third Night)

Same scene, same wind, same clock, same time. At the same time the two sleepwalkers, FATHER *and* DAUGHTER, *appear on the wall, one from the right, one from the left, moving toward each other in the wind. They approach each other, collide, and fall into the void uttering a horrible scream.*

CURTAIN

FORTUNATO DEPERO

Colors / *Colori*

ABSTRACT THEATRICAL SYNTHESIS

Very empty cubic, blue room. No windows. No door frames.

FOUR ABSTRACT INDIVIDUALITIES *(mechanical movements by invisible strings)*	1. GRAY, *dark-gray, plastic, dynamic ovoid.* 2. RED, *red, plastic, triangular, dynamic polyhedron.* 3. WHITE, *white, plastic, long-lined, sharp point.* 4. BLACK, *black multiglobe.*

BLACK (*very profound, guttural voice*): TO COM *momomoo dom* pom grommo BLOMM uoco DLONN

don do-do-do	no
nonnno do do	no
mommo dommo	no
dollomo—dom	no
	no

mom mom mom mom # BLOM

BLOM — BLOM — BLOM (*Very prolonged.*)

WHITE (*sharp, thin, brittle voice*): ZINN—FINN fin ui tli tli dlinn dlinntiflinni tli tli uuuuuuu i i i i i i i i i i i i nin sin tin clin iii iii i i i i i zinz zinz dluinz pinnnzzz pinnnzzz

pinnnzzz

pinnnzzz

pinnnzzz

BLACK: Blom Blommo Blomm
GRAY (*animal-like voice*): Bluma dum du clu umu
 fublú
 flú flú
 flú flú . . . blú . . . blú
 bulubú bulú bulú bulú bulú bulú
 bulú bulú bulú bulú bulú bulú
 fulú bulú bulú . . . (*Very, very prolonged.*)
RED (*roaring, crashing*): SORKRA TI BOM TAM cò
 TE' TO' LICO'
 TUIT TUAT TUE
 tui iiiiiliutautautak taut
 TATATATATA TROK — PLOK

 tititònk
 tititànk
 tititènk
 PATONTA' Klo-klo-klo-klo-klo-klo
 TRAIO' TORIAAAAKRAKTO

 (*Very brief pause.*)

BLACK and GRAY (*together*):
 Each repeats his corresponding parolibero.

WHITE and RED (*together*):
 Each repeats his corresponding parolibero.

 A WHISTLE

MARIO DESSY

I Think It Would Be Correct To Do It This Way / *Mi Pare, che Sarebbe Giusto Fare Così*

The background of the scene is indefinable. Seated on the stage from left to right are a PHILOSOPHER, *a* POET, *a* POLITICAL MAN, TWO LOVERS.

PHILOSOPHER (*glassy eyes, beard ninety-five centimeters long*): That mass of rock that I see before me is the logic of life; one can no longer live without it, the desire to see profoundly of what it consists.

POET (*very young, with blue eyes*): Ah! That enormous mass that I see in front of me! It is suffocating! It constricts my breath! I want to destroy it! Logic no longer has a reason to exist! Men would be able to live without it, only singing!

POLITICAL MAN (*black, penetrating eyes, a cubic meter of paunch*): That enormous mass that I see before me is the state and society. In a furious battle, passions, sentiments, ideas clash within it. My mission is to amalgamate everything, to make everything adhere . . . to make everything fit.

(TWO LOVERS—*kissing, smiling, murmuring sweet words.*)

SOMEONE (*enters from the back with a candle in one hand and a box of matches in the other. He looks around. He sees the five seated people, strikes a match and with it lights the candle, then repeats this two or three times.*): I think it would be correct to do it this way. (*Then he distributes to each one a candle and a box of matches.*)

(*Everyone lights and extinguishes the candles five or six times, murmuring satisfied*):

It is correct, one must do it this way!

(*And they leave skipping about with the lit candles, preceded by* SOMEONE.)

DARKNESS

MARIO DESSY

Madness / *La Pazzia*

SYNTHESIS OF IMPRESSIONS

*The very elegant auditorium of a large, modern movie theatre.
A drama is being shown.*

The protagonist goes mad. The public becomes uneasy. Other characters go mad.

The spectators keep looking fixedly at the scenes of madness that rapidly follow each other on the screen. Little by little everyone is disturbed, obsessed by the idea of madness that comes over them all. Suddenly the spectators get up screaming . . . gesturing . . . fleeing . . . confusion . . . MADNESS.

CURTAIN

MARIO DESSY

The Troop Train / *La Tradotta*
SYNTHESIS OF ENVIRONMENT AND STATE OF MIND

The interior of a carriage of a military troop train that is going toward the front.

Some thirty soldiers: who laugh, sleep, talk, joke; everyone is happy and noisy.

A beautiful, very elegant and perfumed woman climbs on at a stop. Surprise and general amazement.

The woman is looking for someone: she makes a tour of the carriage looking at all the faces, then gets off again.

The train starts again, the perfume disappears. Smiles of those who are going toward

THE WAR.

CURTAIN

MARIO DESSY

Waiting / *Attesa*
COMPENETRATION OF ENVIRONMENTS

At right a sitting room: some chairs, a table with a vase of flowers, etc., a door at the rear. At left a sitting room: furniture of a different style, a door at the rear, another on the left. The two sitting rooms are not separated by any walls.

Sitting room at right: a YOUNG MAN *walks nervously back and forth. He looks at the clock every now and then.*

Sitting room at left: an ELEGANT YOUTH, *dressed in a dinner jacket, is stretched out and smoking. Suddenly he looks at his watch.*

YOUNG MAN: Nine o'clock! In a few minutes she will appear, beautiful like spring, bringing me all the smiles and all the lights of that season. And, unfortunately, it will be the last time. Destiny wishes to separate us . . . if she goes far from here, after several months nothing will remain of me and my love except vague remembrances. I will remain thus, suffering, remembering her, crying for her, in this love nest where the smallest thing is one of her words, one of her smiles,

ELEGANT YOUTH: Already nine o'clock! And she hasn't appeared! (*He leafs through a newspaper. Then he gets up abruptly and walks around.*) She assured me: eight-thirty.

How can I go out now with these shoes that are hurting me? Maybe she will see . . . oh, this waiting makes me nervous . . . (*Looks at his watch.*) five after nine . . . For two cents I would change my shoes. But the others don't fit me, darn it! Oh! What a bore shoes are! (*He walks up and down . . .*

284

one of her perfumes, one of her kisses . . . (*He continues walking.*) The time is passing. . . . She isn't coming. . . . I feel it. (*Takes a rose from the vase of flowers, pulls the petals off and lets them fall.*) They say these petals that are falling from sadness . . . are my tears! The time is passing. But how? How is time measured? (*Falls on his chair looking thoughful.*) Is time long? (*Stretches his legs.*) I want to shorten the waiting. Waiting for whom? for her? No, for death. (*His head falls on the back of the chair.*)

then he stops near the table and looks at a photograph of a woman.) In a few minutes you will be near, my fairy queen! My only good one! And I shall smother my lips in your purple ones. I shall bear the sweet spasms of love near you . . . I shall breathe your flesh . . . Damn these shoes! (*Looks at his watch.*) ten after nine . . . I shall go out with these shoes on . . . but, on my word as a gentleman, when I settle the account with her, I want to deduct ten liras for waiting!

CURTAIN

FILLIA

Mechanical Sensuality / *Sensualità Meccanica*

Stage: five planes of metallic slabs; the first two are black, the intermediate two are gray and the rear one is white. They are placed in regular perspective. In the middle of the stage is a red spiral (SPIRIT) that reaches to the ceiling; at right is a great white cube (MATTER); at left there are different colored geometric figures united in the form of a machine (ACTION).

When the voice comes from the spiral it illuminates the whole stage with one of its red lights and moves upward in an infinite winding motion. When the voice comes from the cube, it radiates a white light while making a circular movement that always pivots exactly on its own center. When the voice comes from the machine, it radiates a yellow light while making rhythmic vibrations like the movement of diverse gears.

Although the three figures move only when they are talking, the five planes of metallic slabs continually quake slightly, giving the impression of an environmental development.

At the rise of the curtain, the slabs and the spiral are moving: this illuminates the stage with a heavy red color; ventilators blow very cool air from three sides of the auditorium; scarcely perceptible noise of metallic dissonance.

THE SPIRAL (*sharp, masculine, very clear voice*):

R TI R	men have been engrossed by me-	R TI R
R TA R	chanical expansion. Necessity	R TA R
R TUM R	constructed from sensual spirit,	R TUM R
R TI R	the enrichment of the environ-	R TI R
R TA R	ment. Heat of human compensa-	R TA R
R TUM R	tions, brutal like males who an-	R TUM R
R TI R	nul the "I" on the cemented	R TI R
R TA R	street of the future. Everything	R TA R
R TUM R	is geometrical—lucid—indispen-	R TUM R
R TI R	sable: splendor of the artificial	R TI R
R TA R	sex that has speed in place of	R TA R
R TUM R	beauty—	R TUM R

(The lights go out: THE SPIRAL, *the noises, and the ventilators stop. White light—circular movement of* THE CUBE—*absolute silence—normal temperature in the auditorium.)*

THE CUBE *(feminine, very sweet voice)*:

> my virgin, unformed, and femi-
> nine material thirsts for love.
> I spasmodically desire to sur-
> render to the violent arms of
> the spirit that gives me power—
> movement—agility—

*(The white light goes out—*THE CUBE *stops.)*

Yellow light—rhythmic movement of THE MACHINE—*very regular noise—normal temperature.*

THE MACHINE *(always in an even voice, without nuance)*:

VRRUM	to live in action, to produce,	VRRUM
TA	modify, to exceed itself; the	TA
TA	world drinks the oxygen of ma-	TA
VRRUM	chines for its insatiable lungs and	VRRUM
TA	sings more strongly!	TA
TA		TA

*(The yellow light goes out—*THE MACHINE *and noises stop.)*

(*A moment of darkness.*)

(*Simultaneously—movements of* THE SPIRAL, CUBE, *and* MA-CHINE—*ventilators blow very hot air.*)

VR_{UM} ^{TI}_{TA} PUM _{TI}^{TA} PUM

TA TA TI
TA TA
TA quickly, more quickly, it TA
TI is necessary to liberate
TI ourselves from TIME, as- pUM
TA cend, ascend, ASCEND! TA
 TA

PUM PUM PUM PUM PUM

GUGLIELMO JANNELLI and LUCIANO NICASTRO

Synthesis of Syntheses / *Sintesi delle Sintesi*

Empty stage: a long dark corridor at the end of which a small red lamp flashes off and on, a long way off. Then, a streak of white light appears like a carpet along the corridor.

Five seconds.

A revolver shot. Scream. Noises. Confused cries.

Pause.

The fresh burst of a woman's laughter.

Simultaneously a door at the back is thrown open by a blow, blinding the audience with a huge, powerful light.

The curtain detaches,
 and falls.

FILIPPO TOMMASO MARINETTI

Feet / *Le Basi*

A curtain edged in black should be raised to about the height of a man's stomach. The public sees only legs in action. The actors must try to give the greatest expression to the attitudes and movements of their lower extremities.

1.

Two Armchairs
(one facing the other)

A BACHELOR
A MARRIED WOMAN

HIM: All, all for one of your kisses! . . .
HER: No! . . . Don't talk to me like that! . . .

2.

A MAN WHO IS WALKING BACK AND FORTH

MAN: Let's meditate . . .

3.

A Desk

A SEATED MAN WHO IS NERVOUSLY MOVING HIS RIGHT FOOT

SEATED MAN: I must find . . . To cheat, without letting myself cheat!

3a.

A MAN WHO IS WALKING SLOWLY WITH GOUTY FEET
A MAN WHO IS WALKING RAPIDLY

THE RAPID ONE: Hurry! Vile passéist!

THE SLOW ONE: Ah! What fury! There is no need to run! He who goes slowly is healthy . . .

4.
A Couch

THREE WOMEN

ONE: Which one do you prefer?
ANOTHER: All three of them.

A Couch

THREE OFFICIALS

ONE: Which one do you prefer?
ANOTHER: The second one.
(*The second one must be the woman who shows the most legs of the three.*)

5.
A Table

A FATHER
A BACHELOR
A YOUNG GIRL

THE FATHER: When you have the degree you will marry your cousin.

6.
A Pedal-Operated Sewing Machine

A GIRL WHO IS WORKING

THE GIRL: I will see him on Sunday!

7.

A MAN WHO IS RUNNING AWAY
A FOOT THAT IS KICKING AT HIM

THE MAN WHO IS GIVING THE KICK: Imbecile!

FILIPPO TOMMASO MARINETTI

A Landscape Heard / *Un Paesaggio Udito*
RADIO *Sintesi*

The whistle of a blackbird, envious of the crackling of a fire, ends by extinguishing the gossip of water.

10 seconds of lapping.

1 second of crackling.

8 seconds of lapping.

1 second of crackling.

5 seconds of lapping.

1 second of crackling.

19 seconds of lapping.

1 second of crackling.

25 seconds of lapping.

1 second of crackling.

35 seconds of lapping.

6 seconds of the whistle of a blackbird.

FILIPPO TOMMASO MARINETTI

Silences Speak Among Themselves /
I Silenzi Parlano fra di Loro
RADIO Sintesi

15 seconds of pure silence.

Do-re-me on a flute.

8 seconds of pure silence.

Do-re-mi on a flute.

29 seconds of pure silence.

Sol on a piano.

Do on a trumpet.

40 seconds of pure silence.

Do on a trumpet.

10 seconds of pure silence.

Do on a trumpet.

Ne-ne-ne of a baby.

40 seconds of pure silence.

Ne-ne-ne of a baby.

11 seconds of pure silence.

1 minute of rrrrr of a motor.

11 seconds of pure silence.

Amazed oooooo's from an eleven-year-old little girl.

FILIPPO TOMMASO MARINETTI

They Are Coming / *Vengono*
DRAMA OF OBJECTS

Luxurious room, evening.—A large lighted chandelier. Open French windows (upstage left) that open onto a garden. At left, along the wall, but separated from it, a large rectangular table with cover. Along the wall on the right (through which a door opens), a huge and tall armchair beside which eight chairs are aligned, four to the right and four to the left (of the armchair).

A MAJORDOMO *and two servants in tails enter from the left door.*

THE MAJORDOMO: They are coming. Prepare. (*Exits.*)

> (*The servants, in a great hurry, arrange the eight chairs in a horseshoe beside the armchair, which remains in the same place, as does the table. When they have finished, they go and look out the door* [1], *turning their backs to the audience. A long minute of waiting. The* MAJORDOMO *reenters, panting.*)

THE MAJORDOMO: Countermand. I am very tired. . . . Many cushions, many stools . . . (*Exits.*)

> (*The servants exit by the right door and reenter loaded down with cushions and stools. Then, taking the armchair, they put it in the middle of the room and arrange the chairs (four on each side of the armchair) with the chairs' backs turned toward the armchair. Then they put cushions on each chair and on the armchair and stools before each chair and, likewise, before the armchair.*

> *The servants go again to look out the French windows. A long minute of waiting.*)

[1] *La porta:* Marinetti apparently means the French windows.—Trans.

294

THE MAJORDOMO (*reenters, running*): Briccatirakamekame.
(*Exits.*)

(*The servants carry the table to the middle of the room, arrange the armchair (at the head of the table) and the chairs around it: then, leaving and reentering from the right door, they rapidly set the table. At one place, a vase of flowers; at another, a lot of bread; at another, eight bottles of wine. At other places, only a knife, fork, and spoon . . . one chair must be leaning against the table, with its rear legs raised, as is done in restaurants to indicate that a place is reserved. When they have finished, the servants go again to look outside. A long minute of waiting.*)

THE MAJORDOMO (*reenters, running*): Briccatirakamekame.
(*Exits.*)

(*Immediately, the servants replace the table, which remains set, in the position it occupied when the curtain went up. Then they put the armchair in front of the French windows, at a slant, and behind the armchair they arrange the eight chairs in Indian file diagonally across the set. Having done this, they turn off the chandelier. The set remains faintly lit by the moonlight that is coming in through the French windows. An invisible reflector projects the shadows of the armchair and chairs on the floor. The very distinct shadows (obtained by moving the reflector slowly) visibly lengthen toward the French windows.*

The servants, wedged into a corner, wait trembling with evident agony, while the chairs leave the room.)

AUGUSTO MAURO

Death and Transfiguration / *Morte e Trasfigurazione*
SYMPHONIC POEM

ELECTRIC—VIBRATING—LUMINOUS
in Four Parts

THEMATIC MOTIFS

LIFE: ovoid expression with RED, DARK BLUE, YELLOW lights.

NOSTALGIA: expression of VIOLET and GREEN points grouped in an oscillating nebula.

AGONY: gradual dissolution of BRIGHT BLUE nebulas with OFF-WHITE stripes.

FIRST PART (The Struggle with Death)

The BLACK velvet curtain rises and the "sensitive darkness" appears, star-spangled with motionless lights placed in concentric circles: a dim tone with a predominance of GREEN and YELLOW. In the center of the smallest circumference the thematic motif of life *slowly unfolds (ovoid expression with RED, DARK BLUE, and YELLOW lights) and endeavors to spread beyond the circular rim in which it was enclosed.*

The circles shrink and enlarge time and again, as if breathing, and in the movement they intensify for an instant the tone of their own color, while the thematic motif of life *undergoes contortions and BRIGHT BLUE shudders.*

SECOND PART (The Dance of the Past)

The theme of life *recomposes in its original form and, after a final* YELLOW *flash, remains immobile radiating luminous vibrations of* RED, DARK BLUE, *and* YELLOW. *The concentric circles enlarge and begin to turn one against the other, unraveling their colors with maximum tonal force. Then their circular forms gradually dissolve, so that the sensitive darkness appears covered with a nebula of luminous drops with a prevalence of* YELLOW.

The thematic motif of nostalgia (*expression of* VIOLET *and* GREEN *points*), *which is located in the upper right corner of the sensitive darkness, appears. The other lights go out with small metallic clicks, and only the* theme of nostalgia *stands out. It begins to disperse in* ORANGE *vibrations around the* theme of life *that is situated below.*

Now from the other corner pour groups of lights that lose themselves, vanishing first by touching the ovoid of life, then by alternating with moments of darkness immediately followed by the musical-luminous comment of the theme of nostalgia. *Thus:*

1. MEMORIES OF CHILDHOOD: *rain of* WHITE *lights, then* PINK, *then* BLUE, *which descend skipping and plucking the* sensitive darkness.—DARKNESS—*the* theme of nostalgia *performs a tune.*
2. MEMORIES OF LOVE: *flashes of* RED—SCARLET—VIOLET *that flow down from above, kneading themselves into an* ORANGE *dart, which darts away from the bottom skimming and making the* thematic motif of life *quake*—DARKNESS—*the* theme of nostalgia *unwinds intensifying the tonalities.*
3. BATTLE OF THE ASPIRATIONS: *turbines of* BLUE, YELLOW, RED, VIOLET, BLACK, WHITE, SCARLET *lights, which resolve in dynamic expressions of* ellipses, curved lines, parabolas, hyperbolas, ellipsoids, *etc., etc., that, by slowly darting, form a homogeneous and compact nucleus, which shatters into many* WHITE *vibrations that lose themselves in every direction* —DARKNESS—*the* theme of nostalgia *unwinds with luminous variations trying to make the tonality of colors brown, until the*

nebula that expresses it, passing from GRAY *to* BROWN *to* BLACK, *will become completely absorbed by the* sensitive darkness.

THIRD PART (The Last Agony-Quivers)

The thematic motif of life *remains on the dark plane, its ovoid expression, serenely moved at first by fixed lights, begins to vibrate intensely and, quaking, assumes queer deformations.*

For several seconds the theme begins unwinding with grotesque contortions and spasms, *then a second of complete darkness, followed by a sharp* rain *of* RED *bars. Darkness again, and the* theme of life *reappears and, rotating in the center of the* sensitive darkness, *grows smaller and becomes intensified into a* SCARLET *point.*

FOURTH PART (Transfiguration)

The SCARLET *point gradually discolors until it becomes* GRAY. *Then* metallically it goes out—DARKNESS— *The point reappears in* BLUE *and suddenly a luminous and roaring spiral turns around it, enlarges over the whole plane, and, turning with fantastic speed, shoots off luminous vibrations of* ALL THE COLORS AND ALL THE TONALITIES.

DARKNESS CURTAIN

BALILLA PRATELLA

Nocturnal / *Notturno*
DRAMATIZED STATE OF MIND

In a garret at night. The WIFE *is seated with her elbows on the table and her head between her hands. In the middle of the table, a lit candle stump. Around her are a bed, some chairs, and old but very clean furniture—misery. At left, an ugly door with a latch. In back, a small window. The* HUSBAND, *silent, is looking out at the darkness through disjointed windowpanes.*

WIFE: Looking at the stars doesn't fill one's stomach.

(*The* HUSBAND *doesn't respond, perhaps he hasn't heard.*)

Ah! What a disgraceful life. I can stand no more of it, really no more! (*The* WIFE *cries.*)

(*The* HUSBAND, *as if dazed, pulls himself away from the window, approaches the table and blows on the candle stump, putting it out. Then he returns and looks out into the darkness.*)

Darkness too! (*She continues to cry.*)

(*The* HUSBAND *slowly opens the window. No noise. Above a grayish expanse of the snow-covered roof, the sky is marvelously serene and flowery with stars.*)

Darkness, cold! You want to make me die. Ah! I will leave here; I will leave you here alone. And then throw yourself out of the window as well, if it pleases you. (*Pause. The* WIFE, *furious, jumps to her feet and clings to the* HUSBAND'S *clothes, shaking and tearing at him violently.*) But are you made of ice? Are you sleeping the dream of the dead!

HUSBAND (*turning slowly*): I recognize ten million stars . . . red, yellow, green ones . . .

299

WIFE (*starting at a mysterious noise*): Ah! What is that?

HUSBAND: How many millions of stars! . . .

WIFE (*trembling*): They are outside the door! Who is it?

HUSBAND (*returning to his former position*): To know all of them
. . . all . . .

(*The door opens and three nocturnal* THIEVES *enter: the last
one closes the door. A* THIEF *strikes a match and with it lights
the candle stump; the other two place themselves in front of
the* WIFE.)

WIFE (*frightened*): What do you want?

FIRST THIEF: We are thieves.

WIFE (*raising her hands*): Hunger, cold, misery . . .

SECOND THIEF (*grabbing her*): We steal women. Come with us.

WIFE (*more tranquil*): I will go with you.

FIRST THIEF (*threatening*): And if you scream . . .

WIFE (*smiling*): No, I won't scream . . .

THIRD THIEF (*discerning the* HUSBAND): There's a man . . .

(*All of them go toward the* HUSBAND. *They drag him to the
middle of the stage; he is impassive and doesn't see or feel
anything.*)

WIFE (*happy*): My husband. Leave him be; he counts stars . . .

FIRST THIEF: Ah! You count stars? Look, I am kissing your wife . . .

SECOND THIEF: Look, I am embracing your wife . . .

THIRD THIEF: Imbecile . . . go to hell . . .

(*A powerful blow; the* HUSBAND *staggers, he stumbles and
falls without a movement or a cry.*)

THREE THIEVES and WIFE (*laughing noisily*): Ha ha ha ha ha ha ha!
(*They flee, embracing one another.*)

(*Silent pause. The* HUSBAND *revives, rises little by little, goes
to close the door, and barricades it. He puts out the candle
stump, and then returns again to the window to contemplate
the stars ecstatically.*)

SLOW CURTAIN

ANGELO ROGNONI

Education / *Insegnamento*

A classroom.

THE PROFESSOR (*thirty years old. He is reading to his students.*):
Dante is a great poet. He wrote the *Divine Comedy* and . . .

(*Several seconds of darkness.*)

THE PROFESSOR (*forty years old. He is reading with a bored voice.*):
Dante is a great poet. He wrote the *Divine Comedy* and . . .

(*Several seconds of silence.*)

THE PROFESSOR (*sixty years old. He is like a gramophone.*): Dante
is a great poet . . .

A PUPIL (*interrupting him*): Why?

THE PROFESSOR (*surprised and embarrassed*): It is printed here. Sit
down and be quiet. Dante is a great poet. He wrote . . .

CURTAIN

ANGELO ROGNONI

Weariness / *Stanchezza*
PHYSICAL STATE WRITTEN AS A SCRIPT

Stage: a gray background.

A MAN *enters. He is visibly tired. He stretches out in an armchair. He closes his eyes.*

Sound of a violin; a dirge without a well-defined tune.

Humming far off.

From above a transparent curtain descends that blurs the environment.

Lengthy hissing far off, insistent.

The sound of the violin ceases.

A faint howling.

From above a black exclamation mark descends at left.

The howling becomes more sinister.

Blue lights.

The humming increases in intensity.

A second, very tall exclamation mark descends at center.

All the noises cease.

Absolute silence.

The MAN *reclines his head. (He is asleep.)*

Darkness.

CURTAIN

302

MARIO SCAPARRO

A Birth / *Un Parto*

PERFORMERS

ALBATROSS, A young and strong airplane enamored of
FEMALE SEAPLANE, An elegant dancer of the Tyrrhenian Sea
FEMALE BIPLANE (Period of pregnancy of the SEAPLANE)
AVIATORS, Identical brothers born from the BIPLANE
WATER, CLOUDS, SKY, WAVE CRESTS, etc., etc.

The fantasy takes place during our days in aviation camp at Torre Astura and on the nearby coast.

First Vision

SEAPLANE (*Stripped of any modesty, she dashes resolutely on the blue-green surface of the water. She slowly performs a voluptuous dance based on spirals, winding and twisting serpentines. Under her caresses the long crests of the waves swell rapidly. The SEAPLANE skims over them all and continues the development of her dance without bothering with them.*)

(*The public, at windows of a great, colossal "Super-Airplane," witness the development of the dance that, from high up, looks like a point of inflamed gold from the sun flying on the carpet of waves.*)

Second Vision

ALBATROSS, *arriving with lightning speed, he races the motors of his muscles to make himself handsome before the SEAPLANE.*
SEAPLANE, *turns slowly upward, sees the ALBATROSS . . . a wave*

splashes against her and, like an enticing giggle, thousands of little teeth of white spray jump into the air.

ALBATROSS, *not being able to restrain himself, he falls with the fury of a howitzer on top of the* SEAPLANE.

(*A screen of clouds enwraps the two young airplanes.*)

Fourth Vision [1]

BIPLANE, *coming down out of the clouds, she slowly proceeds toward the ground. From her physiognomy, one is very well aware that this other plane is only the* SEAPLANE *pregnant. She flies over the ground for several minutes, searching for the grassiest meadow, soft and comfortable like a mattress, then she alights on it. Her belly opens and four* AVIATORS *jump out completely equipped!*

[1] Note that Scaparro has omitted a Third Vision.—Trans.

MARIO SCAPARRO

The Improvised Balloon* / *Il Pallone Improvvisato*

PERFORMERS

THE MAN
THE CLOUD
THE BELLY
THE BASKET
THREE PASSENGERS
THE BALLOON WITH THE HEAD OF A MAN

The fantasy takes place on the balcony of a cottage and in the sky overhead.

Single Vision

THE MAN *appears on the balcony breathing the air deeply.*

THE CLOUD *is rapidly deformed by the inhalation of* THE MAN, *lengthening toward him and disappearing inside his inhaling mouth.*

THE BELLY *gradually swells enormously as* THE MAN *swallows* THE CLOUD. . . . *It becomes an enormous spherical balloon that* THE MAN'S *waistcoat checkers like the rigging of an aerostat. . . . The balcony forms* THE BASKET. . . . *Three people take their places and* THE BALLOON WITH THE HEAD OF A MAN *ascends.*

* Described by Scaparro as a "cinemagraphic poem."—Ed.

305

MARIO SCAPARRO

The Rainbow of Italy* / *L'Arcobaleno d'Italia*

PERFORMERS

THE HURRICANE
THE GOOD WEATHER
A DIRIGIBLE LOADED WITH PAINTERS, BRUSHES, AND PAINTS

The fantasy takes place somewhere in Italy.

First Vision

THE HURRICANE *blows with all the fury and racket produced by the clash of thousands of express trains. Formidable explosions of black clouds. Red thunderbolts.—Raging, they strike Italy knocking over numerous vases that three-hundred and eleven ingenious painters have placed on the ground to collect all the colors of* THE HURRICANE.

Second Vision

THE GOOD WEATHER *has followed* THE HURRICANE—*but the rainbow has still not appeared . . .*
A DIRIGIBLE LOADED WITH PAINTERS, BRUSHES, AND PAINTS *rises . . . going slowly toward the horizon—and moves gradually upward, as the* PAINTERS *paint the tricolor rainbow of Italy on the sky.*

* Described by Scaparro as a "cinemagraphic poem."—Ed.

GIUSEPPE STEINER

"Saul" by Alfieri / Il "Saul" di Alfieri
FUTURIST THEATRICAL SYNTHESIS

Act 1

King SAUL's *encampment on the eve of a battle.*

DAVID (*entering*): Hi, Micol, my wife. Where is your father?

MICOL: Saul is down there talking with a friend, but it would be better if you hid in a cave because he is angry with you, and then he is very nervous these days!

Act 2

SAUL (*entering*): Son of a bitch! Tonight I really had terrible dreams! Maybe I digested badly. I dreamed that my general, that stupid David, wanted to kick me off the throne and make himself king. But you listen to me . . .

DAVID (*entering*): Dear father-in-law Saul, how are you! Is it true that you're angry with me?

SAUL: Oh! David. They have told me certain stories about you, and I have had certain terrible dreams that . . . almost . . . almost . . . Bah! For now, let's leave it at that. Tomorrow is the battle, and you must give me a hand. Let's go get cleaned up and eat breakfast.

Act 3

SAUL (*enters slowly, with an irritated voice*): Poor me! They really want to rob me of everything: peace, sunlight, sons, crown, shoes. Poor me! Poor me! And I think the fault is all David's.

DAVID (*astonished, to his wife*): What! But listen to what he is saying! Has he gone mad?

307

MICOL: Uh! . . .

SAUL (*irritated*): You're the one who is crazy, ugly ape of a David; go away or I'll hit you.

(DAVID *retires strategically.*)

Act 4

The day of the battle.

MICOL: Today is the day of the battle, but it's better if you don't go because my father is so angry that he said if he found you he would kill you.

DAVID: I'm sorry, but when it's like this, I will leave quickly. (*Leaves with* MICOL.)

Act 5

SAUL (*armed and dirty, enters running, with several soldiers*): Oh! Oh! We've been beaten. Damn the enemy! I shall kill myself meanwhile. (*He stabs himself with his sword.*)

END

VOLT [FANI CIOTTI]

Flirt / *Flirt*

A nude woman in the pose of the Venus of Cnidos is under a bell jar. A young man in a smoking jacket dozes in an armchair with a newspaper in his hand.

SHE (*timidly*): I am a respectable woman.

(HE *doesn't rouse.*)

SHE (*with ostentation*): I am a respectable woman.

(HE *turns an absentminded eye, then begins reading the newspaper.*)

SHE (*furious*): I am a respectable woman!
HE (*rises and stretches out his hand, but meets the glass of the bell. In a mellifluous voice.*): My condolences. (*Moves away.*)

(SHE *is seized by a hysterical attack.*)

AMOOOOORE

sintesi teatrale parolibera

LOOOOOVE

Theatrical Parolibera Synthesis

PUPPET SHOWMAN
Moonlight

Hall of a hotel

HIM:	HER:
Give it to me.	I present you with my heart.
Give it to me.	I present you with my heart.
Give it to me.	I present you with my heart.
Give it to me.	I present you with my heart.
Give it to me.	I present you with my heart.
Give it to me.	I present you with my heart.
Give it to me.	I present you with my heart.
Give it to me.	I present you with my heart.
Give it to me.	I present you with my heart.

(sing-song obstinate equal endless)
= piston

uh! ah!

(greedy bestial) (ecstasy falsehood abandonment)

(He tries to kiss her on her mouth.) (She offers him her forehead.)

(puppet-like jumping convulsive)
the kiss lands on her nose

ᵃuh !

Let me come in your room I can't, I swore to be faithful to
others.

Good-bye Good-bye

(He scratches alternatively one — (She goes into the booth.)→
ear then the other ear. Abruptly):

(heroic solemn)

I will go get myself one

(The moonlight
goes out.)

Telephone booth

Musical synchronism ⟨————————————→⟩

OBSCURITY

Electric light

HER:

rrrrrrrrrrrrrrrrrrrrrrrrr.rrrrrrrrrrrrrrrrrrrrrrrrrrrrrrrrrrr

friend
I am fickle but loyal
they have kissed me on the nose
my mouth is saved I am faithful to you. Good-bye!

rr

Est-ce toi Christine?
Bonjour p'tit'amie
Triste? pourquoi?
Moi-aussi!

Viens chez moi demain matin, mon mari sort de bonne heure.
Nous nous amuserons.
Oh! je suis très excitée!!! Nous coucherons ensemble. Où fera un tas
de cochonneries.

Lawyer's office

(slow solemn stupid)
= pendulum

I only kissed her on the forehead.
And she said to me: "You shall not have my body, but no one else
will have it."
And I said to her: "If others kiss you on the mouth, I will kill
myself."
And she said to me: "I will write you everything about myself.
I am fickle but loyal loyal but fickle fickle but loyal loyal but
fickle fickle but loyal loyal but fickle fickle but loyal loyal but
fickleeeeeee . . ." (Yaaaaaaaaaawn.)

rrrrrrrrrrrrrrrrrrrrrrr rrrrrrrrrrrrrrrrrrrrrrrrr

friend
I knew that
aimé! *
good-bye

All the waters of Montecatini would not be enough to purify your
little nose! Is she pure or isn't she pure? Do I kill myself or don't
I kill myself? The truth is in the middle.
I will half-kill myself.
(He cuts the revolver in half with a penknife. Explosion. Exactly half
of his body falls, struck. The globe of moonlight rises like a little
silver ball, breaks through the ceiling, giving off a very white ray
that illuminates the half-corpse for several seconds, then gradually it
goes out. THE OTHER HALF gets to his feet, lights half a Tuscano
cigar, puts on his hat. With half a voice.)
"It is strange how I feel nervous this evening. I can't resist.
I absolutely must leave here to With your permission."
(He salutes the audience and leaves, turning out the electric light.)

* Sic, probably was meant to be amie (French for friend) or aimé (loved).—
Trans.

BURATTINAIO

Chiaro
di
luna

Corridoio d'albergo

Lui					**Lei**				
dammi	la				ti	dono	il	mio	cor
dammi	la				tl	dono	il	mio	cor
dammi	la				ti	dono	il	mio	cor
dammi	la				ti	dono	il	mio	cor
dammi	la				ti	dono	il	mio	cor
dammi	la				ti	dono	il	mio	cor
dammi	la				ti	dono	il	mio	cor
dammi	la				ti	dono	il	mio	cor
dammi	la				ti	dono	il	mio	cor

(cantarellato ostinato eguale interminabile)

= stantuffo

uh! ah!

(cupido bestiale) *(estasi falso abbandono)*

Lui tenta baciarle la bocca Lei gli offre la fronte

(marionettistico saltarellato convulso)

il bacio finisce sul naso

a
u h!

Fammi entrare in camera Non posso, ho giurato fede ad altri

Addio Addio

Si gratta alternativamente l'una e ▶——— *(entra nella cabina)* ———▶
l'altra orecchia. Di scatto:

(eroico solenne)

Vado a farmi una

Il chiaro di luna
si spegne

Hall of a hotel

HIM:	HER:
Give it to me.	I present you with my heart.
Give it to me.	I present you with my heart.
Give it to me.	I present you with my heart.
Give it to me.	I present you with my heart.
Give it to me.	I present you with my heart.
Give it to me.	I present you with my heart.
Give it to me.	I present you with my heart.
Give it to me.	I present you with my heart.
Give it to me.	I present you with my heart.

(sing-song obstinate equal endless)
= piston

uh! ah!

(greedy bestial) *(ecstasy falsehood abandonment)*

(He tries to kiss her on her mouth.) (She offers him her forehead.)

(puppet-like jumping convulsive)
the kiss lands on her nose

$^{a}_{u}$h !

Let me come in your room I can't, I swore to be faithful to
others.

Good-bye Good-bye

(He scratches alternatively one — (She goes into the booth.)→
ear then the other ear. Abruptly):

(heroic solemn)

I will go get myself one

(The moonlight
goes out.)

Cabina telefonica

Sincronismo musicale

←——————————————————————————————→

OSCURITÀ

Luce elettrica

Lei

rr

amico
sono volubile ma leale
mi hanno baciata sul naso
la bocca è salva ti sono fedele. Addio!

rrrrrrrrrrrr rr

Est - ce toi Christine?
Bonjour p'tit'amie
Triste? pourquoi?
Moi - aussi!

Viens chez moi demain matin, mon mari sort de bonne heure.
Nous nous amuserons.
Oh! je suis très excitée!!! nous coucherons ensemble. Ou fera un
tas de cochonneries.

Telephone booth

Musical synchronism

\longleftrightarrow

OBSCURITY

Electric light

HER:

trrrrrrrrrrrrrrrrrrr rrrrrr rrr

friend
I am fickle but loyal
they have kissed me on the nose
my mouth is saved I am faithful to you. Good-bye!

trrrrrrrrrrrrrrrrrrr rrrrrr rrr

Est-ce toi Christine?
Bonjour p'tit'amie
Triste? pourquoi?
Moi-aussi!

Viens chez moi demain matin, mon mari sort de bonne heure.
Nous nous amuserons.
Oh! je suis très excitée!!! Nous coucherons ensemble. Où fera un tas
de cochonneries.

* The translation of the above French might be rendered thus:

Is that you Christine?
Good day little friend
Sad? Why?
Me too!

Come to my house tomorrow morning. My husband leaves early.
We will amuse ourselves.
Oh! I am very excited!!! We will sleep together. We will
be little devils.

Studio d'avvocato

Io sono
l'amico lontano

è pura o non è pura?
è pura o non è pura?
è pura o non è pura?
è pura o non è pura?
è pura o non è pura?
è pura o non è pura?

(lento solenne addormentato)

= *pendolo*

Io non l'ho baciata che sulla fronte.

Ed essa mi ha detto: «Tu non avrai il mio corpo, ma nessun altro l'avrà»

Ed io le ho detto: «Se altri ti bacia sulla bocca, mi uccido»

Ed essa mi ha detto: «Ti scriverò tutto di me. Sono volubile ma leale leale ma volubile volubile ma leale leale ma volubile volubile ma leale leale ma volubile volubile ma leale leale ma volubile (la donna è mobile) volubile ma leale leale ma volubileeeeeeee ... *(sbaaaaaaaaaaaaadiglio)*

trr

amica

Io sapevo

aimè!

addio

Tutte le acque di Montecatini non basterebbero a purgare il tuo piccolo naso! è pura o non è pura? Mi uccido o non mi uccido? La verità è nel mezzo.

Mi ucciderò a metà.

Taglia con un temperino a metà la rivoltella. Esplosione. Metà esatta del suo corpo cade fulminata. Il globo del chiaro di luna si eleva come un palloncino argenteo, sfonda il soffitto, donde un raggio bianchissimo illumina per alcuni istanti la mezza salma, poi si spegne gradatamente. **L'altra metà** *si alza in piedi, accende mezzo toscano, si mette il cappello. A mezza voce:*

«È strano come mi sento nervoso questa sera. Non posso resistere. Bisogna assolutamente che me ne vada a Con permesso»

(Saluta il pubblico ed esce spegnendo la luce elettrica).

(*slow solemn stupid*)
= *pendulum*

I only kissed her on the forehead.
And she said to me: "You shall not have my body, but no one else will have it."
And I said to her: "If others kiss you on the mouth, I will kill myself."
And she said to me: "I will write you everything about myself. I am fickle but loyal loyal but fickle fickle but loyal loyal but fickle fickle but loyal loyal but fickle fickle but loyal loyal but fickleeeeeeee . . ." (*Yaaaaaaaaaawn.*)

trrrrrrrrrrrrrrrrrr rrrrrrrrrrrrrrrrrrrrrrrrrr

friend
I knew that
aimé! *
good-bye

All the waters of Montecatini would not be enough to purify your little nose! Is she pure or isn't she pure? Do I kill myself or don't I kill myself? The truth is in the middle.
I will half-kill myself.
(*He cuts the revolver in half with a penknife. Explosion. Exactly half of his body falls, struck. The globe of moonlight rises like a little silver ball, breaks through the ceiling, giving off a very white ray that illuminates the half-corpse for several seconds, then gradually it*

* Sic, probably was meant to be *amie* (French for friend) or *aimé* (loved).—
Trans.

goes out. THE OTHER HALF *gets to his feet, lights half a Tuscano cigar, puts on his hat. With half a voice.*)
"It is strange how I feel nervous this evening. I can't resist.
I absolutely must leave here to With your permission."
(*He salutes the audience and leaves, turning out the electric light.*)

Selected Chronology
of Futurist Performance

1909

February 20 "Foundation and Manifesto of Futurism" by Marinetti, published in *Le Figaro,* Paris.

1910

January–February Futurist *serate* or "evenings" are presented. The first evening in which the painters took part was held at the Teatro Ciarella, Turin, on March 8, 1910.

1911

January 11 "Manifesto of Futurist Playwrights" published by Marinetti and nineteen others.

March 11 "The Technical Manifesto of Futurist Music" published by Pratella.

1913

February 21 *Musica Futurista per Orchestra* by Pratella, performed at the Teatro Costanzi, Rome.

March 11 "The Art of Noise" manifesto published by Russolo.

June 2 *Intonarumori,* built by Russolo and Ugo Piatti, demonstrated at the Teatro Stocchi, Modena.

August 11 First public performance of *intonarumori* at the Casa Rossa, Milan.

October 1 "The Variety Theatre" manifesto, published in *Lacerba.* Translated into English, it later appeared in the *Daily Mail* (London: November 21, 1913) and *The Mask* (January, 1914).

1914

March 11 "Dynamic and Synoptic Declamation" manifesto published by Marinetti.

March 29 and April 5 *Piedigrotta* by Cangiullo, the first "evening of

dynamic and synoptic declamation," presented at the Sprovieri Gallery, Rome.

April 13 "Funeral of a Passéist Critic" presented at the Sprovieri Gallery.

Early May (possibly April 28–May 5) Three evenings of "dynamic and synoptic declamation" presented by Marinetti at the Doré Gallery, London.

June 15 Russolo directs a concert of *intonarumori* at the Coliseum, London.

1915

January 11 "The Futurist Synthetic Theatre" manifesto signed by Marinetti, Settimelli, and Corra.

February First collection of *sintesi* published.

March "Futurist Scenography and Choreography" by Prampolini, published in *La Balza*.

November 28–December 5 Thirty-six *sintesi* are published by *Gli Avvenimenti* in a supplement on "Futurist Synthetic Theatre." In April, 1916, the newspaper published forty-three more scripts in another supplement with the same title.

During 1915 and 1916 the acting companies of Ettore Petrolini, Luciano Molinari, Gualtiero Tumiati, Annibale Ninchi, and others tour the leading Italian cities presenting programs of *sintesi*.

1916

September 11 The "Futurist Cinematography" manifesto signed by Marinetti, Corra, Settimelli, Ginna, Balla, and Chiti.

Vita Futurista, one of the earliest avant-garde films, produced by Ginna and other Futurists.

Ettore Petrolini presents nine *sintesi* by Cangiullo at the Theatro Adriano, Rome.

1917

January 28 First public showing of *Vita Futurista*, the Niccolini Theatre, Florence.

April 12 *Fireworks (Feu d'Artifice)*, an actorless performance, staged by Balla for Diaghilev's Ballet Russe at the Costanzi Theatre, Rome.

July 8 "Manifesto of Futurist Dance" published by Marinetti. *Radio-*

scopia by Cangiullo and Petrolini mixes actors and audience in a performance in Naples.

1918

Spring Azari performs "Aerial Theatre" in the sky over Busto Arsizio. Depero and Clavel choreograph the *Plastic Dances,* an evening of short pieces performed by marionettes, at the Teatro dei Piccoli, Rome.

1919

April The "Futurist Aerial Theatre" manifesto, published by Azari. Prampolini stages *Matoum et Tevibar* with marionettes at the Teatro dei Piccoli.

1921

January Marinetti publishes "Tactilism," a manifesto calling, in part, for a "theatre of touch."

September 30 The Theatre of Surprise company performs in Naples, then tours Palermo, Rome, Florence, Genoa, Turin, and Milan. The company continues to tour until 1923.

October 11 "The Theatre of Surprise" manifesto signed by Marinetti and Cangiullo. It was published in *Il Futurismo* on January 11, 1922.

1924

"Futurist Scenic Atmosphere" published by Prampolini in *Noi.* The New Futurist Theatre tours twenty-eight Italian cities.

1925

A model of Prampolini's Magnetic Theatre wins a prize at the International Exposition of Decorative Arts in Paris.

1927

Prampolini coproduces the Theatre of Futurist Pantomime in Paris.

1928

Prampolini stages *Sacred Speed* (*Santa Velocità*), an actorless performance.

1933

October The "Futurist Radiophonic Theatre" manifesto, published by Marinetti and Masnata in *Gazetta del Popolo.*

Selected Bibliography

A. In English

PRIMARY SOURCES

Carrà, Carlo. "The Futurist Soirées." *Art and the Stage in the Twentieth Century,* ed. Henning Rischbieter. Greenwich, Connecticut: New York Graphic Society Ltd., 1968.

Clavel, Gilberto. [Gilbert Clavel.] "Depero's Plastic Theatre." *Art and the Stage in the Twentieth Century,* ed. Henning Rischbieter. Greenwich, Connecticut: New York Graphic Society Ltd., 1968.

Depero, Fortunato. *So I Think / So I Paint.* Translated by Raffaella Lotteri. Trento: Mutilati e Invalidi, 1947.

Marinetti, Filippo Tommaso. "Futurism and the Theatre," *The Mask* (January, 1914), pp. 188–193. A manifesto with peevish footnotes, apparently by Gordon Craig. Reprinted in *Total Theatre,* ed. E. T. Kirby. New York: E. P. Dutton & Co., Inc., 1969.

————. "The Meaning of the Music-Hall." *The Daily Mail* (London), November 21, 1913. "The Variety Theatre" manifesto, slightly edited.

————, Settimelli, Emilio, and Corra, Bruno. "The Synthetic Futurist Theatre." *Art and the Stage in the Twentieth Century,* ed. Henning Rischbieter. Greenwich, Connecticut: New York Graphic Society Ltd., 1968.

Prampolini, Enrico. "The Futurist Pantomime." *Art and the Stage in the Twentieth Century,* ed. Henning Rischbieter. Greenwich, Connecticut: New York Graphic Society Ltd., 1968.

————. "Futurist Scenography." *Total Theatre,* ed. E. T. Kirby. New York: E. P. Dutton & Co., Inc., 1969.

————. "The Magnetic Theatre and the Futurist Scenic Atmosphere." *The Little Review* (Winter, 1926), pp. 101–108.

Russolo, Luigi. *The Art of Noise.* Translated by Robert Filliou. New York: Something Else Press, 1967. Russolo's "L'Arte dei Rumori" manifesto. This "Great Bear Pamphlet" also contains a brief de-

scription by Russolo of the "First Concert of Futurist Noise Instruments."

————. "Psofarmoni," *The Little Review* (Winter, 1926), pp. 51–52.

SECONDARY SOURCES

Carrieri, Raffaele. *Futurism*. Milan: Edizioni del Milione, 1963. Concentrating on painting and sculpture, this book contains manifestos, reproductions, and photographs, including some of Bragaglia's 1913 motion photographs.

Cary, Joseph. "Futurism and the French *Théâtre d'Avant-Garde*," *Modern Philology* (November, 1959). Reprinted in *Total Theatre*, ed. E. T. Kirby. New York: E. P. Dutton & Co., Inc., 1969.

Clough, Rosa Trillo. *Futurism—The Story of a Modern Art Movement, a New Appraisal*. New York: The Philosophical Library, 1961. One of the only sources in English that devotes space to Futurist performance as well as the other arts. This somewhat superficial book is of dangerously dubious scholarship, however: much of the material is directly translated from the Italian, but infrequent use of quotation marks often eliminates the distinction between quotation, paraphrase, and the author's own words. It contains a good bibliography.

Craig, Gordon. "Futurismo and the Theatre," *The Mask* (January, 1914), pp. 194–200. Tells little about Futurism but much about Gordon Craig.

Durgnat, Raymond. "Futurism and the Movies," *Art and Artists* (February, 1969), pp. 10–15.

Fagiolo dell'Arco, Maurizio. "Balla's Prophecies," *Art International* (Summer, 1968), pp. 63–68.

Gordon, Maxim. "The Italian Futurists," *Theatre Magazine* (September, 1925).

Kirby, E. T. "Futurism and the Theatre of the Future." *Total Theatre*, ed. E. T. Kirby. New York: E. P. Dutton & Co., Inc., 1969.

"Making a Target of the Audience," *The Literary Digest* (December 3, 1921), p. 27.

Martin, Marianne W. *Futurist Art and Theory 1909–1915*. Oxford: Clarendon Press, 1968. As the title suggests, this excellent book on the origins and early years of Futurism concentrates on painting and sculpture, but there are many illustrations and a chapter on Marinetti's life.

Rischbieter, Henning. "Futurism and the Theatre." *Art and the Stage*

in the Twentieth Century, ed. H. Rischbieter. Greenwich, Connecticut: New York Graphic Society Ltd., 1968.

Taylor, Joshua C. *Futurism.* New York: The Museum of Modern Art, 1961. Another excellent book concentrating on Futurist painting and sculpture. There is a useful chronology, a selected bibliography, and short biographies of many of the Futurists.

B. In Italian

PRIMARY SOURCES

Angelis, Rodolfo De. *Noi Futuristi.* Venice: Edizioni del Cavallino, 1958.

Gli Avvenimenti (Milan). In 1915 and 1916 Pratella wrote a music column in this newspaper, Boccioni wrote on art, and Buzzi on poetry.

Azari, Fedele. "Théâtre Aérien Futuriste." *Roma Futurista,* January 18, 1920.

Buzzi, Paolo. *L'Ellisse e il Spirale.* Milan: Edizioni Futuriste di *Poesia,* 1915.

Cangiullo, Francesco. *Le Serate Futuriste.* Naples: 1930. Republished, Milan: Casa Editrice Ceschina, 1961.

————, and Marinetti, Filippo Tommaso. *Il Teatro della Sorpresa.* Milan: "Il Futurismo," 1922. Republished, Leghorn: Paolo Belforte Editore, 1968.

Carrieri, Raffaele. *La Danza in Italia 1500–1900.* Milan: Editoriale Domus, 1946. Includes rare photographs of Depero's wooden marionettes for the *Plastic Ballets.*

Corra, Bruno. *Per l'Arte Nuova della Nuova Italia.* Milan: Studio Editoriale Lombardo, 1918. A collection of manifestos and essays by Corra.

Depero, Fortunato. "Appunti sul Teatro." *Fortunato Depero.* Turin: Gallerie d'Arte Martano, 1969.

Dessy, Mario. *Vostro Martio non Va? . . . Cambiatelo!* Milan: Edizioni Futuriste di *Poesia,* 1919.

Gambillo, Maria Drudi, and Fiori, Teresa (eds.). *Archivi del Futurismo.* 2 vols. Rome: DeLuca Editore, 1958 (Vol. 1) and 1962 (Vol. 2). An important collection of primary source materials: letters, articles, and manifestos. There is a chronology (1909–1921); the bibliography is extended to 1962 in the second volume, which contains a great number of photographs.

Ginna, Arnaldo. "Note sul Film d'Avanguardia Vita Futurista." *Bianco e Nero* (May-June, 1965), pp. 156–158. This issue also includes material on *Il Perfido Incanto.*

Lacerba (Florence). Published between 1913 and 1915, this review is especially important for its material on Futurist music.

Marinetti, Filippo Tommaso. *Teatro F. T. Marinetti,* ed. Giovanni Calendoli. 3 vols. Rome: Vito Bianco Editore, 1960.

——— (ed.). *Il Teatro Futurista.* Naples: Editrice Clet, 1941. A collection of fifty-three short plays, five radio *sintesi* by Marinetti and nine by Pino Masnata, and five manifestos.

Montalti, Mauro. "Per un Nuovo Teatro 'Elettro-Vibro-Luminoso.' " *Roma Futurista,* January 4, 1920.

Noi (Rome). Published between 1916 and 1925. Several issues of this magazine contain material on Futurist performance.

Prampolini, Enrico. "L'Atmosfera Scènica Futurista." *Enrico Prampolini,* ed. Palma Bucarelli. Rome: DeLuca Editore, 1961.

———. "Scenografia e Coreografia Futurista." *Enrico Prampolini,* ed. Palma Bucarelli. Rome: DeLuca Editore, 1961.

Pratella, F. Balilla. *L'Aviatore Dro.* Milan: Casa Musicale Sonzogno, 1920. A "tragic poem in three acts." Although Pratella is listed as composing the music, it is not included in this volume.

———. "Gl'Intonarumori nell'Orchestra," *Lacerba* (May 15, 1914), p. 151.

———. "La Musica Futurista," *Noi Futuristi,* ed. Riccardo Quintieri. Milan: 1917.

Roma Futurista. Especially in 1920, this Futurist newspaper carried a number of scripts and performance manifestos, as well as articles, poetry, and illustrations.

Russolo, Luigi. "L'Arte dei Rumori," *Noi Futuristi,* ed. Riccardo Quintieri. Milan: 1917.

———. "Conquista Totale dell'Enarmonismo Mediante gl'Intonarumori Futuristi," *Lacerba* (November 1, 1913), pp. 242, 244–245.

———. "Grafia Enarmonica per gl'Intonarumori Futuristi," *Lacerba* (March 1, 1914), pp. 74–75.

———. "Gl'Intonarumori Futuristi," *Lacerba* (July 1, 1913), pp. 140–141.

Scrivo, Luigi (ed.). *Sintesi del Futurismo, Storia e Documenti.* Rome: Mario Bulzoni Editore, 1968. A collection of seventy-eight manifestos covering all phases of Futurism: it includes all of the major manifestos up to 1920 and a number of later ones. Many of the manifestos are photographically reproduced from the originals.

Sipario (December, 1967). This issue is devoted to Futurist theatre. An excellent collection of manifestos, scripts, articles, and photographs.

Teatro (Milan). March–April, 1927. Contains thirty-three *sintesi* and five articles.

"Teatro Futurista Sintètico," *Gli Avvenimenti,* supplement, November 28–December 5, 1915. Contains the "Synthetic Theatre" manifesto and thirty-six *sintesi.*

"Teatro Futurista Sintètico," *Gli Avvenimento,* supplement, April 2–9, 1916. Contains forty-three *sintesi,* all different from those in the 1915 supplement.

Verdone, Mario, (ed.). "Sintesi Teatrali Futuriste." *Carte Segrete* (January–March, 1969), pp. 119–140. A collection of *sintesi* with an introduction by Verdone.

Volt. [Fani Ciotti.] *Archivoltaici.* Milan: Edizione Futurista di *Poesia,* 1916.

SECONDARY SOURCES

Bartolucci, Giuseppe (ed.). *Il "Gesto" Futurista.* Rome: Mario Bulzoni Editore, 1969.

Belloli, Carlo. "Poetiche e Pratiche del Cinema d'Avanguardia dalle Origini agli Anni Trenta," *La Biennale di Venezia,* Number 54 (September, 1964), pp. 35–51.

———. "Lo Spettacolo Futurista: Teatro, Danza, Cinema, Radio," *Fenarete,* Anno XV, No. 1 (1963), pp. 42–53.

———. "Il Teatro Futurista." *Fenarete,* Anno XV, No. 1 (1963), pp. 21–41.

Bucarelli, Palma (ed.). *Enrico Prampolini.* Rome: DeLuca Editore, 1961. The catalogue of the Prampolini exhibition at the National Gallery of Modern Art, Rome. In addition to reproductions of all the paintings in the show, the volume includes a biography, chronologies of Prampolini's work in theatre and his publications, and a selection of his writings, including the manifestos.

Calendoli, Giovanni. "Dai Futuristi a Pirandello Attraverso il Grottesco," *Sipario* (December, 1967), pp. 14–16.

———. "Introduzione." *Teatro F. T. Marinetti,* ed. Calendoli. 3 vols. Rome: Vito Bianco Editore, 1960. A detailed and authoritative discussion of Marinetti's life and his writings for the theatre.

Chiti, Remo. *I Creatori del Theatro Futurista.* Florence: Quattrini [1913?].

Fagiolo dell'Arco, Maurizio. *Balla: Ricostruzione Futurista dell'Universo.*

Rome: Mario Bulzoni Editore, 1968. An excellent and important book that includes scripts and designs by Balla and a scholarly and comprehensive account of the artist's work in theatre.

————. *Omaggio a Balla*. Rome: Mario Bulzoni Editore, 1967.

Falqui, Enrico. *Bibliografia e Inconografia del Futurismo*. Florence: Sansoni, 1959. One section of this bibliography is specifically on theatre.

Fortunato Depero. Turin: Gallerie d'Arte Martano, 1969. The catalogue for an exhibition of Depero's paintings, this booklet includes a detailed biographical and creative chronology, photographs, reproductions, and selected writings.

Gori, Gino. *Scenografia. La Tradizione e la Rivoluzione Contemporanea*. Rome: Casa Editrice Alberto Stock, 1926.

Menna, Filiberto. *Enrico Prampolini*. Rome: DeLuca Editore, [1967?].

Pavolini, C. "Futurismo," *Enciclopedia dello Spettacolo*. Vol. V. Rome: Casa Editrice le Maschere, 1958.

Verdone, Mario. "Cinema e Futurismo," *La Biennale di Venezia*, Number 54 (September, 1964), pp. 15–25.

————. (ed.). *Bianco e Nero* (October-November-December, 1967). A large issue of the film and television journal devoted to "Ginna and Corra—the Cinema and Literature of Futurism." Verdone's long essay is thorough, scholarly, and detailed. An anthology of documents, includes manifestos, scripts, articles, and photographs.

Index

Note: Page numbers in brackets indicate the actual script or manifesto text; those in italics indicate photographs.

MICHAEL KIRBY is a playwright/director who presented his latest play, *The First Signs of Decadence*, in Turin, Italy. He is also an actor who has recently returned from a world tour with the Wooster Group. Kirby has exhibited computer graphic and photographic sculptures internationally. He is the author of numerous articles and books, most recently the forthcoming *A Formalist Theatre*. Kirby was editor of *The Drama Review* for fourteen years and is a professor in the Performance Studies Department at New York University.

VICTORIA NES KIRBY has been a theatre critic, photographer and translator for *The Drama Review* and is the author of numerous articles published in the United States and Europe. Ms. Kirby is also a theatre producer, artists' manager, and a professional singer and performance artist. Based in San Francisco for the past eleven years, Ms. Kirby currently works as a public relations and arts administration consultant.

DATE DUE

DEC 1 6 1988			
FEB 2 2 1999			
MAY 3 1999			

DEMCO 38-297